STORM OVER THE LAND

A Profile of The Civil War

by

Carl Sandburg

KONECKY&KONECKY

Konecky & Konecky
72 Ayers Point Rd.
Old Saybrook, CT 06475

ISBN: 1-56852-042-5

Printed in the United States of America

PREFACE

The United States of America, often termed the American Union of States, had its unity hammered out in storm. After that storm it was something else again—a World Power, figured as a potential in future world affairs. While the storm raged a leading spokesman mentioned its interest for the whole Family of Man.

The story of this storm, if it could all be known and told, would take ten times longer to tell than it took to happen. The longest telling of it in any single book would have to leave out anything like full discussion of the actions and issues involved. Economic, racial, moral, cultural, and climatic factors interwove. Military and political elements tangled. Amid a wilderness of fact and illustration the maker of a narrative picks his way and considers the instruction "Write till you are ashamed of yourself and then cut it down next to nothing so the reader may hope beforehand he is not wasting his time."

The storm aforementioned, however, had its highlight events of beginning and end. While the issues are too vast and complicated for undisputed analysis and crystal-clear statement, we do know when the shooting started and when it stopped. We can be absolute about a few of the big moments dazzling with decisions at bloody crossroads. We can see clear certain definite surface actions, each vast with destiny,

each vocal with its characters on record through fiery trial. These may be presented to readers. Those of inquiring mind may go as much farther as they personally choose in the easily available further source materials primary and secondary. The tale is not idle. It means more than passing the time of day or making a long wait somewhere a little shorter. It holds valor and struggle worth looking at, days of doom and humility not lacking their lessons, psalms of desolation and the silent writhing of the agonized, rainbow promises of hope and dream for the American Union of States.

So runs part of the design of this one volume carved mainly from the pages of the four-volume book *Abraham Lincoln: The War Years*. The plan for such a book was first proposed by Elisabeth Bevier Hamilton, and we are indebted to her for skilled editorial work in the preparation of the manuscript. For the sake of brevity and sequence the author has rewritten some sections of the larger work for service herein, on occasion adding new text. Perhaps the volume can be of use in a time of storm to those inexorably aware "time is short." Perhaps they may find shapes of great companions out of the past and possibly touches of instruction not to be used like broken eggs beyond mending.

<div style="text-align: right">C. S.</div>

CONTENTS

STORM OVER THE LAND

There never was, and probably never will be, a more interesting subject of political study than the present condition of America. Every problem of the past, and every political difficulty of the present, is there working itself out visibly before our eyes. Evils which have perplexed the nations since the dawn of history demand their instant removal, while every form of government from mob-rule to the closest oligarchy is asserting by force its right, not only to exist, but to become supreme. The comparative force of democracy and aristocracy, their relative power of remedying discovered mischiefs, their ultimate tendencies, and their common evils, are exhibited on a scale and with a rapidity which affords to mankind the opportunity of a political education such as it has not enjoyed since Greece was submerged under the Roman wave. And, amidst all these difficulties, the American people alone in history have to work out, not in the course of ages but at once, the problem which is older than any form of government now in existence, the extinction of human slavery.

—The *Spectator* of London, England, 28 December, 1861

FLICKER OF STORM

IN 1861 it was hardly seven years since that meeting of the Anti-Slavery Society near Boston when William Lloyd Garrison had read the Fugitive Slave Act, had then read the court order of a Federal judge handing a fugitive slave back to its owner, and had then lighted matches to both documents, crying as they burned, "And let all the people say Amen!" As a piece of drama it was tense. As a testament and a reality it had a flicker of great storm.

Was a war between States coming? A civil war? Those listening could hear some voices saying a long bloody war was ahead—other voices sure it could be smoothed over and peace fixed by talk and negotiation—and many other voices "Maybe it will blow over, or maybe there will be hell to pay—maybe—nobody knows, everybody guesses." Men of books pointed to old philosophers holding, "The reasons for war are deep and tangled—and a crackpot fool or lunatic can start a war if the conditions have been prepared by time and events." Was a great human storm now to be let loose on the land? Had time and events, political and economic weather laid the way for wild and bloody storm?

Only tall stacks of documents recording the steel of fact and the fog of dream could tell the intricate tale of the shaping of a national fate; of men saying Yes when they meant No and No when they meant Perhaps; of newspapers North

and South lying to their readers and pandering to the cheaper passions of party and class interest; of the men and women of the ruling classes North and South being dominated more often than not by love of money and power; of the Southern planters and merchants being $200,000,000 in debt to the North; of the paradoxes involved in the Northern hope of the black man's freedom in the South; of the race question that was one thing in the blizzard region of New England, where a Negro was pointed out on the streets as a rare curiosity, and something else again in the deep drowsy tropical South, where in so many areas the Negro outnumbered the white man; of the greed of Savannah and Mobile slave-traders; of how the prohibitory law as to fugitive slaves was mocked at by abolitionists stealing slave property and running it North to freedom; of abolitionists hanged, shot, stabbed, mutilated; of the Northern manufacturer being able to throw out men or machines no longer profitable while the Southern planter could not so easily scrap his production apparatus of living black men and women; of stock and bond markets becoming huge gambling enterprises in which fleeced customers learned later that the dice had been loaded; of automatic machinery slightly guided by human hands producing shoes, fabrics, scissors; of the animalism of the exploitation of man by man North and South; of the miscellaneous array of propertied interests in the North which would stand to lose trade and profits, land titles, payments of legitimate debts, through a divided Union of States; of the clean and inexplicably mystic dream that lay in many humble hearts of an indissoluble Federal Union of States; of the certainty that the new Republican-party power at Washington

would be aimed to limit extension of slavery and put it in the course of ultimate extinction; of the 260,000 free Negroes in the South owning property valued at $25,000,000; of the Southern poor white lacking the guarantees of food, clothing, shelter, and employment assured the Negro field hand; of Northern factory workers paid a bare subsistence wage, lacking security against sickness, old age, unemployment while alive and funeral costs when finally dead; of the one-crop Cotton States' heavy dependence on the Border Slave States and the North for food supplies, implements, and clothing; of the Cotton States' delusion that New England and Europe were economic dependents of King Cotton; of the American system having densely intricate undergrowths, old rootholds of a political past, suddenly interfered with by rank and powerful economic upshoots.

Thus might run a jagged sketch of the Divided House over which Lincoln was to be Chief Magistrate. At his home in Springfield, Illinois, and on his way to Washington to be sworn in, Lincoln kept silence on what he would do as President. "Will he start a war?" and "What can he do that will not bring war?" were questions asked everywhere. And in his eleven-day journey across Northern States, stopping in key cities and facing immense crowds, he refused to give out any parts of his inaugural address telling what he would do. Discussion raged and roared as to what he meant by telling the Ohio State Legislature, "There is nothing going wrong . . . nobody is suffering anything." The powerful *New York Herald* in an editorial advised Lincoln to resign in favor of a more "acceptable" man, otherwise he would

"totter into a dishonoured grave . . . leaving behind him a
memory more execrable than that of [Benedict] Arnold."

Lincoln humbled himself and bowed low before what was
to come. "I cannot but know what you all know, that with-
out a name, perhaps without a reason why I should have a
name, there has fallen upon me a task such as did not rest
even upon the Father of his Country." What kind of a Presi-

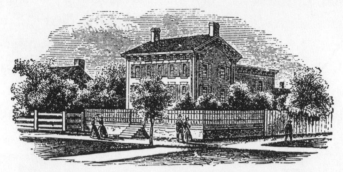

The Home of Abraham Lincoln, Springfield, Illinois

dent would he make? How would he handle the storm? So
people asked over the land. They knew he had come up the
hard way. But now would he, or could any other man, be
hard enough to meet this storm and not be swept away by it?

Born in the Kentucky wilderness in 1809 in a one-room,
clay-floor, log cabin, this Abraham Lincoln had grown up
among pioneers who said, "You never cuss a good ax," had
worked hard in fields and woods, going to school only a few
months, borrowing books and burrowing through them, end-
lessly studying books—and people. What education came to
him, he said, was "picked up." As a lawyer, member of the
Illinois Legislature, Congressman during the Mexican War,
he became no national figure. The country got its first real

look at him in 1858 when he wrestled with the distinguished United States Senator Stephen A. Douglas in nine furious debates over the State of Illinois. They threshed out the slavery question. By the way Lincoln handled himself some thought

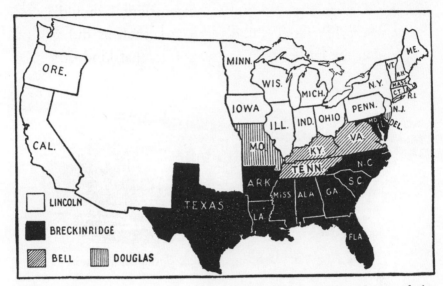

How the States voted in 1860. Lincoln carried all the Free States of the North and the Far West. All States of the Deep South went for Breckinridge, who also won Maryland and Delaware. The Constitutional Union ticket of Bell and Everett carried the three States of Virginia, Kentucky, and Tennessee. Douglas carried Missouri, and received part of the electoral vote of New Jersey. From Albert Shaw's *Abraham Lincoln, Year of His Election.*

he would make a President. In November of 1860 he had enough votes to win though the other candidates against him had a majority of the votes. So the point was raised that while his election was legal he was not favored by a majority of the nation. His personality not yet tried by events, his ability not known nor proved, there was wonder and puzzling about what he would do. Among the country's mystery figures he was Number One.

"Resistance to Lincoln is Obedience to God" flared a banner at an Alabama mass meeting where an orator swore that if need be their troops would march to the doors of the national Capitol over "fathoms of mangled bodies." The sister States forming a Confederacy were satisfied with the Alabama resolution not to submit nor be party to the inaugura-

View of Charleston from the ramparts of Castle Pinckney.
From a sketch made in 1861.

tion of Abraham Lincoln as President. Against the advice of others that South Carolina should not secede till President Buchanan's term was ended, Robert Barnwell Rhett and his forces had manipulated the precise dramatic event Rhett had sought and planned for years.

The driving motive of Rhett's life was to win secession and Southern independence, build a Confederacy on the cornerstone of African slavery, and restore the African slave trade outlawed by the United States Constitution. Rhett

formed combinations and organized minutemen of the revolution and vigilance committees, to make sure of delegates pledged to secession. He wrote the ordinance of disunion and in secret session the convention's 169 delegates at Charleston on December 20, 1860, passed it without debate in forty-five minutes.

That evening at Institute Hall, packed with a breathless crowd, the convention delegates one by one signed the parchment sheet engrossed with Rhett's sentence: "The union now subsisting between South Carolina and other States, under the name of 'The United States of America,' is hereby dissolved." A great shout rocked the hall.

A newly adopted flag was brought out with fifteen stars, one star for each Slave State. Again a great shout rocked the hall, and from lowlands to the upcountry were bells, bonfires, torchlights, parades, shotgun salutes, and cries of jubilee. The convention four days later adopted an Address to the Slaveholding States in which South Carolina asked "to be one of a great Slaveholding Confederacy, stretching its arms over a territory larger than any power in Europe possesses." The hypocrisy and faithlessness of thirty years of antislavery fanaticism had broken the old identity of interests: "The people of the North have not left us in doubt as to their designs and policy. United as a section in the late Presidential election, they have elected as the exponent of their policy one who has openly declared that all the States of the United States must be made Free States or Slave States."

Rhett gave his one-sentence propaganda picture, true in part, of the Northern States which had elected Lincoln: "They prefer a system of industry in which capital and labor

are in perpetual conflict—and chronic starvation keeps down the natural increase of population—and a man is worked out in eight years—and the law ordains that children shall be worked only eight hours a day—and the saber and bayonet are the instruments of order."

When six States established the Confederate Government at Montgomery, Jefferson Davis was introduced to the crowd as its President and a constitution was adopted.

United States Senators and Congressmen stood up in Washington and spoke farewells, some bitter, some sad. United States postmasters, judges, district attorneys, customs collectors, by the hundreds sent their resignations to Washington. The mint for coining United States money at New Orleans, and two smaller mints, were taken over by the Confederate States. Of the 1,108 officers of the United States Regular Army, 387 were preparing resignations, many having already joined the Confederate forces. Governors of seceded States marched in troops and took over seventeen forts that had cost the United States $6,000,000, marine hospitals and arsenals, customhouses and lighthouses at scores of points.

The revolution hinged first on what the United States Government would do about forts, arsenals, customhouses, property gone from its possession. The country expected the President-elect, Abraham Lincoln, to speak out on that subject in his inaugural address on arrival at the capital.

Violence, the smell of the kill, was in the air. If Lincoln should try to retake the seized forts, he would have to kill and kill in sickening numbers, said a Congressman from Kentucky: "From the blood of your victims, as from the fabled dragons' teeth, will spring up crops of armed men, whose re-

ligion it will be to hate and curse you." In the very air of
the City of Washington was coming a sense of change, of
some new deal, of an impending program to be wrought out
on historic anvils in smoke and mist and reckless slang, of
old bonds and moorings broken beyond holding by old
thongs and anchors.

Only the hard of hearing had not heard of the Crittenden
Compromise that winter. All territory north of the southern
boundary line of Missouri, running to the Pacific Ocean,
would be free soil forever, and all territory south of that
line would be slave soil forever, by Constitutional Amend-
ment, said the Crittenden Compromise. And the Constitution
would furthermore declare that Congress was forbidden ever
to abolish slavery or interfere with it in Slave States or in the
District of Columbia. Furthermore, the national Government
would pay slaveowners for slave property lost through action
of mobs or law courts in the North. Thus Old Man Critten-
den would bargain with the seceded States and give them all
they might ask for to stay in the Union.

John Brown, the hanged and buried abolitionist, was out
of jail, out of his grave, stalking as a tall ghost of terror and
insurrection to the South, moving as an evangel telling the
antislavery cohorts of the North that taxes, war, sacrifice,
rivers of blood, intimate death and personal obliteration, were
better than peace and conciliation bought by saying Yes to
slavery. Between extremists South and North, language was
gone, words had been sucked of all meaning, and for them
any compromise would only mark an intermission filled with
further evasions, treacheries, and crimes.

The Crittenden Compromise marched up the hill and then marched down again. The forces against it had been long in growing and breeding, and the snarl of their release was as ancient as it was modern. Behind each event operating for peace came another to cancel it. In November the pale light of the Crittenden concessions might have brought delay and delay would have staved off secession. But the secession conventions, with curses on the Union as they declared for "perpetual separation," had wrought effects.

From the six States signed up for revolution now went Commissioners, agents, and committees, trying to swing the other nine Slave States into line. They pleaded that Lincoln's election was a decree of race equality, a signal to the Southern Negroes to kill their masters, burn the barns and crops, violate the wives and daughters of the South. "Property worth not less than four hundred million dollars" in African slaves, a fixed domestic institution, was to be confiscated. In politics it was time for separation. Why wait longer?

It was sunset and dawn, moonrise and noon, dying time and birthing hour, dry leaves of the last of autumn and springtime blossom roots. "Nobody knows, everybody guesses."

CHAPTER 2

WAR CHALLENGE AT SUMTER

ON the second day he was President, Lincoln made a cool, dry little speech to a visiting Pennsylvania delegation, saying he would like to spread the idea "that we may not, like Pharisees, set ourselves up to be better than other people."

As a President he would prefer them to feel "while we exercise our opinion, that others have also rights to their exercises of opinions, and that we should endeavor to allow these rights, and act in such a manner as to create no bad feeling."

His second speech that day included thanks to a Massachusetts delegation for its sanctioning his inaugural address and assuring him of support. He would hold *national views* as President: "I hope to be man enough not to know one citizen of the United States from another, nor one section from another."

Both these speeches had the equilibrist air of a man refusing to lose self-possession—refusing to be swept off his feet by hotheads—refusing to be put in a hole by shrewd schemers trying to outguess him.

Many balanced points he had considered in naming his Cabinet of seven helpers, seven men to head government departments and give him advice he might need. "They will eat you up," he was told, and replied, "They will be just as likely to eat each other up."

13

The new Secretary of State, William Henry Seward of New York, eight years older than Lincoln, had been, until Lincoln's nomination and election, the leader of the Republican party. Ratings of him ranged from Horace Greeley, editor of the *New York Tribune*, writing to Congressman Schuyler Colfax, "Seward is a poor worthless devil and Old Abe seems to have a weakness for such," to the journalist E. L. Godkin writing Seward was "perhaps the greatest Constitutional lawyer in America, the clearest-headed statesman, and of all public men perhaps the least of a demagogue and the most of a gentleman." Better grounded than Lincoln in economics, history, tariff and railway questions, he served a variety of business interests, though when joined with corrupt forces, he asked only political advancement—not money. He was Welsh-Irish, slouching, slim, middle-sized, stooped, white-haired, "a subtle quick man, rejoicing in power." He had quit snuff and now smoked cigars by the box, drove Arabian horses, served five-course dinners, drank brandy-and-water freely, one loyal friend noticing "when he was loaded, his tongue wagged." As an antislavery moderate in the Senate he had kept an open door to Southerners and understood them better than did the radicals. He liked anecdotes and was the only member of the Cabinet who caught the slants of Lincoln's humor. He underrated the President at first, but after a few clashes they came to better understanding of each other. Just before inauguration he sent Lincoln a note that he must "withdraw" from the Cabinet. Lincoln politely replied that Seward couldn't do that.

The new Secretary of the Treasury, Salmon Portland Chase, Senator from Ohio, an antislavery radical, at first re-

fused to take the appointment, having first heard about it in the newspapers. He was called handsome, having a "stately figure," a "classic face," a massive head. As a lawyer and as Governor of Ohio he earned a reputation as a friend of black people, particularly fugitives from the Kentucky border. His integrity in money matters was beyond question. A restless ambition to be President lay deep in him and seemed to guide him in his main decisions. At the Republican National Convention in 1860 he had hoped to head the party ticket and still had hopes that at times seemed an ailment or even an affliction. Sorrow had followed his home life. In 1852 he could look back on seventeen years in which he had stood at the burial caskets of three wives and four children. A gleaming and vital daughter Kate, born in 1840, had grown to be a chum and a helper, a solace and a light. She too had hopes he would yet be President. Against his wish he had been drafted by Lincoln. To refuse the place might isolate him, with risk to his ambitions. The story was easily half true that he faced a mirror and bowed to himself, murmuring "President Chase."

The new Secretary of War, Simon Cameron of Pennsylvania, had released his fifty white-hatted delegates and started the stampede to Lincoln at the 1860 Chicago convention. Lincoln's managers, without authority from Lincoln, had pledged Cameron a Cabinet place. Born in 1799, he had been a country printer, editor, contractor for state printing, United States Senator, and had built a following and held it together by doing real favors so as to have funds and influence from the rich and votes and cheers from the poor. His nickname of "The Czar of Pennsylvania" rested on a reputation as the

most skilled political manipulator in America. Tall, slim, wearing loose gray clothes, he was smooth of face, sharp-lipped, with a delicate straight nose, a finely chiseled mask touched with fox wariness. Protests came to Lincoln that Cameron was "reeking with the stench of a thousand political bargains," but his efforts to get these accusations against Cameron put in plain writing failed. Congressman Thaddeus Stevens of Pennsylvania warned Lincoln that Cameron had taking ways. "You don't mean to say you think Cameron would steal?" Lincoln asked. "No," clipped Stevens, "I don't think he would steal a red-hot stove." Cameron heard of this from Lincoln and insisted Stevens must take it back, retract. So Stevens at the White House: "Mr. Lincoln, why did you tell Cameron what I said to you?" The President thought it was a good joke on Cameron "and didn't think it would make him mad." "Well," Stevens went on, "he is very mad and made me promise to retract. I will now do so. I believe I told you he would not steal a red-hot stove. I now take that back."

The new Secretary of the Navy, Gideon Welles of Con-necticut, publisher of the *Hartford Times*, was an old An-drew Jackson Democrat, turned Republican on the slavery extension issue. Fifty-eight years old, his short, thickset body had a massive head surmounted by a patriarchal wig. Alto-gether, with his white prophet's beard he had a Neptune look. Lincoln put him at the head of all of Uncle Sam's sea-going vessels, and later made jokes about "Uncle Gideon's" not knowing bow from stern. Welles was the only Cabinet member who from day to day kept a diary of size and sub-

stance. The heavier plans and decisions of the department were to fall on Gustavus Vasa Fox, a naval officer.

The new Attorney General, Edward Bates, born in 1793, had served in the War of 1812, become a lawyer in St. Louis, attorney general of Missouri, a state senator, a Congressman. He was a Whig even after that party was dead. Events piloted him to where he had no place to go but the Republican party. At the Chicago convention it was argued he was the man who as President could soften the shocks between sections. His 48 delegates finally went to Lincoln. He was honest, quaint, old-fashioned, courteous, of a school that was passing.

Of the new Cabinet members Caleb B. Smith of Indiana, Secretary of the Interior, was nearest the class of ordinary perfunctory politician. In dickerings by Lincoln's managers at the Chicago convention he had been promised the place now given him.

The Blair family, the most political family in the country, arrived in the Cabinet through appointment of Montgomery Blair as Postmaster General. Born in 1813, he was the only Cabinet member under fifty years of age. A West Point graduate of Seminole War service, mayor of St. Louis, judge of the court of common pleas, he had moved to Maryland to be near his large Federal Supreme Court practice. His brother Francis P. Blair, Jr., had led the Free Soil party in Missouri and gone to Congress. His father, known as Old Man Blair, a fighting editor, an intimate of Andrew Jackson, a skilled professional politician, had trained the sons, and as political combatants they were both fierce and adroit. Their big farm at Silver Spring near Washington was a head-

quarters for the moderate wing of the Republican party of Maryland.

The President's secretaries John G. Nicolay and John Hay noted of what their chief had picked for advisers: "He wished to combine the experience of Seward, the integrity of Chase, the popularity of Cameron; to hold the West with Bates, attract New England with Welles, please the Whigs through Smith, and convince the Democrats through Blair." In this Cabinet was not one tried and proved friend of the President. He picked his counselors for other reasons than his personal comfort.

In the event of the President's death his place would be taken by Vice-President Hannibal Hamlin of Maine, fifty-two years of age, tall, swarthy, powerfully built. He had been Governor of Maine and one of the first Republicans in the United States Senate.

To the most important of all diplomatic posts, Minister to Great Britain, the President sent the hard-headed and austere Charles Francis Adams, Sr., of Boston, Massachusetts. To Mexico as Minister Lincoln sent his old friend Thomas Corwin of Ohio. They could remember when they opposed the war with Mexico, on the ground that the Mexicans had not invaded the United States, Lincoln losing his seat in the House, Corwin losing his seat in the Senate through his declaration: "Were I a Mexican, as I am an American, I would say to the invader: 'We will welcome you with bloody hands to hospitable graves.' "

Day after day the President had to waste precious hours with office-seekers, some of them deserving party workers and competent enough, the rest of them so-so or worse. The

Toledo, Ohio, humorist David R. Locke under his pen name of Petroleum V. Nasby mocked:

> 1st. I want a offis.
> 2d. I need a offis.
> 3d. A offis would suit me; there4
> 4th. I shood like to hev a offis.

They came in swarms, Lincoln saying: "I am like a man so busy in letting rooms in one end of his house, that he can't stop to put out the fire that is burning in the other."

The morning after inauguration Lincoln studied dispatches from Major Robert Anderson, commanding the Fort Sumter garrison in Charleston Harbor, reporting that his food supplies would last four weeks or by careful saving perhaps forty days. The armed forces of South Carolina had him penned in and would no longer let him receive anything to eat. The Confederates, whose now encircling fortifications and batteries held the United States garrison at their mercy, stood ready to batter Fort Sumter to pieces and run down its flag whenever the word came from their Government at Montgomery.

Lincoln called his Cabinet for its first meeting on March 9, 1861, and put a written question, "Assuming it to be possible to now provision Fort Sumter, under all the circumstances, is it wise to attempt it?" The new Cabinet Ministers went away, considered this written question, returned March 16 on Lincoln's request with lengthy written answers. The seven new counselors stood five against sending food to Anderson, one for it, and one neither for nor against it.

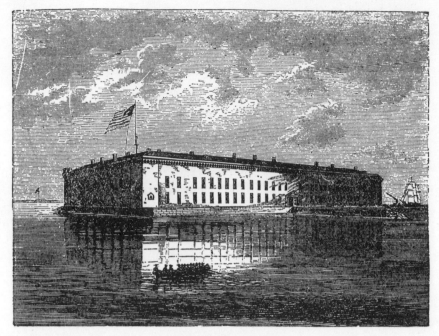

Fort Sumter in 1860

On March 10 it was widely published that the Adminis-
tration intended to withdraw the garrison from Fort Sumter.

The days had been hurrying along and in the heady cross-
currents of events Lincoln may have retreated from his first
position that the forts must be held. Nicolay and Hay, the
two secretaries of the President, however, wrote their obser-
vation, "The idea of the evacuation and abandonment of the
fort was so repugnant, that Mr. Lincoln could hardly bring
himself to entertain it." Whether he did seriously entertain it
for a time or not, the moment came when he gave his mind
completely to somehow staging a combat in the Charleston
Harbor in which his Government would be making the best
fight possible for its authority. He later wrote that the Ad-
ministration in that hour, from a purely military point of view,

was reduced to the mere matter of getting the garrison safely out of the fort. He believed: "That to so abandon that position, under the circumstances, would be utterly ruinous; that the necessity under which it was to be done would not be fully understood; that by many it would be construed as a part of a voluntary policy; that at home it would discourage the friends of the Union, embolden its adversaries, and go far to insure the latter a recognition abroad; that in fact it would be our national destruction consummated. This could not be allowed."

This final decision that the North in the main would interpret a decent necessary withdrawal from Sumter as a shameful slinking away from plain challenge meant immediate action, the end of deliberation over what to do, with every effort concentrated on how to do what was to be done. The President called in Gustavus Vasa Fox, a Swedish-blooded Yankee born in Massachusetts, thirty-nine years of age, a Naval Academy graduate of eighteen years' service in coast survey, of Mexican War experience. Fox had prepared plans for the holding of Sumter, which plans President Buchanan in February had refused to consider, but which now, further elaborated, were personally urged by Captain Fox before the President, the Cabinet, and military officers. Troops on steamers, tugboats from New York Harbor, naval convoys and armed vessels, would co-operate toward crossing sand bars at high water and moving reinforcements into Sumter.

Ward Hill Lamon, Marshal of the District of Columbia and an Illinois law-practice associate of Lincoln, had now returned from a trip to Charleston, where in one day he had seen all he cared to see. His instructions from Lincoln re-

quired him to interview the postmaster of Charleston, from whom he learned in few words that the postmaster was no longer affiliated with the United States Government. A Confederate officer escorted Lamon to Major Anderson at Fort Sumter, where Lamon learned that the food supply would give out at noon of April 15, that Anderson was "deeply despondent" and the garrison "spoiling for a fight."

From the Governor of South Carolina Lamon brought the message to Lincoln: "Nothing can prevent war except the acquiescence of the President of the United States in secession. . . . Let your President attempt to reinforce Sumter, and the tocsin of war will be sounded from every hilltop and valley in the South."

"The new pilot was hurried to the helm in the midst of a tornado," wrote Emerson of Lincoln's first weeks in office. As yet, however, the tornado was merely beginning to get under way. It was, as yet, a baby tornado, its focal whirl in Charleston. There merchant ships from Boston and Liverpool still unloaded cargoes at the wharves. Telegraph, mail, and railway services were much as usual, though the *Charleston Mercury* headed news items from New York, Boston, or Chicago as "Foreign News."

The tall parapets of Fort Sumter, three miles out from the city of Charleston, rising almost sheer with the rock walls of its island, were being ringed round with batteries, guns, and the 5,000 troops recruiting under General P. G. T. Beauregard. Daily the military was in touch with Governor F. W. Pickens of South Carolina and Secretary L. P. Walker of the Confederate War Department at Montgomery. Visitors to the United States Army officers or soldiers at Fort Sumter

were challenged by Confederate pickets, had to show passes from Governor Pickens. It was not quite war, as yet. But the majesty of the United States Government was diminishing at Charleston and her harbor.

Of the seceded Cotton States, South Carolina was the oldest, the proudest, the most aristocratic. Of all the larger cities in those States, Charleston could remember farthest back; her harbor had seen the War of the Revolution come and go; she had set up bronze statues to men who had met their death defending her harbor; the inscription read "These died of their wounds." Her Robert Barnwell Rhett was the foremost Southern voice demanding restoration of the African slave trade. Since the day of Lincoln's election her streets had resounded with musket drill; the youth of the city wanted war, and soon. It was Charleston who had stood first among Southern cities voicing secession.

The North, the South, the civilized nations of the world, felt the drama of this scene. For weeks the excitement of it had been intensifying. The gambler's factor grew, and the dice of destiny shook in the hands of Humpty Dumpty. Fate and the intentions of History had faded into a fog of circumstances at which spectators flung the query "What next?"

Week by week the country had watched the emergence of Major Robert Anderson into a national figure. "Bob Anderson, my beau, Bob," ran a song line. He had kept a cool head and held on amid a thousand invitations to blunder. Northern newspapers paid tribute to his patience and loyalty. Even the *Charleston Mercury* complimented him as a gentleman whose word was good. He was a West Pointer, a sober

churchman, born and raised in Kentucky, saying, "We shall strive to do our duty." He had married a Georgia girl, had owned a plantation and slaves in Georgia and sold the slaves. He could see that his immediate duty was to obey orders from the United States Government but, according to one of his officers, if war came between the South and the North he "desired to become a spectator of the contest and not an actor"; if his State of Kentucky should secede, he would go to Europe.

Anderson was nearly fifty-six years old, and in the Black Hawk War of long ago as a colonel of volunteers he had met Lieutenant Jefferson Davis and had sworn into service troops that included Private Abraham Lincoln. Now Lincoln was preparing a letter to serve as a guide for Anderson, a letter that afterwards no one could have regrets about. Though in Lincoln's language, it was signed by the Secretary of War. Four copies were made, one sent by mail and three by other ways. It read:

<div style="text-align: right;">Washington, April 4, 1861</div>

Sir:

Your letter of the 1st instant occasions some anxiety to the President. On information of Captain Fox he had supposed you could hold out till the 15th instant without any great inconvenience, and had prepared an expedition to relieve you before that period. Hoping still that you will be able to sustain yourself till the 11th or 12th instant, the expedition will go forward; and, finding your flag flying, will attempt to provision you, and in case the effort is resisted, will endeavor also to reinforce you.

You will therefore hold out, if possible, till the arrival of the expedition. It is not, however, the intention of the President to subject your command to any danger or hardship beyond what,

in your judgment, would be usual in military life; and he has entire confidence that you will act as becomes a patriot and a soldier, under all circumstances. Whenever, if at all, in your judgment, to save yourself and command, a capitulation becomes a necessity, you are authorized to make it.

Major Anderson wrote a reply to this letter. He was now surprised at hearing reports that a relief expedition under command of Fox was preparing. "I ought to have been informed that this expedition was to come. Colonel Lamon's remark convinced me that the idea would not be carried out. We shall strive to do our duty, though I frankly say that my heart is not in the war, which I see is to be thus commenced."

This sorrowful letter did not reach the War Department in Washington, nor Lincoln. It was seized and sent to the Confederate War Department at Montgomery. By now Anderson and the Sumter garrison were stopped from getting fresh meat and vegetables at the Charleston market. By now there had arrived in Charleston a War Department clerk from Washington, who on the evening of April 8 read to Governor Pickens a notification from President Lincoln. And having read it, he left a copy for the Governor, its text:

Washington, April 6, 1861

Sir:

You will proceed directly to Charleston, South Carolina, and if, on your arrival there, the flag of the United States shall be flying over Fort Sumter, and the fort shall not have been attacked, you will procure an interview with Governor Pickens, and read to him as follows: "I am directed by the President of the United States to notify you to expect an attempt will be

made to supply Fort Sumter with provisions only; and that, if such an attempt be not resisted, no effort to throw in men, arms, or ammunition will be made without further notice, or in case of an attack upon the fort." After you shall have read this to Governor Pickens, deliver to him the copy of it herein inclosed, and retain this letter yourself.

But if, on your arrival at Charleston, you shall ascertain that Fort Sumter shall have been already evacuated, or surrendered by the United States force, or shall have been attacked by an opposing force, you will seek no interview with Governor Pickens, but return here forthwith.

Thus the doubts of long months were at an end. Thus Lincoln framed an issue for his country and the world to look at and consider. Sumter now was a symbol, a manner of Challenge. The Confederate Cabinet at Montgomery had now a specific challenge. Jefferson Davis called his advisers into session at Montgomery to consider Lincoln's message to Governor Pickens, which had been telegraphed on. Robert Toombs, Secretary of State, read Lincoln's letter, and said, "The firing on that fort will inaugurate a civil war greater than any the world has yet seen; and I do not feel competent to advise you." Toombs paced back and forth with his hands behind him, his head lowered in thought. After a time he gave his opinion on the proposed bombardment of Sumter: "Mr. President, at this time it is suicide, murder, and you will lose us every friend at the North. You will wantonly strike a hornet's nest which extends from mountains to ocean; legions, now quiet, will swarm out and sting us to death. It is unnecessary; it puts us in the wrong; it is fatal."

President Davis, however, decided in favor of attacking

the fort, leaving to Beauregard the choice of time and method. He sent the order: "If you have no doubt of the authorized character of the agent who communicated to you the intention of the Washington Government to supply Fort Sumter by force, you will at once demand its evacuation,

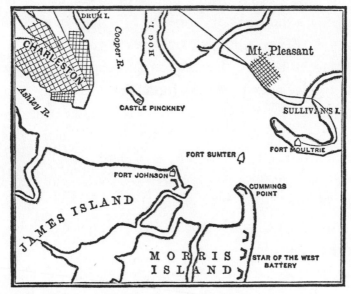

Map of Charleston Harbor

and, if this is refused, proceed, in such manner as you may determine, to reduce it."

Davis justified this bombardment order in writing later: "To have waited further strengthening of their position by land and naval forces, with hostile purpose now declared, for the sake of having them 'fire the first gun,' would have been as unwise as it would be to hesitate to strike down an assailant, who levels a deadly weapon at one's breast, until he has actually fired. He who makes the assault is not necessarily he who strikes the first blow or fires the first gun."

Thus Davis reasoned, as though revolutions can be reasonable and dignified in the mob slogans and mass actions that mark the first crisis and the last. For the wild humor, the headlong passion that ruled the hour, one must rather look at a tall man with blazing eyes and a long black mane of hair which he tosses as he speaks to a crowd serenading him in Charleston on the night of April 10. This man on the balcony is Roger A. Pryor. Only a few weeks ago he sat as a Virginia Congressman in Washington snarling a savage protest at a bill to give added military force to the Lincoln Administration. As to his native State of Virginia, he was now in April not speaking officially: "I wish to God I were; I would put her out of the Union before 12 o'clock tonight."

Pryor told them not to worry as to Virginia, the old Mother of Presidents: "Give the old lady time. She cannot move with the agility of some of her younger daughters. She is a little rheumatic."

Then Pryor spoke the words of passion and pride that were the key to the dominant action and tumult of that beautiful, lazy Southern city, with its Revolutionary memories, with its pink and white marble walls: "I thank you especially that you have at last annihilated this accursed Union, reeking with corruption and insolent with excess of tyranny. Not only is it gone, but gone forever. As sure as tomorrow's sun will rise upon us, just so sure will old Virginia be a member of the Southern Confederacy in less than an hour by a Shrewsbury clock. Strike a blow! The very moment that blood is shed, old Virginia will make common cause with her sisters of the South."

Pryor was the evangel of flame and blood required for revolution.

And now while Lincoln's lonesome little relief ships moved down the Atlantic Coast and were daily, hourly, expected to heave into view off Charleston Harbor, there were notes and telegrams full of polite language sent back and forth. Beauregard on April 11 sent a little boat out to Sumter. Two men handed Anderson a note from Beauregard, his old-time affectionate pupil in artillery lessons at West Point: "I am ordered by the Government of the Confederate States to demand the evacuation of Fort Sumter. . . . All proper facilities will be afforded for the removal of yourself and command, together with company arms and property, and all private property, to any post in the United States which you may select. The flag which you have upheld so long and with so much fortitude, under the most trying circumstances, may be saluted by you on taking it down. Colonel Chesnut and Captain Lee will, for a reasonable time, await your answer. I am, sir, very respectfully, your obedient servant."

Major Anderson read this note and wrote a little answer: "I have the honor to acknowledge the receipt of your communication demanding the evacuation of this fort, and to say, in reply thereto, that it is a demand with which I regret that my sense of honor, and of my obligations to my Government, prevent my compliance. Thanking you for the fair, manly, and courteous terms proposed, and for the high compliment paid me, I am, general, very respectfully, your obedient servant."

However, as Major Anderson handed this note to Beauregard's aides, he made the remark, "Gentlemen, if you do not

batter us to pieces, we shall be starved out in a few days."
And Beauregard telegraphed this remark to his Government
at Montgomery, and was told to get Anderson to fix a stated
time for giving up the fort. Meanwhile the Confederate Com-
missioners at Washington telegraphed a newspaper report that
a force would be landed at Sumter which would "overcome
all opposition." Beauregard replied to the Commissioners that
Sumter's evacuation would be demanded that day and "if re-
fused hostilities will commence tonight."

Now four men from Beauregard went at night in a boat out
to Sumter. At three-quarters of an hour past midnight they
handed Major Anderson a note saying there would be no
"useless effusion of blood" if he would fix a stated time for
his surrender. Anderson called his officers; through the night
hours from one o'clock till three they consulted. And at 3:15
that morning Anderson gave the four men his answer: "Cor-
dially uniting with you in the desire to avoid the useless effu-
sion of blood, I will, if provided with the proper and neces-
sary means of transportation, evacuate Fort Sumter by noon
on the 15th instant, and I will not in the meantime open my
fire on your forces unless compelled to do so by some hostile
act against this fort or the flag of my Government by the
forces under your command, or by some portion of them,
or by the perpetration of some act showing a hostile intention
on your part against this fort or the flag it bears, should I
not receive prior to that time controlling instructions from
my Government or additional supplies. I am, general, very
respectfully, your obedient servant."

Now the four men had full power from Beauregard to de-
cide what to answer Anderson. They could take Anderson's

reply back to Beauregard, have it telegraphed to their Government at Montgomery, and find out whether it would satisfy Jefferson Davis and his Cabinet to wait until April 15, three days more, to see whether Anderson's food was gone and whether he would then surrender.

It seemed almost as though the four men had decided before they came what they would tell Anderson. For within five minutes they gave him his answer, as follows:

<div style="text-align:center">Fort Sumter, S. C., April 12, 1861—3:20 A.M.</div>

Sir:

By authority of Brigadier-General Beauregard, commanding the Provisional Forces of the Confederate States, we have the honor to notify you that he will open the fire of his batteries on Fort Sumter in one hour from this time.

We have the honor to be, very respectfully, your obedient servant,

James Chesnut, Jr.,
Aide-de-Camp.
Stephen D. Lee,
Captain, C.S. Army, Aide-de-Camp.

The four men got into their boat, with Chesnut musing over Major Anderson's parting words, "If we do not meet again on earth, I hope we may meet in Heaven."

An hour later they were at a battery commanded by Captain George S. James. And as Captain Lee reported it, the battery commander said to Roger A. Pryor, "You are the only man to whom I would give up the honor of firing the first gun of the war." Pryor, on receiving the offer, was shaken. With a husky voice he said, "I could not fire the first

gun of the war." His manner, said Captain Lee, "was almost similar to that of Major Anderson as we left him on the wharf at Fort Sumter."

Pryor could not do it. But old Edmund Ruffin, according to Southern press accounts, could and did; a farmer from Virginia, sworn for years to the sacred cause of perpetual separation from the Union, an ally of Rhett, sixty-seven years of age, his face framed in venerable white ringlets of hair— Ruffin pulled the first gun of the war, and swore he would kill himself before he would ever live under the United States Government.

It was a red dawn. The encircling batteries let loose all they had. The mortars and howitzers laughed. Wood fires on hulks at the inner harbor entrance lighted the distant lonesome relief ships from Lincoln; for a hundred reasons they could be of no help; if they could have crossed the sand bars at high tide they would have been bright targets for guns to shatter.

Through daylight of the twelfth and through the rain and darkness of the night of the thirteenth, the guns pounded Sumter with more than 3,000 shot and shell. Eight times the Confederates hit the flagstaff; at last they shot the flag off the peak; Sergeant Hart climbed up with a hammer and nailed it on again.

Smoke, heat, vapor, stifled the garrison; they hugged the ground with wet handkerchiefs over mouths and eyes till they could breathe again. The last biscuit was gone; they were down to pork only for food. The storm and dark of the early morning on the thirteenth ended with clear weather and a red sunrise.

Again offered the same terms of surrender as before, Anderson, after thirty-three hours of bombardment, gave up the fort.

On Sunday, the fourteenth, he marched his garrison out with colors flying, drums beating, saluting his flag with fifty guns. They boarded one of the relief ships and headed north for New York Harbor. They had lost one man, killed in the accidental explosion of one of their own cannon.

In their last glimpse of Fort Sumter they saw the new Confederate flag, Stars and Bars, flying. In his trunk Major Anderson had the flag he had defended; he wished to keep this burnt and shot flag and have it wrapped round him when laid in the grave.

THE CALL FOR TROOPS

RÉVEILLÉ.

ON that same Sunday of April 14, as Anderson marched out of Sumter the White House at Washington had many visitors. They filed in and out all day. Senators and Congressmen came to say that their people would stand by the Government, the President. The Cabinet met. A proclamation was framed to go the next day to the eyes and ears of millions of people, then around the world. It named the States of South Carolina, Georgia, Alabama, Florida, Mississippi, Louisiana, and Texas as having "combinations too powerful to be suppressed" by ordinary procedure of government.

"Now, therefore, I, Abraham Lincoln, President of the United States, in virtue of the power in me vested by the

Constitution and the laws, have thought fit to call forth, and hereby do call forth, the militia of the several States of the Union, to the aggregate number of seventy-five thousand, in order to suppress said combinations, and to cause the laws to be duly executed."

He called on "all loyal citizens" to defend the National Union and popular government, "to redress wrongs already long enough endured." The new army of volunteer soldiers was to retake forts and property "seized from the Union." Also, "in every event the utmost care will be observed, consistently with the objects aforesaid, to avoid any devastation, any destruction of or interference with property, or any disturbance of peaceful citizens."

Thus the war of words was over and the naked test by steel weapons, so long foretold, was at last to begin. It had happened before in other countries among other peoples bewildered by economic necessity, by the mob oratory of politicians and editors, by the ignorance of the educated classes, by the greed of the propertied classes, by elemental instincts touching race and religion, by the capacity of so many men, women, and children for hating and fearing what they do not understand while believing they do understand completely and perfectly what no one understands except tentatively and hazardously.

From day to day since Lincoln was sworn in as President he had moved toward war, seeing less bloodshed in one immediate war than in many smaller inevitable wars to follow. How did he explain Sumter? "The assault upon and reduction of Fort Sumter was in no sense a matter of self-defense on the part of the assailants," he wrote later. "They well knew

that the garrison in the fort could by no possibility commit aggression upon them. They knew—they were expressly notified—that the giving of bread to the few brave and hungry men of the garrison was all which would on that occasion be attempted." Sumter was a symbol, a pawn, a token of power. Two governments each wanted its flag alone and supreme over that little spot of earth.

Lincoln had his way, said the South. He wanted a war and made one, they said. Across a table papers could have been signed. The wayward sisters would have departed with blessings on them. No shooting. No boys thrusting bayonets into each other's vitals. Many States with many flags from coast to coast. Customhouses at the State borders. Many interstate treaties, ambassadors. Many collisions over fugitive Negroes at the border lines of Free and Slave States.

Now came the day of April 15, 1861, for years afterward spoken of by millions of people as "the day Lincoln made his first call for troops." What happened on that day was referred to as the Uprising of the People. Mass action ruled. The people swarmed onto the streets, into public squares, into meeting-halls and churches. The shooting of the Stars and Stripes off the Sumter flagstaff—and the Lincoln proclamation—acted as a vast magnet on a national multitude.

Then came mass meetings, speeches by prominent citizens, singing of "The Star-spangled Banner" and "America," fife-and-drum corps playing "Yankee Doodle."

Events of destructive violence added to the fury of the hour in the week of the Uprising. Three delegates came as a special committee from the Virginia convention to the White House. Their convention had in secret session voted 60 to 53

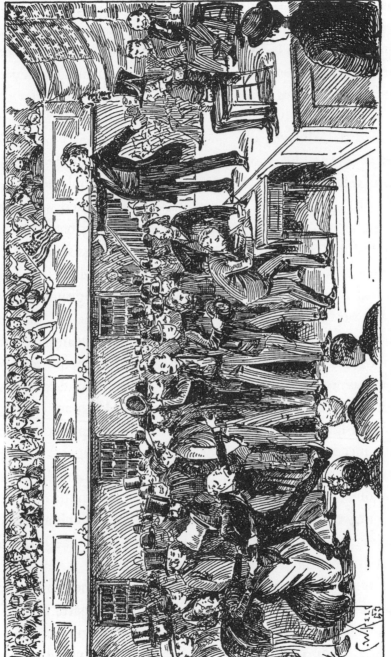

A war meeting

against seceding from the Union. They politely inquired of Lincoln as to his intentions. He replied politely that his intentions were still the same as he reported them in his inaugural. He read over part of his inaugural, as though they had not read it carefully enough, and as though by patience they might find new clews in it: "The power confided in me will be used to hold, occupy, and possess the property and places belonging to the government" and so on. They took their hats, reported back to their convention—and Virginia, the Mother of States, the Mother of Presidents, went out of the Union.

On the day of April 17 when Virginia seceded, her troops were set in motion for a surprise march on the United States fort and arsenal at Harper's Ferry, the most dramatic point northward for raising her new flag. They arrived on April 18 and took the fort and arsenal without fighting. The 45 Union guards heard of their coming and quit the fort after using gunpowder and fire to destroy munitions, guns, and war property worth several million dollars.

Two days later the United States Navy Yard at Norfolk, Virginia, was threatened, or the commander was afraid it was, and guns, munitions, ships, and war property valued at $30,000,000 went up in smoke.

Robert E. Lee, Virginian, resigned from the United States Army, gave up his stately home on Arlington Heights overlooking Washington, to take command of the Army of Virginia; long ago he had quietly opposed slavery; he favored the Union but couldn't fight against his native State. Now Lee had gone to Richmond. Lincoln had lost a commander that General Winfield Scott, head of the army, reckoned as worth

fifty thousand men. "Save in the defense of my native State I never again desire to draw my sword," Lee wrote to Scott. Two months before, in Texas, he had told army associates: "If Virginia stands by the old Union, so will I. But if she secedes (though I do not believe in secession as a constitu-

Arlington, the home of General Robert E. Lee

tional right, nor that there is sufficient cause for revolution) then I will still follow my native State with my sword, and, if need be, with my life."

The seething of propaganda began. Southern newspapers reported elaborate plans in the North to stir up insurrections of slaves, with robbery, arson, rape, murder. Northern newspapers reported a Northern woman teacher in a New Orleans grammar school as being stripped naked and tarred and feathered "for abolition sentiments expressed to her pupils."

North and South, horrors were exaggerated or fabricated. The North was arming Sioux Indian tribes for butchery and scalping of Southern women and children. Likewise the South was arming Cherokee Indian tribes for slaughter and pillage. So newspaper items ran.

Pennsylvania Avenue, Washington, D. C. From a sketch made in 1861.

The day of the President's call for 75,000 troops had passed, and not a trooper arrived in Washington. And the next day and the next passed, and not a regiment nor a company came —not a corporal's squad.

Roger Pryor, the same firebrand whose balcony oratory had chimed with the taking of Sumter, was again on a balcony, now in Montgomery, crying with passion for an "immediate march on Washington."

Washington was hemmed in, its land and water approaches easy; the British in the 1812 war had no trouble taking it.

Richmond and New Orleans newspapers were calling for its capture. The two great arsenals near by at Harper's Ferry and Norfolk were in the hands of Virginia troops. From the White House with a spyglass Confederate flags could be seen flying beyond on Virginia soil. "At night the camp-fires of the Confederates, assembling in force, could be seen on the Southern bank of the Potomac," wrote a journalist. "It was not uncommon to meet on Pennsylvania Avenue a defiant Southerner openly wearing a large Virginia or South Carolina secession badge."

President Davis at Montgomery announced that his Government would issue "letters of marque" giving authority to ships joining the Confederacy to seize United States vessels of commerce. Lincoln proclaimed a blockade of ports of the seceded States. Vessels would be warned not to enter or leave Southern ports; failing to obey, they would be captured and sent to the nearest convenient Northern port. The forty wooden ships of the United States Navy then at hand would patrol 8,000 miles of seacoast—till there were more ships—and more. That was Lincoln's plan.

What was to happen now at Washington? At what moment would some free-going body of Southern troops ride into the capital, seize the city, and kidnap the Government? These questions were asked in Washington. Then and later this was regarded as an easy possibility. There were Southerners eager for the undertaking.

Each day in bureaus and departments at Washington came new resignations, Southerners leaving to go south to fight. On all sides were spies interthreading North and South. Observ-

ers and reporters were free to come in or go out of Washington in any direction.

On April 18 arrived 532 Pennsylvania boys from Pottsville, Lewistown, Reading, Allentown. They had passed through Baltimore safely. Not so the 6th Massachusetts regiment the next day. As they marched from one station to another,

The Confederate flag at the Montgomery convention

Confederate postage stamp with Jefferson Davis's portrait

Seal of the State Department of the United States

changing trains, they met stones, bricks, pistols, from a crowd of Southern sympathizers. They answered with bullets. Four soldiers were killed, and twelve citizens.

Two by two the 6th Massachusetts marched up Pennsylvania Avenue that evening to the Capitol, their seventeen wounded on stretchers. Their dead at Baltimore were packed in ice and sent north for military burial and martyrs' monuments. The news of the street fighting, of heads broken with stones, of innocent bystanders meeting bullets, of taunts and howls and jeers, of shrieking women, went North and South; the war drums beat wilder.

The railroad bridges between Washington and the North were down. Of the 75,000 men called for, a week ago, one

Massachusetts regiment and five Pennsylvania companies had arrived. From the South came reports of a march on Washington; Beauregard, the hero of Sumter, was coming with 10,000 men.

Now came word that the telegraph wires leading to the North were cut. The Baltimore telegraph office was in the hands of secessionists.

With mails stopped, railroads crippled, bridges down, telegraph wires dead, it was not easy in Washington to laugh away the prediction of the *New Orleans Picayune* that Virginia's secession would result in "the removal of Lincoln and his Cabinet to the safer neighborhood of Harrisburg or Cincinnati—perhaps to Buffalo or Cleveland." Under command of Lee at Richmond in latter April were enough troops to take Washington had Lee believed immediate attack advisable.

While Lincoln and his Administration were marooned in the little ten-mile-square District of Columbia surrounded by Slave States, the blame for it was put on Lincoln's "feeble" hands and a movement gained headway in New York for replacing Lincoln with a dictator.

To young John Hay, a secretary who lived in the White House and kept a vivid diary, Lincoln talked that week about what seemed to him the key point of the hour: "For my own part, I consider the first necessity that is upon us, is of proving that popular government is not an absurdity. We must settle this question now,—whether in a free government the minority have the right to break it up whenever they choose. If we fail, it will go far to prove the incapability of the people to govern themselves."

Lincoln, however, was taking to himself one by one the powers of a dictator. He authorized a raid whereby at three o'clock in the afternoon of April 20 United States Marshals entered every major telegraph office in the Northern States and seized the originals of all telegrams sent and copies of all telegrams received during twelve months. Also the President dug into the Treasury of the United States for millions of dollars—without due and required authority of Congress. At a meeting held that Sunday of April 21 in the Navy Department away from any spies and all observers in the White House, the Cabinet members joined with Lincoln in the placing of immense funds.

These government money orders for million-dollar amounts Lincoln sent by private messengers, who instead of the direct route traveled roundabout by way of Wheeling and Pittsburgh to New York.

In the Treasury building now were howitzers. At the Mint were howitzers. In the marble corridors of the Capitol building were howitzers, muskets, provisions, munitions of war. In the Senate chamber slept the 6th Massachusetts boys. In the House of Representatives slept the Pennsylvania boys. The Georgetown flour-mills supply, 25,000 barrels, was seized as a war necessity. At each Capitol doorway was a ten-foot barricade of sandbags, cement barrels, iron plate.

And now by some chance on April 23 a little mail arrived —and newspapers. Anderson and his garrison had arrived in New York and the town had gone wild over them! A Union Square mass meeting with 50,000 people shouting for the Union! Processions, speeches, enlistments of more men than the President called for! Million-dollar appropriations for the

war! The Governor of Rhode Island sailing with troops and guns for Washington! The famous crack regiment, the dandy 7th of New York, had marched down Broadway between vast walls of living people, cheering crowds, heading south for Washington!

Union mass meeting, Union Square, New York City, April 20, 1861

So the news ran. And out of it all nothing had reached Washington except the few boys now sleeping on their guns in the Capitol building.

A locomotive whistle shrieking hallelujah on April 25 was followed by the marching—left, right, left, right—up Pennsylvania Avenue of the 7th New York. Then came 1,200 Rhode Islanders, and the Butler Brigade of 1,200 from Massachusetts. A crippled locomotive at Annapolis had been repaired by Massachusetts mechanics; volunteer tracklayers put the road from Annapolis in running order again. A troop route to the

North had been found. In a few days Washington had 10,000 defense troops. Now, for a time, Lincoln knew that the capital would still be at Washington. And Congress, by summons of the President, was to meet July 4 to review national policy and the acts of the President.

CHAPTER 4

FIRST BATTLE OF BULL RUN

THE Confederate Government, strengthened by the finally seceded States of Arkansas, Tennessee, North Carolina, and Texas, had moved the last week in May from Montgomery, Alabama, to Richmond, Virginia, to be nearer the Border States and the expected heavy fighting. Into Richmond streamed regiments from all parts of the South. The cry in the South, "On to Washington!" snarled straight into the cry from the North, "On to Richmond!"

Among troops at Richmond were farmers and hillmen who never owned a slave nor an acre of ground, and young men from the First Families where a thousand acres and a hundred slaves was the unit. Dapper companies with shining blouses,

The Richmond, Virginia, State House, where the Confederate Congress held sessions

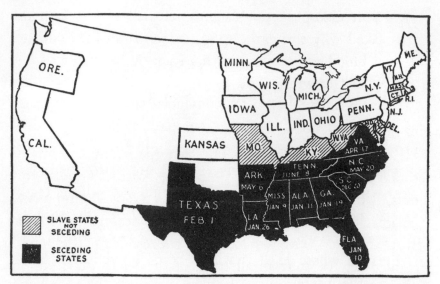

Secession map, South Carolina December 20, 1860, Tennessee June 8, 1861.
From Albert Shaw's *Abraham Lincoln, Year of His Election.*

brass buttons, uniform rifles of recent make, were regimented
with other companies in butternut jeans, carrying shotguns
and squirrel rifles.

From the Potomac River to the Gulf Coast and out where
the Rio Grande trickled over New Mexico ran the recruiting
ground of this Confederate Army. Its line zigzagged 1,500
miles from Chesapeake Bay through Kentucky and out to the
corners of Kansas. Its brain and will centered in the capitol,
the executive mansion, the departments, at Richmond. Its chief
weapon of defense was an army of 100,000 troops. The con-
trols of this Government were out of the hands of those who
had first given it breath and fire. Rhett of the True Perpetual
Separationists was now only a member of the Confederate
Congress. The movement to elect him President and the ef-
forts to appoint him Secretary of War had both failed.

Down in Georgia and Alabama, Russell of the London *Times* asked why this outpouring of men from the South to test their blood against the North. "I am not prepared to say they are right or wrong," he wrote as to secession and Southern independence, "but I am convinced that the South can only be forced back by such a conquest as that which laid Poland prostrate at the feet of Russia." He saw the Southern women a factor in enlistments: "Here are many men who would willingly stand aside if they could, and see the battle between the Yankees, whom they hate, and the Secessionists. But there are no women in this party. Woe betide the Northern Pyrrhus whose head is within reach of a Southern tile and a Southern woman's arm."

Between Charleston and Savannah, wrote Russell: "Our fellow passengers were all full of politics—the pretty women being the fiercest of all—no! the least good-looking were the most bitterly patriotic, as if they hoped to talk themselves into husbands by the most unfeminine expressions toward the Yankees." In Charleston both sexes and all ages were for the war. "Secession is the fashion here. Young ladies sing for it; old ladies pray for it; young men are dying to fight for it; old men are ready to demonstrate it." Russell heard of a Mobile gentleman having a letter from his daughter: "She informs him she has been elected vivandière to a New Orleans regiment, with which she intends to push on to Washington and get a lock of Abe Lincoln's hair." Thus Russell in the Deep South, while J. B. Jones wrote in Richmond: "The ladies are postponing all engagements until their lovers have fought the Yankees. Their influence is great."

A new and a young Government it was at Richmond.

"Where will I find the State Department?" an Englishman asked Robert Toombs, Secretary of State. "In my hat, sir," replied Toombs, "and the archives in my coat pocket." It was a good Toombs answer. He was a contradictory man, secondarily a politician and lawyer and firstly rather a gustatory artist and philosopher.

The impulsive Toombs was soon to resign and take to camp and battlefield. He should have been Secretary of War, said many, but that place went to Leroy Pope Walker of Alabama, a lawyer and a politician, harassed by technical matters of how a people with ports restricted or closed, and with no gun nor arms factories nor powder mills, should create those requisites. He was soon to step from office to field service. Curiously enough, this Confederate War Department at Richmond took on as Acting Assistant Secretary of War one Albert Taylor Bledsoe, a West Point graduate who had become a Protestant Episcopal clergyman, later a professor of mathematics, though part of his ten years as a practicing lawyer was spent in Springfield, Illinois, with an office adjoining that of Lincoln & Herndon.

The finance head, Christopher Gustavus Memminger, an orphan-asylum boy, a German Lutheran born in Württemberg, a lawyer and a politician, was the one South Carolina man in the Cabinet. The Navy head was Stephen R. Mallory of Florida, once chairman of the Committee on Naval Affairs of the United States Senate, and having, as President Davis wrote, "for a landsman much knowledge of nautical affairs." Mallory was the one Roman Catholic of the Cabinet. The one Jew was Judah P. Benjamin of New Orleans, whose wife was a French Roman Catholic. He had twice been elected

United States Senator from Louisiana, and in his advocacy of the legal grounds for slavery once came close to a duel with Jefferson Davis, the affair cooling down when Davis apologized for harsh words spoken; once when defending slavery Benjamin was classified by Senator Wade of Ohio as "a Hebrew with Egyptian principles." He had a rare legal mind, and as Attorney General and later as Secretary of

Jefferson Davis's plantation house below Vicksburg, Mississippi

State was one of the few trusted helpers of President Davis, toiled in his Richmond office from eight in the morning till past midnight, and was sometimes referred to as "the brains of the Confederacy." The one Texan in the Cabinet was the Postmaster General, J. H. Reagan, former Congressman, Indian-fighter, and Southwestern pioneer.

At the helm of this Government was a strange, impressive figure chosen chiefly because he stood foremost of trained Southern statesmen as a military authority who should understand how to make war, because he stood in the public eye as a moderate rather than a radical secessionist, and because of rare personal integrity and distinctively Southern qualities.

This was the Mississippi cotton planter, West Point graduate, Black Hawk War lieutenant, Mexican War veteran wounded in service, United States Senator, Secretary of War under the Pierce Administration, orator, horseman, man of fate—Jefferson Davis.

The American Brothers; or, How will they get out of it?
From *Punch* of London, England.

The Confederate Vice-President, frail ninety-pound Alexander Hamilton Stephens, had been offered the Presidency by a group which asked only that he would "strike the first blow." This offer Stephens, a moderate who had opposed the secession of his native state of Georgia, had met with blazing hazel eyes and the decisive word "No."

Davis and Lincoln were to feel out each other's strength as archantagonists before a clamorous world. Each would stand forth as a target and a symbol. Both were born in Kentucky, Davis a year earlier than Lincoln, one as a child carried north to free soil, the other as a suckling babe taken to the lower South. Each was a treader of lonely rooms enveloped by darkness broken with few and rare stars. The two of them carried under their hats the chief bewildering contradictions gathered around the words "aristocracy" and "democracy."

Davis was a chosen spear of authority heading eleven States committed to him as against twenty-three States formally still in the Union with Lincoln, one side reckoned as having 9,000,000 people (including 3,900,000 slaves) as against 22,-000,000 Northern people.

Each in his Executive Mansion, one in Washington, one at Richmond, one hundred and twenty-two miles apart, Lincoln and Davis were to grapple and hurl destruction at each other.

"All we ask is to be let alone," Davis had said in his April 29 message to the Confederate Congress, a primitive heart cry that the South took for a slogan, that Northern sympathizers quoted often. Lincoln knew precisely and intricately what Davis meant, for Lincoln's elaborate Cooper Union speech in 1859 had dealt with it, Lincoln saying toward the close: "What will satisfy them? Simply this: we must not only let them alone, but we must somehow convince them that we do let them alone. . . . Apparently adequate means all failing, what will convince them? This, and this only: cease to call

slavery wrong, and join them in calling it right. And this must
be done thoroughly—done in acts as well as in words. Silence
will not be tolerated—we must place ourselves avowedly with
them."

Out of what sometimes looked like confusion confounded
and many sorry kettles of fish the Lincoln Administration
hammered away at shaping a new and huge war establish-
ment. Day and night the President, Cabinet, departments,
bureaus, military and naval officers, financiers, arms and sup-
ply divisions, worked on grand strategy and petty details of
an organization having few precedents to guide it and tell it
what to do and how and when.

From the windows of the White House Lincoln's spyglass
caught the Confederate flag flying over the town of Alex-
andria eight miles down the Potomac River, where several
heavy guns and 500 troops had been forwarded from Rich-
mond. Batteries were getting set to blockade vessels up and
down the Potomac. The provisional army authorized by the
Virginia convention was drilling, and some of its detachments
and their flags could be seen down-river.

In a bright moonlight on May 24 at two o'clock in the
morning, squads of cavalry crossed the bridges leading from
Washington across the Potomac into Virginia, and were fol-
lowed by infantry and by engineers, who began a work of
crowning every hill for miles with defense trenches for the
protection of the little ten-mile-square District of Columbia
surrounded by Slave States. This advance Southern advocates
termed the invasion and pollution of the sacred soil of Vir-

ginia, a Northern "aggression" more infamous than the Southern attack on Fort Sumter.

On July 6, 1861, the Secretary of War notified Lincoln that sixty-four volunteer regiments of 900 men each, besides 1,200 regulars, were in readiness around Washington, and the troops enrolled elsewhere over the North made a total of 225,000. Of this army, one of the largest the earth had ever seen, Lincoln was Commander in Chief.

Pierre Gustave Toutant Beauregard, superintendent of the West Point Military Academy the previous winter just before he resigned, of continuous service in the United States Army for twenty-three years, a Mexican War veteran, a professor of the applied science of artillery, now commanded an army of 20,000 Confederate troops near Washington at Manassas Junction. He was a Louisiana Creole, born and bred in French traditions, immersed in Napoleonic legends, a short, compact, abstemious man of pride and temper not afraid to talk back to President Davis if the words came to him—and they did. As a strategist and as the hero who had shot away the flag at Fort Sumter and reduced it to ruins, he was called to Virginia to check "Northern invasion."

On July 4 when Congress assembled it was in the air that soon a battle would be fought near Washington. The *New York Tribune* clamored in headlines: "Forward to Richmond! Forward to Richmond! The Rebel Congress must not be allowed to meet there on the 20th of July! By that date the place must be held by the National Army!"

Business was worse, money scarce, loans slow. A short war was wanted. Everybody agreed on that.

For weeks the picket lines of the opposing armies had been

within rifle-shot of each other, and no fighting. "Why don't they fight?" was a query North and South.

In hotels and saloons along Pennsylvania Avenue in Washington on July 17, 1861, the London *Times* correspondent,

Uniform of the
1st Massachusetts
at Bull Run. From
a photograph.

Uniform of the
11th New York
(Fire Zouaves)
at Bull Run. From
a photograph.

Uniform of the
14th New York
at Bull Run. From
a photograph.

Russell, heard of desperate fighting and the "rebel" army smashed. At the War Office, State Department, Senate, and the White House, messengers and orderlies ran in and out, military aides, civilians with anxious faces. Senator Charles Sumner beamed to Russell. "We have obtained a great success; the rebels are falling back in all directions. General Scott says we ought to be in Richmond by Saturday night." Then

an army officer riding past called out to him, "You have heard we are whipped; these confounded volunteers have run away."

The marching Army of the Potomac, a cub of an army, was a little hilarious moving through Fairfax Court House and into Centerville, pulling down Confederate flags, looting houses, smashing pianos into kindling wood, carrying away any goods or articles they liked, in violation of regulations. They broke ranks and ran to pick blackberries or to take off their shoes and rest their feet under shady trees, while they talked slack to their officers.

The clamor of press and public for a battle had gone on till the President on June 29 gave way to political necessity, called a Cabinet meeting before which General McDowell laid his plans. His army of 30,000 was to fight the 21,900 Confederates at Manassas under General Beauregard. General Scott approved McDowell's battle plan but favored waiting till a larger army, better trained and prepared, could win victories that would be destructive.

Lincoln and his Cabinet, as political authorities yielding to the demand of the country for fighting, overruled Scott. On McDowell's asking for more time to drill and discipline his troops, Lincoln told·him, "You are green, it is true, but they are green also."

The Battle of Bull Run, Sunday, July 21, 1861, was to a large and eager public a sort of sporting event, the day and the place of combat announced beforehand, a crowd of spectators buggy-riding to the scene with lunch baskets as though for a picnic. The word was that the Northern Shovelry would make the Southern Chivalry bite the dust.

than $1,000,000 a day. A hazard was in the air. Would little Mac, the Young Napoleon, slog through in a winter campaign and take Richmond? If he should, said men of the South at Richmond, he would find it as Napoleon did Moscow, a city in ashes.

In Missouri during the summer and fall of 1861 civil war ran red and saw one battle of 5,000 Union troops against

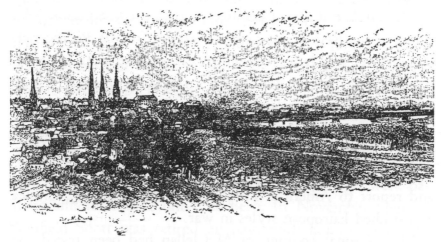

Richmond, Virginia, in 1861. From a sketch.

11,000 Confederates where the slaughter nearly equaled Bull Run. The warfare pointed a sinister forefinger toward the future, and had its weight in moving Lincoln to write in a message to Congress: "In considering the policy to be adopted for suppressing the insurrection I have been anxious and careful that the inevitable conflict for this purpose shall not degenerate into a violent and remorseless revolutionary struggle."

Four men had sat at a table in the Planter's House at St. Louis one day that summer. One was the Governor of

an army officer riding past called out to him, "You have heard we are whipped; these confounded volunteers have run away."

The marching Army of the Potomac, a cub of an army, was a little hilarious moving through Fairfax Court House and into Centerville, pulling down Confederate flags, looting houses, smashing pianos into kindling wood, carrying away any goods or articles they liked, in violation of regulations. They broke ranks and ran to pick blackberries or to take off their shoes and rest their feet under shady trees, while they talked slack to their officers.

The clamor of press and public for a battle had gone on till the President on June 29 gave way to political necessity, called a Cabinet meeting before which General McDowell laid his plans. His army of 30,000 was to fight the 21,900 Confederates at Manassas under General Beauregard. General Scott approved McDowell's battle plan but favored waiting till a larger army, better trained and prepared, could win victories that would be destructive.

Lincoln and his Cabinet, as political authorities yielding to the demand of the country for fighting, overruled Scott. On McDowell's asking for more time to drill and discipline his troops, Lincoln told·him, "You are green, it is true, but they are green also."

The Battle of Bull Run, Sunday, July 21, 1861, was to a large and eager public a sort of sporting event, the day and the place of combat announced beforehand, a crowd of spectators buggy-riding to the scene with lunch baskets as though for a picnic. The word was that the Northern Shovelry would make the Southern Chivalry bite the dust.

That night Lincoln heard eyewitnesses tell what they had seen from saddle, buggy, or gig on the twenty-mile ride from the battlefield. Strewn along roadways for miles were hats, coats, blankets, haversacks, canteens, rifles, broken harness, wagons upside down—the evidence of thousands of soldiers in panic and retreat to Washington.

A Confederate private.
From a tintype.

A Confederate private
of the West.
From an ambrotype.

At three o'clock that afternoon McDowell thought he had the battle won. He had good reason to think so. An hour later his army was going to pieces. Yet back of the enemy lines there was panic; and as Jefferson Davis came from Richmond toward the battle lines, he saw many runaways and asked an old man how the battle had gone. "Our line was broken," was the answer. "All was confusion, the army routed and the battle lost."

McDowell's staff man recorded 16 officers and 444 men killed, 78 officers and 1,046 men wounded, 50 officers and

1,262 men missing. General Johnston officially reported Confederate losses at 378 killed, 1,489 wounded, and 30 missing.

Back of these casualty figures lay personal incidents. A New York artilleryman flat on the ground among trampling horses raised himself as a cavalryman came toward him, lifted two bleeding stumps, and called out: "Don't ride over me! Both hands are gone!" A shell tore the leg of a Fire Zouave nearly off the trunk of the body; he took a photograph of his wife from a shirt pocket, handed it to another Zouave, "Take this to my wife, good-by."

To Colonel William Tecumseh Sherman the anguish of mangled men writhing and crying was less horrifying than "horses running about riderless with blood streaming from their nostrils or lying on the ground hitched to guns, gnawing their sides in death." A Sherman aide saw a sixteen-year-old boy sink his bayonet in a horseman's side. "As the horse swerved, the musket was torn from his hands and bobbed away, fast between the Confederate's ribs; the boy sobbed, 'He took my gun.'" A 2nd Wisconsin man, getting a bullet through the hand, called out, "There goes one hand for the Union, boys!"; then another bullet cut through him near the heart and his last words were, "Tell my father I died like a man fighting for the Union." A surgeon probed the back of a boy for a bullet, a bystander remarking, "It's a bad place to be hit—*in the back*." And the boy twisted onto his back, showed a hole near his armpit, and said, "Here's where the ball went in."

Newspapers reported a North Carolina lad whose pocket Bible stopped a bullet that would have killed him, while a 1st Connecticut boy carried a deck of playing-cards that caught

and held a slug of lead just over the heart. The story was widely told of a boy with a shattered arm, bleeding to death as he repeatedly murmured, "It grows very dark, Mother, very dark."

After the hot, sweltering Sunday of the battle came a Monday of drizzling rain. Across Long Bridge over the Potomac, from daylight on, came lines of bedraggled men. Hour by hour these silhouettes of defeat trod the bridge to the capital. Where was headquarters? When would they eat? Thousands were taken into homes and fed. Mother-hearted women made soups and meat stews in wash boilers, which were set out on sidewalks and the contents ladled to the hungry. Thousands dropped with their blistered feet and slept on sidewalks, lawns, porches.

Congress, the press, politicians, talkers, began fixing the blame. In later study of Bull Run, officers of skill and experience agreed with Sherman that it was one of "the best planned and worst fought" battles in history. "As for blame and causes," wrote George William Curtis in a private letter, "they are in our condition and character. We have undertaken to make war without in the least knowing how. We have made a false start and we have discovered it. It only remains to start afresh."

Lincoln gave his personal attention to the camps around Washington, kept close to men and officers, mixed with them. He rode in an open hack one day across the Potomac. Colonel Sherman at a roadside asked if they were going to his camp. "Yes," said Lincoln. "We heard that you had got over the big scare, and we thought we would come over and see the boys."

Yet it was Sherman's men who under his orders had formed a hollow square and marched last of all from the wild confusion of the battlefield of Bull Run, covering the general retreat, and sending murderous volleys of rifle fire into Confederate cavalrymen who tried to break their ranks.

Off to the war

Of the three division commanders of the Union army at Bull Run only one had ever seen a battle. Of nine Union brigadiers six had never seen smoke in open combat. The nine leading Confederate officers at Bull Run had all been under fire in the Mexican War or in Indian fights.

After the first few days of gloom and woe in the North came a second uprising. The raising of money, troops, supplies, proceeded toward the organization of the most gigantic army in history. Day by day now the new regiments of the Army of the Potomac stepped off trains in the railroad yards,

marched down Pennsylvania Avenue, moving to camp in the tented cities that stretched farther on the river slopes and the hills beyond. Droves of beef cattle plodded through the streets toward the commissary department butchers. Miles of boxes of hardtack, shoes, shirts, underwear, socks, uniforms, caps, lined warehouses and camps. The many varieties and contingents of troops were being shaped into one immense weapon, the most colossal military unit the world had seen in modern historical times. This Army of the Potomac grew into 168,000 in November from 50,000 on July 22, when Washington had received its new commander, General George Brinton McClellan.

In the furious, complex, and driving labors of shaping effective armies for grand strategic campaigns against the prepared Southern States, the ailing, failing octogenarian Scott was slow, pompous, fussy, and his dropsy and vertigo were pathetic afflictions of a one-time hero. In November General Winfield Scott was retired on pay, with honors, and with tributes from the President and others.

McClellan was the man of the hour, pointed to by events, and chosen by an overwhelming weight of public and private opinion. He looked the part, sat his saddle as a trained Man on Horseback, issued commands with a manner of authority, published proclamations modeled on Napoleon's style, thrust his right hand into his coat when photographed and gazed at the camera as though victory might lurk just beyond his well-modeled head and its genius of organization. He had left a $10,000-a-year job as president of the Ohio & Mississippi Railroad at Cincinnati to command an army of 18,000 in West

Virginia, where he had given the North the only actions thus far having semblance of military victories.

Farther back of this victory was a record. He was an engineer, had read all the classics on how to win or lose a war, believed in preparations, maneuvers, strategy. What men who had directed armies in war had written about it, the military technic, filled his mind. His *Manual on the Art of War*, his translation of a French book on bayonet exercises, were reputable. He had directed engineer corps on construction jobs, explored the Red River, begun a survey for the Pacific railway in Oregon. He was chosen for responsible work in peacetime because he was considered a student, observer, writer, technician, an industrious manager having balanced judgment and integrity. At thirty years of age he was one of three army officers appointed by Jefferson Davis, then Secretary of War, to go to see Old World armies at drill, study the art of war, and report to America. They saw action in bloody Crimea and studied European styles in war.

The personal courage of McClellan had been tested. At Contreras in the Mexican War he had two horses shot from under him, grapeshot breaking his sword hilt.

McClellan now had at least three times as many troops as the enemy at Manassas. There had been autumn weather on which many commented—mild, pleasant days and cool nights, perfect weather for an army movement to redeem Bull Run, to end the war. Thus ran hope and talk. Lincoln was trying to keep close to McClellan and get action.

Driving snow came with the last week in November. Winter weather was on. Wool coats, heavy blankets, firewood, tents, huts, were the need. The war was costing more

than $1,000,000 a day. A hazard was in the air. Would little
Mac, the Young Napoleon, slog through in a winter campaign
and take Richmond? If he should, said men of the South at
Richmond, he would find it as Napoleon did Moscow, a city
in ashes.

In Missouri during the summer and fall of 1861 civil war
ran red and saw one battle of 5,000 Union troops against

Richmond, Virginia, in 1861. From a sketch.

11,000 Confederates where the slaughter nearly equaled Bull
Run. The warfare pointed a sinister forefinger toward the
future, and had its weight in moving Lincoln to write in a
message to Congress: "In considering the policy to be adopted
for suppressing the insurrection I have been anxious and
careful that the inevitable conflict for this purpose shall not
degenerate into a violent and remorseless revolutionary
struggle."

Four men had sat at a table in the Planter's House at
St. Louis one day that summer. One was the Governor of

Missouri, Claiborne Fox Jackson, who with a former governor, Sterling Price, had arrived in the city under a "safe conduct," a special permit granted by General Nathaniel Lyon, joined with Frank P. Blair, Jr., Republican Congressman representing the Union Safety Committee. In St. Louis and vicinity the regular State government of Missouri had been overthrown.

What the four men talked about several hours that day was whether Lyon as a Union commander could be free to march his troops anywhere in Missouri. Governor Jackson insisted that Missouri should be a neutral State and allow neither Union nor Confederate soldiers within its borders. In conclusion Lyon said he would see every man, woman, and child in Missouri under the sod before he would consent to Missouri's dictating to the United States Government. He clipped his words to the Governor: "This means war! One of my officers will conduct you out of my lines in an hour."

Then one day Lyon borrowed clothes from Blair's motherin-law and with his red whiskers tucked under bonnet strings he rode in an open carriage through Camp Jackson, to make sure with his own eyes what was going on. The market basket on his arm held a dozen loaded revolvers; he rode past signs: Davis Avenue, Beauregard Street. The next day he surrounded Camp Jackson, took its 635 men prisoners of war. In street clashes of the military with crowds—or mobs— twenty-eight people were killed, two of them women.

Nathaniel Lyon, short and fiery, drove himself hard, some of his raw volunteer troops saying he talked to them the same as if they were mules and "He had no compliments for anybody." The son of a Connecticut Yankee farmer, a West

Pointer, Indian-fighter in Florida, shot in the leg entering Mexico City with the American army, Lyon handled regulars on the West Coast, at Forts Riley and Kearney, and came to St. Louis from Prairie Dog, Kansas. Congressman Frank Blair knew Lyon as a Union man and saw to it early that Lincoln appointed him commandant of the St. Louis arsenal. At the first signs of Governor Jackson's State troops'

Jefferson City, Missouri, in 1861

seizing the 60,000 muskets in his charge, Lyon used part of them to arm Blair's Home Guards and sent the rest across the river into Illinois. Keeping his force of 7,000 men on the hills around the arsenal, he watched the State troops assembling at Camp Jackson and waited till they had received arms and munitions sent upriver from the Confederate War Department at Baton Rouge; then he closed in.

The next day after his telling Governor Jackson at the Planter's House in St. Louis "This means war!" he started with 2,000 men for Jackson and the State government at the capital, Jefferson City. He ran them out of the capital to Booneville, scattered some 1,300 militia there, and sent the Governor and his guard of 200 or 300 men as fugitives southward. Governor Jackson was carrying the State seal with him, issuing proclamations and documents, yet for all its claims

Lyon had made it look like a runaway government without a home to call its own.

Two men, Lyon and Frank Blair, had worked out their plans, which made it impossible for Missouri to secede from the Union. The Germans of St. Louis, who were mainly Union and antislavery, threw in their help as valuable allies.

From cornlands and sandhills came volunteers and State militiamen, thousands whetting to fight for the Southern cause of the neutrality of Missouri. Said one of their officers, "We had no tents, it is true, but tents would only have been in our way; we had no uniforms; the ripening corn fields were our depots of subsistence; the prairies furnished forage, and the people in defense of whose homes we were eager to fight gladly gave us of their stores." The foot soldiers were preceded by the "huckleberry" cavalry. Horsemen from Kansas and Texas threw in. The privates seldom saluted, called an officer "Jedge," and lacking bugles, the first sergeants called, "Oh, yes! Oh, yes! All you who belong to Captain Brown's company fall in here."

Lyon threw his army of 6,000 at more than twice that number of Confederates on August 10, 1861, at Wilson's Creek. Bullets struck him near the ankle, on the thigh; one cut his scalp to the bone; his horse was shot. Mounting another horse, his face white from loss of blood, he ordered a bayonet charge and led it, tumbling off his horse into the arms of his orderly with a bullet hole close to the heart. His army retired, the enemy not following. The losses were about 1,200 killed and wounded on each side. Missouri boys of both armies lay dead in the cornfields alongside Kentucky, Iowa, and Illinois boys.

The Confederates gave over the body of Lyon. Crowds came to gaze on his face as the coffin journeyed to Connecticut, where the General Assembly mourned its "beloved son" and the State received for safekeeping his sword, belt, and hat. Press stories, later denied by his family, said that his will left $30,000, nearly all of his estate, to the United States Government for carrying on the war.

An outcry arose when Congressman Frank Blair and others put the blame for Lyon's death, Wilson's Creek, and other losses on General John Charles Frémont, commander of the Department of the West, with headquarters, troops, and munitions at St. Louis.

Frémont, one of the first major generals appointed by Lincoln, was in 1856 the first Republican-party candidate for President. Born in Savannah, Georgia, expelled from college in Charleston, South Carolina, for "continual disregard of discipline," instructor of mathematics on a United States war sloop, and railroad surveyor in the Tennessee mountains, he became a lieutenant in the United States Topographical Corps, and at Washington fell in love with fifteen-year-old Jessie Benton, daughter of Senator Thomas H. Benton of Missouri. The Senator had him sent west of the Mississippi River on a surveying trip. He came back and ran away with Jessie; they were married, and thereafter the Benton home in St. Louis was his too, but he used it little. He led expeditions west, exploring the Rocky Mountains, South Pass, winning the first recorded climb up the highest point in the Wind River Mountains; Fremont Peak was named for him.

One fourteen-month trip took Frémont to Great Salt Lake, Fort Vancouver, and Sutter's Fort, California, with his men

worn to skeletons and only thirty-three of sixty-seven horses and mules coming through. He clashed with the Spanish rulers of California, took a hand in overthrowing them and setting up the State of California, of which he was the first United States Senator.

Then came land, gold mines, money pouring in at the rate of $75,000 a month, and Frémont's Mariposa estate of 46,000 acres, which had cost him $3,000, was estimated worth $10,-000,000. Then too came squatters, rival claims, and the details of management and finance. He was in Paris trying to sell half of his estate when the news came of Sumter. He offered his services and Lincoln immediately commissioned him a major general. At the White House he had talked with Lincoln of the plan for him to organize an army in the Northwest and go down the Mississippi and split the Confederacy in two.

After being placed in command of the Western Department on July 3, Frémont lingered in Washington, delayed in New York, arrived in St. Louis on July 25, directed entrenchments thrown around St. Louis to make it safe from assault, wore out relays of telegraphers with messages to governors and troop commanders. Many days he worked from five o'clock in the morning till midnight.

Should Frémont have known it would raise evil gossip for him to locate his headquarters in an elegant mansion at a rental of $6,000 paid to a relative of Mrs. Frémont, even though the rental was reasonable? Should he have known it would set unfriendly tongues buzzing for him to be surrounded by Hungarian and Garibaldian officers in trick uniforms, with ungodly titles? To reach his second-story office,

callers passed guards at the street corner, at the gate, at the outer door, at the office door. He was a busy man wrestling with imponderable equations, protecting himself against fool interruptions and time-wasters. Yet his system didn't operate so as to put through the important items and get on with the war. He could handle outfits of one or two hundred men on the plains or desert or in unexplored mountains. Riding the human whirlwind in Missouri was another affair.

Blair called on Frémont with General John M. Schofield, who wrote, "The general received me cordially, but to my great surprise, no questions were asked, nor any mention made, of the bloody field from which I had just come, where Lyon had been killed." Instead of wanting to learn any possible lessons from a tried soldier on the peculiar ways men may have of fighting pitched battles in Missouri, Frémont led Schofield to a table and pointed out on maps the triumphant line of march his army would take to southwestern Missouri and northwestern Arkansas, brushing aside all obstacles, and ending in New Orleans. It was a masterly campaign, as Frémont saw it, on paper. Blair and Schofield left Frémont's office. "We walked down the street for some time in silence. Then Blair turned to me and said, 'Well, what do you think of him?' I replied in words rather too strong to print. Blair said, 'I have been suspecting that for some time.'"

The fantastic tale arose that Frémont was scheming to set up a military republic, a Northwestern Confederacy, of which he would be the head. A young German, Emil Preetorius, who was at Frémont's headquarters and often talked with him, said this was idle chatter: "I had abundant proof that he was a patriot and a most unselfish man. The defect in

Frémont was that he was a dreamer. Impractical, visionary things went a long way with him. He was a poor judge of men and formed strange associations. He surrounded himself with foreigners, especially Hungarians, most of whom were adventurers, and some of whom were swindlers. I struggled hard to persuade him not to let these men have so much to do with his administration. Mrs. Frémont, unlike the General, was most practical. She was fond of success. She and the General were alike, however, in their notions of the loyalty due between friends. Once when I protested against the character of the men who surrounded Frémont, she replied, 'Do you know these very men went out with us on horseback when we took possession of the Mariposa [Frémont's California estate]? They risked their lives for us. Now we can't go back on them.' It was the woman's feeling. She forgot that brave men may sometimes be downright thieves and robbers."

Gustave Koerner, appointed a colonel by Lincoln and one of Lincoln's friends to whom Frémont gave a degree of confidence, wrote: "There were plenty of very warm Union men who yet sought to make very large profits out of their patriotism. These clamored for all sorts of contracts for horses, beef, mules, hay, wagons, etc. And when they did not succeed, they naturally charged Frémont with favoring friends and acquaintances of his from the East or California."

Amid his difficulties Frémont held a theory he once wrote to his wife in a letter: "War consists not only in battles, but in well-considered movements which bring the same results." He recalled that during war it sometimes happens that spoken and written words have powerful effects. His veins ran with

French blood and he may have heard of the Time of the Terror during the French Revolution. At any rate, he was dealing with a revolution in Missouri. And now he would bring out the Terror. Through the night of August 29 and past midnight and far into the morning of August 30 he worked on a proclamation. The gift of tongues had been bestowed on him, he believed. Daylight broke through the windows when Mrs. Frémont came and found him at his desk with a particular friend, Mr. Edward Davis of Philadelphia. "I want you two, but no others," murmured the General.

Then he read them the proclamation. And they, as wife and particular friend, said it was good, it was a stroke of genius, it would end the war, save the country, and send his name down the ages.

"Circumstances, in my judgment of sufficient urgency," ran the proclamation, "render it necessary that the commanding general of this department should assume the administrative powers of the State." In pompous terms and with threats he didn't have power to enforce, he declared "martial law throughout the State of Missouri." Drawing the line of the Union Army across half the State, he promised that all persons north of this line caught "with arms in their hands" would have court-martial and "if found guilty will be shot." Also "the property, real and personal, of all persons in the State of Missouri who shall take up arms against the United States, or who shall be directly proven to have taken an active part with their enemies in the field, is declared to be confiscated to the public use, and their slaves, if any they have, are hereby declared freemen." Thus he would bring the Terror to Missouri before marching his armies southward and

subjugating the hostile populations between St. Louis and New Orleans.

Having written the proclamation in the night, he issued it in the morning. With so important a proclamation there should be no delay, in his judgment. It was too good to be laid aside and read over again on the chance that later judgment might revise it.

Lincoln, along with the country, first heard of the proclamation through the newspapers. After getting an authentic text he wrote Frémont on September 2: "Should you shoot a man, according to the proclamation, the Confederates would very certainly shoot our best men in their hands in retaliation; and so, man for man, indefinitely. It is, therefore, my order that you allow no man to be shot under the proclamation without first having my approbation or consent." Then Lincoln urged that "the confiscation of property and the liberation of slaves of traitorous owners will alarm our Southern Union friends and turn them against us; perhaps ruin our rather fair prospect for Kentucky." He asked Frémont to modify the proclamation so as to conform with an act of Congress passed on August 6 concerning confiscation of property used for insurrectionary purposes. "This letter is written in a spirit of caution, and not of censure. I send it by special messenger, in order that it may certainly and speedily reach you."

Frémont took six days to write a reply to Lincoln. "In the night I decided upon the proclamation and the form of it. I wrote it the next morning and printed it the same day. I did it without consultation or advice with anyone." He still believed it a first-rate piece of work as proclamations go, and

he wouldn't change or shade it. It was equal to a victory in the field. "This is as much a movement in the war as a battle."

And this Frémont letter to Lincoln was carried by a special messenger—Mrs. Frémont herself. She left St. Louis on September 8 with her English maid, sitting two days and nights in a hot, overcrowded car, arriving in Washington the third day. And as she told it: "I had not been able to undress or lie down since leaving St. Louis. I had intended taking a bath and going to bed at once."

She changed her mind and sent from Willard's Hotel to the White House a written request to know when she might deliver Frémont's letter to the President.

A White House messenger brought back a card on which was written: "Now, at once. A. Lincoln."

It was nearly nine in the evening. She walked to the White House with Judge Edward Coles of New York, met the President in the Red Room: "I introduced Judge Coles, who then stepped into the deep doorway leading to the Blue Room —and there he remained walking to and fro, keeping in sight and hearing, just within range of the doorway. For he was struck at once, as I was, by the President's manner, which was hard—and the first tones of his voice were repelling. Nor did he offer me a seat. He talked standing, and both voice and manner made the impression that I was to be got rid of briefly. It was clear to Judge Coles as to myself that the President's mind was made up against General Frémont—and decidedly against me. In answer to his question, 'Well?' I explained that the General wished so much to have his attention to the letter sent, that I had brought it to make sure it would reach him. He answered, not to that, but to the subject his

own mind was upon, that 'It was a war for a great national idea, the Union, and that General Frémont should not have dragged the negro into it,—that he never would if he had consulted with Frank Blair. I sent Frank there to advise him.' He first mentioned the Blairs, in this astonishing connection. It was a *parti pris*, and as we walked back Judge Coles, who heard everything, said to me, 'This ends Frémont's part in the war. Seward and Montgomery Blair will see to that, and Lincoln does not seem to see the injustice, the wrong of receiving secret reports against him made by a man authorized to do so, and as everyone knows, with his mind often clouded by drink and always governed by personal motives' [meaning Frank Blair]."

Thus ran Mrs. Frémont's memorandum of the interview. She added other details later. When she handed General Frémont's letter to Lincoln, "he smiled with an expression not agreeable," and stood under the chandelier to read it. As he read she took a seat—without invitation, travel-worn. He told her he had already written to the General, who knew the Administration's wishes. She said Frémont thought it would be well if Mr. Lincoln explained personally his ideas and desires, for "the General feels he is at the great disadvantage of being perhaps opposed by people in whom you have every confidence."

Lincoln seemed a little startled and asked: "What do you mean? Persons of different views?" Whereupon Mrs. Frémont began talking about the difficulty of conquering by arms alone; England and the wide world would welcome a blow struck against slavery. She thought there was "a sneer-

ing tone" in the President's voice as he remarked, "You are quite a female politician."

She had a caller the next day in the elder Frank Blair, an old friend of the Benton family and chief manipulator in 1856 of Frémont's nomination for President. He was sorry for her, wagged his head. "Who would have expected you to do such a thing as this, to come here and find fault with the President? Look what you have done for Frémont; you have made the President his enemy." His information was that Lincoln had received a letter from Frank Blair at St. Louis bringing charges against Frémont and that Postmaster General Montgomery Blair had been sent to St. Louis to make an examination.

She now wrote a letter to Lincoln asking for a copy of the charges against her husband. The President replied: "It is not exactly correct, as you say you were told by the elder Mr. Blair, to say that I sent Postmaster-General Blair to St. Louis to examine into that department and report. Postmaster-General Blair did go, with my approbation, to see and converse with General Frémont as a friend. I do not feel authorized to furnish you with copies of letters in my possession without the consent of the writers. No impression has been made on my mind against the honor or integrity of General Frémont, and I now enter my protest against being understood as acting in any hostility toward him." And Jessie Benton Frémont returned to St. Louis with contempt for Lincoln, hate for the Blairs, and a sharper eye for conspirators against her husband.

Some degree of her personal influence was indicated when Albert D. Richardson of the *New York Tribune* once wrote:

"In a lifetime one meets not more than four or five great conversationalists. Jessie Benton Frémont is among the felicitous few, if not queen of them all."

When Lincoln spoke to Hay and others at a later time of his interview with Jessie Frémont, he said Frank and Montgomery Blair in the beginning had full and confidential relations with Frémont, thinking he would accomplish great things. "At last the tone of Frank's letters changed. They were pervaded with a tone of sincere sorrow, and of fear that Frémont would fail. Montgomery showed them to me and we were both grieved at the prospect. Soon came the news that Frémont had issued his emancipation order and had set up a Bureau of Abolition, giving free papers, and occupying his time apparently with little else. At last, at my suggestion, Montgomery Blair went to Missouri to look at and talk over matters. He went as the friend of Frémont. He passed, on the way, Mrs. Frémont coming to see me. She sought an audience with me at midnight and taxed me so violently with many things that I had to exercise all the awkward tact I have to keep from quarrelling with her. She surprised me by asking why their enemy, Monty Blair, had been sent to Missouri. She more than once intimated that if General Frémont should decide to try conclusions with me he could set up for himself."

And as Congressman J. B. Grinnell of Iowa heard Lincoln's version of the Jessie Frémont interview, she came "opening her case with mild expostulations, but left in anger flaunting her handkerchief before my face, and saying, 'Sir, the general will try titles with you! He is a man and I am his wife.'"

Donn Piatt wrote that the President demurred not so much

to Frémont's excess of information as at the high valuation
Frémont placed on it, the President with a merry twinkle in
his cavernous eyes once saying, "John Charles knows too
much."

Lincoln's letter to Frémont modifying the General's eman-
cipation proclamation was dated September 11 and began:
"Yours of the 8th, in answer to mine of the 2d instant, is
just received." He was not saying that Frémont was slow
and possibly insubordinate; he was indicating that Frémont
took plenty of time in a matter of urgent policy. In mild
language Lincoln's letter went on: "Assuming that you, upon
the ground, could better judge of the necessities of your po-
sition than I could at this distance, on seeing your proclama-
tion of August 30th, I perceived no general objection to it."
Then, pointing to the clause relating to confiscation of prop-
erty and liberation of slaves, he noted that particular clause
"appeared to me to be objectionable in its nonconformity
to the act of Congress passed the 6th of last August" and he
had therefore written his wish to Frémont that the clause be
modified: "Your answer, just received, expresses the prefer-
ence on your part that I should make an open order for the
modification, which I very cheerfully do."

Also this same week Lincoln wrote to a seasoned, sober,
rather fatherly major general of Western experience, David
Hunter: "General Frémont needs assistance which it is diffi-
cult to give him. He is losing the confidence of men near
him, whose support any man in his position must have to be
successful. His cardinal mistake is that he isolates himself and
allows nobody to see him, and by which he does not know
what is going on in the very matter he is dealing with. He

needs to have by his side a man of large experience. Will you not, for me, take that place? Your rank is one grade too high to be ordered to it, but will you not serve the country and oblige me by taking it voluntarily?" And Hunter started for St. Louis.

From antislavery quarters now rose a sure breeze of hostile criticism. Press, pulpit, men and women of antislavery fervor, spoke and wrote their scorn of Lincoln. "My wife expressed the common feeling about Lincoln's letter to Frémont, by saying it seems to her to be the old conflict of Mr. Feeble-Mind and Mr. Ready-to-Halt with Mr. Greatheart," wrote George Hoadly, superior-court judge in Cincinnati, to Secretary Chase. "I have heard men of sense, such as are called conservative, advocate the wildest steps, such as the impeachment of Mr. Lincoln, the formation of a party to carry on the war irrespective of the President and under Frémont, etc. etc. For myself, I must say that if the letters of Mr. Lincoln to Magoffin [Governor of Kentucky] and Frémont are any fair indication of his character and policy, I pray God to forgive my vote for him. General Frémont is thus far the favorite of the Northwest, because he has come up to the standard. And if the election were next fall, to displace him would be to make him President."

Senator Sumner was writing Dr. Franz Lieber: "The London *Times* is right! We cannot conquer the rebels as the war is now conducted. There will be a vain masquerade of battle, a flux of blood and treasure and nothing done!" The President lacked vision. "Never has there been a moment in history when so much was all compressed into a single line and brought directly under a single mind. Our President is now

dictator, imperator,—what you will; but how vain to have the power of a god and not to use it godlike! I am sad." Even Bill Herndon of the still existing law firm with the sign Lincoln & Herndon was writing from Springfield, Illinois: "Does the war go on to suit you? It does not suit me. Frémont's proclamation was right. Lincoln's modification of it was wrong."

These antislavery men clashed with such others as Montgomery Blair, who wrote, "The truth is, with Frémont's surroundings, the set of scoundrels who alone have control of him, this proclamation setting up the higher law was like a painted woman quoting Scripture."

Orville H. Browning of Quincy, Illinois, Kentucky-born, who had tried criminal and civil cases with Lincoln and who was appointed United States Senator to fill the unexpired term of Douglas, wrote a protest to Lincoln against the modification of the Frémont proclamation, Lincoln replying, "Coming from you, I confess it astonishes me." Browning had helped frame the very act of Congress on which Lincoln based his rebuke of Frémont. "That you should object to my adhering to a law which you had assisted in making and presenting to me less than a month before is odd enough." The proclamation raised the point of dictatorship as to principle. And as to policy: "The Kentucky legislature would not budge till that proclamation was modified; and General Anderson telegraphed me that on the news of General Frémont having actually issued deeds of manumission, a whole company of our volunteers threw down their arms and disbanded. . . . I think to lose Kentucky is nearly the same as to lose the whole game." With Kentucky gone, Missouri

and Maryland would go. "These are all against us, and the job on our hands is too large for us. We would as well consent to separation at once, including the surrender of this capital." As to shooting Missouri farmers caught with guns in their hands, "our adversaries have the power, and will certainly exercise it, to shoot as many of our men as we shoot of theirs. I did not say this in the public letter, because it is a subject I prefer not to discuss in the hearing of our enemies."

And it had happened that General Jeff Thompson, Confederate commander of the First Military District of Missouri, had issued a proclamation to meet Frémont's, announcing "most solemnly" that for every soldier of the State guard or of the Southern army put to death as ordered by Frémont he would "hang, draw, and quarter a minion of said Abraham Lincoln."

The Blairs marked Frémont to be destroyed. Frémont fought back. Mrs. Frémont joined. Between them all there was "dirty work at the crossroads." Stories appeared in New York, Philadelphia, Chicago newspapers that Frémont was to be removed from command, that he lived in the style of a European monarch, that he ordered 500 tons of ice to be used in sherry cobblers for himself and staff, that vouchers showed $25 Colt revolvers bought for $35, $20 Enfield rifles bought for $26.50. Congressman Washburne headed a committee which investigated Frémont's department. Judges David Davis and Joseph Holt were appointed to direct an audit of accounts. War Secretary Cameron, with an adjutant general, went personally to St. Louis.

They all found extravagance, mismanagement, blunders,

but no specific outstanding corruption. The total of contracts for food, guns, steamboats, uniforms, supplies, fortifications, ran to about $12,000,000. Nothing could be fastened on Frémont. He came through the search with a record for personal honesty. He let it be told that Frank Blair had asked him to give a contract for 40,000 uniforms to a friend of Blair and he had refused. He threw Blair into jail, let him go, arrested him a second time, and let him go. He suppressed the *St. Louis News*.

Of a White House caller about this time Thomas W. Higginson wrote to his mother. A friend of Frémont came on to smooth things over with the Government and talked till at last the President turned on him, saying, "Sir, I believe General Frémont to be a thoroughly honest man, but he has unfortunately surrounded himself with some of the greatest scoundrels on this continent; you are one of them and the worst of them."

Meanwhile in Missouri there was marching and countermarching of home guards, regulars, volunteers, Hungarians, hillbillies, and one killed, two, twenty, a hundred, in minor clashes at Monday's Hollow, Underwood's Farm, Big River Bridge, Springfield.

After the Fredericktown fight a volunteer wrote home of counting 142 dead men in a field, most of them with bullets through the head: "Col. Lowe was shot right in the forehead, his brains running out." Another had half his head blown away. A man climbing the top rail of a fence hung there with arms and legs dangling from the top rail: "I counted seven bullet holes in his body."

The Chicago Irish Brigade under Colonel James A. Mulligan defended Lexington eight days against 20,000 of the enemy and surrendered 1,600 men on September 20. Blamed for this fresh loss of good troops, Frémont notified General Scott at Washington: "I am taking the field myself. . . . Please notify the President immediately."

General Scott replied, "The President is glad you are hastening to the scene of action; his words are, 'he expects you to repair the disaster at Lexington without loss of time.' " Yet Frémont went on losing time. On October 7 he was at Tipton with 38,000 men, writing Jessie his dreams: "My plan is New Orleans straight, Foote [with gunboats] to join on the river below. I think it can be done gloriously, especially if secrecy can be kept." The dream reached some of his men. "New Orleans, and home again by summer!" was the word passed along. And for the winter would there be plenty of tents? "Is no need of tents," said General Asboth. "In Hungary we make a winter campaign and we sleep without tents, our feet to the fire—sometimes our ears did freeze."

And while Frémont sat with his dreams of war and glory, a man wearing clothes like a Southern planter got off a horse at the Frémont picket lines just beyond Springfield. And the man told the pickets he was a messenger with information from the rebel lines. They let him in. The officer of the day took the man to the chief of staff. No, he couldn't see General Frémont in person. But they would pass in anything he wanted to tell Frémont. The man in the Southern-planter clothes refused this offer. Hours went by. And late in the

evening the chief of staff took him to the office where General Frémont sat at the end of a long table.

And the man ripped from his coat lining a paper and handed it to Frémont, who nervously unfolded it, read the name "A. Lincoln" signed to it, slammed the document down on the table, and frowned. "Sir, how did you get admission into my lines?" The man said he came in as a messenger bearing information from the "rebel" lines. Frémont waved him out. "That will do for the present."

Thus on November 2 Frémont was removed from command. Lincoln's removal order, dated October 24, had gone to General S. R. Curtis at St. Louis with instructions that the order was not to be handed Frémont if when reached by messenger "he shall then have, in personal command, fought and won a battle, or shall then be actually in a battle, or shall then be in the immediate presence of the enemy in expectation of a battle." Curtis made copies of Lincoln's order and sent three messengers by separate routes with it. Curtis had heard of Frémont's arrangements for no removal order to be delivered.

From German regiments came threats of mutiny; they had enlisted, men swore, to fight only under Frémont. He addressed them, asking for loyalty, praising his successor: "Soldiers! I regret to leave you. . . . I deeply regret that I shall not have the honor to lead you to the victory which you are about to win."

General Hunter temporarily took command. Other plans for reaching New Orleans were under way. Mrs. Frémont told Gustave Koerner: "Oh, if my husband had only been

more positive! But he never did assert himself enough. That was his great fault."

Frémont had lasted in Missouri just a hundred days. In that time he made himself a hero in the eyes of nearly all the antislavery elements of the Northern States and of Europe.

Sober citizens pulled the portraits of Lincoln from their walls and trampled under foot the face of the President, according to the *Cincinnati Gazette*. "He is not a genius," was Wendell Phillips's estimate of Lincoln. "He is not a man like Frémont, to stamp the lava mass of the nation with an idea." At ceremonies honoring Frémont in person, Henry Ward Beecher in his Brooklyn church said, "Your name will live and be remembered by a nation of freemen." James Russell Lowell, Harriet Beecher Stowe's husband, Greeley and his *New York Tribune*, Bryant and the *New York Evening Post*, took deep offense at Lincoln's treatment of Frémont. Worse in effect than another Bull Run disaster was the President's annulment of Frémont's emancipation edict: thus ran the pronouncement of the *Chicago Tribune*.

The *Springfield* (Massachusetts) *Republican*, however, did not trail along; its editor, Samuel Bowles, wrote, "It is gratifying to know that we have a President who is loyal to law —when that is made to meet an emergency—as he is to meet an emergency for which no law is provided." The *New York Herald* presented Lincoln as the nation's hero: "The President, who has always been known as an upright man, of late months has justly earned the reputation of a wise and energetic statesman." If Lincoln read a long editorial headed "President Lincoln Nobly Meeting the Crisis," his mood was partly that in which on the stump once he took a compliment

from Douglas—"Not being used to it, it came to me all the sweeter."

The *Herald* editorial was historical, gratulatory, and not lacking in advice. "While contending in battle array with the insane faction of nigger-drivers at the South, and putting down with the strong hand their murderous and suicidal treason, Mr. Lincoln has been equally mindful that the original cause of evil began with the machinations of fanatical nigger worshippers at the North, and that to them are mainly owing our present troubles. The moderate and effective rebuke contained in his letter to Major-General Frémont is eminently worthy of admiration, both for the dignified and courteous language in which it is couched, and the death blow it strikes at all attempts of badly advised local commanders to overstep the legitimate sphere of their military duties."

Not for long could any man be the hero of the *New York Herald*. The "laughing Ishmael" who was himself that journal had been accused often of inconsistency and replied, "I print my paper every day," his version of Lincoln's "My policy is to have no policy." The foremost innovator in the journalism of his time, James Gordon Bennett, was studied by Lincoln as one of the powers to be kept on the Union side as far as possible. Greeley with his *New York Tribune* was an educator, a reformer, and a personal influence rather than a great editor or publisher. Raymond with the *New York Times* was a Republican-party man and a Unionist slowly coming to understand Lincoln and to sponsor the Administration.

As a strict newspaper, allied to no political party, no reforms nor isms nor special ideas, brilliant and even bawdy in

its endless chatterings, the *New York Herald* was generally acknowledged to have circulation, resources, and prestige surpassing any other American journal. The Polish red-republican Count Gurowski wrote in his diary of August, 1861: "Mr. Lincoln has already the fumes of greatness, and looks down on the press, reads no paper, that dirty traitor the *New York Herald* excepted. So, at least, it is generally stated." The rumor was not correct, but may have arisen out of some chance remark of Lincoln on the news enterprise and editorial audacity of the *Herald*.

Daily printing 84,000 copies, the *Herald* rated itself on April 9, 1861, as "the most largely circulated journal in the world." Two days before the bombardment of Fort Sumter the *Herald* said that the only hope against civil war seemed to lie "in the overthrow of the demoralizing, disorganizing, and destructive sectional party, of which 'Honest Abe Lincoln' is the pliant instrument."

Self-announced as "daily daguerreotype of American manners and thought," the *Herald's* sixty-six-year-old owner and editor, born of Roman Catholic parents of French descent in Strathbogie, Scotland, had trained for priesthood at Aberdeen, had starved as a bookseller in Boston, had lived shabbily as a hack writer in New York, had served a year as Spanish translator for the *Charleston Courier*. In politics he had yoked himself to varied flickering interests, then become hard, gay, elusive. He issued his first four-page penny *New York Herald* in 1835, doing all the work except the printing himself, writing and shaping the whole paper on an editorial desk of one board slung over two dry-goods boxes, "one poor man in a cellar against the world," as he phrased it.

Then with years of toil from five in the morning till ten at night, scrambling, scandalizing, dramatizing, playing with a scale of shrieks and whispers delicately manipulated, Bennett built a world-famed newspaper. "The newspaper's function," he said, "is not to instruct but to startle." Rivals were forced to imitate his elaborate legitimate news service, while his chameleon viewpoints, his breezy and idle chatter, his irresponsible gossip and lurid topics setting the town agog, were not so easy to match. He charmed, dazzled, shocked, so independently or flagrantly that his enemies agreed with Park Benjamin writing him as "obscene foreign vagabond, a pestilential scoundrel, ass, rogue, habitual liar, loathsome and leprous slanderer and libeller."

Yet Bennett was first of newspaper editors to print financial news on a large scale, regularly to expose stock-market frauds, to publish lists of bankrupts, to mock at social functions and to satirize a "high society" he did not have time for, to print religious news, though his church items were at first resented and scorned.

On four occasions in public places Bennett was beaten with canes and cowhides, on each occasion giving his readers a full report of the event as he saw and felt it. His enemies overreached in hoping to destroy him. He was, as they printed it, "humbug," "venomous reptile," "instrument of mischief," "profligate adventurer," "venal wretch," "daring infidel," "prince of darkness," "ribald rascal," "cheat," "common bandit," "infamous slanderer," "veteran blackguard," "murderer of reputations," "nuisance," "black-hearted blasphemer," "turkey-buzzard," "villain," "forger," "ignorant hypocrite bloated with conceit," "immoral monstrosity." An

advertisers' boycott of the *Herald* was attempted and failed.

Physical beatings, verbal castigation, social ostracism, attacks on credit and advertising income, all failed to stop the course of Bennett striding onward toward power, telling his readers he was "a friend of the human race" and "from my earliest days there were implanted in my burning soul those lofty principles of morals, honor, religion, that all the editors or bankers in Christendom cannot intimidate."

Though he mocked at New York aristocracy and held no individual reputation too clean for him to smutch, he kept close to the needs of business expansion and the widening streams of Northern capital that sought new fields and larger earnings. As a Catholic apostate and supporter of Know-Nothing principles he quarreled with Archbishop John Hughes, who proclaimed Bennett "a very dangerous man." As a Know-Nothing he was rather anti-Catholic than anti-foreigner and took pleasure in printing statistics to show that 507,137 "poor emigrants" arriving in ten years had brought $21,900,000 into the country. He was metropolitan rather than rural, and had none of Greeley's influence with the farmers.

Greeley had arrived in New York a greenhorn from Vermont farms who had picked up the trade of printer, a stick and bundle over his shoulder, $10 in his pocket; twenty years old. His first work was on a job no other printer in the city would take, setting the type on a 32mo New Testament with Greek references and supplementary remarks. He edited the *New Yorker*, the *Jeffersonian*, the *Log Cabin*, and in 1841 started his penny morning paper, the *New York Tribune*, which for twenty-one years was at the forefront reporting,

if not advocating, every reform, radical idea, and ism that
came to view. His *Tribune* writers had included Charles A.
Dana, George William Curtis, William Henry Fry, Bayard
Taylor, Margaret Fuller, George Ripley, Count Gurowski,
Henry J. Raymond.

"I have been branded aristocrat, communist, infidel, hypo-
crite, demagogue, disunionist, traitor, corruptionist, and so
forth and so forth," he once declared in urging a friend not
to class him also as a poet. He kept close to workingmen's
movements, leaned to the ideas of the French Utopian So-
cialist Fourier and in the first year of the *Tribune* said, "We
have written something and shall yet write more, much more,
in illustration and advocacy of the great social revolution
which our age is destined to commence, in rendering all
useful labor at once more attractive and honorable, and ban-
ishing want and all consequent degradation from the globe."

"Mr. Greeley," commented one of his staff men, John Rus-
sell Young, "would be the greatest journalist in America if he
did not aim to be one of the leading politicians of America."
He often refused to print important speeches of Democrats
as news, saying he would do so when Democratic newspapers
began printing equally important addresses of Republicans.
His personal ways, plain and queer, his abrupt manners and
peculiar clothes, made him a half-myth that the country
talked about. In a sense he embodied the vague, grandiose
ambitions and hopes of Americans from coast to coast; the
overseas world looking on would yet copy American de-
mocracy and be redeemed.

Next to writing for the public he enjoyed lecturing to it,
and often took the platform. Henry Ward Beecher asked

him what he called "success" in a lecture and he answered,
"Where more folks stay in than go out." He was the first
president of Typographical Union No. 6 in New York,
though he later fought the union when a strike was ordered
on the *Tribune* to stop the publication of an advertisement
for printers by a rival paper. Though a member of the Uni-
versalist Church teaching that there is no hell, when he was
once asked to subscribe to a fund that would save sinners
from going to hell, he told the solicitor: "I won't give you a
cent. There don't half enough go there now." He owned a
farm at Chappaqua, thirty-three miles from New York, and
liked to call himself a farmer; his farmer readers knew well
enough that Greeley could not run the country and a farm,
both.

Once, making a political denial, he declared: "I never said
all Democrats were saloon-keepers. What I said was that all
saloon-keepers were Democrats." His office was open to the
public, and occasionally a man came in and bawled at Greeley
for the *Tribune's* sins and errors as Greeley quietly scratched
away at his two daily columns of writing. Once when such a
caller had about used up his profanity and vituperation and
was leaving, Greeley squeaked to him, "Come back, my
friend, come back and relieve your mind."

Thousands of "self-made men" echoed his saying, "Of all
horned cattle the most helpless in a printing office is a col-
lege graduate." Junius Henri Browne, of many years' service
under Greeley, noted him "a character combining numerous
antagonisms," wayward, moody, undisciplined. "His friends
could not be certain of him, for he could not be certain of

himself. He was not only unlike other men—he was unlike himself often. General rules failed to apply to him."

James R. Gilmore quoted Greeley in late '61: "We are all going to the devil . . . all owing to stupidity at Washington. . . . It pains, it grieves me to think of it. For you know it is said that but for my action in the convention, Lincoln would not have been nominated. It was a mistake—the biggest mistake of my life."

As the war dragged on Greeley refused to co-operate with Lincoln and at a later time Secretary Welles wrote in his diary: "Concerning Greeley, to whom the President has clung too long and confidingly, he said to-day that Greeley is an old shoe—good for nothing now, whatever he has been. 'In early life, and with few mechanics and but little means in the West, we used,' said he, 'to make our shoes last a great while with much mending, and sometimes, when far gone, we found the leather so rotten the stitches would not hold. Greeley is so rotten that nothing can be done with him. He is not truthful; the stitches all tear out.' "

When in early '62 Cameron resigned, the President appointed Edwin McMasters Stanton Secretary of State. This tempestuous, asthmatic lawyer from the Buckeye State got results. He was highhanded, arrogant, even domineering, yet his money honesty was unquestioned, and that helped. He was the bureaucrat incarnate. Most of the time he worked like a house afire. Lincoln, hearing that Stanton might run away with the works, recalled a Methodist minister out West so excited and jumpy they had to "put bricks in his pockets to keep him down."

DONELSON AND SHILOH

DURING the winter of 1861-62 Lincoln probably considered one concrete question more than any other: "Why doesn't McClellan move with his army and how can we get him to fight?" Six months had gone in January of 1862 since McClellan had been put at the head of the Army of the Potomac. Weeks had dragged on without fighting, though he had three men to one in the Confederate army near by at Manassas.

Money, men, bread, beef, gunpowder, arms, artillery, horses, had been given McClellan on a colossal scale. The army under him was published and spoken of as the largest

"Turning him Pediculus Boiling them
over" vestimenti

Flipping pancakes

and finest known in modern history. That he drilled, maneuvered, practiced, two, three, four months was understood—without murmuring. But when he settled into winter quarters, with an enemy army only two days' easy march away, there was exasperation.

His army was made up mainly of boys in the early twenties, thousands of them nineteen and under. They wrote to the folks back home, letters about their winter huts, pork and beans, coffee and soup from tin cups, epidemics of

Army huts in a winter camp

measles and mumps, digging trenches, putting up telegraph wires, clearing range for artillery with pick and shovel, throwing up earthworks, driving beef to camp, hauling military stores, dysentery, sore feet, roaches in hardtack, target practice, washing shirts and underwear in creeks and rivers.

Early in December Lincoln had handed McClellan a carefully worked out memorandum asking specific and technical questions about a forward movement. McClellan kept the memorandum ten days and sent it back with replies scribbled in pencil and a note dismissing all of Lincoln's suggestions: "The enemy could meet us in front with equal forces nearly, and I have now my mind actively turned towards another plan of campaign."

General Joseph Johnston of the enemy army at Manassas was reporting to Richmond an "effective total" of about 47,-000 men, while McClellan was claiming that Johnston's force was three times its actual size. When officers of other armies called for more troops McClellan was surprised, sometimes shocked. General Tecumseh Sherman wired for 75,000 men to help the Western forces drive south, and McClellan handed the dispatch to Lincoln, then at his headquarters, with the remark, "The man is crazy."

Lincoln called to Washington a St. Louis man who had spent many days on the bottom sand and mud of the Mississippi River, salvaging ships with a diving bell he invented. They talked about the best way to carry on the war on the Western rivers. James B. Eads, for that was the man's name, went back to St. Louis and under government contract got 4,000 men scattered over the country working on his plans.

In one hundred days he had ready eight iron-plated, steam-propelled gunboats.

These gunboats and more, carrying over 140 large-caliber guns, made up a flotilla commanded by Andrew H. Foote. On February 6 of '62 Commodore Foote and his gunboats escorted a line of steamboats up the Tennessee River carrying eighteen regiments under Brigadier General Ulysses S. Grant.

Foote's flotilla of gunboats

They crowded the decks watching the scenery, 18,000 troops, cornhuskers, teamsters, rail-splitters, shopmen, factory hands, college students, from Iowa, and Nebraska, from Illinois, Indiana, Ohio, Missouri, many of them not yet old enough to vote. Many of them had a mystic belief that the Mississippi River should fly one flag from upper Minnesota to the Gulf, and the Union of States should be held together from Atlantic to Pacific. From the decks these prairie boys watched the river scenery.

The gunboats stopped at Fort Henry on the Tennessee River, filled it with exploding shells, and troops marched in and took its Confederate flag. The garrison had left for Fort Donelson, twelve miles away on the Cumberland River. Grant

marched his army this twelve miles across country to Fort
Donelson in fair weather, so warm and balmy that thousands
of soldiers threw away their blankets, overcoats, or both.

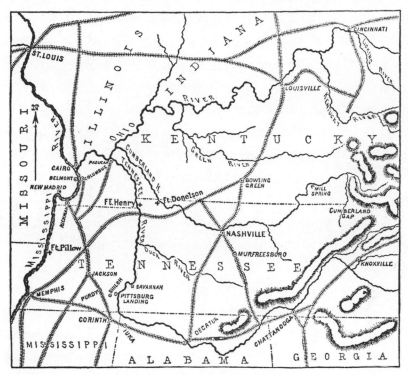

The campaigns in Tennessee

Foote took his gunboats up to the Ohio River, up the
Cumberland, and exchanging shots with the Fort Donelson
guns was disabled so that he had to steam upriver. This left
Grant with 27,000 troops, counting new arrivals, to contest
with 18,000 troops inside a fort.

Before the fighting began a cold wind came, snow fell, the
roads froze, and in ten-above-zero weather men fired and
loaded their muskets, and in the night huddled and shivered,

seeking fences, brush, trees, logs, to keep off the wind. Neither side dared light a bivouac fire. Men and boys were found next morning frozen stiff.

Grant went aboard Foote's flagship to arrange for the gunboats, though disabled, to keep up the best fire they could from a distance so as to worry the cannoneers in the fort. Riding back from this conference, Grant found his right wing battered and wavering. Some word dropped led him to order Confederate prisoners searched. They were carrying three days' rations in their haversacks. Grant sent word along the line that the enemy in desperation was trying to cut its way out and retreat. "Gentlemen, the position on the right must be retaken."

Nearly all the correspondents mentioned the personal quality of the individual soldiers on both sides. They had come for fighting and they fought. "Cold and hungry, with garments stiff with frost, the soldiers were still hopeful and firm," wrote one. "I did not find a single discouraged man, or one who, if he were so, would admit it. The universal sentiment was, 'We came here to take that fort, and we will take it.' Our troops fought with the coolness of veterans and the desperation of devils."

On Sunday, February 16, 1862, telegrams began trickling into the War Department at Washington. General Simon B. Buckner, commanding Fort Donelson, had sent a messenger to Grant asking for "terms of capitulation" and Grant replied: "No terms except an unconditional and immediate surrender can be accepted. I propose to move immediately upon your works." And the Confederate commander surrendered the fort and 13,828 prisoners. The battle losses were: Union,

500 killed, 2,108 wounded, 224 missing; Confederate, 231 killed, 1,534 wounded.

The victory clinched Kentucky to the Union, gave a foothold in Tennessee, sent Union armies two hundred miles forward into enemy territory. More than anything else it lighted up the gloom of the North. Over the country were outpourings of people to celebrate with bonfires, fireworks, bells ringing, whistles blowing, meetings, speeches, subscriptions for the wounded.

Lincoln had first taken particular notice of the Donelson victor when he read the proclamation Grant issued in September to the citizens of Paducah, Kentucky: "I have come among you, not as an enemy, but as your friend and fellow-citizen, not to injure or annoy you, but to respect the rights, and to defend and enforce the rights of all loyal citizens. . . . I have nothing to do with opinions. I shall deal only with armed rebellion and its aiders and abettors." Lincoln commented, "The modesty and brevity of that address show that the officer issuing it understands the situation, and is the proper man to command there at this time."

The country listened to hear what kind of a man this Ulysses S. Grant was. He broke over the rules of war, seemed to be an original. When he left Fort Henry marching to Fort Donelson he had only about as many soldiers as there were in Fort Donelson, while military theory required that he should have five men to one in the fort to be taken. He expected reinforcements, of course, but they might not arrive. Also he fought in winter weather over mud and through ice, sleet, and snow, even though spring was only a few weeks off.

He was an Ohio boy who graduated at West Point as
number 21 in a class of 39. He was marked down for being
late at roll call, for not having his coat buttoned or brushed,
for not keeping his musket clean, and for wearing another
coat, jacket, or cap than required by regulations. He slouched
at West Point, saying before he went there that he did not
hope to get through. He slouched afterward. The way he
made war was slouchy. He was an original. As a boy twelve
years old hauling logs for his father's tanyard at Georgetown
he made a trip for a final load but arrived when the gang
of workers who lifted the logs onto the wagon with hand-
spikes had gone home. The boy slanted a sugar tree from the
wagon, hitched a horse to one log after another and snaked
it onto the wagon. The father was amazed. Not even the
grown men in that neighborhood had thought of so simple
a way of getting a load of logs onto a wagon.

At West Point he rode a horse over a hurdle 6 feet 6, a
new record. At Monterey in the Mexican War he went for
ammunition relief, riding under fire in Comanche style, cling-
ing to the saddle with one leg while holding his head and
body close to the side of the horse away from the enemy.
He could break horses and had tried his hand at breaking
troops who had not learned discipline. An odd number. He
loved horses, dogs. But he never hunted, couldn't shoot ani-
mals. He was 5 feet 8 in height, wore whiskers, was nearly
always a little disheveled, even sat for his picture with coat
or hair in disorder. He had quiet manners, gravity, gray eyes,
and a face with economy of expression. At Fort Vancouver
on the West Coast in 1854 no works nor projects challenged
him. He was homesick, carried in his inside coat pocket a

worn pack of letters from his wife, one day showing the men at this army post a letter page inked with a baby handprint—his second boy, Ulysses, Jr., two thousand miles away with the mother.

Grant had married her without a regular proposal; they were buggy-driving across a flooded bridge when she cried, "I'm going to cling to you no matter what happens," and safely over, he asked, "How would you like to cling to me for the rest of your life?"

One day there came to Fort Vancouver a locket holding a long thin braid of a woman's hair interwoven with a little curl of a child's hair; this Grant wore around his neck. Why did he drink harder at this time? Was it loneliness for home? For he was warned that as a captain his drunkenness was bad for the regiment. He wrote out a blank resignation and gave it to the colonel; it was to be dated and sent to the War Department if whisky again got the best of him, which it did. He quit the army, saying, "Whoever hears of me in ten years will hear of a well-to-do old Missouri farmer."

Grant cleared land on 80 acres near St. Louis let to him by his wife's father. He became accustomed to two slaves given to his wife by her father, a slaveholder. He hauled wood ten miles into St. Louis at $10 a cord, wearing blue army overalls tucked into his boots, sometimes eating, drinking, and talking over old times with some West Point or Mexican War comrade of old days. He built himself a two-story house of logs, a masterpiece of simple design and craftsmanship, and named the place Hardscrabble. The word would pass for a nickname; it was hard scrabbling he had fallen on. His hands grew hard and horny, his shoulders bent from work.

They traded Hardscrabble for a house and lot in St. Louis. As a real-estate salesman Grant failed. Friends said ague and rheumatism still held him; chills shook him on spring afternoons, weakened him so that he was dizzy and had to be helped to the omnibus he rode home in. He looked glum and felt useless. The family moved to Galena, Illinois, where he was selling hides to shoemakers and harness- and saddle-makers, his income $800 a year, when the war commenced. At a public meeting in Galena after Sumter Captain Grant was elected chairman. He wrote the Government at Washington offering his services, and the Government not answering, he went to Springfield, Illinois, was made a colonel, and took a regiment to Missouri.

When ordered by General John C. Frémont, head of the Department of Missouri, to "make a demonstration" against Confederates at Belmont, he did more than ordered. He was expected merely to harass them so that they would not send reinforcements to another Confederate command. As he took 3,000 troops on steamboats down-river he changed his intentions. "I saw that the officers and men were elated at the prospect of at last having the opportunity of doing what they had volunteered to do—fight the enemies of their country. I did not see how I could maintain discipline, or retain the confidence of my command, if we should return to Cairo without an effort to do something." So he landed them, marched through cornfields and scrub timberland, charged, and drove the Confederates out of camp. And while the cornhuskers and shopmen were looting the camp, yelling, cheering, making patriotic speeches, some drinking whisky, the reinforced Confederates came back, and an officer rode up to Grant

calling, "We are surrounded and will have to surrender."
And Grant was cool. "I guess not. If we are surrounded we
must cut our way out as we cut our way in." Which they
did. And Grant was the last man to ride his horse up the
gangplank of the last boat to leave. Of his 3,000 men against
an enemy force of 7,000, Grant lost 90 killed, 173 wounded,
235 missing, while the enemy lost 261 killed, 427 wounded,
278 missing.

Grant did not like show-off. He seldom swore; admirers
said, "No impure word ever escaped his lips." His profanity
was mostly limited to "doggone it" and "by lightning." The
country had now nicknamed him "Unconditional Surrender"
Grant.

Lincoln gave to Grant the stars of a major general. The
President was more than interested in this plain fighter who
had given the Union cause its first victories worth mentioning.
Lincoln saw among the driving motives in the Fort Donelson
victory the passion of the Northwest, his own region, for an
unbreakable Union of States.

The laughter at McClellan now was wry, bitter. The
Western forces had battled and won big points sooner than
commanded in Lincoln's general order setting February 22
as the day for a general movement of land and sea forces.
Washington's Birthday came while McClellan's colossal
Army of the Potomac kept to its tents and winter huts
around Washington.

Lincoln now stepped publicly into the handling of the
Army of the Potomac, to the extent of publishing on March
7 and 8 his General War Orders No. 2 and No. 3. One di-

rected McClellan to organize his army for active field opera-
tions into four corps, Lincoln naming the generals to com-
mand. The second ordered that whatever the field operations
might take, enough troops should be left in and about Wash-
ington to leave the capital secure. This and other matters
brought McClellan to the White House for a call on the
President.

It was Sunday, March 9, 1862, and while McClellan sat in
conference with Lincoln and Stanton a message came which
upset McClellan, though it was no surprise to the others.
The news was that the rebel batteries on the Potomac River
were abandoned, and Johnston's army at Manassas had moved
out of its entrenchments, broken from winter quarters, and
moved southward, leaving as mementoes many "Quaker
guns"—logs on wheels, painted to look like cannon.

McClellan was shocked into action. That very Sunday he
ordered his army to march on the enemy's deserted camp.
He arrived at Bull Run Creek, at Manassas, and found it as
reported—empty. Then he marched his army back again
to Washington.

Nathaniel Hawthorne wrote from Washington to his
daughter: "The outcry opened against McClellan, since the
enemy's retreat from Manassas, is really terrible, and almost
universal; because it is found that we might have taken their
fortifications with perfect ease six months ago, they being
defended chiefly by wooden guns. Unless he achieves some-
thing wonderful within a week, he will be removed from
command."

Besides delays there were peculiar blunders. McClellan, for
instance, planned a permanent bridge at Harper's Ferry to be

made of canalboats. He telegraphed for cavalry, artillery, and a division of infantry, intending that they should cross the bridge and move up the Shenandoah Valley. So far, so good. But when the canalboats came up the Potomac and arrived at the lift locks at Harper's Ferry it was found that they were 6 inches too wide to pass. Therefore no bridge—and $1,000,000 spent.

More serious was the point that McClellan had stripped Washington of all defense troops except some 20,000. Therefore Lincoln ordered General Irvin McDowell with 40,000 to stay in and near Washington. In both political and military circles it was agreed that the capture of Washington by the enemy would probably bring Britain and France to recognize the Richmond Government, the blockade would be broken, arms and supplies would pour into the South, and the South would win the war hands down. So Lincoln wrote McClellan: "My explicit order that Washington should, by the judgment of all the commanders of [army] corps, be left entirely secure, had been neglected. It was precisely this that drove me to detain McDowell."

Then came bickering. Over and again across the coming weeks and months McClellan was to claim he had only so many troops—giving the number—and he must have more. The War Office would answer that so many troops—giving the number—had been sent him and asking why he did not have more than he claimed.

"There is a curious mystery about the number of troops now with you," wrote Lincoln. "When I telegraphed you on the 6th, saying you had over 100,000 with you, I had just obtained from the Secretary of War a statement, taken as

he said from your own returns, making 108,000 with you and *en route* to you. You now say you will have but 85,000 when all *en route* to you shall have reached you. How can the discrepancy of 23,000 be accounted for?"

He tried to prod McClellan gently into moving forward and fighting. "Once more let me tell you it is indispensable to you that you strike a blow. I am powerless to help this." Whether the troops went by a water route to the Peninsula and moved on Richmond or whether they went overland would not change the essential difficulty. "We would find the same enemy and the same or equal intrenchments at either place. The country will not fail to note—is noting now—that the present hesitation to move upon an intrenched enemy is but the story of Manassas repeated." Lincoln closed the letter: "I beg to assure you that I have never written you nor spoken to you in greater kindness of feeling than now, nor with a fuller purpose to sustain you, so far as in my most anxious judgment I consistently can; but you must act."

In April of '62 McClellan's Army of the Potomac lay on the Peninsula before the Confederate entrenchments at Yorktown. Moving this army from Washington by water had required 113 steamers, 188 schooners, 88 barges, hauling for three weeks 121,500 men, 14,592 animals, 1,150 wagons, 44 batteries, 74 ambulances, besides pontoon bridges, telegraph materials, equipage, cattle, food, supplies.

McClellan kept his army at Yorktown for weeks while he threw up entrenchments, built batteries, installed big guns. "Do not misunderstand the apparent inaction here," he wrote to Lincoln. "Not a day, not an hour has been lost. Works have been constructed that may almost be called gigantic."

General Joseph E. Johnston was writing Robert E. Lee, "No one but McClellan would have hesitated to attack." For when McClellan landed and began his gigantic works, the Confederate entrenchments were held by 5,000 men. During the weeks McClellan was getting ready to fight, the Confederates recruited thousands of troops, partly through the use of a conscription act passed by the Richmond Government. And when at last McClellan's big guns were set to blow the enemy off the map, when finally Union troops moved out to capture the foe, they found nobody to fight. Again he had not heard Lincoln's warning: "the present hesitation to move upon an intrenched enemy is but the story of Manassas repeated."

At unfailing intervals McClellan called to Washington for more men, more guns. When at last after a month of siege the empty Confederate entrenchments were captured, McClellan telegraphed: "Yorktown is in our possession. . . . No time shall be lost. . . . I shall push the enemy to the wall." The total force under Johnston, who had evacuated, numbered 55,633 men, about one to two of McClellan's. They had waited till McClellan had finished building elaborate batteries, till McClellan was perfectly satisfied that he could shell and shatter all opposition. Then they drew off.

During the weeks McClellan was moving to the Peninsula and entrenching at Yorktown, other actions were staged elsewhere and with different results. Three days' fighting went on at Pea Ridge in the northwest corner of Arkansas between Missouri, Iowa, Illinois, and Ohio regiments against Missouri, Arkansas, and Texas regiments along with three Red Indian regiments. The Union forces lost 203 killed, 972 wounded,

174 missing, as against 800 to 1,000 killed, 200 to 300 missing, of the Confederates. The Southern commander had planned to carry the war to St. Louis and on into Illinois, but the prolonged and bloody combats at Sugar Creek, Leesville, Elkhorn Tavern, dispersed his army, freed Missouri from all but guerrilla warfare, and crippled Southern military power west of the Mississippi.

Near Santa Fe, New Mexico, Texas and Colorado cavalry clashed, with 32 Union killed and 36 Confederate. Fort Pulaski, Georgia, was captured with 360 prisoners. On the Mississippi River Commodore Foote and General John Pope took Island No. 10 with over 2,000 prisoners, threatening all down-river traffic of the South.

An action came as a "thrust into the vitals of the Confederacy." The sea dogs Commodore David Glasgow Farragut and Commodore David Dixon Porter, with battleships and mortar boats, along with Major General Ben Butler heading an army of land troops, ran and battered their way through the forts and batteries at New Orleans and captured the largest seaport and the most important metropolitan center of the South, a city of 168,000. An army of 10,000 Confederates left the city, their torches lighting 15,000 bales of cotton, a dozen large ships, several fine steamboats, unfinished gunboats, and property worth millions of dollars.

On the Tennessee River near the Mississippi State line at Shiloh Church and Pittsburg Landing, General Albert Sidney Johnston had hurled 40,000 Confederate troops in attack on 36,000 under Grant. In the Sunday morning sun Johnston had told his staff men, "Tonight we will water our horses in

the Tennessee River." To generals who advised other plans Johnston said, "I would fight them if they were a million." His troops sent the Union front lines reeling. One Union division fell back to its eighth position during the twelve hours of combat that day. Grant came on the field several hours

Pickets on duty before Shiloh. From a sketch by Winslow Homer in *Harper's Weekly*.

after the fighting began; he was at breakfast nine miles up the river when he first heard the firing. At times the battle seemed to be the swaying and surging of many mobs, the gray and the butternut-brown against the blue. Men fought from tree to tree, with sometimes the cry, "How about Bull Run?" met by the answering cry, "How about Fort Donelson?" One Union division was cut off and 2,200 were taken prisoner.

The Union lines were steadily forced back. Would night

find them driven to the bank of the wide Tennessee River and no bridge to cross? Tecumseh Sherman had three horses shot under him, got a bullet in the hand, another through his hat; a third grazed his shoulder. One tree about as thick as a lean man received ninety bullets, another tree sixty. In a clearing between woodlands dead men lay so thick that careful walking was required not to step on corpses. One soldier lay on his back holding in a rigid hand a daguerreotype of a woman and child he had been gazing on when death came. A private who kept a diary recorded seeing a soldier who had been killed while taking aim; he lay with one eye open, the other closed, his hands clutching a rifle. "During the engagement riderless horses were flying in all directions. Wounded were borne off the field by hundreds, some with arms and legs off, writhing in agony." Two Kentucky regiments fought each other with fury and hatred, one of the Union soldiers wounding and taking prisoner his own brother. As the Confederate brother was started toward the rear he took notice of his Union brother firing at a man near a tree and shouted, "Hold on, Bill, don't shoot there any more! That's father!"

Toward evening Grant sat his horse, watching the Confederates try to take a hill guarded by a battery and Union gunboats. Someone asked him if things looked gloomy. He answered: "Delay counts for everything with us. Tomorrow we shall attack them with fresh troops, and drive them, of course."

Darkness fell on the Sabbath slaughter. Rain came in torrents on the tentless soldiers of the two armies. Grant lay under a tree and tried to sleep, but a swollen foot and ankle,

caused by a horse's slipping in mud and falling on him, kept him awake. He went to a log house near by where it was dry and where wounded soldiers came to surgeons for treatment. Their cries of pain kept him awake and he went back to his tree under the rain.

In the gray of dawn the Union troops moved in attack and that day, reinforced by 20,000 under Buell and 6,000 under Lew Wallace, drove the enemy to retreat. Albert Sidney Johnston, counted among brilliant Confederate commanders, was killed the day before, it was learned. The Union army lost 13,047 in killed, wounded, and missing, the Confederates 10,694.

One lesson sank home to the Union troops at Shiloh: From then on they dug trenches; even a 1-foot ditch with another foot of dirt piled in front of it reduced the human-target area to be shot at by the enemy.

Grant felt that a hard long war was ahead. He had seen the Confederates lose an army at Fort Donelson and then had seen them collect a new army, take the offensive, and show courage and endurance beyond all expectation. The motives that drove the Southern men and women on lay deeper than was generally believed in the North. "I give up all idea of saving the Union except by complete conquest," was Grant's thought after Shiloh.

Nineteen melancholy steamboats loaded with thousands of gashed and perforated Union soldiers moved north and brought the war home to Peoria, Chicago, Detroit. Still other steamboats carried thousands of men clothed in butternut and gray—to be held in Camp Douglas at Chicago as prisoners of war.

At first the joy over victory ran high in the North. Then this was modified by a widely spread story that Grant was drunk at Shiloh, that he was a butcher who without a heart sent men to sacrifice. Lincoln received at the White House one night at 11 o'clock his friend A. K. McClure, who as spokesman for a number of Republicans talked for nearly two hours on how "the tide of popular sentiment" was against Grant.

Lincoln let McClure talk with few interruptions. Then, as McClure reported it afterward: "When I had said every thing that could be said from my standpoint, we lapsed into silence. Lincoln remained silent for what seemed a very long time. He then gathered himself up in his chair and said, in a tone of earnestness that I shall never forget, 'I can't spare this man —he fights!' "

CHAPTER 6

FAREWELL, WOODEN WARSHIPS!

ON Sunday, March 9, 1862, news came to the Navy Department that sent Secretary Welles hurrying to President Lincoln, who at once called the Cabinet to the White House for quick thinking and emergency action. The facts were that a United States 40-gun frigate, the *Merrimac*, sunk at Gosport about a year before, had been raised by the Confederates, fitted with a cast-iron ram, and covered with 4-inch iron plates. Moving out from Norfolk on Saturday afternoon, she had met in battle two Union war vessels, the *Congress* and the *Cumberland*, and shot and rammed their wooden hulls till they were helpless. Another Union war vessel, the *Minnesota*, also wooden, had been run aground. And the news was that the *Merrimac* would smash her on Sunday morning and then be free to move on Washington or New York. Welles told the President of their one hope, their one chance, the *Monitor*, a new type of sea fighting craft, arrived at Hampton Roads the night before.

Then from Hampton Roads came the story of what happened. Towed by a tug out of New York Harbor three days before, the little *Monitor* met rough weather; water broke over the engines, down the blower pipes and smokestacks; hand pumps were rigged and worked; then the wind and high waves went down, or the *Monitor* would have gone to sea bottom. Once again fighting rough sea in shoals the

captain and crew wondered if the hawser running to the tug would hold. It did. That was luck, or Providence. They rode out two storms. So far, so good.

At last they came to Hampton Roads, saw the shattered ship *Congress* burning, took a pilot on board and steamed near the *Minnesota*, a wooden frigate. They were a tired crew on the *Monitor*, twice nearly sunk, no food but hard sea biscuit on a storm-soaked vessel, and no sleep in forty-eight hours. Their commander, Lieutenant John Worden, said no captain ever had a better crew; the crew swore their captain was the best that ever walked a deck. As the *Merrimac* came on toward the *Minnesota* the next morning, the little *Monitor* made straight for her, a David against a Goliath, ten guns on the *Merrimac* against two on the *Monitor*. "A cheesebox on a raft," "a tin can on a shingle," that was the *Monitor*, equipped with a revolving steel tower or turret, so that she could shoot from any position; and her raftlike deck was so low that the big *Merrimac* could not ram her.

During the shooting the tiny *Monitor* moved and maneuvered around the giant *Merrimac* like a fast bantamweight boxer circling a ponderous heavyweight. The big one crashed its ten guns against the little one. And the little one did not move except to answer with its two guns. A deep thrill went round the hearts of the men handling the guns in the *Monitor* turret when the first heavy slugs of the *Merrimac* thundered their impact on the outside of the turret. The men looked gladly into each other's faces as if to say, "She's a tough giant but this shortboy is tougher." Sometimes it was hard to start the turret revolving. They hoped it would not snarl.

"Once the *Merrimac* tried to ram us," wrote S. Dana

Greene, lieutenant commander, "but Worden avoided the direct impact by skillful use of the helm, and she struck a glancing blow which did no damage. At the instant of collision I planted a solid 180-pound shot fair and square on the forward part of her casemate. Had the gun been loaded with thirty pounds of powder, which was the charge subsequently used

The *Monitor* and the *Merrimac* trading shots in Hampton Roads

with similar guns, it is probable that this shot would have penetrated her armor; but the charge being limited to fifteen pounds, in accordance with peremptory orders from the Navy Department, the shot rebounded without doing any more damage than possibly to start some of the beams of her armor-backing."

The *Monitor* turret ran out of shells and she drew off for fifteen minutes to bring up fresh ammunition. The *Merrimac*, drawing 22 feet, could not follow the *Monitor*, which could steam into water a little over 12 feet deep.

The *Monitor* came back. Again the two guns against ten trying to cripple or kill each other.

"Again she came up on our quarter and fired twice," said

a Confederate on the *Merrimac* after the fight. "The impact forced the side in bodily two or three inches. All the crews of the after guns were knocked over by the concussion, and bled from the nose or ears. Another shot in the same place would have penetrated."

The *Merrimac* ceased firing, and a gunnery officer was asked by his superior, "Why are you not firing, Mr. Eggleston?" "Why, our powder is very precious," called the lieutenant, "and after two hours' incessant firing I find that I can do her about as much damage by snapping my thumb at her every two minutes and a half."

At ten yards' distance a shell from the *Merrimac* hit the sighthole of the pilothouse, stunning Commander Worden, filling his eyes with powder and blinding him, his face covered with blood.

The *Monitor* drew off to care for its commander and to examine how badly the pilothouse was wrecked.

The *Merrimac* drew off and steamed to Norfolk.

After six hours it was a drawn battle. Each side made its mistakes. If the *Merrimac* had concentrated its entire fire on the *Monitor* pilothouse from the first, she would have destroyed the *Monitor's* control. If the *Monitor* had shot at the *Merrimac's* water line, where the armor was weak, she would have sunk the *Merrimac*.

However, the two ships had taught the navies of the world a lesson. London and Paris declared that the era of wooden fighting craft was over. The Washington Government would now begin building a fleet of monitors. The blockade of Southern ports would go on.

In the crews of both ships were men writing home, as did

S. Dana Greene, of being worn. "My men and myself were perfectly black with smoke and powder. All my underclothes were perfectly black, and my person was in the same condition. . . . I had been up so long under such excitement that my nervous system was completely run down. . . . My nerves and muscles twitched as though electric shocks were continually passing through them. . . . I lay down and tried to sleep—I might as well have tried to fly."

News of the battle came with pleasure to John Ericsson, the Swede who designed the *Monitor*. He was type and symbol of the industrial, mechanical North, the machine-age man from whose head incessantly sprang new tools, wheels, devices. He grew up among mines and ironworks in Sweden, became a captain in the army, resigned, invented an instrument for taking sea soundings, a self-acting gunlock for naval cannon, a steam carriage in 1829 which ran thirty miles an hour. He came to the United States in 1839, and two years later furnished designs for a screw warship, the *Princeton*, "the first vessel having propelling machinery below water-line, out of reach of hostile shot."

Ericsson's very bodily strength was a curious item. He asked two workmen in his shop one day to remove a bar of iron he had tripped on. They said it was too heavy. He looked at them, picked it up, carried it and threw it on the scrap pile. They later put it on a scale and found that it weighed six hundred pounds.

This granitic man of quiet pride had written to the President in August of '61 that "steel-clad vessels cannot be arrested in their course by land batteries" and New York would be "at the mercy of such intruders," wherefore he would

offer plans. "Attachment to the Union alone impels me to offer my services in this fearful crisis—my life if need be—in the great cause which Providence has called you to defend." Respectfully he stated, "I seek no private advantage or emolument of any kind." In the event that his plans were approved he could within ten weeks construct a vessel to destroy the "rebel" fleet at Norfolk, leaving stolen ships sunken "and the harbor purged of traitors." Having planned upward of one hundred marine engines, designed naval structures for thirty years, and feeling at home in the science of artillery, he trusted his anxiety to serve would be understood. He was fifty-eight years old when in '61 he laid before a Naval Board of three commodores his plans for "an impregnable steam-battery of light draught," which he had been perfecting for eight years. They told him that his plans had been considered when previously presented by a friend of Ericsson—and they were rejected.

Ericsson came near walking out of the room and letting the whole matter slide; his New York shop was filled with more contracts than he could handle. Then he stopped and asked why they rejected the plans. Mainly, it turned out, they were afraid that the *Monitor* as designed would upset; it lacked stability. So Ericsson talked about stability of vessels that day, and one commodore told him, "Sir, I have learned more about the stability of a vessel from what you have now said than all I knew before."

At one session of the Naval Board President Lincoln and Cabinet members were present. "All were surprised at the novelty of the plan. Some advised trying it, others ridiculed it." A naval captain who was hostile said that to worship the

little model would not be idolatry "because it was in the image of nothing in the heaven above or in the earth beneath or in the waters under the earth." The session closed with Lincoln holding a pasteboard model of the *Monitor* in his hand and remarking: "All I have to say is what the girl said when she put her foot into the stocking. It strikes me there's something in it."

Finally they gave Ericsson a contract with a clause saying that if the *Monitor* did not prove "invulnerable" he was to refund all government money paid him. He did not read this clause, being in a hurry to get to work, or he might have handed the contract back instead of signing it. He asked to build 12-inch guns, but the naval experts told him 11-inch were plenty big. He asked to use thiry pounds of powder instead of fifteen for a shot, but the ordnance chief said No. He was told that "the concussion in the turret will be so great that men cannot remain in it and work the guns." Others had "calculated her displacement" and could prove, they were sure, that the *Monitor* would not float. These and other croakings were in his ears as he went to New York, drew his final plans, and saw the ship built in exactly one hundred days. When she went into action the final government payment on her had not been made.

Now John Ericsson could read a letter from the chief engineer of the *Monitor* saying: "Thousands have this day blessed you. I have heard whole crews cheer you." The New York Chamber of Commerce offered to raise a fund which would be "suitable return for his services" and "evince the gratitude of the nation." Ericsson replied: "All the remunera-

tion I desire for the *Monitor* I get out of the construction of it. It is all-sufficient."

The day after the battle Lincoln found his way to a house and an upstairs room where Commander John Worden lay. The President stood gazing down on Worden in bed, the scorched eyes closed, the shell-torn face bandaged. A naval lieutenant spoke: "Jack, here is the President come to see you." Worden murmured, "You do me great honor."

No answer came to Worden. The naval lieutenant turned to see Lincoln in tears with nothing to say for the moment. Then he did find words: "It is not so. It is you who honor me and your country, and I will promote you." And he made Worden a captain that very day.

CHAPTER 7

SEVEN DAYS OF BATTLES

McCLELLAN'S army having had nine months of organization, practice, drill, instruction in theory, saw its first active field service and went under fire in April of '62. Leaving his elaborate defenses at Yorktown to follow the retreating Confederates, McClellan fought a rear-guard action at Williamsburg, and moved to White House Landing, twenty miles from Richmond. Meanwhile he renewed his calls on the War Department and the President for more men and guns.

Troops and supplies on the road between Yorktown and Williamsburg

Rain, mud, heavy roads, bogged his army, McClellan complained to Lincoln, as though the enemy had fair weather and smooth going.

The wounded Confederate commander Joseph E. Johnston was replaced by Robert E. Lee, and the issue was whether McClellan could outguess Lee. Lee sent Stonewall Jackson to the Shenandoah Valley, let his best fighter go away, on a job that Lee guessed Jackson could accomplish while McClellan delayed, waited. Jackson with 17,000 men swept hither and yon in the valley region and in fourteen days marched his army one hundred and seventy miles, routed 12,500 of the enemy, captured $250,000 worth of supplies and property, took 3,000 prisoners and 9,000 rifles. It was a Napoleonic raid and foray on a large scale, which threatened Washington so seriously that Lincoln called off McDowell from co-operation with McClellan. Lincoln sent orders to some 60,000 men under McDowell, Frémont, and Banks, three different armies, and tried to surround Jackson. Frémont, however—always sure that his own judgment was superior to that of any other man alive—disobeyed two of Lincoln's orders, "resting" his men one day when they were ordered to march, and another day taking a route different from the one ordered by Lincoln. On paper the strategy worked out by Lincoln, for bagging Jackson's army in the clutch of three Union armies, was logical enough. But Jackson was an illogical phantom, got away with his supplies and prisoners, and joined Lee at Richmond—as Lee had guessed he would.

McClellan guessed that Lee must have at least 200,000 troops or he would not have dared to detach Jackson for the

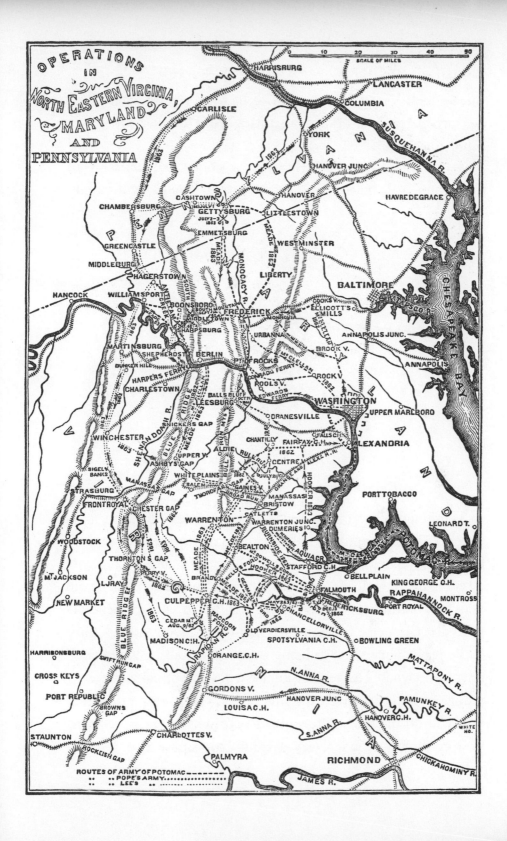

Shenandoah Valley operation. Lee had less than 83,000 when reinforced by Jackson, but this McClellan neither knew nor could guess.

McClellan pushed his troops to a point four miles from Richmond, still believing he was short of troops, still calling

The route step of "Jackson's Foot Cavalry"

to Washington for more men. On a day when his army outnumbered the enemy by 30,000 to 40,000 he telegraphed to the War Department: "The rebel force is stated at 200,000. I regret my inferiority in numbers, but feel that I am in no way responsible for it, as I have not failed to represent repeatedly the need for reinforcements." Lincoln wired him: "The probability of your being overwhelmed by 200,000, and talking of where the responsibility will belong, pains me very much. I give you all I can, and act on the presumption that you will do the best that you can with what you have, while you continue, ungenerously I think, to assume that I could

give you more if I would. I have omitted and shall omit no opportunity to send you reinforcements whenever I possibly can."

McClellan let himself be guided by reports of his secret service headed by Allan Pinkerton, often exaggerating the size of the Confederate army. Once, at another of McClellan's repeated calls for more troops, Lincoln groaned that sending troops to that army was "like shoveling fleas in a barnyard."

Lincoln understood with McClellan that if the Army of the Potomac could smash the enemy army, take Richmond, and send the Confederate Government a fugitive flying southward, it would set big bells ringing over the North. On the other hand, the wreck of McClellan's army might mean the end of the Union cause. The hazards affected McClellan's mind. Over and again in the many letters to his wife, written often at midnight and "1 A.M.," he told her of his courage, his resolution, how firm he was. He mentioned his faith and his fearlessness often enough to show his own doubt of himself.

In April the War Department ordered recruiting stopped, as though the forces in the field were enough to win the war. Weeks passed, and it was seen that more men were needed— and more money; that perhaps desperate years lay ahead.

Lincoln wrote a letter for Seward to use among men of financial and political power who were insisting that they must know precisely where the President stood, whether he really meant to carry on a war, and if so for how long, and what were his immediate intentions. Lincoln's letter outlined immediate plans "to hold what we have in the West,

open the Mississippi, and take Chattanooga and East Tennessee" besides going on with the Virginia campaign. "Then let the country give us a hundred thousand new troops in the shortest possible time, which . . . will take Richmond."

Then came in this letter a manner of oath: "I expect to maintain this contest until successful, or till I die, or am conquered, or my term expires, or Congress or the country forsake me." He would appeal to the country at once for new forces "were it not that I fear a general panic and stampede would follow, so hard it is to have a thing understood as it really is." The President was convincing. Seward and others got the governors of the North to sign a request that more troops be raised.

Lincoln on July 1 made a call for 300,000 three-year men —wondering how the country would take it. He wrote to McClellan, who was calling for 50,000 more soldiers, to be patient. Meanwhile Lincoln's circular letter to the Northern governors was going out, telling them that even with 50,000 troops raised in a month, 20,000 would be leaving and the gain would be only 30,000. "Time is everything. Please act in view of this."

The raising of new troops came addedly hard now because of McClellan's handling of his army. The enemy struck at his White House Landing base of supplies, where food, guns, powder, wagons, mules, arrived from Washington. And McClellan ordered a change of base to Harrison's Landing on the James River. And during the Seven Days' battles, in McClellan's changing of base, Lee put in every last man and gun he had and tried to crumple up McClellan and capture

his army. In the finish, and after bloody fighting, McClellan still held Harrison's Landing and had lost only 16,000 men as against 20,000 Confederate losses.

A complex and weary McClellan, after the first of the Seven Days' battles, telegraphed to Secretary Stanton: "I have seen too many dead and wounded comrades to feel otherwise

Hospital at Fair Oaks battlefield

than that the government has not sustained this army. If you do not do so now the game is lost."

Lincoln replied to the telegram: "Save your army, at all events. Will send reinforcements as fast as we can." As it was a two-hundred-mile water route, he added, "Of course they cannot reach you to-day, to-morrow or next day." He would comfort McClellan, reason with him: "I feel any misfortune to you and your army quite as keenly as you feel it yourself. If you have had a drawn battle, or a repulse, it is the price we pay for the enemy not being in Washington. We protected Washington, and the enemy concentrated on you. Had

we stripped Washington, he would have been upon us before the troops could have gotten to you."

McClellan's effort in the Peninsula had a world audience. His campaign was a commanding historic event. He was the first man in the Western world to command 100,000 men. He was extraordinarily outfitted and supplied, in tents, clothes, shoes, blankets, guns; his men were far better off than the enemy troops, who after a battle took shoes off dead men for living barefoot troops. Hundreds of miles of logs laid over mud, corduroy roads, had been built by McClellan's men. Their pontoon bridges by the score had been torn away by rising rivers and rebuilt by the laughing engineer corps. They had wrestled in rain and deep red clay with mules and wagons bringing up cannon, ammunition, coffee, hardtack, pork and beans. In artillery and rifles they surpassed the enemy in numbers and in late models.

At Malvern Hill a Confederate artilleryman sat in comfort behind a tree. "A moment later," noticed General D. H. Hill, "a shell passed through the huge tree and took off the man's head. This gives an idea of the great power of Federal rifled artillery." A Federal balloon, piloted by its inventor, Professor T. S. C. Lowe, rose 1,000 feet above Richmond, sending balloon telegraph and signal messages to McClellan; it was beyond range of the Confederate guns, but with their steady fire at it Lowe became known as "the most shot-at man in the war." A Confederate creation known as the Silk Dress Balloon, made from hundreds of wedding-gowns and evening dresses sent with prayers to Richmond by the women who had worn them, it was said, drifted onto a sand bar and was captured on the way to its first flight.

At one time, as McClellan came near Richmond, the gold and the archives of the Confederate Government were loaded on railroad cars ready to move in case McClellan reached the city.

On both sides was courage, tenacity. A correspondent saw a Federal soldier brought into a field hospital, "both legs torn off by a shell, both arms broken by bullets, the film of death glazing his eyes," but when spoken to he cried out, "I trust to God we are licking them!" At Malvern Hill a Confederate colonel had shouted: "Come on, come on, my men! Do you want to live forever?"

Surgeon Daniel W. Hand of the 1st Minnesota Volunteers told of a day of work at amputations in a field hospital: "It was late in the night before my own cares allowed me to rest, and then, where should I lie down? A cold wind was blowing, and we shivered in our scanty clothing. Every foot of sheltered ground was covered with sleeping men, but near the operating table, under a tree in the house-yard, there lay a long row of dead soldiers. My steward, Cyrus Brooks, suggested we make a windbreak by piling them up against the remnants of a fence. We did so, and then lying down behind them, we slept soundly until morning."

Gay humor lighted grim incidents. General O. O. Howard's right arm was shattered, and when he met General Phil Kearny, who had lost his left arm in Mexico, the two men shook hands on Howard's saying, "Hereafter we buy our gloves together."

At White House Landing, in order to keep supplies out of the enemy's hands, McClellan ordered railroad trains loaded with powder and food run off an embankment into the deep

mud of the Pamunkey River; other trains of cars were burned where they stood on the tracks. A South Carolina regiment gathered 925 rifles thrown away in a wheat field at Shirley; these were part of 35,000 small arms that fell to the Confederates as McClellan retreated. Strewn for miles were broken army wagons, axes, shovels, camp kettles, medicine chests, blankets, overcoats, stacks of flour barrels and mess beef, much of it burned or spoiled to make it useless to the enemy.

Not with pride did Northern people read of Confederate cavalry under the twenty-nine-year-old General J. E. B. Stuart making a ride that took them around the whole of McClellan's army, with no interruptions.

Yet for all his losses of men and material McClellan had won a victory. His cannon mounted tier on tier at Malvern Hill had mowed down the repeated lines of Confederates ordered up by Lee. Moving from Yorktown toward Richmond, McClellan had killed more of the enemy forces than they had of his. And now, having broken the fiercest blow the enemy could bring against him, he shrank under the protection of his gunboats at Harrison's Landing. When the order came to fall back, Chaplain Marks heard the one-armed New Jersey army officer who had fought among Indians, Arabs, Italians, say to other high officers: "I, Philip Kearny, an old soldier, enter my solemn protest against this order for retreat; we ought, instead of retreating, to follow up the enemy and take Richmond. And in full view of all the responsibility of such a declaration I say to you all, such an order can only be prompted by cowardice or treason."

Slowly the news had trickled out, and at last the whole story had to be told to the country of the Seven Days' battles,

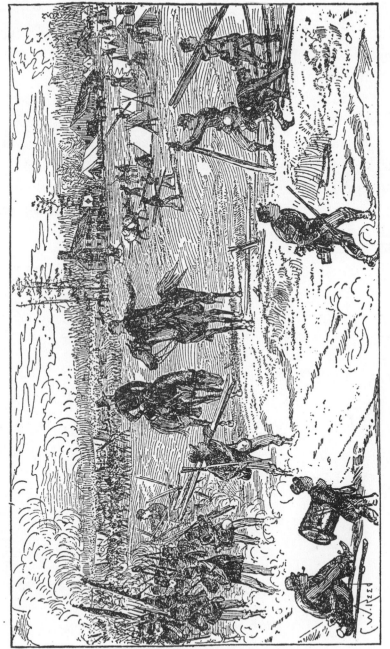

Ending march and going into camp

of superb valor and endurance, of beating the enemy and then retreating, of a great army that seemed to have everything in men and material foiled, thwarted, sent shrinking to the protection of its gunboats.

And now the Army of the Potomac, its sick and wounded, its cannon and horses, its mules and wagons, its trophies and battle flags, its farm hands, shopmen, college boys, store clerks, ditch-diggers, all in uniform, was brought back from the Peninsula to old places on the Potomac River within sight of the Capitol. And McClellan was relieved of command in the field and told to report himself for orders at Alexandria.

CHAPTER 8

SECOND BULL RUN

DURING that desperate, hammering summer of 1862 Lincoln revolved often in his mind the curious failure of his 200,000 men in Virginia against half that number. Would he have to try one general, another, and still another, and for how long?

A new combination named the Army of Virginia was headed by General John Pope. The new commander was a dashing horseman, a figure to look at, his valor in battle impetuous and undisputed. He was Kentucky-born, a West Pointer, a Mexican War officer promoted for gallantry on the field, an engineer, an explorer. John Pope had been continuously an army man, soldiering his lifework. His victories had brought in 1,300 prisoners at Blackwater, Missouri, and some 6,000 at Island No. 10 on the Mississippi. In his new Eastern command it was supposed or hoped that he embodied somehow the fighting quality or luck of the Western armies.

He issued an address to his new command. "I have come to you from the West, where we have always seen the back of our enemies." The Western policy was attack and not defense, he would have them know. "I presume that I have been called here to pursue the same system and to lead you against the enemy. It is my purpose to do so, and that speedily."

Was General Pope strutting to scare the enemy, or blustering to hide his personal embarrassment over the job just

ahead of him? His overconfidence ran into bombast almost inconceivable unless possibly it served to ease his own misgivings. For Pope was facing two great proved fighters, two strange captains of men, Lee and Jackson.

Robert Edward Lee had become the most portentous personality with whom Lincoln would have to contend in the months ahead. For Lee had two rare gifts, patience with men and patience with unforeseen circumstance. His training in handling and understanding men had been long, hard, varied, and thorough. The smooth reciprocal functioning of Lee with Davis was almost startling as a contrast to Lincoln and Mc-Clellan. Militarily Lee and Davis were one head of the Army of Virginia. Where Jefferson Davis would often fail to read the enemy mind Lee supplied the deficiency. Neither jealousy nor envy nor ambition, in any ordinary sense, gnawed at the heart of Lee. He sacrificed personal pride or ease to immediate ends in his handling of men, whether dealing with the President of the Confederacy or with staff generals or with barefoot privates.

Robert E. Lee had sunk himself in the tradition of George Washington, who had been in his near-by tomb at Mount Vernon only ten years when Lee arrived in a family coach at Alexandria, Virginia, a baby to grow up as a boy hearing of General Washington's letter to his father wishing him "all imaginable success and happiness," to live near the post office where Washington often came in person, and to walk in the market place where Washington had drilled troops. This could only fascinate the boy whose father had spoken in eulogy of Washington as "first in war, first in peace, first in the hearts of his countrymen." The boy later, grown to

manhood, sojourned at Arlington Heights with George Washington Parke Custis, grandson of Mrs. Washington and adopted son of George Washington, and married the daughter, Mary Ann Randolph Custis.

So he became further immersed in the shadows, legends, and personal testimonies of George Washington. What this did to the inside of Lee no man could say, but men who studied him closely said that one of his secrets was a grip on the character of Washington as a model, a hope, and a light. The reserve, the tenacity, the scruples, the exactitude in petty detail, the piety, the patience and forbearance, the balances of justice and fair dealing, the bearing of distinction touched with aristocratic outlook—these ways of Washington he pondered. They haunted him.

Robert E. Lee's mother, Ann Hill Carter Lee, was the daughter of Charles Carter, whose James River plantation and other possessions gave him reputation as the richest man in Virginia except George Washington. Her inheritance had dwindled so far that West Point was the advisable place for her son's education. On the basis of his father's brilliant Revolutionary War record, John C. Calhoun signed his appointment, and he went away to West Point.

On leaving West Point Lee was flung into the realities of handling engineers and work gangs to cut ditches in Georgia mudbanks, to blast rock from the bed of the Mississippi for river-channel improvement at St. Louis, to repair casemates in New York Harbor, to run pile-drivers in Baltimore Harbor. He came to know measurably that odd bird, the regular-army soldier, and that enigma, the American workingman. His reputation for fair dealing spread far, and once when he

assured an offending soldier, "You shall have justice," the answer was quick—"That is what I am afraid of." From his first assignment of duty in 1829, which put him to his arm-pits in mud while building fortifications at Cockspur Island in the Savannah River, through his duties thirty-one years later policing Indian tribes and fighting Mexican bandits on the plains of Texas, he was a military man to whom the word "duty" had peculiar meaning. "Duty," he wrote, "is the sublimest word in the language."

Lincoln in March of '61 had signed a commission appointing Lee a colonel in the United States regular army at the same time that the Confederate Government offered Lee a commission as brigadier general. It had been made plain that Lee was the choice for high command of the Union armies. "I declined the offer," wrote Lee, "stating as candidly and courteously as I could, that though opposed to secession and deprecating war, I could take no part in the invasion of the Southern States."

Into the smoke of battles and onto slopes strewn with the corpses of Southern and Northern boys Lee had gone because, as he said with an undeniable sincerity, he could not do otherwise: the first step was his decision that he could not fight against Virginia; the second and inevitable other step for him was his decision that, Virginia invaded, he must fight for her and against her invaders. Yet he was neither a revolutionist nor a secessionist nor a Union-hater nor temperamentally joined to the men who had created the Confederacy and then asked him to fight for it. Lee was a conservative whose instincts favored a strong government to hold down disorder, tumult, and insurrection.

When General Joseph Johnston was wounded, Lee had been sent forward to take in hand four different armies, weld them into a unit for action. In a four months' campaign, at times outnumbered two to one, he had stopped McClellan and earned a name as the savior of Richmond and the Confederacy.

To a doubting inquirer one of Lee's generals had said his first name was "Audacity," that he would tower head and shoulders above all others in audacity. In a conference with generals just before the Seven Days' battles, one of them, busy with pencil and paper, was showing that McClellan with superior forces could sweep on to Richmond. "Stop, stop!" said Lee. "If you go to ciphering we are whipped beforehand."

His items inserted in Richmond newspapers helped to mislead McClellan as to his numbers and designs. He sent one of his old West Point cadet students, J. E. B. Stuart, to get information as to McClellan's actual strength, and Stuart's 1,200 horsemen made their estimates in a ride around McClellan's entire army. He approved Magruder's marching the same 10,000 men back and forth on a level of ground, into the woods and out again, giving an imitation for McClellan's observers of a vast horde preparing to slaughter its foe.

Lee read in Lincoln a diplomatic sensitivity about the capture of Washington, knew what the loss of the Union capital would mean in the eyes of London and Paris, and sent Jackson on threatening operations that kept troops near Washington and away from McClellan. His patience was required to stand up under the *Richmond Examiner's* sneer at "the bloodless and masterly strategy of Lee," while his General

D. H. Hill officially reported of an attack under fierce artillery fire at Malvern Hill, "It was murder, not war."

Line after line Lee had hurled at the tiers of artillery planted by McClellan at Malvern Hill. And the lines broke under shattering fire and the hillsides in the gloaming and the moonless night were ghastly with the moans and writhing of the wounded. Lee admitted failure and, riding among bivouacs of troops, asked, "General Magruder, why did you attack?" The answer was: "In obedience to your orders, twice repeated." In one battle a Texas regiment lost nearly 600 of its 800 men. The losses during the Peninsular campaign in Lee's army of 85,000 and McClellan's army of 150,-000 were officially tabulated:

Killed	Wounded	Missing
Confederate 3,286	Confederate 15,909	Confederate 946
Union..... 1,734	Union..... 8,062	Union..... 6,053

Lee had won victories, though McClellan had killed nearly two for one of Lee's men. Lee had stopped McClellan from getting to Richmond and had persuaded McClellan's mind into calling for more troops and guns from Washington. Lee knew better than McClellan that war is a conflict of wills, and had imposed his will on McClellan to the extent that McClellan believed he was a loser when he was not, which was why McClellan did not try to push through and take Richmond after Malvern Hill, which was why McClellan retreated to Harrison's Landing after murderously punishing Lee at Malvern Hill. And while Lee's mind was concentrated entirely on the point of whether he could drive McClellan into the James River in spite of gunboat protection, leaving

all Southern politics to Jefferson Davis, McClellan concentrated his mind for many hours on the political difficulties of the North.

More than once in the campaign before Richmond Lee's army had outslugged and outplayed the heavier opponent and then come to a standstill, bleeding and too weak to follow up the advantage gained. Lee had burned up more of the available man power of the South than was good for his cause.

Lee's right-hand man Thomas Jonathan Jackson too was born for war. His valley campaign up and down the Shenandoah, in which he captured half of one Union army, beat off three other armies with which Lincoln was trying to trap him, and slipped through for a rapid march to join Lee, had become one of the shining chronicles of the Confederacy.

Jackson was putting on a campaign that for swift troop movement amazed the world and was later soberly and in detail compared to the famous performances of Napoleon of France and Charles XII of Sweden. Thirty miles in twenty-four hours his infantry marched. "Mystify, mislead and surprise," was his counsel of approach, and then "hurl overwhelming numbers at the point where the enemy least expects attack." With 17,000 men in this one month he won five battles, took many prisoners, sent to Richmond great wagon trains of muskets, munitions, medicines, and supplies, threw Washington into a scare, made McDowell's army of 40,000 hug Washington so close that it could not co-operate with McClellan.

Jackson joined Lee for the defense of Richmond, he and his men in main decisive actions before Richmond fighting poorly, the general explanation being that they were too

worn with their valley campaign. They were soon to perform again, under their leader nicknamed "Stonewall" from a story that a Confederate general at Bull Run had pointed at him while the bullets were flying and men fleeing and said, "There stands Jackson like a stone wall." The tale was "sheer fabrication," said D. H. Hill, Jackson's fellow general and brother-in-law, and "the name was least suited to Jackson, ever in motion, swooping like an eagle on his prey; but the name spread like wild-fire."

An orphan boy who managed to get into West Point, Jackson had graduated far below the class leader, George B. McClellan. His Mexican War record bright, he became professor of natural philosophy and artillery tactics in the Virginia Military Institute at Lexington. Tall, rawboned, with big hands and a peculiar stride, he would walk alone, raise his right hand high over his head and let it down; he was either praying or easing himself physically—the onlookers could not tell which. He had many books and two favorites, which he always carried in his mess kit—the Bible and a volume of Napoleon's maxims on war. His spiritual guide was Jesus of Nazareth, his professional and military inspiration the Little Corsican, whose eighty-eight campaigns he had mastered from A to Z.

As Jackson now marched toward Pope he was told, "The new general claims your attention." He replied, "And please God, he shall have it." Lee in one dispatch alluded to the "miscreant Pope," who had directed his army to live off the country and reimburse only loyal citizens, who had ordered instant destruction of any house from which any soldier was shot, who had further ordered the arrest of all male non-

combatants within the Federal lines and the expulsion of those who refused to take an oath of loyalty to the Union and to give security for their good behavior. This to Lee was not civilized warfare, and he was saying, "Pope must be suppressed."

In the last week of August, 1862, Lincoln sat up till late every night, and one night all through into a bitter dawn. He telegraphed Colonel Hermann Haupt, railroad chief in the field with Pope's army, "Is the railroad bridge over Bull Run destroyed?" He received a reply at 4:25 A.M. saying of the bridge "if it is not destroyed . . . probably will be."

Minutes counted. Lee and Jackson were performing around Pope. And what with jealousy, spite, bickering, officialism, politics, pride, sloth, ignorance, a large army of troops stayed quiet and safe along the Potomac while Pope was outguessed, flanked, surprised, hacked and harassed, and driven off from Bull Run Creek with slaughter. In combat and retreat he lost 14,000 out of 80,000; Lee lost 9,000 out of 54,000.

Stormy tides rocked Washington as the broken pieces of a defeated army straggled in. Outbound railroad trains were packed; thousands fled the national capital. Jackson's foot cavalry would cross the Potomac at Georgetown, ran a rumor. The Federal Treasury building was barricaded with hundreds of barrels of cement. By order of the President clerks in the civil departments enrolled and began military drill. Stanton had important papers gathered into bundles to be carried away on horseback, if necessary.

In the trail of the Union army were thousands of wounded. Fletcher Webster, son of Daniel Webster, leading a regiment

he had raised, fell with a bullet in his lungs. Six soldiers lay in an orchard, not in the shade but in a broiling sun, each with a leg off, and with them a corporal with both legs off. Still another of this orchard squad had his side torn by a shell, and he heard the boys with legs off wishing for ripe apples. He dragged himself inch by inch through long grass till he reached apples and threw them to comrades. Then he faded out.

Three thousand convalescent soldiers were moved from Washington to Philadelphia to make room for serious cases from Bull Run. Floors in the Capitol, in the Patent Office building, were cleared for torn and mutilated men. Signs went up on street walls calling for volunteer nurses, each to bring a bucket and a tin cup, a bottle of brandy, and if possible, transportation toward the battlefield.

The War Department call on Northern cities for surgeons, lint, linen bandages, liquor, hospital supplies, was answered by volunteer medical men, by gatherings of women scraping lint and tearing sheets to make bandages, by public meetings to raise funds.

Pope was relieved of command and assigned to the Northwest to curb Indian tribes. Lincoln clearly believed that the departing general had not had a fair chance. "Pope," said the President, "did well, but there was an army prejudice against him, and it was necessary he should leave."

BLOODY ANTIETAM

THE yellow corn stood ripe in the fields of Maryland. Lee and Jackson mentioned it. That corn would help feed their armies. They marched gray and butternut battalions across the Potomac, ragged and footsore men who could fight, as the world knew. Lee gave out a proclamation to the people of Maryland, a Slave State, her folk of Southern traditions and leanings. His men had come to "aid you in throwing off this foreign yoke."

And where would he hit first? Would it be Harrisburg, Philadelphia, Baltimore? Thus ran the questions that worried the North and harried those cities.

Meantime McClellan with an army marched toward Lee. He was feeling better. His friend, Lincoln, against a majority of the Cabinet, had again put him at the head of a great army in the field.

On top of the turmoil set going by Lee's invasion of the North came more excitement because of news from the West. Telegrams tumbled into the White House telling of Bragg's Confederate army slipping past Buell's army, which had been set to watch him. Bragg was marching north toward Cincinnati and Louisville; those cities were anxious. Also Kirby Smith's men in gray had marched into Kentucky, chased the State legislature out of Frankfort, and captured Lexington.

"Where is General Bragg?" Lincoln queried in telegrams to several generals in the field.

Into Frederick City, Maryland, marched Stonewall Jackson's men, followed later by Union troops. A woman, Barbara Frietchie, nearly a hundred years old and remembering 1776, leaned from a window and waved the Stars and Stripes at the Union troops to show her loyalty. And a story spread that she had unfurled the Union banner with grand words of defiance to Jackson's troops. Whittier wrote a poem about her that was put in the schoolbooks and committed to memory by millions of children enacting her as saying, "Shoot if you must this old gray head, but spare your country's flag," which she had not said at all. But it was good Union propaganda. And a poet of the Southern cause could have given fame to another old woman in Frederick City, whose love ran to the other flag. She stood on her doorstep as the Southern boys marched past, tears in her eyes and hands raised— "The Lord bless your dirty ragged souls!"

The first big action of Lee's army in Maryland made the Northern gloom heavier. For Stonewall Jackson smashed at the Union garrison in Harper's Ferry, trapped them, and took 11,000 prisoners. Then four days later, on September 17, came Antietam, to be remembered for long as a blood-soaked word.

McClellan's 90,000 troops met Lee's army, about half that of McClellan in troop numbers, at Antietam Creek. Around a cornfield and a little white Dunker church, around a stone bridge, and in a pasture lane worn by cowpaths surged a human tornado. Fighting Joe Hooker rode in the worst of the storm, and said of it, "Every stalk of corn in the northern

and greater part of the field was cut as closely as could have
been done with a knife, and the slain lay in rows precisely as
they had stood in their ranks a few moments before." Hooker
fell from his saddle with a bleeding foot. An old man with

Harper's Ferry in May, 1861

his white hair in the wind, Major General J. K. F. Mansfield,
fell from his saddle, a corpse. Four other Union generals fell
off their horses with wounds. General Sedgwick was three
times wounded, in shoulder, leg, and wrist. Colonel B. B.
Gayle of Alabama was surrounded, drew his revolver, called
to his men, "We are flanked, boys, but let's die in our tracks,"
and fell riddled with bullets. Longstreet, heading one of Lee's
corps, took two bullets in his right leg, one in his left arm;
another ripped his shoulder, and he sent Private Vickers of

Alabama to tell Lee that he was still on the field—but Vickers tumbled with lead through the head, and the next bullet received by Longstreet was in the face and he was carried away to live on. "Don't let your horses tread on me," a wounded

View of Antietam from the grove where McClellan watched the battle.
Sketch by Benson J. Lossing.

man called from a huddle of corpses where officers were picking their way through.

Into Shepherdstown, Virginia (later West Virginia), on that hot and dusty autumn day the wounded poured, and Mary B. Mitchell, the volunteer nurse, said, "They filled every building and overflowed into the country around, into farm-houses, barns, corn-cribs, cabins; six churches were all full, the Odd Fellows' Hall, the Freemasons', the Town Council room, the school-houses." She saw men with cloths

about their heads, about their feet, men with arms in slings, men without arms, with one leg, with bandaged sides and backs; men in ambulances, wagons, carts, wheelbarrows, men on stretchers or leaning on comrades, men crawling with inflamed wounds, thirsty, bleeding, weak.

At the center of the red harvest stood the little white Dunker church, where the teaching on Sundays was that war is sin and no man who enlists for war can be a Dunker. There the dead lay in blue and gray. And on the breast of one in blue a pocket Bible was open at the Psalm reading "Yea, though I walk through the valley of the shadow of death, I will fear no evil: for thou art with me; thy rod and thy staff they comfort me." On the flyleaf a mother had written, "We hope and pray that you may be permitted by a kind Providence, after the war is over, to return."

In the fields lay men by thousands. Flat corn leaves fallen over some of the bodies were spattered and blotched with blood drying and turning rusty. On a golden autumn Sabbath morning three-mile lines of men had faced each other with guns. And when the shooting was over the losses were put at 12,000 on each side.

Lee crossed the Potomac, back into the South again. McClellan did not follow. Lincoln had telegraphed him: "God bless you, and all with you. Destroy the rebel army, if possible." But McClellan had again won a victory and did not know it. He still believed the enemy outnumbered him.

McClellan's chances of wiping out Lee's army were estimated by Longstreet: "We were so badly crushed that at the close of the day ten thousand fresh troops could have come in and taken Lee's army and everything it had. But McClel-

lan did not know it." He had two soldiers to the enemy's one, completely superior cannon, rifles, supplies. He had failed when it lay in his hands to "destroy the rebel army if possible," as Lincoln urged. He had 93,000 men answering roll call as Lee was fading down the Shenandoah Valley with less than 40,000. He might have brought the war shortly to a close. But his fate lay otherwise.

McClellan felt himself called on to be a statesman and po-litical theorist while at the same time a military strategist and field commander. At Harrison's Landing he had handed Lincoln a long letter he had written. Lincoln read it with McClellan looking on, told McClellan he was much obliged, and put the letter in his pocket. Several hours, more likely days, it had taken McClellan to write for the President his ideas on how the country should be run, instructions to his Commander in Chief that the war should be "conducted upon the highest principles known to Christian civilization," as though perhaps Lincoln hadn't thought about that. Private property should be respected; "radical views, especially upon slavery," would melt away the armies. McClellan believed it healthy advice, for he wrote his wife: "I have written a strong, frank letter to the President. . . . If he acts upon it the country will be saved."

McClellan's political sincerity, and the frankness he mentioned with pride to his wife, were incomplete, else he would have informed Lincoln that Fernando Wood, the Mayor of New York who in '61 tried to get his city to secede from the Union and set up as a Free City, had called on him in camp to talk politics. With a furious and relentless campaign raging, time pressing and time short, he gave hours of con-

ference to one of the most insidious and corrupt of politicians who, with an associate Democrat, told him he ought to be the party's next candidate for President. McClellan wrote his wife that the President had neglected to answer his letter. Lincoln, when asked what he would do about the letter, was reminded of the man who mounted into the saddle of a horse that got to acting up and the man said, "Well, if you're going to get on I'm going to get off!"

A folk tale epitomized much. Lincoln had scolded McClellan, the drollery ran, for not sending more complete and detailed reports of his army's progress. So McClellan sent a telegram to Lincoln one day: "Have captured two cows. What disposition should I make of them?" Lincoln: "Milk 'em, George."

Once in a conference Lincoln remarked he would "like to borrow" the Army of the Potomac from McClellan if it could be made to do something. Once he had called at McClellan's house in Washington; finding the General away, Lincoln waited. The General came home, went to bed, ignored the President, who walked away telling John Hay it was no time to stand on dignity, and he would willingly hold General McClellan's horse if that would bring victories. "McClellan is a great engineer, but he has a special talent for a stationary engine," was an early comment. Later Lincoln told the elder Frank Blair, "He has got the slows," and wearily replied to a demand of McClellan for more shoes, mules, horses: "I have just read your despatch about sore-tongued and fatigued horses. Will you pardon me for asking what the horses of your army have done since the battle of Antietam that fatigues anything?"

While McClellan "rested" his troops a White House visitor casually asked Lincoln what number of men he supposed the "rebels" had in the field. And as *Leslie's Weekly* published the President's reply, he said seriously, "1,200,000 according to the best authority." The visitor turned pale and cried, "My God!" "Yes, sir," went on the President, "1,200,000—no doubt of it. You see, all our generals, when they get whipped, say the enemy outnumbers them from three to five to one, and I must believe them. We have 400,000 men in the field, and three times four makes twelve. Don't you see it?"

Stanton, Chase, Greeley, and other unrelenting enemies of McClellan believed they solved him and saw through him as though he were transparent. Which he was not. McClellan lived much of the time in a peculiar world of his own making. He would almost get ready to hurl his army into a great campaign, then hesitate, think of more to be done, make excuses, get sore at his own excuses, and finally find himself in mental operations and defensive vocabularies difficult to analyze. Scores of letters he wrote to his wife indicated how little he realized that any political business he mixed in should be restricted to the immediate needs of the Army of the Potomac and not include broad national policies. Only by sticking strictly to military affairs could he have had a chance to outplay the Washington authorities and the powerful antislavery factions who sought to pull him down.

No case was ever made out that McClellan was not brave and able. Only politicians, personal enemies, loose talkers, called him coward or sloven. At Malvern Hill and Antietam he performed superbly—and then failed to clinch and use what he had won. If he had been the ambitious plotter that

Stanton, Chase, and others feared, he would have marched his army to Washington and seized the Government there, as he said many urged him to do. His defect was that while he could not have instigated such treason himself, he did allow approaches to such treason to be talked freely in his staff and army without rebuke or repression from him. His political dabbling with Fernando Wood of New York over the future Presidency of the United States was not by his device; he did not ask Wood to come down to the Peninsula the first time, nor to Maryland for the second visit.

Yet it was also true that the slippery, conniving Wood did not see McClellan as a presidential figure until McClellan set himself up as a spokesman of governmental policy, virtually used his position as head of a great army to carry on an advocacy of measures easily construed as proslavery. When this drew the slimy Wood to his camp, he did not kick Wood out. He welcomed Wood, took up with Wood's proposal he should be made President and held to it till his friend General "Baldy" (William Farrar) Smith showed him that it could look like a betrayal of trust. A second time he welcomed Wood to his headquarters, and this time took up with Wood's plan, which looked so rotten that Baldy Smith broke with him.

His friend William H. Aspinwall, the New York steamship-railway magnate and financier who came to his camp, gave McClellan the keen advice to go along with Lincoln's policy as to the Negro, say nothing, and be a soldier. From the way he wrote his wife of what Aspinwall told him, it would almost seem as though this was the first time McClellan seriously considered the gift of silence on politics for a

general heading an army given to him by a government wrestling with delicately shaded political questions. He did not know that he had by his political trafficking, and by his unceasing gabble of "imbeciles" and "geese" at Washington, hampered unity of his staff, lowered the fighting quality of his army, and so muddled the army objectives that the President might have to take action—even if it led straight into worse muddles.

Two plans the President struggled with incessantly, like an engineer wrestling to put bridges over a swollen river during a flood rush. One of these was to make practical the colonization of Negroes to be freed. The other was gradual compensated abolishment of slavery.

Thus far all laws passed by Congress fully protected the ownership of slaves held by men loyal to the Union, or men not partaking in the rebellion. Not many were there of such Unionist slaveowners. All other owners of slaves were under the threat of confiscation of their property if and when the Union armies reached their plantations.

Months earlier, as far back as December, 1861, Lincoln spoke to Senator Sumner about sending a message on emancipation to Congress. But the armies were slow. The North got no grip on the South to warrant action. The President waited.

The idea of emancipation as a war measure, a military necessity, began developing. Even the Copperhead Democrats would have added difficulty arguing against emancipation if it could be shown as necessary to win the war.

At a Cabinet meeting on September 22, 1862, there was a

final discussion of the Emancipation Proclamation before its going out for the round world to read and think about. Lincoln spoke with a solemn deliberation. They had considered such a proclamation earlier, and he reminded them of that. "I have thought all along that the time for acting on it might probably come. I think the time has come now."

Lincoln read the proclamation, commenting as he went along, as though he had considered it in all its lights. It began with saying the war would go on for the Union, that the efforts would go on for buying and setting free the slaves of the Border States, and the colonizing of them; that on January 1, 1863, all slaves in States or parts of States in rebellion against the United States "shall be then, thenceforward, and forever free," and the Federal Government would "recognize the freedom of such persons." It was a preliminary proclamation, to be followed by a final one on next New Year's Day.

Two days later, September 24, 1862, on a Monday morning, this preliminary Emancipation Proclamation was published, for the country and the world to read. The President held that to have issued it six months earlier would have been too soon. What he called "public sentiment" would not have stood for it.

The President's act had been like a chemist tossing a tiny pinch of some powerful ingredient into a seething and shaking caldron. Colors and currents shifted and deepened. New channels were cutting their way far under the surface. The turmoil and the trembling became unreadable by any man. But below the fresh confusion was heaving some deep and irrevocable change.

A wave of fury swept the South. Lincoln was breaking the laws of civilized warfare, outraging private-property rights, inviting Negroes to kill, burn, and rape, said statesmen, orators, newspapers. Members of the Confederate Congress talked of running up the black flag, killing all prisoners and those wounded in battle.

Lincoln had warned nearly a year ago that the contest might develop into "remorseless, revolutionary warfare." The awful responsibility of carrying on and finishing a war of conquest lay ahead.

Towering over all other immediate issues, just after the Emancipation Proclamation was given out, stood the sphinx of McClellan's army—how to get it moving, how to use it as a weapon and a hammer, how to keep it from going into winter quarters without fighting, as in the winter before.

A telegram went to McClellan saying: "The President directs that you cross the Potomac and give battle to the enemy, or drive him south. Your army must move now, while the roads are good." McClellan was to advise Washington what his line of action would be, the time he intended to cross the river, and at what point fresh troops were to be sent to his army.

During early October, while McClellan asked shoes, horses, mules, and new bridges for his army, the telegrams poured into Washington from the Western armies winning victories on shoes, horses, and mules worse than McClellan had. For days the cities of Louisville and Cincinnati telegraphed Lincoln for help, for troops to save them from Bragg's army. But Bragg found it hard going in Kentucky, and he turned

southward with his army. At Perryville, Bragg collided with the Union army under Buell. The slopes were strewn with thousands of dead and wounded as Bragg moved further south.

In the Deep South, down in Mississippi, a Confederate army tried to take Corinth, a railroad and supply point. They were beaten off, losing 7,000 in dead and wounded as against 2,000 Union losses. Lincoln telegraphed Grant, "I congratulate you and all concerned."

Three weeks had gone by since Antietam. Yet McClellan stayed north of the Potomac with 100,000 men while Lee not far off in Virginia was recruiting his army from conscripts called up by the Richmond Government.

Lincoln had called General Henry W. Halleck from the West to serve as General in Chief of all land forces. He was forty-seven years old, a New York boy, a West Pointer, an engineer with artillery in the Mexican War. He not only understood army regulations but could write them. Twelve lectures at Harvard on the science of war were for Halleck merely introductory. He wrote a book justifying war, telling how it should be carried on. He helped occupy California and organize it as a Territory, was lieutenant governor, and wrote most of the State constitution. Resigning in 1854, he went into law; when the war opened in '61 he was head of the leading law firm of San Francisco and major general of the State militia. On the word of General Scott that Halleck had extraordinary military talent Lincoln appointed him a major general. He took over the Department of Missouri when Frémont stepped out. In St. Louis those who liked him nicknamed him "Old Brains." His department got re-

sults, whether it was his work or his management or the rising genius of Grant and Sherman.

After Shiloh he had taken the field, replacing Grant, heading 100,000 men against the Confederate 50,000 at Corinth. Outnumbering the enemy two to one, Halleck had advanced with pick and shovel, entrenching, bridge-building, road-making. After six weeks he had arrived at Corinth when the enemy had slipped out and was fifty miles away again. He had reported this to Washington as a victory. Yet he had proved an efficient administrator at St. Louis, and Nicolay and Hay wrote of him: "He was a thinker and not a worker; his proper place was in the military study and not in the camp. No other soldier in the field equalled him in the technical and theoretical acquirements of his profession." Welles in his diary noted Halleck as given to overpretense and too often "scratching his elbows."

McClellan now complained again about lacking horses and Lincoln telegraphed: "To be told, after more than five weeks' total inaction of the army, and during which . . . we have sent to the army every fresh horse we possibly could, amounting in the whole to 7918, that the cavalry horses were too much fatigued to move, presents a very cheerless, almost hopeless prospect for the future."

The autumn weather was perfect for marching an army. McClellan telegraphed Lincoln asking whether he should march on the enemy at once or "wait the reception of new horses." General in Chief Halleck now replied, "The President does not expect impossibilities, but he is very anxious that all this good weather should not be wasted in inactivity." McClellan came back with a long letter asking instructions

as to many details, getting a reply that "the Government has intrusted you with defeating and driving back the rebel army on your front." He could use his own discretion as to details. And as McClellan had mentioned in his long letter that perhaps Bragg was marching his Confederate army from Tennessee eastward, General Halleck ended his telegram, "You are within twenty miles of Lee, while Bragg is distant about four hundred miles."

McClellan now slowly moved his army across the Potomac and put it about where Pope's army had lain before Second Bull Run. It was November. Lincoln told one of his secretaries that he had a test by which he would make a final judgment of McClellan. If that commander should permit Lee to cross the Blue Ridge and place himself between Richmond and the Army of the Potomac, Lincoln would remove McClellan from command. Now when Lee's army reached Culpeper Court House the test of McClellan was over. Lincoln prepared a removal order.

Two men traveled in a driving snowstorm near midnight of November 7 to find the tent of General McClellan near Rectortown. They stepped in and shook off the snow from their big overcoats. One of the men was Adjutant General C. P. Buckingham of the War Department. The other was Major General Ambrose Everett Burnside. Buckingham handed McClellan a message relieving him of command of the Army of the Potomac and ordering him to turn it over to Burnside.

FREDERICKSBURG

"ON to Richmond once more!" cried *Harper's Weekly* at the end of November of '62. The Army of the Potomac under Burnside would not go into winter quarters. It would fight, was the general prediction.

Nevertheless Burnside knew that he was not a great soldier, a true man for high command. When Lincoln's order came that he should take charge of the post from which McClellan was removed, he was "shocked," as he himself said.

Twice before Burnside had told Lincoln that he could not take it; he wasn't the man for it. He called two staff officers, listened to them for an hour and a half while they urged and pleaded with him to accept. He was "not competent to command so large an army," he told them. Not until he talked with McClellan that night did he make ready to command. McClellan told him that an order is an order, and he, as a soldier, had to obey.

Burnside spent three days with McClellan; they sat up nearly all of one night going over the army organization and plans. Burnside said that on taking command he "probably knew less than any other corps commander of the positions and relative strength of the several corps of the army."

He was thirty-nine years old, a log-cabin boy, born at Liberty, Indiana, one of nine sons. After a seminary education, the boy Ambrose Everett Burnside learned the tailor's

trade, opened a shop in Liberty. His father, a State senator, got him a cadetship at West Point, where he met McClellan, Stonewall Jackson, and others who rose in the army.

Burnside's Rhode Island regiment had been among the first troops to arrive in Washington. At Bull Run he commanded the brigade that opened the battle. His chief distinction was

Fredericksburg in 1863; a demolished bridge in the foreground

in leading a joint naval and military force that early in 1862 captured Roanoke Island with 2,600 prisoners and 32 guns. This won applause, an embellished sword from Rhode Island, and the thanks of the Massachusetts and Ohio legislatures. Lincoln liked a candor, modesty, and spirit of co-operation he saw in Burnside.

Now came Fredericksburg, a trap. Lee with 72,000 men was ready and waiting for Burnside with 113,000. For a month Burnside had been waiting for pontoons to cross the river. While the pontoons were on the way Lee made arrangements. Burnside's columns crossed over. They found hills spitting flame and metal, a sunken road swarming with riflemen waiting human prey. "A chicken cannot live on that field

when we open on it," a Confederate engineer had told General Longstreet of the plain facing Marye's Hill. Meagher led his Irish Brigade of 1,315 up the hill and left 545 in the frozen mud. Hancock's division lost 40 of each 100 of its men. Between the fog of morning and twilight of evening 7,000 killed and wounded Union soldiers fell. The wounded lay forty-eight hours in the freezing cold before they were cared for. Some burned to death in long, dry grass set afire by cannon. Total Confederate losses were 5,309; Union, 12,653.

In a rainy windstorm Burnside drew off his troops from Fredericksburg, back across the Rappahannock.

Governor Curtin of Pennsylvania came to Washington, fresh from the Fredericksburg battlefield. Lincoln sent for him. At midnight in the White House they talked. "Mr. President, it was not a battle, it was a butchery," said Curtin of what he had seen.

The President issued an address to the Army of the Potomac: "Although you were not successful, the attempt was not an error, nor the failure other than accident. The courage with which you, in an open field, maintained the contest against an intrenched foe, and the consummate skill and success with which you crossed and recrossed the river in the face of the enemy, show that you possess all the qualities of a great army, which will yet give victory to the cause of the country and of popular government."

On New Year's Eve, 1862, came telegrams to the War Department. One of the bloodiest battles of the war was opening at Murfreesboro, Tennessee, along Stone's River, between the Union army of Rosecrans and the Confederates under Bragg. The Confederates drove the right wing of the Union

army back two miles, and Bragg sent a telegram of victory to Richmond on New Year's Eve. "God has given us a happy New Year," wired Braxton Bragg. The war news that Lincoln went to bed on that night was of men marching in rain, sleeping on wet ground, fighting through mud, the South

One corner of Fredericksburg on the morning of December 12, 1862

having made the gains of the day. Two days more of maneuvering and grappling went on between 41,000 under Rosecrans and 34,000 under Bragg. They fought in the rain and fog of raw winter days of short twilights. On the second day horses could not take the artillery over the soaked and slippery ground.

One out of four men on the field was shot down, killed or wounded, or taken prisoner, the Union army losing 12,906 and the Confederates 11,739. Bragg retreated south.

Rosecrans saw three of his orderlies shot down. He was

grazed by a cannon ball that took off the head of his chief
of staff. Riding in the thick of the fighting, he was told of
a general who had gone down. "Never mind, brave men must
die in battle; we must seek results." The headless trunk of
another general toppled near his horse's feet. Rosecrans rode
on. News was brought of his friend General Alexander McD.
McCook, as lost. "We cannot help it; men who fight must be
killed." Colonel George W. Roberts fell from his saddle with
three bullets in him. "Boys, put me on my horse again." They
lifted him, but his breath was gone before he reached the
saddle.

In a stretch of cedar timber the fighting Irishman, Phil
Sheridan, commanded a division of 6,500 men that lost 1,700,
including 70 officers, two of whom were brigadiers. The Vir-
ginian George H. Thomas emerged as calm and granitic,
holding the left wing firm while the right was crumpling. A
brigade of Southern troops plucked cotton from bolls stand-
ing in the fields and stuck them in their ears during a shatter-
ing artillery fire. "Dozens of horses were torn to shreds," said
an eyewitness. A single shell crashed into three horses and
piled them in one heap. Wounded men lay in pools of blood,
frozen to the ground in changing weather.

And this huggermugger of smoke and steel, flame and
blood, in Tennessee meant to the President far off in the
White House one episode. The Union men of Tennessee
would have easier going. The man power of the South was
cut down by so many figures. The war would never be ended
by any one event, any single battle. It might go on twenty
or thirty years, using up a generation of people.

✦

The next day, New Year's Day of 1863, Seward brought to the White House Lincoln's own draft of the Emancipation Proclamation. Lincoln had left it with him for the State Department to engross duly. It needed one thing to be a complete document. The President must sign it.

The President was alone in his office. The broad sheet was spread out before him on a table. He dipped his pen in an inkstand, held the pen in the air over the paper, and hesitated, looked around, and said: "I never, in my life, felt more certain that I was doing right, than I do in signing this paper." It read:

BY THE PRESIDENT OF THE UNITED STATES OF AMERICA:

A Proclamation.

Whereas, on the twenty-second day of September, in the year of our Lord one thousand eight hundred and sixty-two, a proclamation was issued by the President of the United States, containing, among other things, the following, to wit:

"That on the first day of January, in the year of our Lord one thousand eight hundred and sixty-three, all persons held as slaves within any State or designated part of a State, the people whereof shall then be in rebellion against the United States, shall be then, thenceforward, and forever, free; and the Executive government of the United States, including the military and naval authority thereof, will recognize and maintain the freedom of such persons, and will do no act or acts to repress such persons, or any of them, in any efforts they may make for their actual freedom.

"That the Executive will, on the first day of January aforesaid, by proclamation, designate the States and parts of States, if any, in which the people thereof, respectively, shall then be in rebellion against the United States; and the fact that any State, or the people thereof, shall on that day be in good faith represented in the Congress of the United States, by members chosen thereto at elections wherein a majority of the qualified voters of such State shall have participated, shall, in the absence of strong countervailing testimony, be deemed conclusive evidence that such State, and the people thereof, are not then in rebellion against the United States."

Now, therefore I, Abraham Lincoln, President of the United States, by virtue of the power in me vested as commander-in-chief of the army and navy of the United States in time of actual armed rebellion against the authority and government of the United States, and as a fit and necessary war measure for suppressing said rebellion, do, on this first day of January, in the year of our Lord one thousand eight hundred and sixty-three, and in accordance with my purpose so to do, publicly proclaimed for the full period of one hundred days from the first day above mentioned, order and designate as the States and parts of States wherein the people thereof, respectively, are this day in rebellion against the United States, the following, to wit:

Arkansas, Texas, Louisiana, (except the Parishes of St. Bernard, Plaquemines, Jefferson, St. John, St. Charles, St. James, Ascension, Assumption, Terre Bonne, Lafourche, St. Mary, St. Martin, and Orleans, including the city of New Orleans), Mississippi, Alabama, Florida, Georgia, South Carolina, North Carolina, and Virginia, (except the forty-eight counties designated as West Virginia, and also the counties of Berkeley, Accomac, Northampton, Elizabeth City, York, Princess Anne, and Norfolk, including the cities of Norfolk and Portsmouth), and which excepted

parts are for the present left precisely as if this proclamation were not issued.

And by virtue of the power and for the purpose aforesaid, I do order and declare that all persons held as slaves within said designated States, and parts of States are and henceforward shall be free; and that the Executive government of the United States, including the military and naval authorities thereof, will recognize and maintain the freedom of said persons.

And I hereby enjoin upon the people so declared to be free to abstain from all violence, unless in necessary self-defence; and I recommend to them that, in all cases when allowed, they labor faithfully for reasonable wages.

And I further declare and make known that such persons of suitable condition, will be received into the armed service of the United States, to garrison forts, positions, stations, and other places, and to man vessels of all sorts in said service.

And upon this act, sincerely believed to be an act of justice warranted by the Constitution upon military necessity, I invoke the considerate judgment of mankind and the gracious favor of Almighty God.

In witness whereof, I have hereunto set my hand and caused the seal of the United States to be affixed.

[SEAL.] Done at the city of Washington this first day of January, in the year of our Lord one thousand eight hundred and sixty-three, and of the independence of the United States of America the eighty-seventh.

By the President: Abraham Lincoln

William H. Seward,
Secretary of State

To this the President slowly and carefully signed his full name of Abraham Lincoln at the bottom. Then Seward

signed, the great seal was affixed, and the document went into the archives of the State Department.

Salutes of a hundred guns were fired in Pittsburgh, Buffalo, Boston, after newspapers published the proclamation. Anti-slavery crowds held jubilation meetings, though some of the extremists said the document should have gone farther, was too moderate. Jefferson Davis in a message to the Confederate Congress assumed lofty ground: "Our own detestation of those who have attempted the most execrable act recorded in the history of guilty men is tempered by profound contempt for the impotent rage which it discloses."

Lincoln issued no statement nor argument to support the proclamation. He let the paper go forth for whatever it might do, sent it fluttering to the four breezes of a continent and a world.

The Emancipation Proclamation struck at property valued on tax books at nearly $3,000,000,000. If not retracted and if finally sustained by the Union armies in the field, the newly issued document would take from Southerners, by force and without compensation, livestock classified and assessed with horses, cattle, and mules, more than 3,900,000 head. The property value of these 3,900,000 and more chattels would be written off and erased if and when the Union armies won their objectives.

Down across the Southern States the word spread among Negroes: the "Linkum" Government at Washington had declared them free; if the Union armies won the war they would no longer be bought and sold. They could move from one place to another if they saw better chances in moving.

No longer would it be a crime to read, to be found with a book.

As a metaphor of the hour Lincoln remarked: "We are like whalers who have been on a long chase. We have at last got the harpoon into the monster, but we must now look how we steer, or with one flop of his tail he will send us all into eternity."

CHANCELLORSVILLE

THE Army of the Potomac in early '63 had lost—on the Peninsula, twice at Bull Run, and again in the slaughter at Fredericksburg. It had, however, kept enemy bayonets out of Washington and the Free States, besides taking costly toll of Southern man power. And other Northern armies, with naval co-operation, had captured all the Confederate strongholds—except Forts Sumter and Morgan—on the seacoast from Fortress Monroe in Virginia to points in Texas. Rosecrans was marching close to the Alabama line, Grant was in Mississippi, Curtis in Arkansas, Banks at New Orleans.

The *Richmond Examiner*, reviewing the scene on January 20, 1863, said, "The pledge once deemed foolish by the South, that he would 'hold, occupy and possess' all the forts belonging to the United States Government, has been redeemed almost to the letter by Lincoln."

In this month, however, major generals of the Army of the Potomac talked about the Government's crumbling and a military dictator's being needed. "The loyal North," said *Harper's Weekly*, was "filled with sickness, disgust and despair" over "unequivocal evidences of administrative imbecility." Such massacres as that at Fredericksburg must not be repeated.

Burnside, under the weight of his command of the Army of the Potomac, was crumpling. He frankly said to the Presi-

dent that the Secretary of War and the General in Chief had lost the confidence of the soldiers, and he himself "ought to retire." To a letter from Burnside resigning as major general, Lincoln replied, "I do not yet see how I could profit by changing the command of the Army of the Potomac." And to show publicly his faith in Burnside the President told a *New York Times* correspondent, for publication: "Had Burnside had the same chances of success that McClellan wantonly cast away, today he would be hailed as the savior of his country."

Raymond of the *New York Times* visited the army, asked a Michigan colonel why Burnside was estimated so low among officers and men, and heard that it was because Burnside rated himself so low. This might be only the natural modesty of a truly capable man, Raymond suggested. Yes, said the colonel, that was true, but Burnside had not only *spoken* of his incompetency, but had gone before a congressional committee and *sworn* to it. This was extraordinary conduct. Burnside was peculiar in his integrity, in his unabashed admissions that he was a poor instrument for what was to be done. When he wrote for publication a letter taking all blame on himself for the Fredericksburg disaster, Lincoln told him that he was the first man found who was willing to relieve the President of a particle of responsibility.

Burnside planned a night attack on Lee's army. The pontoon corps would march to the river, lay bridges across the Rappahannock; the cavalry, artillery, foot troops, would follow, and smash Lee. Generals Baldy Smith and William B. Franklin came to Burnside's tent and argued for hours that

the enemy was too strong, their own troops not in fighting mood.

Burnside insisted, and on the night of January 20 as the army started rain began slowly, a wind came up, the rain turned to sleet, horses and wagons sank in the mud and were stuck for all night; men and mules failed to make headway

On the march in a storm

with the pontoons or with the unhitched cavalry steeds and the early morning ration of whisky ordered by Burnside for every man.

After breakfast at staff headquarters the next morning General Joseph Hooker talked with a newspaperman about how the commanding General was incompetent, the President and Government at Washington were imbecile and "played out," a dictator was needed and the sooner the better.

What with failure in the field, grumbling and mutiny among officers and men, Burnside was harassed and weary. He resigned, was persuaded to withdraw his resignation, was

relieved of duty, and on January 25, 1863, the President ordered Hooker to the command of the Army of the Potomac. Hooker himself had not played politics to win the appointment. However, an observer on the inside at army headquarters noted: "There were men about Hooker who believed in, and hoped to rise with him." Joined with these efforts was "the unselfish labor of earnest men" who believed in Hooker's fighting qualities.

A handsome soldier, Hooker looked warlike for those to whom war is color, dash, valor. Blond of hair, with wavy ringlets, with a flushed and rosy face, forty-nine years of age, he was tall, blue-eyed, had a martial air. A West Point graduate, brevetted captain for bravery at Monterey in the Mexican War, he was a farmer and superintendent of military roads on the West Coast when the war began. Time and again Hooker had led his division into slaughter where men fell by platoons and his lines held their ground. At Williamsburg on the Peninsula under McClellan he had 2,228 killed and wounded. The nickname came of "Fighting Joe" Hooker. Shot in the foot at Antietam, he stayed in the saddle on the field with his men till the fighting was over.

Slowly across weeks of February, March, April, the gloom of the Army of the Potomac changed toward gaiety. Hooker had found at the close of January that in round numbers 3,000 officers and 82,000 men of the ranks were absent; they were on the rolls of the army, but not answering roll call. Some were sick, wounded, on furlough. Others had run away. Homesickness, gloom, and a general feeling of uselessness had brought an average of 200 desertions a day during the winter; relatives and friends sent express bundles to their

loved ones, citizen's clothing for escape. Under the new rule
express trains were searched, all citizen's clothing burned.

A new regime operated. Steadily a sulky army became
willing and eager to fight. It lay at Fredericksburg, a day's
phaeton or buggy ride from Washington, so that important

Sleeping a strictly forbidden sleep

public men came for personal inspections, accompanied by
their wives and daughters in crinoline.

Early in April Hooker said that under his command was "a
living army, and one well worthy of the republic." He also
rated it "the finest army on the planet." He had 130,000
troops against Lee across the river with 60,000.

In the Confederate army across the river horses were gaunt
from lack of forage. Scurvy had begun to appear among
troops lacking balanced rations. Cattle had arrived so thin
that Lee asked to have them kept to fatten in the spring and
that salt meat be issued instead. Through an unusually bleak
and frigid winter some of Lee's troops had no blankets. Many

wore coats and shoes in tatters. In subsistence and clothing it was known that the neighboring Union army was vastly superior. Valorous men were hungry, Lee directly implied in his patient letter of April 23, 1863, to the Confederate Secretary of War. "I am painfully anxious lest the spirit and efficiency of the men should become impaired, and they be rendered unable to sustain their former reputation, or perform the service necessary for our safety."

True it was "the Yanks were licked" at Charleston, dispatches told Lincoln. A fleet of ironclad vessels, long and carefully prepared, had failed to batter down Fort Sumter, and under fire from heavy shore batteries had retired somewhat crippled with one vessel sunk and two disabled. Because Charleston was a symbol, a starting-point of secession, many in the North hoped it could be taken; they had expected much; they would wait.

On May 1 Hooker had brought most of his army across the Rappahannock River, to a crossroads named Chancellorsville, for a frontal combat with Lee, while an army corps under General John Sedgwick had crossed the river at another point aiming to harass Lee, flank or rear. Hooker believed he had Lee in a tight box and issued an address: "Our enemy must either ingloriously fly or come out from behind his defences and give us battle on our own ground, where certain destruction awaits him."

Hooker attacked, Lee counterattacked, and Hooker ordered his men to fall back. "Just as we reached the enemy we were recalled," wrote General Meade, while General Couch, second to Hooker in command, said: "Hooker ex-

pected Lee to fall back without risking battle. Finding himself mistaken he assumed the defensive."

Early the next morning Lee sent half his army under Stonewall Jackson on a march that took them till late in the afternoon, when they delivered a surprise attack that smashed the Union flank and rear. The next day Lee outguessed and outfought Hooker. With an army half the size of Hooker's, he so mangled and baffled the Union forces that Hooker called a council of his generals, of whom four voted to stay where they were and fight, two voted to retreat across the river. Hooker then ordered the retreat.

The white moon by night and the red sun by day had looked down on over 20,000 men who lay killed or wounded on the open farms and in the wilderness of trees, thickets, and undergrowth, the figures giving Union losses at 11,000, Confederate at 10,000, not including 6,000 prisoners captured by Lee and 2,000 by Hooker.

Numbers, however, could not tell nor measure the vacancy nor the Southern heartache left by the loss of Stonewall Jackson, shot by his own men, it was reported, as he was inspecting positions in the zone of fire. "You have lost only your left arm, while I have lost my right," mourned Lee to his dying lieutenant. In delirium Jackson's mind roamed to the battlefield. "Tell A. P. Hill to prepare for action." Peace came after the storm and Stonewall Jackson went with a murmur—"Let us pass over the river and rest in the shade of the trees."

At the old brick mansion serving as headquarters, a cannon ball had broken a pillar against which General Hooker leaned, knocked him down, left him senseless a half-hour,

dazed for an hour or more, while the battle lines rocked and tore on the second day. Under the puzzling maneuvers and swift stinging blows from Lee, Hooker had lost his nerve, disappointed his friends.

Always until Chancellorsville Hooker galloped, swore, and gave blow for blow. Now it was as though he would play chess and outthink an opponent. He had gone into battle with a good plan and dropped it when the enemy refused to do what he expected. He was sick with himself and was ready to turn over the army; he had had enough and almost wished he had never been born.

Of course there was one large excuse for Hooker. Against him during the three days he had Lee, a genius with a chest of stratagems, whose gray and butternut battalions had given Hooker the impression they were retreating when they were flanking, seemed to be going when they were coming. Detachments executed a repulse on one front and swung to another to support attacking columns. While Hooker failed to put half his men into combat, Lee came near making one soldier count for two. But again, as at Fredericksburg, Lee's army was too gashed and spent to follow up its hard-won victory.

Lee was carefully screening a movement that seemed to be aimed northward, possibly another invasion of Maryland. "I think Lee's army, and not Richmond, is your true objective point," wrote Lincoln. "If he comes toward the upper Potomac, follow on his flank and on his inside track, shortening your lines while he lengthens his. Fight him, too, when opportunity offers. If he stays where he is, fret him and fret him."

On June 14 Lincoln queried Hooker: "If the head of Lee's army is at Martinsburg and the tail of it on the plank road between Fredericksburg and Chancellorsville, the animal must be very slim somewhere. Could you not break him?" On Lee's moving toward Harper's Ferry, Lincoln wrote to Hooker that it "gives you back the chance that I thought McClellan lost last fall."

As late as June 26, nearly seven weeks since the battle of Chancellorsville, Hooker had done nothing to fret or harass Lee, and Lincoln gave to Welles the first inkling that he might have to let Hooker go. Welles in his diary quoted the President: "We cannot help beating them, if we have the man. How much depends in military matters on one master mind! Hooker may commit the same fault as McClellan and lose his chance. We shall soon see, but it appears to me he can't help but win."

Across the weeks after Chancellorsville, Lee rested his army, received new divisions of freshly conscripted troops, slipped away into the Shenandoah Valley, and by June 29 had crossed the Potomac, marched over Maryland, and had an army of 75,000 on Pennsylvania soil. Having learned that Lee had left the Rappahannock, Hooker broke camp with his army and moved it northward in scattered formation.

At Frederick, Maryland, a man in civilian clothes, riding in a buggy, begging, buying, and wheedling his way through straggling parties of soldiers and wagon trains, arrived at three o'clock in the morning of June 28 and went to the tent of General George Gordon Meade, was let in after wrangling. He woke Meade from sleep, saying he had come to give him

trouble. Meade said his conscience was clear; he was prepared for bad news.

A letter from General in Chief Halleck was put in Meade's hands, reading: "You will receive with this the order of the President placing you in command of the Army of the Potomac. . . . You will not be hampered by any minute instructions from headquarters. Your army is free to act as you may deem proper under the circumstances as they arise."

Meade did not want the place. But he was ordered as a soldier to accept, which he did, issuing notice that day: "By direction of the President of the United States, I hereby assume command of the Army of the Potomac." He informed his officers and troops that he was obeying an order "totally unexpected and unsolicited"; they would have fatigues and sacrifices; it was with "diffidence" he relieved in command "an eminent and accomplished soldier."

Meade's father was a merchant, shipowner, United States naval agent in Cadiz, Spain, and the boy was born in Cadiz in 1815. Graduating from West Point, he took a hand in fighting Seminole Indians, resigned from the army, worked on War Department surveys, was brevetted first lieutenant for gallantry in the Mexican War, and for five years was a lighthouse-builder among Florida reefs. He had been appointed brigadier general of volunteers on August 31, 1861, and had seen active and often front-line service in every battle of the Army of the Potomac—except for a short interval of recovery from a gunshot wound at New Market Road on the Peninsula.

Lincoln met his Cabinet on this same Sunday morning that Meade took command: "The President . . . drew from his

pocket a telegram from General Hooker asking to be re-
lieved," noted Welles. "The President said he had, for several
days as the conflict became imminent, observed in Hooker
the same failings that were witnessed in McClellan after the
Battle of Antietam—a want of alacrity to obey, and a greedy
call for more troops which could not . . . be taken from
other points."

The next great battle, it seemed to many, would be a duel
between Meade and Lee, somewhere in Pennsylvania, at
Philadelphia, Chambersburg, Harrisburg, perhaps Gettys-
burg. Welles pondered what Lee's men might do "should
they cross the Susquehanna." So did Lincoln, the country,
the press, the pulpit, the man in the street, the farmer in the
field.

Lee would be missing Jackson, of whom a sweet fantasy
was now told—that a legion of angels had left Heaven to
bring him up home, but not finding him on earth, gave up
their search, flew back to Heaven, and found that Jackson
had "executed a swift flanking movement" and got to Heaven
before them.

Now the war had begun and had gone on. Now the war
already had a considerable past. In a little wilderness clearing
at Chancellorsville, a living soldier had come upon a dead
one sitting with his back to a tree, looking at first sight al-
most alive enough to hold a conversation with the living. He
had sat there for months, maybe a year, since the fight that
gave him his long rest. He seemed to have a story and a phi-
losophy to tell if the correct approach were made and he
could be led into a quiet discussion. The living soldier, how-

ever, stood frozen in his foot tracks a few moments, gazing at the ashen face and the sockets where the eyes had withered—then he picked up his feet, let out a cry, and ran. He had interrupted a silence where the slants of silver moons and the music of varying rains kept company with the one against the tree who sat so speechless, though having much to say.

WILL GRANT TAKE VICKSBURG?

THE Southern Confederacy, worn ragged and bleeding, fighting at odds, still had stamina and resources. President Davis, though emaciated, was determined.

Rhett, Yancey, Toombs, and other revolutionists who by agitation and direct action had swung the plunge into secession scored Davis for failures, for not getting more guns from Europe before the blockade went into effect; for not trading millions of available bales of cotton to England and France for gold, credit, and supplies; for mistaken appointments of generals; for not carrying the war into the North.

Yet for all the difficulties, the ruling class of the South had common understandings, maintained a cohesion of forces and a more widespread loyalty, were less troubled by mixed bloods and breeds, than the more loosely allied ruling class of the North.

One question weighed heavily on the Richmond Government in the spring of '63. Would Grant take Vicksburg? If so the Mississippi River would pass wholly into Union possession. Lincoln had talked about such a result to Commander D. D. Porter, pointing at a map and saying, as quoted by Porter: "See what a lot of land these fellows hold, of which Vicksburg is the key. Here is the Red River, which will supply the Confederates with cattle and corn to feed their armies. There are the Arkansas and White Rivers, which can supply

cattle and hogs by the thousand. These supplies can be distributed by rail all over the Confederacy. Then there is that great depot of supplies on the Yazoo. Let us get Vicksburg and all that country is ours. The war can never be brought to a close until that key is in our pocket. . . . We may take all the northern ports of the Confederacy and they can still defy us from Vicksburg. It means hog and hominy without limit, fresh troops from all the States of the far South, and a cotton country where they can raise the staple without interference."

Then New Orleans was taken; the navy delayed moving up to Vicksburg, lacking troops for land assault; and the Confederates had erected heavy batteries on the tall hills, adding near the levee a water battery of twelve guns which the Union sailors nicknamed "The Twelve Apostles." The ablest military engineers of the Confederacy gave attention to Vicksburg, and when they had finished President Davis termed it "a Gibraltar."

David Dixon Porter was appointed commander of the Mississippi squadron for immediate duty.

From the fall of '62 till July 1 of '63 Grant performed with armies roundabout Vicksburg, marching them along the Yazoo River, the Yalobusha, the Tallahatchie, amid the miasma of swamps and the tangles of live oak and Spanish moss, digging ditches and canals, chopping wood, building bridges, throwing up breastworks, standing waist-deep in the mud of rifle pits, sleeping in soaked fields and slogging on through monotonous heavy rains, enduring plagues of malarial fever, measles, mumps, and smallpox. They became familiars of Five Mile Creek, Deer Creek, Eagle Bend, Moon

Lake, Rolling Fork, the Big Sunflower, Muddy Bayou, the inlets and curves of the Mississippi River with its great sudden twist at the bluffs of Vicksburg, a city of 5,000 people two hundred and fifty feet above the river.

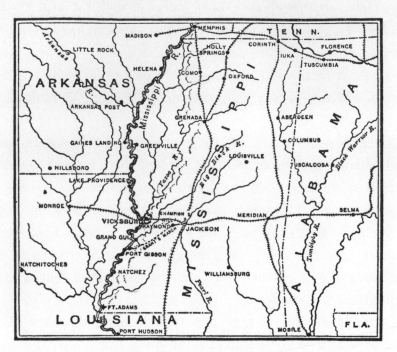

The Vicksburg campaigns

Grant's home-town Congressman, E. B. Washburne, wrote to Lincoln in May that Grant lacked style. "On this whole march for five days he has had neither a horse nor an orderly or servant, a blanket or overcoat or clean shirt. His entire baggage consists of a tooth brush." For weeks the army lived on the country, took the cattle, hogs, grain, supplies, from the farming sections where they were fighting. Mississippi citizens, seeing their food supplies running low, came to Grant asking, "What are *we* to do?" He replied his army

had brought along its own food but Confederate cavalry had torn up the railroads and raided his supply depots; their friends in gray had been uncivil; men with arms must refuse to starve in the midst of plenty.

Grant slogged and plodded, trying a plan to find it fail, devising another plan, hanging to one purpose, that of taking Vicksburg and clearing the Mississippi. His men marched one hundred and eighty miles; fought five battles, killed more than the enemy; took 6,000 prisoners, 90 cannon, in twenty days. Porter's ironclad gunboats ran the fire of the heavy shore batteries around the long U-bend of the Mississippi, took terrific pounding, lost coal barges and one transport, but came through with the armored flotilla safe. Two other flotillas were put on the Vicksburg operation, cutting off that city from all lines of communication in three directions. Thus with the navy taking care of three sides by water and Grant's army moving on the fourth or land side, the Mississippi River was in control of Union forces aiming to make the temporary control permanent.

By keeping his plans to himself till ready for action, by hauling and hacking, by outguessing the enemy and making war according to plain facts developed from day to day, Grant made headway toward his one design. Of his men he wrote to the War Department at Washington, "Since leaving Milliken's Bend they have marched as much by night as by day, through mud and rain, without tents or much other baggage and on irregular rations without a complaint and with much less straggling than I have ever before witnessed."

The people in the North, fed by alarmist newspaper correspondents, expected any day to hear that Grant's army had

been crushed between two Confederate armies outnumbering his own. Grant meantime took Jackson, the Mississippi State capital, destroyed railroads, bridges, factories there, ended with cooping up in Vicksburg the army of General John C. Pemberton.

Twice Grant had tried to storm his way into Vicksburg, and failing, had settled down to pick and shovel, advancing trenches, stopping food and supplies for the city.

The commander of Vicksburg, John C. Pemberton, was a favorite of President Davis, a West Pointer, a Mexican War veteran, an Indian-fighter, Pennsylvania-born and raised. His Northern birth was a liability; ill-based accusations arose in the South that he was plotting to sell Vicksburg to the North.

After Grant's second storming attempt, Pemberton made a short speech to his troops: "You have heard that I was incompetent and a traitor; and that it was my intention to sell Vicksburg. Follow me and you will see the cost at which I will sell Vicksburg. When the last pound of beef, bacon and flour, the last grain of corn, the last cow and hog and horse and dog shall have been consumed, and the last man shall have perished in the trenches, then, and only then, will I sell Vicksburg."

The weeks of May and June had dragged on with artillery and sharpshooters sending soldiers and citizens into cellars, bombproofs, caves burrowed in the hillsides. Night and day guns of both armies howled, shell explosions tore the earth and air. This clamor, this pandemonium, had become a secondary factor not comparable to the silent one: starvation. Vicksburg's army would surrender when hunger said so.

For six months and more Grant, to many people in the

North, seemed to be wandering around, stumbling and bungling on a job beyond him. He had outplayed enemy armies twice his own in number, far in the Deep South, a long way from home, with climate, mosquitoes, swamp fever of a stranger soil, ever a threat. Food, guns, powder, had to be hauled hundreds of miles to reach his men. The imagination

Caves near Vicksburg occupied during Grant's bombardment

of the North was slow at picturing what Grant was doing. What was a bayou or a jigger to any citizen of Chicago or Boston? The adventure sagged, came forward, sagged again.

"We have been to Vicksburg and it was too much for us, and we have backed out," wrote General William Tecumseh Sherman, Grant's right-hand man, to his wife in January of '63. And Sherman wrote again at the end of April: "I look upon the whole thing as one of the most hazardous and desperate moves of this or any war."

He was redheaded, lean, scrawny, this Sherman, with a mind of far wider range than usual in the army. One of the eleven children of a lawyer who served as judge of the supreme court of Ohio, when his father died he was adopted

by Thomas Ewing, lawyer and famous Whig. An 1840 West Pointer, Sherman saw Indian fighting in Florida, studied law, was an adjutant general in California during the Mexican War, managed a bank in San Francisco, operated a New York office for a St. Louis firm, practiced law in Leavenworth, Kansas, and at the opening of the war was superintendent of Louisiana State Military Academy at Alexandria. He had seen the United States and anxiety rode him about it; newspapers, politicians, the educated classes, were corrupt, blind, selfish, garrulous, to the point of tragedy.

At the opening of the war Lincoln had been pleased at Sherman's saying he didn't want appointment to high rank; he would be a subordinate and perhaps work his way up while learning the art of war. He was a Midwestern man, at home with an Iowa farm hand or an Illinois college boy. The spare living of active service he accepted with humor.

Early in the war it had racked Sherman's mind that there was to be wholesale and organized slaughter by prolonged combat between his Northern people against others "as good as ourselves." He had paced to and fro in the hall of a hotel in Cincinnati mumbling to himself, and his high-pitched commentaries had earned him the nickname of "Crazy" Sherman among those who misunderstood.

Letters of Sherman to his wife and brother, as the war wore on, gave evidence he was anguished mentally by the cost in lives and money required to conquer the Southern people. He was the one Union general from whom would most naturally flow the remark "War is hell." For what seemed to him a just cause he would invoke terror. "To secure the navigation of the Mississippi River I would slay mil-

lions; on that point I am not only insane, but mad." Thus
far only a few among important men knew in any degree
the sincerity and the sensitively human quality of Sherman.
Lincoln was yet to get acquainted with this lean, restless,
hawk-eyed rider of war and apostle of conquest.

Dana reported three remarkable men heading the Vicks-
burg campaign, Grant, Sherman, and James B. McPherson,
the last "thirty-two years old . . . a very handsome and
gallant-looking man, with rather a dark complexion, dark
eyes, and a most cordial manner," a natural engineer, having
graduated number 1 in his class at West Point. Dana noted
that these three leading generals, all Ohio-born, had between
them "utmost confidence," no jealousy nor bickering. "In
their unpretending simplicity they were as alike as three
peas." John A. Logan from Illinois, Dana reported, was prov-
ing a heroic, brilliant, sometimes unsteady brigadier general,
"full of generous attachments and sincere animosities"—few
officers more effective and faithful.

During June, Grant's army, earlier numbering only about
40,000, was reinforced to 70,000 and more. The plantations
of Jefferson Davis and his brother Joseph had been captured
and supplies from them lent aid to the Union cause. A world
audience was looking on and wondering how many days or
months the siege might last.

The marching of Lee with 80,000 Confederate troops up
into Pennsylvania, with Meade and the Army of the Potomac
trailing him for battle, hoping to stop him, was a bold move-
ment, partly made on the chance that the danger to Northern
cities would cause Lincoln and Halleck to draw off troops
from Grant to fight Lee. In such event it was believed that

Pemberton might, as ordered by his superior, General Joseph E. Johnston, cut his way out of the seven miles of Union trenches encircling Vicksburg. Kirby Smith to the west had an army that might try coming to Vicksburg. At any time, too, Johnston eastward might get reinforcements, march to Vicksburg, and turn the siege into a battle. Johnston was

Cave life in Vicksburg while Federal guns shelled the city

rated by many as in military genius second only to Lee among living Confederate generals. The anxiety of the North was phrased: "Grant is a long way from home and anything can happen to him."

In hundreds of caves dug in the clay hillsides of the besieged city, women and children wondered how long till the end. One eyewitness told of seeing a woman faint as a shell burst a few feet from her. He saw three children knocked down by the dirt flung out from one explosion. "The little ones picked themselves up, and wiping the dust from their eyes, hastened on."

Yet these were minor incidents to the thousands whose daily monotonous menu of mule and horse meat with parched corn had run out in latter June. Pemberton, as he had said he would, killed the last dog for food. Then what? Then he fed the men of his garrison on rats, cane shoots, and bark. Some of the men standing in the firing trenches were wobbly on their legs. Pemberton was obeying instructions from President Davis to hold Vicksburg at all costs.

CHAPTER 13

GETTYSBURG—VICKSBURG

THE President on June 15 of '63 issued a call for 100,000 troops, from Pennsylvania (50,000), Maryland (10,000), West Virginia (10,000), Ohio (30,000), to serve for six months, unless sooner discharged, against "armed insurrectionary combinations threatening to make inroads" into the States named. Nothing like the number called for sprang forward to enlist.

The Pennsylvania Governor urged that with the enemy six miles from Chambersburg, and advancing to threaten the State capital, men should not quibble; the President had fixed the term of service at six months, but it was not intended they should serve longer than the immediate emergency. The Governor of Maryland issued an appeal to loyal men, trying to overcome their fears that once sworn into the United States service they would be sent out of the State. The Governor of New Jersey hurried two regiments of militia to Harrisburg, but when they learned they must take an oath and be mustered into the Federal Army they went back to New Jersey. The Secretary of War called for help from the governors of thirteen States. Thirty regiments of Pennsylvania militia, besides artillery and cavalry, and nineteen regiments from New York, were mobilized at Harrisburg under General Couch from the Army of the Potomac.

From day to day through latter June the news overshadow-

ing all else in the public prints was that of Lee's army. Far behind Lee now was Richmond and its small defensive force. When he had requisitioned for rations, it was said the Confederate Commissary General replied, "If General Lee wishes rations let him seek them in Pennsylvania." When Lee had been asked about a Union army taking Richmond while he was away, he smiled, it was said. "In that case we shall swap queens." He and his chief, Davis, had decided that "valuable results" might follow the taking of Harrisburg, Philadelphia, Baltimore, Washington. In that case, besides immense amounts of supplies, provisions, munitions, there might be European recognition of the Confederate States as a nation.

As his troops steadily plodded up the Cumberland Valley Lee's orders were strict against plundering and straggling. The army would seize needed supplies and pay for them in Confederate money, a currency that would be good and valid if they should capture Harrisburg, Philadelphia, Baltimore, Washington. On June 15 Lee's vanguard drove Union troops out of Hagerstown, Maryland, ordered all stores kept open, telegraph wires cut and poles pulled down, cattle seized, payments in Confederate paper money. Into McConnellsburg, Chambersburg, York, Greencastle, Gettysburg, the lone lines of gray- and butternut-clad soldiers moved, living on fat rations they had not tasted the like of in many months. Many who had marched barefoot out of Virginia again wore socks and shoes, taken from storekeepers' stocks and paid for with Confederate money.

Men well informed believed that Lee had nearly 100,000 men and 250 cannon. Retreating Union forces burned a bridge a mile and a half long. The Mayor of York went out

several miles from town to meet the enemy, arranging for peace and immunity; he surrendered his borough, and the Confederates left it with tribute of $28,000 in United States Treasury notes, 40,000 pounds of fresh beef, 30,000 bushels of corn, 1,000 pairs of shoes, besides sundries.

Lee's men were in a high and handsome stride, off on a great adventure. In two contests within seven months they had routed, sent reeling, threatened to crush, the Army of the Potomac. Soon again they would meet that old rival, this time overwhelm it, they were sure. They had the officers of genius and the rank and file of proved endurance and courage to perform on a grand scale.

"There were never such men in an army before," said Lee. "They will go anywhere and do anything if properly led." They believed this themselves, and had reasons. An English officer, traveling from day to day with the invading army, noted that the universal feeling in the army was "one of profound contempt for an enemy whom they have beaten so constantly, and under so many disadvantages." The fear that smote deep among classes and masses in the North was of Lee "putting forth his whole energy in one great and desperate struggle which shall be decisive; he means to strike a blow of serious consequences, and thus bring the war to a close."

When Lee's army had vanished into the Shenandoah Valley to reappear in Pennsylvania, Lincoln's instructions to Meade ran that not Richmond but Lee's army must be the objective. Meade followed Lee with orders from Lincoln "to find and fight" the enemy. From day to day neither Meade nor Lee had been certain where the other was. Lee would

rather have taken Harrisburg, its stores and supplies, and then battled Meade on the way to Philadelphia. In that case Lee would have had ammunition enough to keep his artillery firing with no letup, no orders during an infantry charge that ammunition was running low and must be saved.

Lee rode his horse along roads winding through bright summer landscapes to find himself suddenly looking at the smoke of a battle he had not ordered nor planned. Some of his own marching divisions had become entangled with enemy columns near Gettysburg, traded shots, and a battle had begun that Lee could draw away from or carry on. He decided to carry on. He said Yes. His troops in their last two battles and on general form looked unbeatable. Against him was an untried commander with a jealous staff that had never worked as smoothly as his own. If he could repeat on Fredericksburg and Chancellorsville, he could then march to Harrisburg, use the State capitol for barracks, replenish his needs, march on to Philadelphia, Baltimore, and Washington, lay hold of money, supplies, munitions, win European recognition and end the war.

The stakes were immense, the chances fair. The new Federal commander had never planned a battle nor handled a big army in the wild upsets of frontal combat on a wide line. Also fifty-eight regiments of Northern veterans who had fought at Antietam, Fredericksburg, Chancellorsville, had gone home, their time up, their places filled by militia and raw recruits.

One factor was against Lee: he would have to tell his cannoneers to go slow and count their shells, while Meade's artillery could fire on and on from an endless supply. Another

factor too was against Lee: he was away from his Virginia, where he knew the ground and the people, while Meade's men were fighting for their homes, women, barns, cattle, and fields against invaders and strangers, as Meade saw and felt it.

To Lee's words, "If the enemy is there, we must attack him," Longstreet, who now replaced Stonewall Jackson, spoke sharply, "If he is there, it will be because he is anxious that we should attack him—a good reason, in my judgment, for not doing so." This vague and involved feeling Longstreet nursed in his breast; attack was unwise, and his advice rejected. It resulted in hours of delay and wasted time that might have counted.

Lee hammered at the Union left wing the first day, the right wing the second day, Meade on that day sending word to Lincoln that the enemy was "repulsed at all points." On the third day, July 3 of '63, Lee smashed at Meade's center. Under Longstreet's command, General George Edward Pickett, a tall arrow of a man, with mustache and goatee, with long ringlets of auburn hair flying as he galloped his horse, sent in his 15,000 men, who had nearly a mile to go up a slow slope of land to reach the Union center.

Before starting his men on their charge to the Union center, Pickett handed Longstreet a letter to a girl in Richmond he was to marry if he lived. Longstreet had ordered Pickett to go forward and Pickett had penciled on the back of the envelope, "If Old Peter's [Longstreet's] nod means death, good-bye and God bless you, little one!"

Across the long rise of open ground, with the blue flag of Virginia floating ahead, over field and meadow Pickett's 15,000 marched steadily and smoothly, almost as if on a drill

ground. Solid shot, grape and canister, from the Union artillery plowed through them, and later a wild rain of rifle bullets. Seven-eighths of a mile they marched in the open sunlight, every man a target for the Union marksmen behind stone fences and breastworks. They obeyed orders; Uncle Robert had said they would go anywhere and do anything.

As men fell their places were filled, the ranks closed up. As officers tumbled off horses it was taken as expected in battle. Perhaps half who started reached the Union lines surmounting Cemetery Ridge.

Then came cold steel, the bayonet, the clubbed musket. The strongest and last line of the enemy was reached. "The Confederate battle flag waved over his defences," said a Confederate major, "and the fighting over the wall became hand to hand, but more than half having already fallen, our line was too weak to rout the enemy."

Meade rode up white-faced to hear it was a repulse and cried, "Thank God!" Lee commented: "They deserved success as far as it can be deserved by human valor and fortitude. More may have been required of them than they were able to perform." To one of his colonels Lee said, "This has been a sad day for us, a sad day, but we cannot expect always to gain victories."

As a heavy rainfall came on the night of July 4 Lee ordered a retreat toward the Potomac.

Meade was seen that day sitting in the open on a stone, his head held in his hand, willing it should rain, thankful that his army had, as he phrased it, driven "the invaders from our soil." For three days and nights Meade wasn't out of his clothes, took only snatches of sleep, while he had spoken the

controlling decisions to his corps commanders in the bloodiest battle of modern warfare up till that time. Tabulations ran that the Union Army lost 23,000 killed, wounded, and missing, the Confederate Army 28,000. Pickett came out of it alive to write his Virginia girl, "Your soldier lives and mourns and but for you, he would rather, a million times rather, be back there with his dead to sleep for all time in an unknown grave."

One tree in line of fire had 250 bullets in it, another tree 110 lead messengers that missed human targets. Farmer Rummel's cow lane was piled with thirty dead horses. Farmer Rummel found two cavalrymen who had fought afoot, killed each other and fallen with their feet touching, each with a bloody saber in his hand. A Virginian and a 3d Pennsylvania man had fought on horseback, hacking each other head and shoulders with sabers; they clinched and their horses ran out from under them; they were found with stiff and bloody fingers fastened in each other. The pegleg Confederate General Ewell, struck by a bullet, had chirped merrily to General John B. Gordon, "It don't hurt a bit to be shot in a wooden leg."

Military experts studied 27,000 muzzle-loading muskets picked up on the battlefield; 24,000 were loaded, one-half had two loads, many had ten loads; and the experts deduced that in the bloody work and the crying out loud that day many soldiers lost their heads, loaded, forgot to fire, and then forgot their muskets were loaded. Also they figured it out that each soldier in battle fired away about his own weight in lead before he killed one of the opposition.

Where cannon and muskets had roared with sheets of flame

on Cemetery Ridge was a tall graveyard gate with a sign forbidding the use of firearms out of respect to the dead and decently buried on the premises. The dead on the battlefield lay where they had fallen during three days' fighting. "Through the branches of the trees and among the gravestones in the cemetery a shower of destruction crashed ceaselessly," wrote one correspondent.

Companies of students from the Lutheran Theological Seminary and from the Pennsylvania College of Gettysburg took a hand in the action. A seventy-year-old farmer, John L. Burns, in a swallowtail coat with brass buttons, joined up with the Iron Brigade, went under fire, amazed the youngsters with his coolness, took three wounds and was carried to the rear. When a Wisconsin sergeant asked Burns whatever made him step out into the war without being enlisted, the old man said "the rebels had either driven away or milked his cows and he was going to be even with them." A son of Harriet Beecher Stowe was sent to the rear with bad wounds. Joseph Revere, a grandson of the famous Paul Revere of Boston, was killed.

Confederate bayonets had taken Union cannon and Union bayonets had retaken the cannon. Round Top, Little Round Top, Culp's Hill, rang with the yells of men shooting and men shot. Meadows of white daisies were pockmarked with horse hoofs. Dead and wounded lay scattered in rows, in little sudden piles, in singles and doubles, the spindrift of a storm wave.

The names of Plum Run, Peach Orchard, Devil's Den, Ziegler's Grove, Trostle's Barnyard, became sacred and terrible to those who had touched a mystery of human struggle

and suffering in those ordinarily peaceful landscape corners where spiders could ordinarily weave their webs and linger in the sunshine without interruption.

The first battle of the war fought outside a Slave State was over. Lee could have managed it better. So could Meade. The arguments began. Longstreet said Lee was "off his balance" in major decisions. Sickles, a Union general, said Meade did him wrong.

Meade issued an order thanking the Army of the Potomac for glorious results: "An enemy superior in numbers and flushed with the pride of a successful invasion, attempted to overcome and destroy this Army. Utterly baffled and defeated, he has now withdrawn from the contest. . . . The Commanding General looks to the Army for greater efforts to drive from our soil every vestige of the presence of the invader."

Fry of the Adjutant General's office had noticed Lincoln clinging to the War Office and devouring every scrap of news as it came over the wires. "I saw him read General Meade's congratulatory order to the Army of the Potomac. When he came to the sentence about 'driving the invaders from our soil,' an expression of disappointment settled upon his face, his hands dropped upon his knees, and in tones of anguish he exclaimed, ' "Drive the *invaders* from our soil." My God! Is that all?' "

On July 6 Lincoln and Halleck talked with Brigadier General Hermann Haupt, direct from Gettysburg, where he had been in charge of transportation, roads, bridges, telegraph lines. Haupt had commandeered a railroad locomotive for his ride to Washington in a hurry to report his three-hour con-

versation of the previous day with Generals Meade and Pleasanton. "General Meade was much surprised to learn that the bridges and telegraph lines had nearly been reconstructed, and that in a few hours he could begin to send his wounded to the hospitals. General Pleasanton made the remark that if Longstreet had concentrated his fire more and had kept it up a little longer, we would have lost the day; to which Meade made no reply. I remarked to General Meade that I supposed he would at once follow up his advantage and capture the remains of Lee's army before he could cross the Potomac. The reply was, 'Lee's pontoon-trains have been destroyed, and the river is not fordable. My army requires a few days' rest, and cannot move at present.' "

Haupt had argued with Meade that his construction corps could put an army across the Potomac in less than forty-eight hours "if they had no material except such as could be procured from barns, houses, trees, and it is not safe to assume that the enemy cannot do what we can." Haupt could not convince Meade, and feeling sure that Lee would escape across the river, had gone to Washington to report what he considered a sorry situation.

The next day Lincoln sent a telegram to Halleck saying that he had left the war telegraph office "a good deal dissatisfied." He quoted from Meade's address to the army at Gettysburg about driving "the invaders from our soil," saying, "You know I did not like the phrase." Since then had come word that the enemy was crossing his wounded over the Potomac, while the news of troop movements seemed to connect with a purpose to cover Baltimore and Washington "and to get

the enemy across the river again without a further collision, and they do not appear connected with a purpose to prevent his crossing and to destroy him."

While the battle of Gettysburg was being fought the President had wondered a good deal what was happening to Grant down at Vicksburg, Mississippi. Grant was trying to starve out one Confederate army in Vicksburg while he held off other Confederate armies from reaching Vicksburg. Against many representations and pleadings Lincoln had kept Grant in command and was hoping for great results.

Then came a dispatch from Admiral Porter at Vicksburg, with news that the city, its defenses, and Pemberton's army of some 30,000 troops had surrendered, fallen into the hands of Grant and the Union army.

Lincoln directed Halleck to send word at once to Meade that Vicksburg had surrendered to Grant on July 4, and furthermore: "Now, if General Meade can complete his work so gloriously prosecuted thus far, by the literal or substantial destruction of Lee's army, the rebellion will be over."

Over the North as the news spread were mass meetings and speeches, rejoicing, firing of guns, ringing of bells. In hundreds of cities large and small were celebrations with torchlight processions, songs, jubilation.

An odd number was Grant, a thousand miles from home, bagging an entire army, winning the greatest Union victory of the war thus far, clearing the Mississippi River of the last Confederate hold on it, yet failing to send word to Washington about his grand performance unless he let it go at telling

Admiral Porter that the navy should be first to wire the big news to the Government at Washington.

The detailed facts arrived at Washington of Grant receiving 31,600 prisoners, 172 cannon, 60,000 muskets of improved pattern that had most of them run the blockade, and of the uniform caliber needed in many of the Northern commands. Port Hudson, a little farther south on the Mississippi, had fallen to General Nathaniel Banks with 6,000 prisoners, 51 cannon, 5,000 muskets. The starved Confederates filed out of Vicksburg in silence, the Union soldiers obeying Grant's instructions "to be orderly and quiet as these prisoners pass, and to make no offensive remarks." They were paroled, Grant explaining they were largely from the Southwest. "I knew many of them were tired of the war and would get home just as soon as they could. A large number of them had voluntarily come into our lines during the siege, and requested to be sent North where they could get employment until the war was over." The prisoners included Lieutenant General John C. Pemberton, four major generals, fifteen brigadiers, eighty staff officers.

The City of a Hundred Hills, termed by Davis "The Gibraltar of the West," was a Confederate ruin, where flour had risen to $400 a barrel, payment in gold, where for days lead and steel had poured as in a rain, where a diarist wrote on July 4: "One man had his head shot off while in the act of picking up his child. One man had a shell to explode close by him and lift him some distance in the air. One shell exploded between two officers riding on the street and lifted both horses and riders into the air without hurting man or beast."

Lincoln's mental picture of events around Vicksburg, his eager anxiety about a military drama enacted along river bends where he had navigated flatboats, was told in a tender handshake letter of July 13, 1863, that went to Grant, a letter he gave shortly to press and public:

"My dear General: I do not remember that you and I ever met personally. I write this now as a grateful acknowledgment for the almost inestimable service you have done the country. I wish to say a word further. When you first reached the vicinity of Vicksburg, I thought you should do what you finally did—march the troops across the neck, run the batteries with the transports, and thus go below; and I never had any faith, except a general hope that you knew better than I, that the Yazoo Pass expedition and the like could succeed. When you got below and took Port Gibson, Grand Gulf, and vicinity, I thought you should go down the river and join General Banks, and when you turned northward, east of the Big Black, I feared it was a mistake. I now wish to make the personal acknowledgment that you were right and I was wrong."

Four days after Lee had moved his army from Gettysburg toward the Potomac Halleck wired Meade to watch the "divided forces" of the enemy. "The President is urgent and anxious that your army should move against him by forced marches." Lincoln wrote to General Lorenzo Thomas at Harrisburg that Lee was moving faster than Union troops far behind in pursuit, and the pursuers "will in my unprofessional opinion be quite as likely to capture the 'man in the moon' as any part of Lee's army."

Lee was writing to Davis on July 11 that rainstorms had swollen the Potomac beyond fording, that his army was in good condition and he would accept battle if the enemy offered it. On the next day he wrote to Davis that "but for the power the enemy possesses of accumulating troops" he would await attack; his supplies were running low, the river

The bridge built by soldiers over the Potomac Run

was going down and he might cross the next day on a bridge that was being built. Meade was writing to Halleck on July 8, "I think the decisive battle of the war will be fought in a few days," receiving from Halleck two days later the advice, "I think it will be best for you to postpone a general battle till you can concentrate all your forces and get up your reserves and reinforcements."

On July 12 Meade reported to Halleck that he would attack the next day "unless something intervenes to prevent it," recognizing that delay would strengthen the enemy and would not increase his own force. A war-telegraph office

operator said that when this dispatch arrived from Meade, Lincoln paced the room wringing his hands and saying, "They will be ready to fight a magnificent battle when there is no enemy there to fight."

The next day a telegram went from Halleck to Meade in words surely Lincoln rather than Halleck: "You are strong enough to attack and defeat the enemy before he can effect a crossing. Act upon your own judgment and make your generals execute your orders. Call no council of war. It is proverbial that councils of war never fight. Reinforcements are being pushed on as rapidly as possible. Do not let the enemy escape."

The night before, however, Meade had already called a council of war, finding that only two of his corps commanders wanted to fight. Meade himself was for immediate combat, but when the discussion was over decided to wait.

On the Monday following Meade's council of war, July 13, Hay's diary noted "the President begins to grow anxious and impatient about Meade's silence." On the morning of the fourteenth "the President seemed depressed by Meade's despatches of last night. They were so cautiously & almost timidly worded—talking about reconnoitering to find the enemy's weak place, and other such." The President said he feared Meade would do nothing. About noon came a dispatch. The enemy had got away unhurt.

"We had them within our grasp," the President said to Hay. "And nothing I could say or do could make the Army move. This is a dreadful reminiscence of McClellan. The same spirit that moved McC[lellan] to claim a great victory because P[ennsylvani]a and M[arylan]d were safe. The hearts of 10

million people sunk within them when McClellan raised that shout last fall. Will our generals never get that idea out of their heads? The whole country is our soil."

Now the war, already too long, would run longer.

"To hell with the draft and the war!" yelled rioters in New York as they took over that city for three days, July 13, 14, 15, in that summer of '63. They drove the United States draft authorities out of their offices, wrecked the machines for drawing names of drafted men, tore records to pieces, broke the furniture, burned to the ground one draft office and six buildings next to it. They smashed windows and doors and looted the home of the Republican Mayor George Opdyke, burned at midnight the home of United States Postmaster Abram Wakeman after stripping it of furniture and clothing. A ferry house, hotels, drugstores, clothing stores, factories, saloons where they were refused free liquor, went up in smoke. Also police stations, a Methodist church, a Protestant mission, the Colored Orphan Asylum at Forty-third Street and Lexington Avenue, burned to the ground.

The mobs drove out forty policemen and fifteen armed workmen from a state arsenal, took muskets and cartridges, set the building on fire, killed thirty Negroes, put up street barricades, stoned and kicked to death a State guard colonel, gave knife stabs and slashes nearly killing Superintendent of Police John Kennedy. Property damage was estimated at $5,000,000, and of rioters, police, and bystanders more than 400 were killed and wounded. With club and revolver a police force of 1,500 fought night and day, and their dead

lay in scores, their wounded, gashed, and bruised in the hundreds.

Six daily newspapers had been saying in one way and another, for many months, the same thing the rioting mobs yelled, "To hell with the draft and the war!" The Governor of New York, Horatio Seymour, the former President of the United States, Franklin Pierce, and other men of high place had made speeches the Fourth of July previous giving the Union Government at Washington a bad name for the way it was carrying on the war and the draft. What the people heard from the *World*, the *Journal of Commerce*, the *Express*, the *Daily News*, the *Day Book*, the *Mercury*, and from Seymour, Pierce, and others, could, if the people believed what they read and heard, become dynamite—as it did. On the second day of the rioting Governor Seymour spoke to a noisy crowd, "I implore you to take care that no man's property or person is injured," yet the burning, looting and killing went on.

Then Federal and local authorities published a newspaper notice: "The draft has been suspended in New York City and Brooklyn." This had a quieting effect. The storm in the streets began to go down as though winds had changed. And of course there was added quieting effect as infantry, cavalry, artillery from the Army of the Potomac commenced arriving.

After 150 regular-army soldiers with ball cartridges had faced a crowd of 2,000, fired in the air and received a volley of stones in reply, and had then shot into the swarming and defiant mass, killing twelve and wounding more, the hullabaloo began to die down. "The left wing of Lee's army,"

as some had called the New York mobs, could not stand against the arriving regiments from the Southern battle fronts.

On August 19 of '63 no less than 10,000 foot troops from the Army of the Potomac, three batteries of artillery, and cavalry patrols were on duty in New York City and Brooklyn. The draft began, as first planned in its essentials. Upward of $5,000,000 came from the city treasury for draft-evasion purposes, politicians, lawyers, examining physicians, and fixers doing their work for their constituents. Of 292,441 called, 39,877 failed to report, 164,394 were exempted, 52,288 bought exemption at $300 apiece, 26,002 hired substitutes to go to war for them. The fixing over, there were 9,880 who lacked political pull or seemed to want to join the Union Army and fight for its cause.

These and other events led Lincoln, Stanton, and Adjutant General James B. Fry in charge of conscription, to ask Congress for passage of a bill making it no longer possible for a drafted man to pay the Government $300 for exemption or to hire a substitute. The "$300 clause," as it was called, had made no end of trouble, giving rise to the cry that it was "a rich man's war and a poor man's fight." Opposition newspapers quipped, "We are coming, Father Abraham, three hundred dollars more, is the tune sung by the conscripts." Artemus Ward in a lecture struck the comic phase: "I have already given two cousins to the war, & I stand reddy to sacrifiss my wife's brother, ruthurn'n not see the rebellion krusht. And if wuss comes to wuss, I'll shed every drop of blood my able-bodied relations has got to prosekoot the war."

The House of Representatives seriously debated the $300 clause, made slight modifications in the law, but in the end still permitted any drafted man to hire a substitute to do military service for him. One result of this was to increase the number of foreigners and newly arrived immigrants from Europe fighting to save the Union. Another result was "the bounty-jumper." He would pocket the bounty paid him, enter the army, and desert. In some cases he more than once or twice took bounty and "jumped" the army. A few of these went down before firing squads while thousands of soldiers stood at "attention" as witnesses.

CHICKAMAUGA

HAVING fought a drawn battle at Murfreesboro in the first week of January, 1863, General Rosecrans kept the Army of the Cumberland at the same place in Tennessee for six months, fortifying, drilling, setting no troops into motion to stop Confederate armies from hitting Grant at Vicksburg, letting three brigades of Confederate cavalry get away to raid and terrorize southern Indiana and Ohio.

Late in June of '63 Rosecrans marched his forces through rough and broken country, and by September 9 had, without a battle, maneuvered the Confederate army under Bragg out of Chattanooga and put his own troops into that strategic center.

Major General William S. Rosecrans was now forty-four years old, born in Kingston, Ohio, graduating fifth in the class of 1842 at West Point, serving four years as professor of natural philosophy and of engineering at the national academy. He had organized a kerosene manufacturing company just before the war began, quit coal oil and money-making, served with credit under McClellan in West Virginia; he came through hard fighting at Corinth and Murfreesboro, rated as an able commanding officer, not lacking piety.

At first Rosecrans felt elated over his position. Then reports came indicating that Bragg had received reinforcements

and more were coming, that Bragg had his army well concentrated while Rosecrans' forces were scattered over a fifty-mile line. Rosecrans did not know that Longstreet with 20,000 troops from the Army of Northern Virginia had been sent by railroad down across the Carolinas and up into far northern Georgia to the help of Bragg. This gave Bragg 70,000 troops as against Rosecrans' 57,000.

The two armies grappled at Chickamauga Creek near Crawfish Spring on September 19 of '63. Lincoln that day read dispatches from Charles A. Dana, Stanton's assistant and observer. At 10:30 A.M.: "As I write enemy are making diversions on our right. . . . An orderly of Bragg's just captured says there are reports in rebel army of Longstreet's arrival, but he does not know that they are true. Rosecrans has everything ready to grind up Bragg's flank." At 2:30 P.M.: "Enemy repulsed on left has suddenly fallen on right of our line of battle . . . musketry there fierce and obstinate . . . decisive victory seems assured to us." At 3:20 P.M.: "Thomas reports that he is driving rebels and will force them into the Chickamauga tonight. . . . The battle is fought in thick forest, and is invisible to outsiders. Line is two miles long." At 4:30 P.M.: "I do not dare to say our victory is complete, but it seems certain. Enemy silenced on nearly whole line. Longstreet is here." At 5:20 P.M.: "Firing has ceased. . . . Enemy holds his ground in many places. . . . Now appears to be undecided contest." At 7:30 P.M.: "Enemy defeated in attempt to turn our left flank and regain possession of Chattanooga. . . . His repulse was bloody and maintained to the end. If he does not retreat, Rosecrans will renew the fight at daylight."

Late on Sunday afternoon, September 20, came a telegram from Dana at Chattanooga: "My report today is of deplorable importance. Chickamauga is as fatal a name in our history as Bull Run." At noon that day Dana was twelve miles from Chattanooga and, worn for sleep, lay down on the grass near where Rosecrans was directing troop movements.

"I was awakened," wrote Dana later, "by the most infernal noise I ever heard. Never in any battle I had witnessed was there such a discharge of cannon and musketry. . . . I saw our lines break and melt away like leaves before the wind. The headquarters around me disappeared. . . . The whole right of the army had apparently been routed. . . . Bull Run had nothing more terrible than the rout and flight of these veteran soldiers. The enemy came upon them in columns six lines deep. . . . I do not think our lines would have been broken but for a gap in them caused by taking Wood's division from the centre to reinforce the left. Through that gap the rebels came in. . . . I never saw anything so crushing to the mind as that scene. I was swept away with part of Rosecrans' staff, and lost in the rabble. . . . I rode twelve miles to Chattanooga . . . and found the road filled all the distance with baggage-wagons, artillery, ambulances . . . wounded men limping along, Union refugees from the country around leading their wives and children, mules running along loose, every element that could confuse the rout of a great army."

The right and the center were shattered. The left wing, under the Union Virginian General George H. Thomas, held. Till sunset, till darkness and night, his 25,000 men held solid on a horseshoe of a rocky hillock against twice their

number. One brigade ran out of ammunition and met Long-street's veterans with the bayonet. The next day Thomas began moving in good order to Chattanooga, Bragg failing to make another attack.

A heavy day's work had been done that Sunday, with Union killed, wounded, and missing reckoned at 16,000, Confederate at 18,000, a larger affair in blood loss than Antietam.

For long Lincoln had wished to see the Federal force thrust down as deep as Chattanooga. Now he read despairing words telegraphed by Rosecrans, and instructed Halleck that it was important for Rosecrans to hold his position at or about Chattanooga; it kept Tennessee clear of the enemy and broke important railroad lines of the enemy. "If you concur, I think he [Rosecrans] would better be informed that we are not pushing him beyond this position; and that, in fact, our judgment is rather against his going beyond it."

On September 24 appeals for help had come over the wires from Rosecrans and Dana; unless relief came soon the enemy might cut off their communications and supplies. It was decided after a conference to send reinforcements from the Army of the Potomac. Meade was ordered by telegraph to prepare two army corps, under General Hooker, ready for transport, with five days' cooked provisions, with baggage, artillery, ammunition, horses, to follow.

Superintendent Thomas A. Scott of the Pennsylvania Railroad was called in. Officers of the Baltimore & Ohio, and of other railroads, were called to Washington, and arrangements completed. From Bealeton, Virginia, to Chattanooga, Tennessee (1,233 miles), 23,000 men were transported in eleven and a half days.

Every day while Rosecrans had operated around Chattanooga that month the President had been keeping an anxious watch on East Tennessee, a region of mountaineers and hill people who owned no slaves and whose hearts, many of them, Lincoln knew were with the Union cause. Month after month since early in the war he had urged the importance of taking and holding East Tennessee. The sufferings of the Union people of Missouri or Kansas were slight in comparison. The East Tennessee people had voted more than two to one against secession. They had lost horses, cattle, and grain to the Confederate armies. They had by thousands journeyed in stealth over the steep Cumberland Mountains, through brush and timber, to Union enlistment camps. Hundreds staying at home had been thrown into prison, hanged on suspicion of burning bridges, picked off by sharpshooters who regarded them as Yankees and traitors.

Then in three weeks, early in September, Burnside and the Army of the Ohio had crossed the Tennessee line, entered Kingston, and marched into Knoxville to be met by cheering crowds. Flags long hidden were flashed out into sunlight, officers and soldiers welcomed into homes.

Though repeatedly ordered to join Rosecrans, Burnside delayed, and on September 25 Lincoln sent him two telegrams suggesting that troops be rushed to Rosecrans at Chattanooga.

Rosecrans under strain was cracking, putting into telegrams to Lincoln many complaints of poor communications and subsistence, and such generalities as "Our future is not bright." Dana feared starvation or that the Confederates would soon drive Rosecrans' army out of Chattanooga. Rose-

crans, wrote Dana, was sometimes as obstinate and inaccessible to reason as at others he was irresolute and vacillating. "I have never seen a public man possessing talent with less administrative power, less clearness and steadiness in difficulty, and greater practical incapacity. . . . I consider this army to be very unsafe in his hands."

The Confederates had a hold on the Tennessee River by which they blocked water transport of food and supplies for Rosecrans' army; and the long rough wagon route that met rail connections with Nashville was threatened. The Dana reports ran more gloomy that second week in October. Rosecrans was "dawdling" while catastrophe hung close, starvation or disorderly retreat. "The incapacity of the commander is astonishing, and it often seems difficult to believe him of sound mind. His imbecility appears to be contagious." Thus on October 16.

On the same day Halleck wrote to Grant at Cairo, Illinois, a letter beginning: "You will receive herewith the orders of the President of the United States placing you in command of the Departments of the Ohio, Cumberland and Tennessee."

Thus Lincoln put Grant at the head of all military operations west of the Alleghenies.

After a personal conference at Indianapolis with Stanton, Grant, by a rail route and a final horseback trip of fifty-five miles, arrived at Chattanooga on October 23.

Slowly in the trampling and grinding of events the men of genius for war were being sifted out, and in this process George Henry Thomas was arriving at his own. Appointed a colonel in April of '61, Thomas was now forty-seven years

old, a West Pointer of service in Indian wars and in the Mexican War, an artillery instructor at West Point, a cavalry major in a pet regiment of the then Secretary of War Jefferson Davis. His regiment had included Robert E. Lee, Fitzhugh Lee, Albert Sidney Johnston, Kirby Smith, William J. Hardee, John B. Hood, and others later to go into the top ranks of the Confederate Army. A quiet man, deliberate in motion, taking his time in preparations, something cool and massive about him. At Murfreesboro Thomas had shown fire and flint, at Chickamauga granite steadiness and volcanic resistance.

Now General Thomas was joined with Sherman and other tried commanders, with Grant as chief of the West, with forces massed at Chattanooga near the Alabama and Georgia State lines, wedging toward the Deep South as if hoping to cut it in two. Jefferson Davis had come personally from Richmond to confer with his friend Bragg, in command. On the coming grapple at Chattanooga hung the decision whether the Confederates would retake Tennessee and Kentucky, perhaps Vicksburg, and control of the Mississippi. Thus far the Northern wedge had always split deeper into the South, the map of areas occupied by the Union armies month by month showing a wider spread.

CHAPTER 15

LINCOLN SPEAKS
AT GETTYSBURG

A PRINTED invitation came to Lincoln's hands notifying
him that on Thursday, November 19, 1863, exercises would
be held for the dedication of a National Soldiers' Cemetery
at Gettysburg. In the helpless onrush of the war too many
of the fallen had lain as neglected cadavers rotting in the
open fields or thrust into so shallow a resting-place that a
common farm plow caught in their bones. Now by order of
Governor Curtin of Pennsylvania seventeen acres had been
purchased on Cemetery Hill, where the Union center stood
its colors on the second and third of July, and plots of soil
had been allotted each State for its graves.

The sacred and delicate duties of orator of the day had
fallen on Edward Everett, perhaps foremost of all distin-
guished American classical orators. Serene, suave, handsomely
venerable in his sixty-ninth year, a prominent specimen of
Northern upper-class distinction, Everett was a natural choice
of the Pennsylvania commissioners, who sought an orator
for a solemn national occasion.

Lincoln meanwhile, in reply to the printed circular invi-
tation, sent word to the commissioners that he would be
present at the ceremonies. This made it necessary for the
commissioners to consider whether the President should be
asked to deliver an address when present.

And so on November 2 David Wills of Gettysburg, as the special agent of Governor Curtin and also acting for the several States, by letter informed Lincoln that the several States having soldiers in the Army of the Potomac who were killed, or had since died at hospitals in the vicinity, had procured grounds for a cemetery and proper burial of their dead. "These grounds will be consecrated and set apart to this sacred purpose by appropriate ceremonies on Thursday, the 19th instant. I am authorized by the Governors of the various States to invite you to be present and participate in these ceremonies, which will doubtless be very imposing and solemnly impressive. It is the desire that after the oration, you, as Chief Executive of the nation, formally set apart these grounds to their sacred use by a few appropriate remarks."

Lincoln's personal touch with Gettysburg, by telegraph, mail, courier, and by a throng of associations, made it a place of great realities to him. Just after the battle there, a woman had come to his office, the doorman saying she had been "crying and taking on" for several days trying to see the President. Her husband and three sons were in the army. On part of her husband's pay she had lived for a time, till money from him stopped coming. She was hard put to scrape a living and needed one of her boys to help.

The President listened to her, standing at a fireplace, hands behind him, head bowed, motionless. The woman finished her plea for one of her three sons in the army. He spoke. Slowly and almost as if talking to himself alone the words came and only those words:

"I have two, and you have none."

He crossed the room, wrote an order for the military dis-

charge of one of her sons. On a special sheet of paper he wrote full and detailed instructions where to go and what to say in order to get her boy back.

In a few days the doorman told the President that the same woman was again on hand crying and taking on. "Let her in," was the word. She had located her boy, camp, regiment, company. She had found him, yes, wounded at Gettysburg, dying in a hospital, and had followed him to the grave. And, she begged, would the President now give her the next one of her boys?

As before he stood at the fireplace, hands behind him, head bent low, motionless. Slowly and almost as if talking to himself alone the words came and as before only those words:

"I have two, and you have none."

He crossed the room to his desk and began writing. As though nothing else was to do she followed, stood by his chair as he wrote, put her hand on the President's head, smoothed his thick and disorderly hair with motherly fingers. He signed an order giving her the next of her boys, stood up, put the priceless paper in her hand as he choked out the one word, "There!" and with long quick steps was gone from the room with her sobs and cries of thanks in his ears.

By many strange ways Gettysburg was to Lincoln a fact in crimson mist.

Fifteen thousand, some said 30,000 or 50,000, people were on Cemetery Hill for the exercises on November 19. On the platform sat governors, major generals, foreign Ministers, members of Congress, officials, together with Colonel Ward

Hill Lamon, Edward Everett and his daughter, and the President of the United States.

The United States House chaplain offered a prayer while the thousands stood with uncovered heads.

Benjamin B. French, officer in charge of buildings in Washington, introduced the Honorable Edward Everett, orator of the day, who rose, bowed low to Lincoln, saying, "Mr. President." Lincoln responded, "Mr. Everett."

The orator of the day then stood in silence before a crowd that stretched to limits that would test his voice. Beyond and around were the wheat fields, the meadows, the peach orchards, long slopes of land, and five and seven miles farther the contemplative blue ridge of a low mountain range. His eyes could sweep them as he faced the audience. He had taken note of it in his prepared and rehearsed address. "Overlooking these broad fields now reposing from the labors of the waning year, the mighty Alleghanies dimly towering before us, the graves of our brethren beneath our feet, it is with hesitation that I raise my poor voice to break the eloquent silence of God and Nature. But the duty to which you have called me must be performed,—grant me, I pray you, your indulgence and your sympathy." He spoke for an hour and fifty-seven minutes, some said a trifle over two hours, repeating almost word for word an address that occupied nearly two newspaper pages, as he had written it and as it had gone in advance sheets to many newspapers.

Everett came to his closing sentence without a faltering voice: "Down to the latest period of recorded time, in the glorious annals of our common country there will be no brighter page than that which relates THE BATTLES OF GETTYS-

BURG." It was the effort of his life and embodied the perfections of the school of oratory in which he had spent his career. His erect form and sturdy shoulders, his white hair and flung-back head at dramatic points, his voice, his poise, and chiefly some quality of inside goodheartedness, held most of his audience to him, though the people in the front rows had taken their seats three hours before his oration closed.

Having read Everett's address, Lincoln knew when the moment drew near for him to speak. He took out his own manuscript from a coat pocket, put on his steel-bowed glasses, stirred in his chair, looked over the manuscript, and put it back in his pocket. Ward Hill Lamon rose and spoke the words "The President of the United States," who rose, and holding in one hand the two sheets of paper at which he occasionally glanced, delivered the address in his high-pitched and clear-carrying voice:

Fourscore and seven years ago, our fathers brought forth upon this continent a new nation, conceived in liberty and dedicated to the proposition that all men are created equal.

Now we are engaged in a great civil war, testing whether that nation—or any nation, so conceived and so dedicated—can long endure.

We are met on a great battle-field of that war. We are met to dedicate a portion of it as the final resting place of those who have given their lives that that nation might live.

It is altogether fitting and proper that we should do this.

But, in a larger sense, we cannot dedicate, we cannot consecrate, we cannot hallow, this ground. The brave men, living and dead, who struggled here, have consecrated it, far above our power to add or to detract.

The world will very little note nor long remember what we say here; but it can never forget what they did here.

It is for us, the living, rather, to be dedicated, here, to the unfinished work that they have thus far so nobly carried on. It is rather for us to be here dedicated to the great task remaining before us; that from these honored dead we take increased devotion to that cause for which they here gave the last full measure of devotion; that we here highly resolve that these dead shall not have died in vain; that the nation shall, under God, have a new birth of freedom, and that government of the people, by the people, for the people, shall not perish from the earth.

The applause, according to most of the responsible witnesses, was formal and perfunctory, a tribute to the occasion, to the high office, to the array of important men of the nation on the platform, by persons who had sat as an audience for three hours. Ten sentences had been spoken in five minutes, and some were surprised that it should end before the orator had really begun to get his outdoor voice.

The ride to Washington took until midnight. Lincoln was weary, talked little. He had stood that day, the world's foremost spokesman of popular government, saying that democracy was yet worth fighting for. He had spoken as one in mist who might head on deeper yet into mist. He incarnated the assurances and pretenses of popular government, implied that it could and might perish from the earth. What he meant by "a new birth of freedom" for the nation could have a thousand interpretations. The taller riddles of democracy stood up out of the address. It had the dream touch of vast and furious events epitomized for any foreteller to read what

was to come. He did not assume that the drafted soldiers, substitutes, and bounty-paid privates had died willingly under Lee's shot and shell, in deliberate consecration of themselves to the Union cause. His cadences sang the ancient song that where there is freedom men have fought and sacrificed for it, and that freedom is worth men's dying for. For the first time since he became President he had on a dramatic occasion declaimed, howsoever it might be read, Jefferson's proposition which had been a slogan of the Revolutionary War—"All men are created equal"—leaving no other inference than that he regarded the Negro slave as a man. His outwardly smooth sentences were inside of them gnarled and tough with the enigmas of the American experiment.

Back at Gettysburg the blue haze of the Cumberland Mountains had dimmed till it was a blur in a nocturne. The moon was up and fell with a bland golden benevolence on the new-made graves of soldiers, on the sepulchers of old settlers, on the horse carcasses of which the onrush of war had not yet permitted removal.

In many a country cottage over the land, a tall old clock in a quiet corner told time in a tick-tock deliberation. Whether the orchard branches hung with pink-spray blossoms or icicles of sleet, whether the outside news was seedtime or harvest, rain or drouth, births or deaths, the swing of the pendulum was right and left and right and left in a tick-tock deliberation.

The face and dial of the clock had known the eyes of a boy who listened to its tick-tock and learned to read its minute and hour hands. And the boy had seen years measured

off by the swinging pendulum, and grown to man size, had gone away. And the people in the cottage knew that the clock would stand there and the boy never again come into the room and look at the clock with the query, "What is the time?"

In a row of graves of the Unidentified the boy would sleep long in the dedicated final resting-place at Gettysburg. Why he had gone away and why he would never come back had roots in some mystery of flags and drums, of national fate in which individuals sink as in a deep sea, of men swallowed and vanished in a man-made storm of smoke and steel.

The mystery deepened and moved with ancient music and inviolable consolation because a solemn Man of Authority had stood at the graves of the Unidentified and spoken the words "We cannot consecrate—we cannot hallow—this ground. The brave men, living and dead, who struggled here, have consecrated it, far above our poor power to add or detract. . . . From these honored dead we take increased devotion to that cause for which they gave the last full measure of devotion."

To the backward and forward pendulum swing of a tall old clock in a quiet corner they might read those cadenced words while outside the windows the first flurry of snow blew across the orchard and down over the meadow, the beginnings of winter in a gun-metal gloaming to be later arched with a star-flung sky.

MISSIONARY RIDGE
AND END OF '63

NOW the epic of action around Chattanooga came to its high point. The legs of men, mules, horses, tugged and hauled at this epic in mud and rainstorms, in fog and moonlight, moving rations, munitions, cannon, laying pontoon bridges, clearing steamboat routes. It was chaos and order, paradox and common sense, at the center of it Grant, of whom it was said, "Where that man goes things always seem to git!" As he had looked over the plans of Rosecrans, Grant said they were excellent; he wondered why they had not been put into action.

Ten thousand animals in a few weeks had perished hauling rations overland to Chattanooga before a river route was opened. Bragg's army had hoped to starve out the Union forces at the time Grant was taking command, when Thomas wired Grant, "We will hold the town till we starve." Jeff

A six-mule team and a supply wagon

Davis had gone back to Richmond proclaiming fresh faith in Bragg and his army. Bragg, hoped Davis, was to bag Grant at Chattanooga as Grant had bagged Pemberton at Vicksburg.

Grant's army lay south and east of Chattanooga, the Tennessee River at its back. Facing it, in a big half-circle, and high over it on Lookout Mountain and Missionary Ridge, some four hundred feet and higher up, lay Bragg's men with cannon and rifle pits amid rocks, timber, and chasms. From their witness gallery up close to the clouds the Confederates saw Union regiments march out on the plain below as if for drill, review, or parade. Then they saw the troops in blue form into storming columns that soon traded shots with the first line of defense up Missionary Ridge and captured that first line.

The Union troops kept going on up the slopes. It was against orders. They had been told to take only the first rifle pits. On up they went.

Grant at Orchard Knob saw them, turned to Thomas, "Who ordered those men up the ridge?"

Thomas did not know, turned to General Granger, "Did you?"

"No," said Granger, "they started up without orders." Phil Sheridan and others had sent back for orders to go on up and take the crest of the mountain but the orders that came were not clear. "How!" said Sheridan in a toast learned from red men, waving a whisky flask toward the enemy, taking a drink and joining his men. They swept on up.

The killed and wounded fell by scores, hundreds. They fought above the clouds, some columns in rain and mist, past afternoon into evening under clear moonlight. On Missionary

Ridge the same drama was enacted of foot troops moving up, dislodging and routing a naturally fortified enemy. It was told afterward as an event where men suddenly smitten with strength hurled themselves upward as smoothly and madly as though plunging downward.

View of Lookout Mountain and Valley from Chattanooga

They said they couldn't tell how or why they did it. To some it was a howling, inexplicable jamboree. To others it was a miracle.

Lincoln read a Grant telegram: "Lookout Mountain top, all the rifle-pits in Chattanooga Valley, and Missionary Ridge entire, have been carried and now held by us," and a dispatch from Thomas: "Missionary Ridge was carried simultaneously at six different points. . . . Among the prisoners are many who were paroled at Vicksburg." And again from Grant on November 27: "I am just in from the front. The rout of the enemy is most complete. . . . The pursuit will continue to Red Clay in the morning, for which place I shall start in a few hours."

For the first time in a large-scale combat, Confederate soldiers had been routed, had run away. They had valor, as

they had shown at Chickamauga. What explained their panic? The usual answer was Bragg, upright, moral, irascible, disputatious, censorious, dyspeptic, nervous, so harsh with his corrections and criticisms that the discipline of his army had gone to pieces.

Grant had studied Bragg, knew him as Lee knew McClellan, and gauged his plans accordingly. Bragg had cornered Grant, put his army within gunshot range overlooking the Union army, making retreat for Grant "almost certain annihilation," said Grant. Then the rank and file of Grant's army had thrown orders to the wind and taken mountains away from an army holding the top ridges of those mountains with cannon and rifle pits.

Anger at Jeff Davis, and mistrust of him, arose among some of his best aides because of his not knowing Bragg was second-rate. And Jeff Davis answered by appointing his friend Bragg Chief of Staff of the Confederate armies, with headquarters in Richmond.

"The storming of their ridge by our troops was one of the greatest miracles in military history," wrote Dana to his chiefs in Washington. "No man who climbs the ascent by any of the roads that wind along its front can believe that 18,000 men were moved up its broken and crumbling face unless it was his fortune to witness the deed. It seems as awful as a visible interposition of God. Neither Grant nor Thomas intended it. . . . The order to storm appears to have been given simultaneously by Generals Sheridan and Wood, because the men were not to be held back. Besides the generals had caught the inspiration of the men. . . . Bragg is in full retreat, burning his depots and bridges."

Newspapers of the North spread the story before their readers on the last Thursday of November. More good reason than expected had arisen for the Day of Thanksgiving that had been proclaimed by the President weeks earlier.

Now Sherman could be released with an army to march on Knoxville and relieve Longstreet's siege of Burnside there— which Sherman did in a clean, fast operation.

Now Grant and Sherman could lay their plans to move farther south—on Atlanta—perhaps drive a wedge and split the Confederacy that lay east of the Mississippi.

Minor operations took place, such as General William W. Averell raiding food supplies of Longstreet, cutting telegraph wires, crossing his cavalry over the Alleghenies, feeding his horses in a poor country, burning his own wagons, swimming his men across Jackson's River, capturing 200 prisoners and 150 horses, his own losses figured at 6 men drowned, 1 officer and 4 men wounded, reporting to Washington on December 21, "My command has marched, climbed, slid and swam 350 miles since the 8th instant."

The Union Navy was tightening its blockade of the enemy. More than 1,000 vessels had been captured; prizes amounted to $13,000,000. Of the 578 vessels built or being built, 75 were ironclad or armored steamers. New navy yards were wanted. The naval force on interior waters had doubled in two years and now was larger than the entire naval force when the war began. Mechanics and artisans were creating a new form of naval power. Enlisted seamen in 1861 numbered 7,500, now 34,000.

The year of 1863 saw glimmering of the last hopes of the Richmond Government for European recognition. The de-

spair of Jefferson Davis as to overseas help, as to ships or money from the England he had often referred to as "the mother-country," was set forth in his December message to the Confederate Congress. Davis dwelt at such length and so bitterly on the point that he was rebuked by some of the Southern newspapers for overemphasis of it.

A mortar boat in action

In the North were those who felt that Grant won battles by sheer overwhelming numbers, by cold, brutal, mass sacrifices of human material. This feeling in the North had gone down somewhat as Grant slowly rode into national popularity and fame, out of nothing much to start with. His string of combats and victories had won the imagination of many who wanted the war to end soon in favor of the Union. And Grant, the plain, plodding, short, stoop-shouldered Grant, with no put-on, no show-off about him, seemed to be the hero they had been looking for. He had captured two armies and routed a third, his dramatic actions touched with shock and

surprise. Donelson was the first Union shout from early dark-ness, Vicksburg an engineering and surgical exploit cutting a deep incision, Chattanooga an onrush with slaughter beyond prediction.

From Grant no promises beforehand, no signs of bragging, but suddenly out of rain and mud, long marches and spade-work interspersed with skirmish and assault, would come the word of a certain piece of workmanship toward winning the war. Many days his comings and goings, or the mystery of where he was and what doing, crowded out all others as the foremost newspaper items of the hour. On the hazards of Grant hung the anxieties and wonderings of millions of people. When he came out of those hazards with another complete operation of neat and final skill, reporting it in words modest and almost bashful, it took the hearts of those who prefer their heroism plain and unexpected.

Early in February of '64 bills in both House and Senate proposed to revive the rank of Lieutenant General of the Armies of the United States. This bill on February 26 passed both houses, leaving it to the President to appoint by and with the advice of the Senate a lieutenant general from among the major generals of the army. On February 29 the President signed the bill, named Grant for the newly created office. Only two men, George Washington and Winfield Scott, had hitherto in American history held the rank of lieutenant gen-eral. The Senate confirmed the President's appointment.

And now Halleck at last was to go. The diatribes of poli-ticians and newspapers against him had never let down; his critics ever sought new ways of saying he did nothing or if

he did he blundered. Lincoln had told Hay and others on various occasions, "I am Halleck's friend because he has no others." Also to Hay, Lincoln had said that Halleck was "little more . . . than a first-rate clerk," and had now become "nothing but a staff officer." Hay's diary quoted the President: "When McClellan seemed incompetent to the work of handling an army & we sent for Halleck to take command he stipulated that it should be with the full power and responsibility of Commander in Chief. He ran it on that basis till Pope's defeat; but ever since that event, he has shrunk from responsibility wherever it was possible."

Lincoln's load of care over vast military affairs was now somewhat lightened. Being told he was looking better, he brightened: "Oh, yes! I feel better, for now I'm like the man who was blown up in a steamboat explosion and said, on coming down, 'It makes no difference to me,—I'm only a passenger.'"

To many men of his own party in Washington in early 1864 Lincoln looked "too slow," "indecisive," "vacillating." Opinion at the national capital agreed with the *Detroit Free Press* correspondent at Washington writing, "Not a single Senator can be named as favorable to Lincoln's renomination for President." The Illinois Senator Lyman Trumbull, always keen in reading political trends, wrote to a friend in February of '64: "The feeling for Mr. Lincoln's reëlection *seems* to be very general, but much of it I discover is only on the surface. You would be surprised, in talking with public men we meet here, to find how few, when you come to get at their real sentiment, are for Mr. Lincoln's reëlection.

There is a distrust and fear that he is too undecided and in-efficient. . . . You need not be surprised if a reaction sets in before the nomination, in favor of some man supposed to possess more energy." This was the mild comment of an extraordinarily decent politician and statesman. What other Senators of Lincoln's own party were saying and writing was not so mild. And in the House of Representatives only one member took the floor to say Lincoln was worth keeping in the White House.

A Pennsylvania editor visiting Washington said to Thaddeus Stevens, Chairman of the Ways and Means Committee and Republican party floor leader, "Introduce me to some member of Congress friendly to Mr. Lincoln's renomination." Stevens took the editor to the desk of Isaac N. Arnold of Chicago, saying: "Here is a man who wants to find a Lincoln member of Congress. You are the only one I know, and I have come over to introduce my friend to you." "Thank you," said Arnold. "I know a good many such and I will present your friend to them, and I wish you, Mr. Stevens, were with us." Thus the very scrupulous Arnold recorded the incident. The other friends of Lincoln in Congress to whom Arnold referred were not named by him, nor did their wish to continue Lincoln as President show in their speeches.

Isaac N. Arnold, once a country schoolteacher in New York State, city clerk of Chicago in 1837, a practicing attorney-at-law, early in January of '64 took the floor to quote from Lincoln's House Divided speech, holding it prophetic, bold, honest, characteristic of "the man who, then obscure, has become already to-day, the foremost character

in American history." Toward saving the Union Lincoln had "labored and toiled through difficulties and obstacles known only to himself and God," said Arnold. . . . "The great fault of his administration, the too tardy removal of incompetent men, has arisen from a too scrupulous care to be just. . . . The masses of the people everywhere trust and love him. They know his hands are clean and his breast is pure. The people know that the devil has no bribe big enough, no temptation of gold, or place, or power, which can seduce the honest heart of Abraham Lincoln. They know that while he is President there is no danger of a *coup d'état* . . . that their liberties and laws are safe in his hands. . . . You have a Chief Magistrate . . . somewhat rude and rough, it may be, but under this rough exterior you have the real and true hero."

In a smoldering volcano of impatience and frayed nerves threatening to erupt into a volcano of straightout antagonism, Lincoln so managed that he never got into open hostilities with the main body of Congress. "The opposition to Mr. Lincoln," wrote the Indiana Republican Congressman George W. Julian later . . . "was secretly cherished by many of the ablest and most patriotic men of the day." Thaddeus Stevens in a letter written in '64 showed the mixed motives of himself and associates: "How little of the rights of war and the law of nations our Pres't knows! But what are we to do? Condemn privately and applaud publicly!" There was nothing "private" about some of the condemnation, and once as Lincoln read a sheaf of editorials Henry Ward Beecher had written and published in a religious

weekly, the *Independent,* his one comment was "Is thy serv-
ant a dog?"

Legislatures and assemblies of Northern states, however,
responded partly to Lincoln's quiet political manipulations
and still more to a deep and genuine feeling among the
masses of people that Lincoln had handled a tough job pretty
well and was worth another term in the White House. One
after another in early '64 these state legislative bodies passed
resolutions naming Lincoln as the man for the National
Union party to nominate for President at its coming conven-
tion in June. Against these positive and unanimous declara-
tions the slight and furtive moves to find another candidate
to oppose Lincoln began to fade away. In March of '64 the
Chicago Tribune carried a paragraph: "A sturdy farmer
from Oskaloosa, Iowa, one of the bone and sinew class,
called upon us yesterday in relation to business matters.
Before leaving, we asked him how Mr. Lincoln stood in
Iowa. 'Stands?' said the old farmer, with glistening eyes and
raising his brawny fist, 'Old Abe stands seventeen feet higher
in Iowa than any other man in the United States!' "

This farmer understood better than official Washington
what John Bright of the British House of Commons told an
American interviewer: "Mr. Lincoln is like a waiter in a
large eating house where all the bells are ringing at once; he
cannot serve them all at once, and so some grumblers are to
be expected."

GRAND STRATEGY

GRANT was at Nashville when word came that the President had named him for the Senate to confirm as lieutenant general. Grant had been directing railroad rebuilding, gathering of supplies, minor troop movements, looking toward a spring drive to end the war west of the Alleghenies. He had approved a raid of Sherman's army which made a swift, quiet march across the State of Mississippi to Meridian, burned an arsenal, two large hotels, and gristmills, destroyed railroads within a radius of twenty-five miles. Sherman said as he returned to Vicksburg that the enemy losses were $50,000,000. To Sherman on March 4, 1864, Grant wrote that he was ordered to Washington to take office as lieutenant general if the Senate confirmed the President's appointment. His personal success in the war, Grant wrote Sherman, was due to the energy and skill of his subordinates, above all to Sherman and McPherson. "I feel all the gratitude this letter can express, giving it the most flattering construction."

Sherman replied with groaning over the prospect of Grant's leaving. "For God's sake and your country's sake, come out of Washington. . . . Come West; take to yourself the whole Mississippi Valley. Let us make it dead-sure, and I tell you the Atlantic slope and Pacific shores will follow its destiny as sure as the limbs of a tree live or die with the main trunk. . . . Here lies the seat of coming empire." Sherman knew

that for Grant, as for himself, the war was for a river and the point of whether that river should belong to one or several nations. Also both of them knew that political forces in Washington could hamstring the best of commanders.

Grant traveled toward Washington. His intention was (for Sherman had read him right) to return to Chattanooga and make that his headquarters, unless what he saw and heard in Washington told him he must stay East.

On March 9 the Cabinet, Halleck, Nicolay, and a few others assembled to hear two little speeches that were telegraphed to the wide world.

Lincoln, facing Grant, read four sentences: "General Grant, The nation's appreciation of what you have done, and its reliance upon you for what remains to do, in the existing great struggle, are now presented, with this commission, constituting you lieutenant-general in the Army of the United States. With this high honor devolves upon you also a corresponding responsibility. As the country herein trusts you, so, under God, it will sustain you. I scarcely need add, that with what I here speak for the nation, goes my own hearty personal concurrence."

Grant held a half-sheet of note paper. On it was a hurried lead-pencil scrawl. And he wasn't sure what he had written to read off to the important though small audience. "His embarrassment was evident and extreme," noted Nicolay. "He found his own writing very difficult to read." The speech, however, as he finally made the grade, fitted Grant. He read, facing Lincoln, his three-sentence response: "Mr. President, I accept the commission, with gratitude for the high honor conferred. With the aid of the noble armies that have fought

in so many fields for our common country, it will be my earnest endeavor not to disappoint your expectations. I feel the full weight of the responsibilities devolving on me; and I know that if they are met, it will be due to those armies, and above all to the favor of that Providence which leads both nations and men."

The two leaders then had a short talk. Grant asked what special service was required of him. "The President replied," noted Nicolay, "that the country wanted him to take Richmond; he said our generals had not been fortunate in their efforts in that direction and asked if the Lieutenant-General could do it. Grant, without hesitation, answered that he could if he had the troops. These the President assured him he should have. There was not one word said as to what route to Richmond should be chosen."

Meade and Lee still had come to no grapple. They had maneuvered and countermarched and clashed with minor detachments, the result a standoff.

Grant rode by rail to the Army of the Potomac headquarters at Brandy Station, talked with Meade, felt out the spirit of the officers and men, said nothing much.

Grant found Meade sincere, generous, open-minded, saying that Grant might want an officer to command the Army of the Potomac who had been with him in the West, possibly Sherman. Meade begged Grant not to hesitate about making a change; the work before them was so vast that the feelings or wishes of no one person should stand in the way of selecting the right man; he would serve to the best of his ability

wherever placed. Grant told Meade he had no thought of a substitute for him, and as to Sherman, he could not be spared from the West.

Grant returned to Washington and told Lincoln he would go West, be gone about nine days, then return and direct operations from Eastern headquarters. And that evening he

A wagon train crossing the Rappahannock on a pontoon bridge.
From a photograph.

started West. He had been formally put in command, Halleck relieved. He had changed his mind about staying West. "When I got to Washington and saw the situation it was plain that here [East] was the point for the commanding general to be." No one else could resist for him the pressure to change plans, to follow other plans than his own. And even before starting West, he saw that orders were issued giving Sherman command of all Western armies, McPherson to take Sherman's department, John A. Logan being given McPherson's corps. He rode to Nashville, talked with Sherman on a campaign plan, huge but simple, as Sherman put it: Grant "was to go for Lee and I was to go for Joe Johnston."

That was all. The two of them believed they would start a never-ending hammering, a pressure of irresistible pincers—and close out the war.

Short Phil Sheridan in Washington early in April did not look the part he was to play. Grant had appointed him to head the combined cavalry of the Army of the Potomac. Sheridan was only five feet five inches high, less than a hundred and thirty pounds in weight—and a total stranger to Washington and service in the East. So young-looking he was —and only thirty-three years old. Cool and guarded he was, refusing to tell anybody how to win the war.

A black-haired Irish Catholic boy who went from Perry County, Ohio, to West Point, Sheridan had followed soldiering ever since. He seemed made for the army life, and as a fighter leading men against odds had proved his wild and stubborn ways at Murfreesboro, Chickamauga, and Chattanooga. Grant heard doubts spoken in Washington about Sheridan. They would soon find out whether Sheridan could fight, answered Grant. Lincoln dismissed one request for his opinion of Sheridan with saying he was "one of those long-armed fellows with short legs that can scratch his shins without having to stoop over."

In snow and rain of the last week in March, Grant and Rawlins, his chief of staff, set up headquarters at Culpeper Court House with the Army of the Potomac. Into their hands came daily reports and dispatches from troops on a line that ran 1,200 miles from the Atlantic to the Rio Grande, 21 army corps, 18 departments, with 800,000 men enrolled, 533,-000 present and fit for duty. On a day soon to come the

armies were to move, Butler up the James River, Grant and
Meade across the Rapidan, Sigel up the Shenandoah, Averell
in West Virginia, Sherman and Thomas from Chattanooga,
and Banks up the Red River toward Texas.

Hitherto armies had acted independently, "like a balky
team, no two ever pulling together," said Grant, as he ex-
plained to Lincoln that each army was to hammer away and
keep on with the hammering against the enemy armies, enemy
railroads and supplies, "until by mere attrition, if in no other
way, there should be nothing left to him." Grant and Meade
in the East, and Sherman and Thomas in the West, were to
be a giant nutcracker having the South crushed when they
should finally meet. Thus Grant outlined the grand strategy
to Lincoln.

Grant was to hit Lee so hard in Virginia that Lee could
send no help to Johnston in Georgia. Sherman was to hit
Johnston so heavily in Georgia that Johnston would never
shift troops to Lee in Virginia. So they hoped and planned.

Grant's orders to his scattered subcommanders were relayed
through Halleck at Washington. Meade as commander of
the Army of the Potomac received orders and suggestions
from the near-by headquarters of Grant. But the newly ar-
rived corps under Burnside was not under Meade, because
Burnside ranked Meade as an older head of the Army of the
Potomac; so Burnside was taking his orders from Grant.

The Burnside corps had mobilized at Annapolis, its veterans
of Roanoke, the Peninsula, Antietam, Fredericksburg, Chan-
cellorsville, and Knoxville being joined by new recruits that
included several Negro regiments.

✦

The grinding drama of drums and blood and agony went on. The lines of boys in blue poured south and ever south, fractions of them returning horizontal and groaning in ambulances; others by thousands in shallow rain-soaked graves where hurried burying squads had shoveled them over, still others by thousands, as at Shiloh, Malvern Hill, Gettysburg, with ribs and skulls picked clean and bare by scavenger birds, rain and sunlight finally giving them an ancient and inviolable dignity.

Three years of these rocking lines of destroyers seeking each other and unable to destroy to an end. Three years of it and no foreteller had foretold it as it happened. Inexorable laws and deep-running forces of human society and national life had operated.

BLOOD AND ANGER

GENERAL BANKS headed in March the Red River expedition of some 40,000 men, hundreds of wagons, a fleet of 20 gunboats, as many more transports, tenders, and supply ships. They started across western Louisiana aiming to stop interference from that direction with Mississippi River navigation, to put down whatever Confederate armies joined up against them, and to take Shreveport. This would make a starting-point from which to overrun Texas and set up the United States flag as a warning to the French imperial army across the Mexican border, where the Austrian Archduke Maximilian had been put on a throne by Napoleon III. Lincoln wrote Banks that recent events in Mexico rendered early action in Texas "more important than ever." Halleck with Banks had worked out the campaign plan, Grant opposed it, though Grant in his first days as lieutenant general would not go so far as to countermand the Red River expedition.

His army at Natchitoches was over halfway to Shreveport on April 2 when General Banks wrote to John Hay that the enemy seemed to be fortifying far away on the Sabine River and he was only anxious lest he should not have a battle with the foe. Hay showed the Banks letter to Lincoln and Hay thought it set going in Lincoln an instinct like a sixth sense for bad news to come. "I am sorry," said Lincoln, "to see

this tone of confidence; the next news we shall hear from there will be of a defeat."

Amid pine barrens in a broken hill country, with wagon roads few and cleared spaces for open battle rare, the Banks forces moved against inferior-numbered Confederate forces who knew the land and how to live on it and maneuver rapidly across it. And the Banks forces were mishandled and beaten and sent reeling so that Banks was glad to get his army safe in Alexandria, eighty miles back eastward from the town where twenty days earlier he had written John Hay he was anxious lest the enemy might not give him battle. A bullet had torn through Banks's coat in one major action where General William B. Franklin had two horses killed under him and where Franklin said of the wild runaway of a scared army, "Bull Run was not a circumstance in comparison." The *Philadelphia Press* correspondent, who had also been at Bull Run, saw it as the same kind of a rout, except that fewer men were engaged and before their flight they fought with a valor not seen at the first panic of the war. It started like a thunderbolt, how or why the correspondent could not see. "We found ourselves swallowed up in a hissing, seething, bubbling whirlpool of agitated men . . . and if we hoped to live we must ride with the rest of them. Our line of battle had given way."

At Pleasant Hill General A. J. Smith, who had trained under Grant and Sherman in the Vicksburg campaign, commanded troops who threw back the enemy with heavy punishment. An Ohio soldier wrote home that General Banks remarked, "General Smith, you have saved my army," and General Smith busted out, "By God! I know it, sir." When

told that Banks would soon have reinforcements, General Smith flashed, "The fellow has more men now than he knows how to use." No other Western military operation brought such disgust over the commander as did the Red River expedition.

Far up the river was the navy, Admiral Porter's fleet of boats he figured worth $2,000,000, stranded in rapids and shallow water, unable to move down-river. The officers prepared in their minds to hand over the fleet to Confederate armies due to arrive soon. Then a young Wisconsin engineer, Lieutenant Colonel Joseph Bailey, worked out a scheme of dams, cribs, and chutes, built in record time by thousands of soldiers cutting down trees and toiling to their armpits in running water. The job began on April 30 and was finished May 8. They raised the river-water level seven feet. The fleet moved down-river and was saved. Young Bailey, at first laughed at as crackbrained, was a hero.

Banks called his generals for a council of war. The council voted to retreat. At Alexandria General David Hunter arrived with dispatches ordering Banks to end the expedition. These orders were countermanded in fresh dispatches from Halleck. Grant sent peremptory orders that 10,000 troops loaned by Sherman be sent back May 1. A crop of quarrels sprang up among the generals.

Charges arose that, after all, the collapsed and inglorious Red River expedition was not so much to win Texas and threaten the French imperialists in Mexico, nor to widen the area of reconstruction across Louisiana, nor incidentally to clear the Southwest of armed Confederate forces. The main objective, these charges implied, was capture of immense sup-

plies of cotton to be sold by the Union Government to relieve the textile-mill famine and to put millions of dollars into the United States Treasury.

The navy did manage to gather in some cotton which the Government sold at St. Louis, but the available bulk of it went out of sight when the Confederate General Kirby Smith

Alexandria, on the Red River. From a wartime photograph.

first became sure that the army and navy were coming up Red River. He then ordered bonfires south of Alexandria and east of the Ouachita River that sent up in smoke 150,000 bales valued at $60,000,000.

In May, Banks was relieved of his command and resigned his army commission. His Red River campaign had been "one damned blunder from beginning to end," said Sherman. Grant suggested General E. R. S. Canby to supersede Banks and it was so ordered.

Meanwhile in this month of April, 1864, came news of an affair in which the central figure was the Confederate Major General Nathan Bedford Forrest, born for war. Fifteen horses

had been killed under him in various actions. In the battles at Murfreesboro, Shiloh, Chickamauga, he was in the vortex. "War means fighting and fighting means killing," was a saying from him, and no other commanding officer North or South, it was believed, had sat his horse and personally sabered to death so many of the enemy. A log-cabin boy from middle Tennessee, Forrest had never seen West Point nor read a book on military tactics. In Memphis as a real-estate dealer and slave-trader he had made a fortune. He had raised several regiments, sometimes outfitting them with horses, equipment, and rations by raids on Union supply centers. His record for swift movement and fast fighting was compared to that of Stonewall Jackson.

As a slave-trader he had the faint enigmatic odor of something or other that traditionally excluded slave-traders from exclusive social circles of the South. When it was urged that the war was for Southern independence and not slavery, Forrest replied, "If we ain't fightin' fer slavery then I'd like to know what we are fightin' fer." Slowly and by degrees he had built so solid a record as a military leader, as a brilliant and incessant destroyer of the enemy, that it became ridiculous for the West Pointers at Richmond to hold off appointing him a major general. A born killer made for war, he was tireless, sudden, merciless, with a gorgeous abandon, a high scorn of any death to come.

With some 4,000 men Forrest moved up from Mississippi into Tennessee, jolted 7,000 Union troops under General William Sooy Smith aiming to join Sherman farther south at Meridian, sent Smith reeling back to Memphis. Forrest carried his columns up north across Kentucky to the Ohio River,

held Paducah for hours while he mounted a command of new Kentucky recruits who insisted on horses. He struck at Sherman's supply connections, enlarged and strengthened his army, and took several Union garrisons. One of these was at Fort Pillow, on the Mississippi forty miles north of Memphis.

What happened there at Fort Pillow on April 12 of '64 became a livid national issue. Forrest with 6,000 troops drove the 600 defenders from outworks into the fort. While his white flags of truce were in the air he served notice that he would storm the fort. The Union commanders claimed that while thus negotiating under flags of truce Forrest moved his troops into better positions, violating the laws of civilized warfare. Forrest's regiments rushed the fort, took it, and put to death over half the garrison, Forrest claiming that the fort flag had not been hauled down in token of surrender and in accord with civilized military law. Of the 262 Negro soldiers in the garrison nearly all were killed, wounded in escape, or buried alive.

Perhaps half or more than half of Forrest's men were horrified at what was happening. What they saw was not war but mass murder out of race hatred. They tried to stop it. But it was a cyclone. Repeatedly the witnesses told of Southern officers ordering men not to shoot, or of Confederate men in the ranks pleading for mercy to enemy Negroes and whites. But discipline was gone. What began as a battle ended as a mob scene with wholesale lynching.

Of course, Forrest in what he let happen at Fort Pillow did not know that he was playing into the hands of the abolitionists, whose fury and thirst for vengeance were beginning to match his own lust for the kill. Whatever hap-

pened at Fort Pillow could be made by the pro-Negro, anti-slavery press, pulpit, and politicians of the North to look like Negroes fighting for freedom given mass murder by cruel masters who would rather kill them than see them have freedom.

Lincoln in a speech at Baltimore phrased the contradiction of the hour: "Plainly, the sheep and the wolf are not agreed upon a definition of the word liberty; and precisely the same difference prevails to-day among us human creatures, even in the North, and all professing to love liberty."

In the storm of guns and blood and death soon to be let loose by Grant and Sherman against Lee and Johnston, in the reddening streams and the shouting and the crying with black silence after, and then the renewal of crimson explosions and the gray monotonous weariness—in this terrific grapple of guns and living wills and dying testaments the Fort Pillow affair was to sink to a lesser significance.

CHAPTER 19

GRANT'S OFFENSIVE '64

ACROSS the Rapidan River and into the Wilderness of Spotsylvania, Grant with some 120,000 men had vanished at midnight of May 4. On a piece of ground ranging ten to twelve miles across in any direction Grant was to meet Lee's army. Grant had two men to Lee's one. Lee, as Grant came on, could choose where he wanted to fight Grant. For Grant's men, crossing a river, seeking their opponent and going to him, it would be at times a groping in the dark. Around swampland and swale, in red clay and sandy land, in thickets of jack pine intermixed with scrub oak, cedar, ash, walnut, and a tanglefoot underbrush, the men of Grant and Lee were to grapple and to lie by thousands in rows and piles and sudden disorderly huddles, some of them pillowed in peace on a smooth green wilderness moss that had seldom seen the great white sun.

On part of this very ground these same armies, then under Hooker and Lee, had fought just a year ago, and their campfires and rusty canteens, their rotting artillery axes, their skeletons of men and horses, met the eyes of living fighting men. On one spot ten rods square could be counted fifty skulls of men, their eye sockets staring at the path of war. From a half-open grave would stand out a rotted trouser leg and a knee bone or a mildewed sleeve and the clean frame of a man's hand.

Watering horses in the Rapidan

Amid scrawny and tenacious timbers the wild rose came because it was spring. Out of a reddish bitter clay stood honeysuckle and huckleberry in bloom. The dogwood and the shad-blow floated their accustomed annual blossoms.

Here where Hooker had failed and Jackson had died and Lee had earned new stars of military merit, Grant was to hammer and recoil to a standstill and then return to hammer again.

On Saturday night, May 7, Grant sat by a campfire, his hat slouched low, the collar of his blue overcoat hiding most of his worn, haggard face. He smoked a cigar, he slowly chewed the cigar, he sat motionless except for an occasional shift of one leg over the other. Grant had lost 14,000 men, killed, wounded, or missing, in forty-eight hours of fighting. The ambulances streaming north choked the roadways. Lee had lost more than he could spare as Grant hour on hour ordered up assaulting columns. After such desperate fighting it was customary to rest an army. Grant could decide to hold back—or go on. His decision must consider his promise to

Sherman that he would keep Lee fighting so hard and fast that Lee would send no troops to Georgia to oppose Sherman's campaign against Johnston and Atlanta. Also Ben Butler was landing an army near Richmond and by moving into another battle with Lee, Grant would stop Lee from action against Butler.

Sitting at a campfire as hours passed after midnight, slouched and grizzled, outwardly calm as bronze and steel but underneath shaken in turmoil, Grant did his thinking and made his decision. He would move on. His reasoning included his proposition "Accident often decides the fate of battle." He could name the simple accidents that had operated against him and against Lee that day. He reasoned too that there would be an advantage in doing what the other fellow did not want him to do. He would move on, toward Richmond, by the left, toward Spotsylvania Court House. He determined "to use the greatest number of troops practicable" and to hammer the enemy, "until, by mere attrition, if in no other way, there should be nothing left to him."

By a keen guess or by accident Lee was at Spotsylvania, again in Grant's path. Back and forth in smoke and fog and rain sagged the battle lines. At the parapet of one salient men were pulled over the bloody slippery logs and made prisoner. Bayoneted muskets were hurled like spears. Over ditches filled with dead, in mud and blood, the living waded and clambered at Bloody Angle. One tree of twenty-two inches diameter and another of two inches less were gnawed and cut down clean by bullet fire. Till the dawn of May 13 the combat went on at Spotsylvania. For ten days the Army of the Potomac had marched and fought continuously, losing 26,815 killed

and wounded, 4,183 missing. The Confederates gave out no records of losses, though on the basis of prisoners taken by Grant, it was plain that Lee's army was being mercilessly slashed of irreplaceable man power.

"What word have you to send?" asked Grant's home-town Congressman Washburne as he started to leave Grant's headquarters for Washington after the hardest fighting was over at Spotsylvania Court House.

In his tent, with no pauses, and without reading it after it was written, Grant scribbled a note which Stanton gave to the country: "We have now ended the 6th day of very hard fighting. The result to this time is much in our favor. But our losses have been heavy as well as those of the enemy. I think the loss of the enemy must be greater; we have taken over four thousand prisoners in battle, whilst he has taken from us but few except . . . stragglers. I purpose to fight it out on this line if it takes all summer."

Now emerged Phil Sheridan. His cavalry swept round the flank of Lee's army, tore up ten miles of railway, released 400 Union prisoners, struck the reserve stores of Lee's supplies, destroyed 504,000 rations of bread and 904,000 of meat, and in combat six miles from Richmond killed the dauntless and priceless J. E. B. Stuart, thirty-one years old, Lee's most irreplaceable general officer, "the eyes of the army."

Grant's pride and joy among major generals, the dauntless and priceless John Sedgwick, took a sharpshooter's bullet in his brain one May day as he smiled in jest to his soldiers his last words, "Don't duck; they couldn't hit an elephant at that distance."

"The importance of this campaign to the administration

of Mr. Lincoln and to General Grant leaves no doubt that every effort and every sacrifice will be made to secure its success," wrote Lee to Davis on May 18. The hope at Richmond was that they might be able in defensive tactics to drag out the contest and make the Northern people war-weary and ready to negotiate.

A bombshell in an artillery campfire—an incident of Cold Harbor. From a sketch made at the time.

By the left again Grant moved, to Cold Harbor, almost in sight of the steeples of Richmond. There he ordered a frontal assault that in twenty-two minutes lost 3,000 men. The night of June 3 saw 7,000 Union soldiers dead or ready for hospitals, as against Confederate losses of 1,200 to 1,500. "I have always regretted that the last assault at Cold Harbor was ever made," wrote Grant later. It was thirty days since he had crossed the Rapidan and forced Lee into a succession of battles. Never before had the Army of Northern Virginia been pressed from point to point and day to day of fighting by an Army of the Potomac that never rested nor quit. A new mental and psychic factor was entering the war.

Who and what was this hammer Grant that came and came and never gave way? Was he some merciless incarnation of a prophecy that the North was stronger than the South and was it written in a Book of Fate that the Union of States in blood and iron should be welded together for all time? What was this new triple combination of Grant in Virginia, Sherman in Georgia, and Lincoln at Washington? Would Lincoln, the recruiting agent and supply man at Washington, and Grant and Sherman with men and bayonets, carry on till they established the authority of the Federal Government at Washington over all the States that had each a star in the Union flag? Was this as a grim portent and a melancholy idea beginning to seep through the mass of the Southern people?

Soaked in mud and blood, soaked in a psychic bewilderment of issues and methods, yet managed by Grant as a force that persisted in going on, the Army of the Potomac in its vital centers was beginning to suspect itself a tool of destiny, an Instrument of History.

No longer could Lee go out in the open and send assaulting columns at the Army of the Potomac. The Richmond Government was near its last line of conscripts. Against McClellan, Burnside, Hooker, Pope, Meade, on Virginia soil Lee could afford to spend men and win delay. Other commanders when punished and beaten retreated or stood still and waited. Grant came on for more. It was not a duel or a sporting affair between gentlemen. It was war and the Four Horsemen of the Apocalypse.

Grant "puzzles me as much as he appears to the rebels,"

wrote in a letter a cavalry officer at Grant's headquarters. "He fights when we expect him to march, waits when we look for motion, and moves when we expect him to fight."

"I now find, after over thirty days of trial, the enemy deems it of first importance to run no risks with the armies they

A hand litter

now have," Grant wrote to Halleck after the Cold Harbor slaughter.

Thirty days' fighting had changed morale in both armies. Among Lee's men the question was: Will this battle never end? Why kill and kill only to see that army come further south? Among Grant's men the question was: Why should we over and again lose two and three to one fighting an entrenched enemy who forces us to come to him?

Suddenly Grant made a complete shift in his style of fighting. While Lee waited for direct combat and more bloody frontal assaults, Grant moved—by night—in so shrouded a secrecy that only a few high officers knew where the army was going. Lee's skirmishers the next day brought him word that the long trenches in front of Cold Harbor were empty.

Grant was gone. A long march, and the wide James River crossed, brought Grant's army to the Petersburg defenses of Richmond. In four days of assaults 10,000 Union troops were lost as against half that number of the enemy. On June 19 Grant sent word to Washington that he would order no more assaults. For a time he would rest his army. From the Wilderness through Cold Harbor he had lost 54,000 men, nearly as many as the entire force under Lee, but reinforcements had brought his army to about the same number he had when he crossed the Rapidan in early May.

Grant was directing several armies. Sigel in the Shenandoah had failed him. Butler on the James River had dallied and lost big chances. Heading an army that landed from transports near Richmond, he had failed to get the results Grant asked for. But Sheridan had come through and performed, while Sherman in a series of flanking movements and battles was steadily approaching Atlanta. Long toils were ahead. Could Sherman and Grant press through and join their armies? If so, the war would be over.

Over the land stood houses where the war losses came close home. "My oldest boy, not yet twenty," wrote the poet Longfellow to a friend, "in the last battle on the Rapidan shot through both shoulders with a rifle-ball, is now at home. He comes down into my study every day, and is propped up in a great chair. How brave these boys are! Not a single murmur or complaint, though he has a wound through him a foot long. He pretends it does not hurt him."

Homeward went a musician from the Virginia fighting.

When he had arrived in hospital, according to the *New York Tribune*, the surgeon said he must be lashed down while a leg was amputated. "No," said the soldier. "Never! Is there a violin in camp?" They brought one. He put it under his chin, tuned it, laughed. "Now, doctor, begin." And he went on playing the violin "without missing a note or moving a

A bulletproof in the woods at Cold Harbor

muscle" during some forty minutes while they sawed his leg off.

Patriotism before the war had been fireworks, salutes, serenades for holidays and summer evenings, though the reality was "cotton thread and complaisance," wrote Emerson in his diary. "Now the deaths of thousands and the determination of millions of men and women show it real."

From Cold Harbor on June 7 Grant's kindly shadow, Rawlins, wrote to his wife that he had taken dinner in the house of Edmund Ruffin, who at Sumter had fired the first gun of the war. "His fine plantation is abandoned, and I understand that he is dead. I enclose a lily picked in the yard." Ruffin, in fact, was not dead—but his house and lands were lost and the

lily that dropped out of the letter Mrs. Rawlins had from her husband might be a foretokening.

On May 18, 1864, at 4 A.M. and the press deadline near, one Joseph Howard sent to all the newspapers of New York a forged proclamation in which the President fixed May 26 as a day of fasting, humiliation, and prayer for the nation, called for 400,000 men to be conscripted, and took on a tone of mourning as though the war was lost. Dated at the Executive Mansion, Washington, it opened: "In all exigencies it becomes a Nation to carefully scrutinize its line of conduct, humbly to approach the Throne of Grace and meekly to implore forgiveness, wisdom and guidance. For reasons known only to Him, it has been decreed that this country should be the scene of unparalleled outrage, and this Nation the monumental sufferer of the nineteenth century. With a heavy heart but an undiminished confidence in our cause, I approach the performance of duty, rendered imperative by sense of weakness before the Almighty, and of justice to the people."

The *Herald*, *Tribune*, and *Times* editors had received in their offices the same Associated Press manifold sheets as the *World* and the *Journal of Commerce*. But the late hour of arrival for such a document from the President, the fishy tone of its opening: "Fellow Citizens of the United States"—a phrase of address not employed by the President in his proclamations—made it suspect. The *Herald* printed it, but did not send out the early edition containing it. The two newspapers foremost in violent opposition to the President, however, could not resist the temptation to print and circulate it. As news it was what they wanted as a follow-up on their re-

peated items about the President's shattered physical health, on their exaggerations of Grant's colossal battle losses in the Wilderness.

Stanton the next morning sent orders for the seizure of the offices, arrest of managers, superintendents, and operators of the Independent Telegraph Company, and later in the day had telegrams from New York, Harrisburg, Baltimore, Pittsburgh, that those offices had been closed and the arrests made. Dix at New York arrested the editors of the *World* and the *Journal of Commerce,* under later orders let them go, but for two days would not let them print and sell their papers.

Dix telegraphed Stanton on May 20 he had arrested and was sending to Fort Lafayette one Joseph Howard, found to be the author of the forged proclamation. "He is a newspaper man and is known as Howard of the 'Times.' He has been very frank in his confession, says it was a stock-jobbing operation and that no person connected with the press had any agency in the transaction, except another reporter, who distributed the copies to the newspapers."

President Lincoln directed that, while the editors had no right to shield themselves behind a plea of ignorance or want of criminal intent, he was not disposed "to visit them with vindictive punishment," hoped they would exercise more caution in the future, and authorized Dix to restore to them their establishments. So once more they could print and sell papers. The editor of the *World*, Manton Marble, put his signature to column on column of editorials addressed to President Lincoln, calling the Chief Magistrate tyrant, usurper, and despot who had destroyed "freedom of the

press." By his methods Marble invited and defied the President to again close down the *World*, which didn't happen.

Stanton, "the fiery Secretary," had rushed the matter without asking the President about it, according to Nicolay and Hay. The President's secretaries implied it was a case similar to General Burnside's actions in the arrest of one Congressman Vallandigham and the suppression of the *Chicago Times*, in both of which the President indicated afterward that he would have preferred another course of action. "The momentary suppression of the two New York newspapers," wrote Nicolay and Hay . . . "arose from an error which was, after all, sufficiently natural on the part of the Secretary of War." Seward, it was evident from Welles's diary, had no hesitations and wanted the two newspapers "shut up"; they had been "published a minute too long."

Meantime Joe Howard, as the newspapermen called him, meditated behind the bars of a cell at Fort Lafayette on what his lively imagination had brought him to, on the easy money he had expected from the rise of gold resulting from his hoax, on the brokers in cahoots with him who had also lost out, on his former days as secretary to the Reverend Henry Ward Beecher, on newspapers over the country saying with the *New York Tribune*, "Howard was with President Lincoln at the time of his tour from Springfield to Washington and wrote the hoax story in relation to Mr. Lincoln's escape 'in a Scotch cap and long military cloak,' which had not a shadow of truth in it." After a few weeks in jail, Howard was released by order of the President, on the request of Beecher.

Elsewhere over the land mobs of Union men had gone

much farther than Dix in New York under Lincoln's orders, in the suppression of newspapers. In the three preceding months the *Constitution and Union* at Fairfield, Iowa, was destroyed, likewise the *Northumberland Democrat* and the *Sunbury Democrat* in Pennsylvania, also the Youngstown *Mahoning Sentinel* and the *Dayton Empire* and the *Greenville Democrat* and the *Lancaster Eagle* and the *Wauseon Democrat* in Ohio, likewise the *Laporte Democrat* in Indiana, also the *Chester Picket Guard* and the *Gallatin County Democrat* in Illinois, the *Belleville Volksblatt* and the *Louisiana Union* in Missouri. In these cases the mobs wrecked and demolished office and plant so it could not get out a paper. In Columbus, Ohio, the editor of the *Crisis* was seized and imprisoned; the editor of the *Mahoning Sentinel* narrowly escaped death. Editors at several points were "seized" and sometimes roughly handled. In his two-day suppression of two New York newspapers Lincoln was in accord with a mass trend of the first half of that year and could have gone farther had he chosen.

On the morning the bogus proclamation was published, the price of gold made fast upswings and the New York Stock Exchange was feverish. To those gold speculators who took it as genuine the proclamation meant that Grant was losing and gold would go higher. The antics and greed of these gamblers had recently been attacked by Congress in a bill empowering the Secretary of the Treasury to sell surplus gold. The painter Carpenter in the White House heard Governor Curtin remark to Lincoln one day, "I see by the quotations that Chase's movement has already knocked gold down several per cent."

Lincoln's face knotted. "Curtin, what do you think of those fellows in Wall Street, who are gambling in gold at such a time as this?"

"They are a set of sharks."

"For my part," bringing a clenched fist down on a table, "I wish every one of them had his *devilish* head shot off."

Into the political scene had stepped John Charles Frémont, John Cochrane, Wendell Phillips, Emil Preetorius, Worthington A. Smythers, Elizabeth Cady Stanton, Caspar Butz, B. Gratz Brown, Pantaleon Candidus, General Gustave Paul Cluseret, and others, including the Reverend George Barrell Cheever of the Church of the Puritans of New York City. In Cosmopolitan Hall in Cleveland, Ohio, May 31 of '64, they organized a political party, the Radical Democracy, having a single main objective declared by its leaders—the defeat of the Lincoln Administration. They met eight days before the National Union convention at Baltimore in order to warn that convention it must not nominate Abraham Lincoln for President. Their platform: the constitutional prohibition of slavery, free speech and a free press, a one-term Presidency, reconstruction of States to be left entirely with Congress. For President they nominated Major General John C. Frémont of New York, and for Vice-President Brigadier General John Cochrane of New York.

New York and St. Louis, the draft-riots metropolis and the war-torn Border State of Missouri, were the main centers of the movement, with additions from antislavery radicals. The rules had not been very strict as to who could be a delegate, and the proceedings at moments had comedy.

Frémont in accepting announced he had resigned his commission as major general in the United States Army. He approved of the Cleveland platform, except the plank which called for seizure of conquered slave soil and its division among soldiers and sailors of the United States. "Had Mr. Lincoln remained faithful to the principles he was elected to defend, no schism could have been created and no contest would have been possible," declared the man who had been the Republican-party candidate for President in 1856. If the Baltimore convention should nominate a man of fidelity "to our cardinal principles," there need be no division among really patriotic men. "My own decided preference is to aid in this way and not to be myself a candidate. But if Mr. Lincoln should be nominated, as I believe it would be fatal to the country, cost us the lives of thousands of men and needlessly put the country on the road to bankruptcy, there will remain no other alternative but to organize against him every element of conscientious opposition with a view to prevent the misfortune of his election. In this contingency I accept the nomination."

The news from Cleveland put wrath into some of Lincoln's friends. The President himself saw a comedy fringe. On the morning after the convention, according to Nicolay and Hay, a friend gave him an account of it, and said that instead of the many thousands expected there were present at no time more than 400 people. The President, struck by the number mentioned, reached for the Bible on his desk, searched a moment, then read the words: "And everyone that was in distress, and everyone that was in debt, and everyone that was discontented, gathered themselves unto

him; and he became a captain over them; and there were with him about four hundred men."

To illustrate Garrison trailing with Lincoln and the other extremist Phillips flying the Frémont kite, there was rehearsal of old lines, of Horace Mann sniffing to Samuel J. May, "I hate your doctrine that we should think only of the right and not at all of the expedient," and Samuel J. May sniffing in return, "And I hate your doctrine that we should think of the expedient, and not only of the right."

In the week of the Cleveland convention the *New York Herald* gave its readers another of the hymns of hate to which the ears of Lincoln had now become accustomed. The *Chicago Times* and other newspapers reprinted the editorial which put its curse on a National Union mass meeting in Cooper Union, New York, "a gathering of ghouls, vultures, hyenas and other feeders upon carrion" authorized by "the great ghoul at Washington," ran the poisoned pen. "In the midst of the terrible conflicts of the past three weeks, while thousands of lives were being sacrificed for the national cause, and while every patriotic man was watching with intense and anxious interest the painful progress of events, these ghouls thought only of Lincoln's renomination, the control of the Baltimore convention and their own chances for petty offices. At the sound of the cannon which was to decide the fate of the country, these ghouls hurried down from the mountains, these vultures flocked from the plains, these hyenas sneaked out of their holes to feast upon the bodies of the slain. There was Clay Smith, the Kentucky ghoul, and Oglesby, the military ghoul, and Arnold, the Congressional ghoul, and Spencer, the legal ghoul. These

were the orators of the meeting, and they all devoted themselves to praising Lincoln, the great Presidential ghoul, and advocating his renomination and reëlection. Their logic was that because Lincoln had killed so many men he ought to be allowed another term to kill as many more. The head ghoul at Washington had not sense enough to forbid the meeting."

Toward its end the motive for the editorial became more evident. Lincoln's re-election was impossible, said the same *New York Herald* which four and five months before had declared nothing could stop him. Now it again saw hopes of Grant. The shadowy and powerful interests to which the *Herald* was responsive had chosen Grant as the best man to run if they could somehow put Grant at the head of a ticket. The editorial was a final shriek of horror meant to have its effect on the Baltimore convention twenty days off. "The people long ago decided that Grant is to be our next President," shouted the *Herald* editorial near its close.

The melodramatic ghoul editorial was one stage effect of a tremendous effort to project Grant into a spot where his name would cut down Lincoln. On June 4, three days before the Baltimore convention was to meet, a mass meeting of 20,000 people in Union Square heard ex-Mayor George Opdyke, Senator Pomeroy, Magnus Gross, Hiram Walbridge, James T. Brady, General T. F. Meagher, and other orators pay tributes to General Grant. The announced and express purpose of the meeting was "to honor General Grant." The inference was that Grant should be nominated at Baltimore instead of Lincoln. Grant's name in the air as the man of the hour, the doer of straightway deeds, might suddenly be plucked for service by the emotional delegates

of the Baltimore convention. Had not Seward in 1860 just before the hour of fate looked nearly as formidable as Lincoln in 1864? Therefore keep Grant's name and deeds where the delegates could never for a moment forget him in case any of them should suddenly be asking who could do better than Lincoln. This was the motive of the New York glory-to-Grant mass meetings and the Lincoln-is-a-ghoul editorials.

Senator Morgan of New York, executive committee chairman of the Baltimore convention, came to his brother-in-law Welles on May 9 with worries. "To-night," wrote Welles, "Governor Morgan informs me that the hall in which the convention is to meet has been hired by the malcontents, through the treachery and connivance of H. Winter Davis, in whom he confided." Morgan and Welles talked about whether to rent a theatre, build a wigwam, or move the convention to Philadelphia. After more worrying Morgan rented the Front Street Theatre in Baltimore, had stage scenery shifted away, floored the parquet, and finally had a place for the convention to sit and deliberate.

As the convention date drew near it was evident that many a radical politician had seen that it would be easier sledding in his home territory if he was for Lincoln. Senator Jim Lane of Kansas, who had once led in taking a committee of Missouri-Kansas radicals to the White House to protest the President's policy, was now on the band wagon, and bringing to Baltimore a set of delegates he said were "all vindictive friends of the President." Congressman William D. Kelley of Pennsylvania was publicly hailing the President as "the wisest radical of us all." In his paper, the *Philadelphia Press*, John W. Forney, clerk of the Senate and a political inform-

ant and adviser of the President, wrote and published an article the day before the convention saying the delegates could not originate but would simply republish a policy already absolutely established by the acts of the President and accepted and ratified by Congress and the people. "Yet for this reason it is transcendently the more imposing in its expression of the national will." The convention had no candidate for President to *choose*. "Choice is forbidden it by the previous action of the people. It is a body which almost beyond parallel is directly responsible to the people, and little more than an instrument of their will. Mr. Lincoln is already renominated, and the Convention will but formally announce the decision of the people. If this absence lessens the mere political interest of the Convention in one respect, the fact that it will thoroughly and unquestionably obey national instructions gives it higher importance."

Of the many who took the road to Washington to win perhaps an inkling of what the President might wish or to let him know their names and faces and that they were for him, Lincoln's secretaries noted: "They were all welcomed with genial and cordial courtesy, but received not the slightest intimation of what would be agreeable to him. The most powerful politicians from New York and Pennsylvania were listened to with no more confidential consideration than the shy and awkward representatives of the rebellious States, who had elected themselves in sutlers' tents and in the shadow of department headquarters."

Baltimore was only two hours by rail from Washington. Delegates, party leaders, and aspirants visited the White House on their way to the convention. Hay wrote in his

diary on June 5 that for a day or two the Executive Mansion was "full of patriots on their way to Baltimore who wish to pay their respects & engrave on the expectant mind of the Tycoon, their images in view of future contingencies." Delegations genuine, bogus, and irregular saw the President. C. Bullitt "with Louisiana in his trousers' pocket," somewhat stampeded by political rumors in New York, was feeling "uneasy in his seat." "Florida was sending two delegations," Hay noted. Then came an odd paragraph in Hay's diary:

"The South Carolina delegation came in yesterday. The Prest says, 'Let them in.' 'They are a swindle,' I said. 'They won't swindle me,' quoth the Tycoon. They filed in: a few sutlers, cotton-dealers, and negroes, presented a petition & retired."

June 7 the Baltimore convention of the National Union party met. June 7 Grant was still burying his dead four days after bloody repulse at Cold Harbor. June 7 the gold-speculators in New York were crazy and wild-eyed over the betting that gold, now higher than ever, would go higher yet. June 7 and potatoes quoted at $160 a bushel in Richmond, cabbageheads $10 apiece.

Yes, on June 7 the convention met. The croaker Adam Gurowski was there and saw "everywhere shoddy, contractors, schemers, pap-journalists," although present were Parson Brownlow of Tennessee and Robert J. Breckinridge of Kentucky and Jim Lane of Kansas and others whose lives in the drive of civil war had often been as candle flame in a wind. Of course the schemers, soiled adventurers who sought what they could lay their hands on, creatures hunting pelf and loot, were there, some of them in high places. Yet

there was also a long roll call of the men who had stood fast when the Union was crumbling and had at personal cost and with toil helped buttress the Union.

To what extent Lincoln had indicated his wishes to the executive chairman, the temporary chairman, the permanent chairman, the platform-committee chairman, who swayed the proceedings, was not known to such intimates of the President as Nicolay and Hay or Noah Brooks. It was assumed that the color of doctrine and idea to dominate the convention would come directly or indirectly from the President.

The executive committee chairman, Senator Morgan, called the convention to order at noon of June 7 in sweltering hot weather, after music from the military band of Fort McHenry, while a brigade of boys passed along the aisles with ice water. Morgan's brief speech warned that the convention would fail of its great mission unless it should declare "for such an amendment of the Constitution as would positively prohibit African slavery in the United States." Morgan then turned the convention over to the Reverend Dr. Robert J. Breckinridge of Kentucky, temporary chairman, while the roof rang with cheers for the "Old War Horse of Kentucky."

At that very moment the Confederate cavalry raider John Morgan was loose in Kentucky, that week seizing $60,000 from the Farmer's Bank of Mount Sterling, and at Lexington taking all the hats, shoes, saddles, horses, in the town, including the famous stallion Skedaddle, valued at $8,000. Delegates knew they were gazing on an old man who had a nephew and two sons serving as officers in the Confederate

Army. He spoke with "a weak voice and an irresolute manner," according to one reporter, while another heard low melodious tones with "every word dropping from his lips like a coin of gold—clear-cut, bright and beautiful."

A whirlwind of applause shook rafters and beams at a sentence of Breckinridge: "Does any man doubt . . . that Abraham Lincoln shall be the nominee?" But other solemn duties lay ahead. They would have to tell the country why they were fighting the war. They would have to beware of party politics and sink all for the Union. "As a Union party, I will follow you to the ends of the earth, and to the gates of death. [Applause.] But as an Abolition party—as a Republican party—as a Whig party—as a Democratic party—as an American party, I will not follow you one foot."

Breckinridge made reference to the bones of two generations of his ancestors in his home State that he loved, of his children there, buried where his own bones would soon lie, and of how some would hate him for what he was saying. Lifting his long arms over his head, he rang the slow words "We have put our faces toward the way in which we intend to go, and we will go in it to the end."

After prayer, Thad Stevens took the floor and objected to the admission of delegates from States "in secession." He had no doubt "excellent men . . . from such States" were present, but protested against any "recognition of the right of States which now belong to the Southern Confederacy to be represented here, and, of course, to be represented in the Electoral College."

Then arose Horace Maynard of Tennessee, tall and spare, his long black hair, high brow, and strong straight nose hav-

ing brought him the nickname of "The Narragansett Indian." Maynard's high-pitched voice measured out sentences, punctuated by gestures with a forearm and a quivering index finger; he carried to every seat in the theatre. His eyes grew wet with tears and many in the audience sobbed aloud as he pictured the conditions of his people and faltered at voicing their desolation. "For you that drink in the cool breezes of the Northern air, it is easy to rally to the flag. . . . But we represent those who have stood in the very furnace of the rebellion, those who have met treason eye to eye, and face to face, and fought from the beginning for the support of the flag and the honor of our country. [Great applause.]" Outnumbered and often outlawed, they had seen their sons conscripted in the Confederate Army, their property confiscated, homes burned, brutal guerrilla raids, imprisonment and execution of leaders, and all the woe of a land where contending armies sweep back and forth. A storm of applause swept the main floor and galleries when Maynard finished. He had said to begin with that he was speaking not so much for the political rights of his delegation as of the heroic suffering, loyalty, and patriotism of the hundreds of thousands of Unionists in the South.

At the evening session the speech of the permanent chairman of the convention, ex-Governor William Dennison of Ohio, was "drab and meaningless," according to one reporter, and if you believe others it was "brief and eloquent." He too alluded to the forthcoming unanimous nomination for the Presidency of the United States, certain it would go to "the wise and good man whose unselfish devotion to the country, in the administration of the Government has se-

cured to him not only the admiration, but the warmest affec-
tion of every friend of constitutional liberty. [Applause.]"

The lean and stubborn Parson Brownlow of Tennessee,
just out of a sickbed, was given the floor near adjournment,
after the appointment of organizational committees. So "rash
an act" as excluding the Tennessee delegation would be a
recognition of secession, he warned, with thrusts that won
him the crowd. "We don't recognize it in Tennessee.
[Applause.] We deny that we are out. [Applause.] We
deny that we have been out. [Applause.] . . . We may
take it into our heads, before the thing is over, to present
a candidate from that State in rebellion for the second
office in the gift of the people." This first reference to
Governor Andrew Johnson of Tennessee as a possible vice-
presidential candidate brought applause from the galleries.
"We have a man down there," continued Brownlow, "whom
it has been my good luck and bad fortune to fight untiringly
and perseveringly for the last twenty-five years—Andrew
Johnson. [Applause.] For the first time, in the Providence
of God, three years ago we got together on the same plat-
form, and we are fighting the devil, Tom Walker and Jeff
Davis side by side. [Applause.]"

The next morning the Credentials Committee reported its
majority recommendation that the "Radical Union" delega-
tion from Missouri be seated. The convention then voted
440 to 4 in favor of seating the Missouri radicals. The vote
meant that a convention overwhelmingly committed to Lin-
coln was giving seats to a set of delegates who had obstructed
and harassed Lincoln the year before to the point where he
said he was "tormented" by them. They were the fellows of

whom he had remarked to Hay they were "the unhandiest devils in the world to deal with" though after all "their faces are set Zionwards." They were welcomed into the convention almost unanimously, while the Blair pro-Lincoln delegates from Missouri were frozen out.

What of the delegations from Virginia, Tennessee, Louisiana, Florida, Arkansas? The majority report of the Credentials Committee said they should have seats in the convention without the right to vote. What would the convention do about the report? The convention might indicate where it stood on the issue between Lincoln on the one hand and Sumner and Stevens on the other, Lincoln holding that no State could secede and therefore none had seceded, while Sumner and Stevens held that in seceding each State had committed suicide and would again have to be admitted to the Union in order to be a State. Of course the issue was not clear-cut, because of the fact that some of the delegations came from States where a process of reconstruction had begun and the Union Government had re-established a hazy twilight authority. For the delegates from these States an argument could be made.

By a series of roll calls the convention sifted what delegates it wanted. Only the delegates from South Carolina were thrown out entirely. The Virginia and Florida delegations were admitted to seats with no right to vote. Arkansas and Louisiana were given seats and the right to vote. By 310 to 151 the convention gave Tennessee delegates seats with the right to vote, this being welcome to the boomers of Andrew Johnson for Vice-President.

The Platform Committee offered its report through its

chairman, Henry J. Raymond, a confidant of Lincoln, editor
of the *New York Times*, the one Manhattan newspaper then
unfailing in co-operation with Lincoln. The platform re-
solved in favor of the war, the Union, the Constitution;
pledged itself to everything possible to quell the then raging
rebellion; no compromise with rebels; a deathblow at the
gigantic evil of slavery through a constitutional prohibition
of it; thanks and everlasting gratitude to the soldiers and
sailors of the Union cause and promise of "ample and per-
manent provision for those of their survivors who have re-
ceived disabling and honorable wounds in the service of the
country"; approval and applause of "the practical wisdom,
the unselfish patriotism and unswerving fidelity to the Con-
stitution and the principles of American liberty, with which
Abraham Lincoln has discharged, under circumstances of
unparalleled difficulty, the great duties and responsibilities of
the Presidential office," and full confidence in his future
determinations; justice and protection to all men employed
in the Union armies "without regard to distinction of color";
liberal and just encouragement of foreign immigration to
"this nation, the asylum of the oppressed of all nations";
speedy construction of the railroad to the Pacific Coast; in-
violate redemption of the public debt, economy and respon-
sibility in public expenditures, vigorous and just taxation.

The radical mood was seen in a pledge of the first plank
for "bringing to the punishment due to their crimes the
Rebels and traitors arrayed against" the Government. Lin-
coln had often let it be known that he favored the killing of
rebels until the rebellion was put down. Beyond that he was
completely reserved. The platform indicated criminal trials

and hanging of Confederate leaders if the North won the war. This part of the platform Lincoln would have revised or deleted.

The roll call on a nominee for President began. Maine announced 16 votes for Lincoln. New Hampshire, coming next, tried a little speechmaking but was choked off with cries of "No speeches!" From then on each State announced its vote without oratory. One by one the undivided delegations threw in their ballots for Lincoln. Only one snag broke the smooth and orderly unanimity. The Missouri delegation, its chairman John F. Hume announced, was under positive instructions to cast its 22 votes for Ulysses S. Grant; he and his associates would support any nominee of the convention, but they must obey orders from home. "This caused a sensation," wrote Noah Brooks, "and growls of disapproval arose from all parts of the convention." Before the result of the balloting was announced Hume of Missouri moved that the nomination of Lincoln be declared unanimous. This under the rules could not be done until the secretary read the results: 484 votes for Lincoln, 22 for Grant.

Missouri then changed its vote, and the secretary gave the grand total of 506 for Lincoln. A storm of cheers was let loose, lasting many minutes, dying down and then flaring up again.

The hilarity over, they settled down to nominating a candidate for Vice-President. Cameron presented, under instructions of his State of Pennsylvania, he said, the name of Hannibal Hamlin. A New York delegate "in behalf of a portion" of his delegation proposed Daniel S. Dickinson of New York. Indiana, under instructions of its State conven-

tion, offered the name of Governor Andrew Johnson of
Tennessee. Horace Maynard seconded this, saying Johnson
"in the furnace of treason" would stand by the convention's
declarations "as long as his reason remains unimpaired, and
as long as breath is given him by his God."

The convention secretary announced the result of the first
and only ballot: Johnson 494, Dickinson 27, Hamlin 9.

What had happened? Practically all the political fore-
casters, friendly and hostile, had taken it as a matter of
course that Hamlin would be renominated, that the 1860
ticket would be named again. Who had brought this change
with results that looked as though a spontaneous upheaval
had dictated Johnson as Lincoln's running mate? To what
extent had Lincoln's hand moved to pick Johnson for a run-
ning mate?

To these questions came many answers. Political experts
and official insiders couldn't agree on what had happened.
Indications were that Lincoln and Seward, as well as they
liked Hamlin and his good record, saw the need for a stanch
Union man from a seceded State, already well dramatized
before the country in his acts as Governor of Tennessee, on
the National Union party ticket through a momentous cam-
paign. They had steered a delicate course that in the end led
the convention to see the political wisdom of taking Johnson
over any other candidate. Supporting neither Lincoln nor
Douglas but Breckinridge in 1860, Johnson had turned and
fought tooth and nail against secession and as United States
Senator from Tennessee cried on March 2 of '61 that any
man firing on the American flag was a traitor, and "If I were
President of the United States, I would have all such arrested,

and when tried and convicted, by the Eternal God, I would hang them." More than once he had brought out his loaded revolver facing crowds ready to lynch him.

With never a day of regular school in his life, it was said, Johnson had learned to read while sitting cross-legged at his trade of tailor in Greenville. Marrying the sixteen-year-old Eliza McCardle in 1827 turned out to be one of the blessings of his life; she was comely, knew more of books and reading than he did and was a helper as he moved up. Sometimes he overdid his role of a commoner. And again he could wear democracy as a natural garment, to Jefferson Davis's question, "What do you mean by the laboring classes?" replying, "Those who earn their bread by the sweat of their face and not by fatiguing their ingenuity." On coming to Washington his daughter Martha said, "We are plain people from the mountains. I trust too much will not be expected of us."

Of medium height, a little swarthy of skin, well formed with fine shoulders and a deep chest, Johnson carried a massive head and his deep-set and darkly piercing eyes looked at men without fear, seemed to be afraid of nothing. He wore clean linen, was near dainty about his collar and shirt front, had small hands and feet—and scorned "high society." No personal scandal trailed his name at Baltimore. In the poverty and obscurity of his early days he was compared to Lincoln. In the choice of him by the convention was a touch of the unreal, of a guess in twilight and prayers such as fishermen say when violence of wind and water lash a boat and the steersman can only hope.

The *New York World* spoke for several wealthy and respectable Democrats on June 9: "The age of statesmen is

gone, the age of rail-splitters and tailors, of buffoons, boors and fanatics, has succeeded. . . . In a crisis of the most appalling magnitude, the country is asked to consider the claims of two ignorant, boorish, third-rate backwoods lawyers, for the highest stations in the government. . . . God save the Republic!" The *Troy Times* spoke otherwise: "If Mr. Lincoln has fallen into errors and made mistakes—if he has done some things that he ought not to have done, and left undone some things that he ought to have done, who that was ever called upon to do so much has erred so little?"

Wendell Phillips as an abolitionist favoring Frémont saw the Baltimore convention as "largely a mob of speculators and contractors," hoped the country would see "disaster" in Mr. Lincoln's re-election, hoped voters would not "keep the present turtle at the head of the Government." William Lloyd Garrison, Harriet Beecher Stowe, Theodore Tilton, and other abolitionists, however, termed Lincoln "satisfactory."

To a Union League committee the President said he could not take the nomination as a personal compliment. "I have not permitted myself, gentlemen, to conclude that I am the best man in the country, but I am reminded in this connection of a story of an old Dutch farmer who remarked to a companion once that 'it was not best to swap horses when crossing a stream.'"

DARK SUMMER OF '64

IN July of '64 Confederate sharpshooters in battle aimed their rifles at the President of the United States and sent cold lead bullets whining and snarling around their target. This was in the first battle fought on District of Columbia soil with the Capitol dome and its Goddess of Liberty looking on.

Once more General Robert E. Lee played a bold defensive game and struck fear into the heart of the Union cause. He gave Jubal A. Early and John C. Breckinridge an army of 20,000 men. Sheltered by the Blue Ridge Mountains, they marched up the Shenandoah Valley, slipped through a pass, headed for Washington, and only by a nod of fate as whimsical as a throw of dice John C. Breckinridge failed to reach the White House.

Early's men had legs and grit, could march thirty miles a day, and in their stride toward Washington their commander collected $20,000 cash at Hagerstown and from Frederick City, Maryland, which he threatened to lay in ashes, came $200,000 more. The foot soldiers tore up twenty-four miles of Baltimore & Ohio Railroad tracks, wrecked and burned mills, workshops, factories, while Early's horsemen got as far as the environs of Baltimore and burned the home of Governor Bradford of Maryland. Turning their horses toward Washington, they reached Silver Spring and in sight of the

Capitol dome seized private papers, valuables, whisky, in the home of Postmaster General Blair and then set the house afire.

"Baltimore is in great peril," telegraphed a mayor's committee to President Lincoln, asking for troops. From Philadelphia arrived a telegram that some "assuring announcement" must come from Washington to quiet the public mind. A Confederate army of 75,000 to 100,000 under Lee himself was again footloose and aiming for a stranglehold on Washington, ran another telegram that tumbled into Washington. To the Baltimore mayor's committee Lincoln wired: "I have not a single soldier but whom is being disposed by the military for the best protection of all. By latest accounts the enemy is moving on Washington. They cannot fly to either place. Let us be vigilant, but keep cool. I hope neither Baltimore nor Washington will be sacked."

Wallace had marched troops out to Monocacy, fought a battle, and, heavily outnumbered, was routed. His defeat delayed Early's army one day. That one day, it was generally admitted, saved Washington from the disgrace of capture. At Point Lookout near by were 17,000 Confederate prisoners whom Lee hoped Early would free and arm. But Early didn't find time. Every hour counted. His objective, as he later told of it, was practically the same as reported by a Union prisoner who escaped from Early's men and informed the War Department, "They claimed the object of their raid was to get horses and provisions, that they did not expect to take Washington and hold it, but thought they could raid through the city and capture the President, if there, and draw Grant's forces from Petersburg."

Raw troops and soldiers just out of hospital made up the

20,000 men scraped together for manning the forts around Washington against Early, who had cut all wires north and July 11 marched his men on the Seventh Street Road that would lead him straight to the offices, the arsenals, the gold and silver, of the United States Government. Early halted his men just a little over two miles from the Soldiers' Home, where Lincoln the night before had gone to bed when a squad from the War Department arrived with word from Stanton that he must get back into the city in a hurry. The President put on his clothes and rode to the Executive Mansion.

The next day would decide whether a Confederate flag was for once to be run up over the Capitol dome. The next day the President looked from the south windows of the White House and saw through a glass transport steamers at Alexandria coming to unload two magnificent divisions of veteran troops fresh from Grant at City Point.

Out on the Seventh Street Road the same day Jubal Early sat his horse and looked at Fort Stevens (later Stephens), which blocked his path. The fort was "feebly manned," as he saw it. And he was correct. But while he was still gazing, and while the attack he had ordered was getting under way, his eye caught a column of men in blue filing into the works. The fort guns began speaking. A line of skirmishers strung out in front. On one of the parapets Lincoln was a watcher and saw the first shots traded. He was too tall a target, said officers who insisted till the President put himself below the danger line.

Early stopped his attack, sent his cavalry to hunt another door into the city. That night while Early held a council

of war just north of Washington, more newly arrived troops
at the south stepped off transports and tramped through the
streets with a certainty that the Capitol dome the next day
would be saved from a Confederate flag over it. The sun was
throwing long slants of gold over that dome the next morn-
ing as Jubal Early looked at it and wondered what this day
of July 12 would bring.

No mail, no telegrams, arrived from the outer world that
day of July 12 in Washington.

From where Lincoln stood on a Fort Stevens rampart that
afternoon he could see the swaying skirmish lines and later
the marching brigade of General Daniel Davidson Bidwell, a
police justice from Buffalo, New York, who had enlisted in
'61 as a private, was a colonel through the Seven Days and
Malvern Hill, and with his men had heard the bullets sing
from Antietam through Gettysburg and the Wilderness. Out
across parched fields, dust, and a haze of summer heat
marched Bidwell's men in perfect order, to drive the enemy
from a house and orchard near the Silver Spring Road. Up a
rise of ground in the face of a withering fire they moved and
took their point and pushed the enemy pickets back for a
mile. The cost was 280 men killed and wounded.

For the first time in his life Abraham Lincoln saw men in
battle action go to their knees and sprawl on the earth with
cold lead in their vitals, with holes plowed by metal through
their heads. Before this day he had seen them marching away
cheering and laughing, and he had seen them return in ambu-
lances, and had met them on crutches and in slings and casts,
and in hospitals he had held their hands and talked with them.

Now for the first time he saw them as the rain of enemy rifle shots picked them off.

While he stood watching this bloody drama a bullet whizzed five feet from him, was deflected, and struck Surgeon Crawford of the 102d Pennsylvania in the ankle. While he yet stood there within three feet of the President an officer fell with a death wound.

In officially reporting the afternoon's losses at 300, Halleck wrote that "a few men in the trenches were picked off by rebel sharpshooters." The fire of those who came near picking off Lincoln was at long range, it would seem from the report of a chief of staff who suggested to Major General Augur, in command, the driving away of "a thin line of the enemy (not more than 500), who occupy a crest and house near our line and 1,100 yards only from Fort Stevens," the special object being "to put them out of a large house occupied by sharpshooters." So it was probable the men 1,100 yards away were shooting that day at a man, any man on a rampart or in a trench who made a good target, though they would concede that a man six feet four in height was a shade the easier to draw a bead on. Twice they nearly got the tall man. "Amid the whizzing bullets," wrote Nicolay and Hay, the President held to his place "with . . . grave and passive countenance," till finally "General Wright peremptorily represented to him the needless risk he was running."

Another onlooker that day, facing Lincoln from a mile away, was the man whom the South in 1860 voted for overwhelmingly as its choice for President of the United States, the Kentuckian who hoped to pay a promised call at the Executive Mansion, General John C. Breckinridge.

In his diary Welles wrote of riding out in the afternoon to Fort Stevens, of Senator Wade coming up beside him, the two of them entering the fort. "As we came out of the fort," wrote Welles, "four or five of the wounded men were carried by on stretchers. It was nearly dark as we left. Driving . . . out, we passed fields as well as roads full of soldiers, horses, teams, mules. Camp-fires lighted up the woods . . . stragglers by the wayside were many. Some were doubtless sick, some were drunk, some weary and exhausted. Then men on horseback, on mules, in wagons as well as on foot, batteries of artillery, caissons, an innumerable throng. It was exciting and wild. Much of life and much of sadness."

Official records of the only battle of the war where Lincoln was an eyewitness and a target gave the Union losses at 380 killed and 319 wounded.

The next morning Early's army was gone. Again on July 14 Washington had mail and telegrams. Somewhere toward the Shenandoah Valley marched Early's army with its plunder-laden wagons, audacity on its banners, money in its strongboxes, shoes on feet that had started north barefoot.

An incidental adventure of the Early raid was the ride of McCausland's gray cavalry up into Chambersburg, Pennsylvania, where a demand was presented for payment of $100,000 in gold or $500,000 in greenbacks. The citizens said they couldn't scrape together any such amount of money. An officer drew from his pocket a paper and read to the citizens a written order from General Early that on refusal of payment of the money demanded the Confederate troops should burn the town "in retaliation for the depredations committed by General Hunter." The courthouse, town hall, banks, and

stores were first set blazing. Then a turpentine supply in a
drugstore was used to soak cotton balls which riders lighted
and threw into shops and houses. Women and children took
to the woods and fields, to near-by farms, where they watched
nearly two-thirds of Chambersburg go up in smoke. Three
hours later Union cavalry reached the town and began
pursuit of McCausland, somewhat crippling his force in
skirmishes. "The affair," commented Early later, "had a very
damaging effect upon my cavalry for the rest of the cam-
paign."

Early got away for the same reason that he arrived. "No-
body stopped him."

And why? The answer would require a diagram of the
overlapping authorities and departments; of many physical
and psychic factors, of slackness, fears, jealousies, rivalries;
of Dana, the Assistant Secretary of War, telegraphing Grant
on the night of July 12 when Early was leaving Washington
by a night march: "General Halleck will not give orders
except as he receives them; the President will give none, and
until you direct positively and explicitly what is to be done,
everything will go on in the deplorable and fatal way in
which it has gone on for the past week." Nicolay and Hay
recorded: "Everybody was eager for the pursuit [of Early]
to begin; but Grant was too far away to give the necessary
orders; the President, true to the position he had taken when
Grant was made general-in-chief, would not interfere, though
he observed with anguish the undisturbed retreat of Early."
Halleck assumed that he was in fact, as he ranked, a chief
of staff and not a commander from whom strategy was
required.

On July 25 Grant sent a dynamic constructive proposal in a letter to President Lincoln on "the necessity of having the four departments of the Susquehanna, the Middle, West Virginia, and Washington under one head." He had made this proposal before and the War Department had rejected it. Now he was urging it again. And again he was naming General William B. Franklin, clearly one of the cleaner and abler major generals of distinguished field service, "as a suitable person to command the whole."

Two days after Lincoln received this proposal from Grant, the Secretary of War notified not General Franklin, but Halleck, that "the President directs me to instruct you that all the military operations" of the four departments and all the forces in those departments "are placed under your general command."

Why the President did this and whether he did it as peremptorily as Stanton's order indicated, the record did not show. It seemed to be the first time that Grant had asked for something definitely important that rested on Lincoln's Yes and Lincoln said No. It seemed that Grant wanted Franklin, or some other proven field general, at the head of the defense of Washington, while Stanton wanted the desk strategist, Halleck, elevated from staff chief to commander. And as between Stanton and Grant the President was saying Yes to Stanton and No to Grant. On the face of the matter Lincoln was going back on Grant and taking a stand with the established political bureaucrats who muddled instead of performing. Stanton's order accommodating Grant by joining four departments into one, and then giving Grant the last man

Grant would have picked to head the new four-in-one department, was dated July 27.

And on that day Grant took to drink. Had Rawlins been there, Rawlins would have cursed him and put up arguments and returned to cursing and Grant would have stayed sober.

The death of McPherson may have had something to do with Grant's drinking on July 27. Five days before Major General James B. McPherson, bronzed, tall, tireless, in boots and gauntlets on a beautiful black horse, had ridden away from a talk with Sherman to examine the cause of a new roaring note in the firing on the left of their army near Atlanta. McPherson was only thirty-five years old, with a future of hope ahead of him and a sweetheart dated to marry him when Atlanta should be taken. And McPherson's black horse had come racing back with saddle empty and later they had found McPherson with a bullet near his heart—a soldier so rare that Grant had him in mind to take Sherman's place if anything happened to Sherman, a friend and comrade so rare that Sherman at the news paced back and forth in a headquarters room barking orders, barking his grief, tears running down his cheeks into the red beard and off on the floor. Grant too at the news had wet eyes, and his voice broke in saying, "The country has lost one of its best soldiers, and I have lost my best friend."

On the heels of this tragic personal loss came the first refusal Grant had received from Lincoln. The Washington miasma of politics, intrigue, and crossed authorities of which Sherman warned him had come home to Grant.

In the cross play of hates, guesses were made as to whether some of the Federal Government servants hated each other

any less than they hated the enemy they were at war with. A peculiar mental attitude or a hoodoo spell pervaded much of Washington. Lincoln and Grant were aware of it. Grant on August 1 acted to evade it. Lincoln approved the action. Grant notified Halleck that he was sending Sheridan to "expel the enemy from the border." Sheridan's record and status, his complete aloofness from the desk strategists of Washington, were such that there was nothing they could do about it. They could officially harass him and they could look on skeptically at what he was attempting and they would change their minds about him if and when he did what was expected. Lincoln lighted up and August 3 sent to Grant a telegram momentous in its confession of a spirit that held powerful sway, reading:

"I have seen your despatch in which you say, 'I want Sheridan put in command of all the troops in the field, with instructions to put himself south of the enemy, and follow him to the death. Wherever the enemy goes, let our troops go also.' This, I think, is exactly right as to how our forces should move; but please look over the despatches you may have received from here, ever since you made that order, and discover, if you can, that there is any idea in the head of anyone here of 'putting our army south of the enemy,' or of following him to the 'death,' in any direction. I repeat to you, it will neither be done nor attempted, unless you watch it every day and hour, and force it."

Sheridan arrived in Washington the day after Lincoln sent Grant this dispatch and the next day was ordered to report to General Grant at Monocacy Junction. So important did Grant consider the work of clearing the Shenandoah Valley

that he had left the Army of the Potomac south of Richmond
and journeyed to the north of Washington without paying
a call at the War Department or the White House in Wash-
ington. Grant had found General Hunter's army at Monocacy.
"I asked the general where the enemy was," wrote Grant
later. "He replied that he did not know. He said the fact was,
that he was so embarrassed with orders from Washington
moving him first to the right and then to the left that he had
lost all trace of the enemy." When Grant suggested that
Hunter could have his headquarters at Baltimore or Cumber-
land while Sheridan took charge of the troops in the field,
General David Hunter said he thought he had better be re-
lieved entirely. "He said," Grant noted, "that General Halleck
seemed so much to distrust his fitness for the position he was
in that he thought somebody else ought to be there. He did
not want, in any way, to embarrass the cause; thus showing
a patriotism none too common in the army. . . . Not many
major-generals . . . would voluntarily have asked to have
the command of a department taken from them on the sup-
position that for some particular reason, or for any reason,
the service would be better performed. I told him, 'very well
then,' and telegraphed at once for Sheridan."

On Sherman's hearing of Sheridan's new assignment he
wrote to Grant, "I am glad you have given General Sheridan
the command of the forces to defend Washington. He will
worry Early to death."

Weeks were to pass with Sheridan on trial, with Sherman
on trial, one in the Shenandoah, the other in Georgia, two
commanders not yet proved as Grant had been proved, both
of them held by Grant as unbeatable. And the delays and

failure of immediate victory were blamed, by those in black moods for blaming that summer, chiefly on President Lincoln, who upheld all three and never let up on his efforts to meet their requirements.

In the war chronicle of the summer of '64, with its plodding in blood and muck, were two bright spots for the Union cause. On a Sunday morning in June, outside the international line off the coast of France at Cherbourg, two ships met and battled, in view of thousands of spectators on the French shore five miles away and other gazers on boats that had come out to be near the fight. In length, beam, guns, and men, the equipment of the fighting ships was about equal, though the one flying the Union flag had 400 horse power against 300 of its opponent. The one flying the Confederate flag had cruised thousands of miles in the South Atlantic and Indian oceans since August of '63, had captured 62 merchantmen, and burned most of them at sea. She was the hated and feared *Alabama*, her commander, Raphael Semmes. She was British-built, her seamen and gunners mainly British.

The *Kearsarge* had long trailed the *Alabama* and at last penned her in Cherbourg Harbor. Now the *Alabama* must fight for her freedom of the seas. Ninety minutes the two ships circled, shifted, blazed at each other. Three hundred and seventy shells from the *Alabama* left the *Kearsarge* practically undamaged, with only the loss of a smokestack, while nearly every one of the 173 projectiles from the *Kearsarge* found its target and tore the sides of the *Alabama* open till she began sinking. Forty were killed on the *Alabama* under

the Confederate flag; on the *Kearsarge* the losses were three men wounded, of whom one died.

As the immemorial waters of the ancient sea took to their bosom the vanished *Alabama*, the only formidable dread that had haunted United States merchantmen on the seven seas was gone.

Then in August the Confederacy lost its most essential port on the Gulf of Mexico. Lashed to a flagship mast and leading his fleet into Mobile Bay, Admiral Farragut saw one of his ships wavering, shouted through his trumpet, "What is the trouble?"

"Torpedoes."

"Damn the torpedoes! Captain Drayton, go ahead! Jouett, full speed!"

One of the monitors sank with crew and commander. Ahead were torpedoes. Behind was retreat. "O God," prayed Farragut, "who created man and gave him reason, direct me what to do. Shall I go on?"

His order, "Damn the torpedoes! Full speed ahead!" became a Unionist slogan. His fleet captured the ram *Tennessee*, rated one of the most powerful vessels of war afloat on any waters, and with land forces reduced the three forts guarding Mobile. Lincoln termed it a "brilliant achievement."

Lincoln with Grant believed a stranglehold was being put on the South. But a large number of people, some of them highly vocal in this August of '64, did not so believe or were not particularly interested in believing in anything connected with continuance of the war.

SHERMAN AND SHERIDAN

WITH the Armies of the Cumberland, Tennessee, and Ohio joined into a force of 99,000 Sherman had begun his campaign from Chattanooga aimed at the capture of Atlanta. Between him and Atlanta was the Confederate army of 41,000, soon reinforced to 62,000, commanded by the master strategist General Joseph E. Johnston. Carrying scars of wounds from Florida Indian wars, from wounds in the Mexican War, from wounds at Seven Pines in the Peninsular campaign near Richmond, a West Pointer, a clean sportsman of a fighter—little Joe Johnston, familiar with the red hills of Georgia, seemed the one marshal in gray best able to stop or delay Sherman. He led Sherman on. He fought and faded and waited. At Dalton, past Buzzard's Roost, through Snake Creek Gap, back to Resaca and Cassville, across the Etowah, through Allatoona Pass, and after clashes at New Hope Church, not until Kenesaw Mountain did Johnston in his slowly maneuvered retreat lure Sherman into a frontal attack.

The two armies were twenty-five miles from Atlanta and Sherman piled in his men on the fortified lines of Johnston hoping to break through and win victory and Atlanta. Sherman lost 3,000 as against the Confederate's 800.

Johnston persisted in waiting, fading, waiting. He had several hopes. One was that Sherman would be led so far south that his food and munitions line running hundreds of miles

toward the north would in its requirements draw off more and more men from Sherman's army, bringing it down to a size where Johnston would have better hope in combat with it. Johnston hoped also for some misplay on the part of the younger and perhaps rasher Sherman. With his admirable management, his care and saving of resources, in two months of skirmishes and minor brushes without a decisive battle the Union losses were 16,800 as against the Confederate 14,500.

Davis and Bragg at Richmond wanted more decisive action. Johnston on July 17 was replaced by General John B. Hood, who, they knew, would not wait and fade and hope. In eleven days Hood fought and lost three battles at a cost of 10,841 men to Sherman's 9,719. Sherman had at last reached the Atlanta area. But would he take Atlanta? This was the question over the North and the South during the hot weeks of August. The North hoped. And the North despaired. Why did it take so long? Why had the whole war gone on so long?

Sherman would no more take Atlanta than Grant would take Richmond, the incessant critics said. Even Grant came under a shadow early in August as the reports came through of the battle in the Crater. An enormous dynamite mine was sprung at Petersburg, hoisting some two hundred Confederate troops into the air and burying some of them alive, demolishing Confederate trenches, and leaving a huge crater into which Union troops marched. The Confederates in a quick recovery soon had artillery at the crater's edge playing on a disordered, helpless mass of Union troops. "The effort was a stupendous failure," was Grant's later comment. "It cost us about four thousand men, mostly, however, captured; and all due to inefficiency on the part of the corps commander and

the incompetency of the division commander who was sent to lead the assault."

Then fate stepped in. Like a moving hour hand on a clock of doom came news flung world-wide, news setting crowds of Northern loyalists to dancing with mirth and howling with glee, news centering about one little dispatch wired to Washington by Sherman September 3: "So Atlanta is ours and fairly won."

The dull ache of defeat and failure that had stirred in many Northern hearts took a change. A strategic crossroads, supply depot, and transportation center of a pivotal Cotton State in the Deep South was gone. Vicksburg, New Orleans, and the Mississippi River gone, Kentucky, Tennessee, and Nashville gone, Mobile gone. Lee and his army penned between Grant and Richmond for how long? As Union men of the North looked at the picture it had more hope. Because Atlanta was "ours and fairly won," the picture had changed. Bells rang again, guns boomed in salute. Grant wired Sherman he was ordering "every battery bearing on the enemy" to release shot and shell.

Now in this month of September Phil Sheridan was heard from. Since August 7, when he took command of the Army of the Shenandoah, Sheridan had not won the results predicted for Grant's thirty-three-year-old tryout against the veteran Early, whose men had in July marched into sight of the Washington Capitol dome. The press already complained that Sheridan was not heard from. Halleck had been telegraphing Grant that if Sheridan was not strong enough to break Early's hold on railroads hauling coal to Washington,

Sheridan should be reinforced, for fuel supplies in Washington and Baltimore were running low.

Yet Sheridan had not been idle in moving his army from Frederick, Maryland, by way of Slabtown and Buckystown on down to Cedar Creek and into camp at Charlestown, where five years before Old John Brown was hanged after prophesying that many more lives than his would be spent before slavery vanished. "I think I can manage this affair," Sheridan said in one telegram to Halleck. "I have thought it best to be very prudent everything considered." And to Grant: "Mosby has annoyed me and captured a few wagons. We hung one and shot six of his men yesterday. I have burned all wheat and hay, and brought off all stock, sheep, cattle, horses, &c., south of Winchester."

For the first time in the war the Shenandoah Valley saw a destroyer with a system. Whatever would nourish man or provide fodder for beast was to be taken or burned or spoiled. When Grant's order should be met, then a crow would have to carry its own rations flying over the valley. At Harrisonburg from Gibbs Hill residents counted twenty barns in the same hour lighting the dark night of the valley as the flames roared upward and later sunk sputtering.

After four days' fighting at Winchester and Fisher's Hill Sheridan's telegram to Grant the night of September 19 hummed on the wires and had first place in all news sheets of the country: "I attacked the forces of General Early . . . and after a most stubborn and sanguinary engagement, which lasted from early in the morning until five o'clock in the evening, completely defeated him, and driving him through Winchester, captured about 2,500 prisoners, 5 pieces of artil-

lery, 9 army flags, and most of their wounded." Two days later, on September 22, Sheridan telegraphed Grant: "I achieved a most signal victory over the army of General Early at Fisher's Hill today . . . only darkness has saved the whole of Early's army from total destruction. My attack could not be made until four o'clock in the evening, which left but little daylight to operate in. . . . The victory was very complete."

There was a note here that the North had not heard before from the Shenandoah Valley. The tone ran as though the war was on and would yet be over. "We have just sent them whirling through Winchester and we are after them tomorrow," was a Sheridan sentence picked from one of his telegrams to Grant and passed along on street and farm in the North. The combined losses in the two battles had been: Union 749 killed, 4,440 wounded, 357 missing; Confederate 250 killed, 1,777 wounded, 2,813 captured. Valor enough there had been on both sides, with the result that a Confederate army of proved fiber had been routed. Lincoln appointed Sheridan a brigadier general in the regular army and placed him in permanent command of the Middle Division.

Down the Shenandoah went the destroyer, 6,000 head of cattle and 500 horses being taken by one cavalry body, not less than 3,000 sheep killed and issued to his army. One telegram to Grant served notice that Sheridan had "destroyed over two thousand barns filled with wheat, hay and farming implements," over seventy mills "filled with wheat and flour." In Rockingham County a committee appointed by the county court later estimated $25,000,000 worth of property had been destroyed by Sheridan's troops, itemizing 50,000 bushels of

corn, 100,000 bushels of wheat, 450 barns, 1 furnace, 3 factories, 30 dwelling houses, 31 mills, besides livestock. Grant's order had aimed at desolating the Shenandoah Valley this year and the next. "Carry off stock of all descriptions, and negroes, so as to prevent further planting. If the war is to last another year we want the Shenandoah Valley to remain a barren waste." From the Blue Ridge to North Mountain, Sheridan wrote to Grant to show the order was being strictly followed, the country had been "made untenable for a rebel army." Now indeed the crows could eat—if they brought their own rations.

Gloomy August became a September edged with a few splinters of dawn.

Again Sheridan, his men, his horses, were heard from. Below the northern end of Massanutton Mountain, Virginia, over which it was supposed no troops could cross, his men encamped at Cedar Creek. Sheridan left his army, arrived at Washington October 17 for a few hours of conference with Stanton and Halleck. Leaving Washington the afternoon of October 17, he arrived at Martinsburg, an easy journey, and stayed there overnight. On October 18 he could easily have rejoined his army, but he paused at Winchester and stayed overnight. Why Sheridan traveled so slowly on these two days and what transactions or pleasure might have delayed him became nobody's business in the light of what happened on the nineteenth.

A few nights before, Early's officers on the headland of Massanutton Mountain had looked down through field glasses on Sheridan's sleeping army, its campfires and pickets. Now on the morning of October 19, clear, cold and still, before

daybreak in the light of a waning moon, Early and his forces
marched over trails near the river, skirting the base of the
mountain. The moon waned and faded and dawn arrived and
a slow fog began sliding into the valley.

While Sheridan slept at Winchester fourteen miles away,
Early surprised and smashed the first lines of the left flank of

Cedar Creek, where the armies of Sheridan and Early clashed

the Union army at Cedar Creek, tore through the second
lines, and in an irresistible sweep of fighting sent Sheridan's
forces reeling and routed up the valley, up toward where
Sheridan slept, their hurried retreat covered by the 6th Corps
under General Horatio Wright.

The five-o'clock fog held through six, seven, and eight
o'clock. In that fog the broken Union columns were saying
they had lost a battle. In that same fog the Confederates were
saying at last they had won—and they lingered. They might
in those hours have clinched a victory. Why some of them

rested on their arms and waited, why others looted the Union camps and stores, became afterward a matter of dispute. In the fog destiny was kind to Sheridan while he slept at Winchester fourteen miles away.

At six o'clock an officer knocked on Sheridan's door. "I hear artillery firing at Cedar Creek."

"Is it a continuous firing?"

"No, it is irregular and fitful."

"It's all right. Grover has gone out this morning to make a reconnoissance. He is merely feeling the enemy."

General Sheridan tried to go to sleep. But it was not his morning for sleep. He got into his clothes. The officer came to the door again. "The firing is still going on, sir."

"Does it sound like a battle?"

"No."

"It probably is Grover banging away at the enemy to find what he is up to."

Then suddenly Sheridan ordered breakfast in a hurry and the horses saddled. On his powerful black Rienzi he began riding toward the gunfire. Rienzi knew Sheridan wanted speed and gave it, Rienzi who had been given him by a 2d Michigan Cavalry colonel and had taken wounds and seen fighting from the Shenandoah Valley to near the gates of Richmond when Jeb Stuart was killed.

Here were soldiers at the roadside, lighting fires, cooking coffee. "Turn about, boys. We're going to sleep in our old camp tonight. We'll lick them yet!"

Farther along on the pike as he pulled in the reins on the now sweating Rienzi were lines of stragglers. "Men, by God, we'll whip them yet! We'll sleep in our old camp tonight!"

These were men who had come to believe in him as a commander. He had taken care of them in rations and supplies, and when he had ordered fighting it had always turned out right. "Fighting Phil! Hurrah!" They swung their hats. He doffed his. An officer galloped up crying out bad news in the uproar. And Sheridan in a soft voice, leaning over the foaming neck of his black horse: "Damn you, don't yell at me!"

When the hour cried for it Sheridan had the genius of a daredevil who could make other men in the mass want to be daredevils. At ten o'clock that night of October 19 Sheridan telegraphed Grant: "My army at Cedar Creek was attacked this morning before daylight, and my left was turned and driven in confusion; in fact, most of the line was driven in confusion with the loss of twenty pieces of artillery. I hastened from Winchester, where I was on my return from Washington, and found the armies between Middletown and Newtown, having been driven back about four miles. I here took the affair in hand, and quickly united the corps, formed a compact line of battle, just in time to repulse an attack of the enemy, which was handsomely done at about 1 P.M. At 3 P.M., after some changes of the cavalry from the left to the right flank, I attacked, with great vigor, driving and routing the enemy, capturing, according to the last report, forty-three pieces of artillery, and very many prisoners. . . . Affairs at times looked badly, but by the gallantry of our brave officers and men disaster has been converted into a splendid victory."

General Early, whose daring and adroit operations three months before had brought him in sight of the Capitol dome

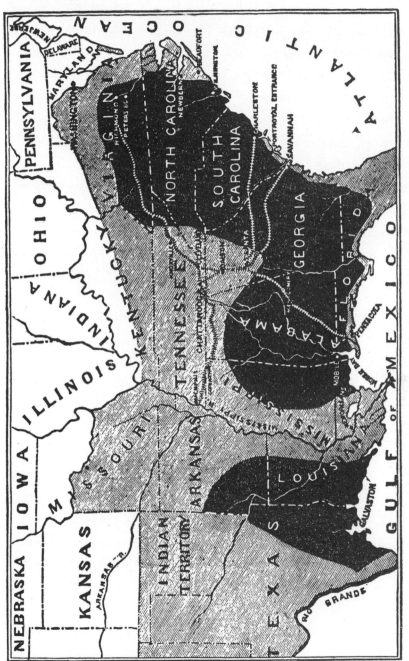

A map circulated in the 1864 campaign by the National Union Party,
showing Confederate areas taken by Federal armies

at Washington with the hope of capturing an Executive Mansion and carrying away its most hated occupant, wrote later his view of what had happened: "This was the case of a glorious victory given up by my own troops after they had won it, and it is to be accounted for on the ground of the partial demoralization caused by the plunder of the enemy's camps, and from the fact that the men undertook to judge for themselves when it was proper to retire."

Lincoln telegraphed Sheridan October 22: "With great pleasure I tender to you and your brave army the thanks of the nation, and my own personal admiration and gratitude, for the month's operations in the Shenandoah Valley; and especially for the splendid work of October 19, 1864."

CHAPTER 22

CROSSING A POLITICAL HIGH DIVIDE

BEFORE boarding a train in Washington for the journey to Chicago to report for newspapers the Democratic National Convention, young Noah Brooks in a White House visit heard Lincoln say, "They must nominate a Peace Democrat on a war platform, or a War Democrat on a peace platform; and I personally can't say that I care much which they do." In the same Wigwam in Chicago where Lincoln had been nominated for the Presidency in June of '60, the convention met August 29 of '64, a boiling kettle of partisans that included Peace Democrats, War Democrats, Whigs, Know-Nothings, Conservatives, States' Rights extremists who endorsed the doctrine of secession, millionaires in broadcloth, run-down politicians in paper collars, men who had braved the wrath of violent communities and suffered for the rights of free speech and a free press, and a remnant of Confederate loyalists who necessarily could not be open in their efforts.

The delegates were called to order by August Belmont of New York City, a German-born Jew, head of the American branch of the Rothschild international banking house, president of the American Jockey Club, chairman of the Democratic National Committee, saying: "We are here not as war democrats nor as peace democrats, but as citizens of the great

Republic, which we will strive to bring back to its former greatness and prosperity, without one single star taken from the brilliant constellation that once encircled its beautiful brow. [Cheers.] . . . Under the blessings of the Almighty, the sacred cause of the Union, the constitution and the laws, must prevail against fanaticism and treason." Belmont dwelt on "four years of misrule, by a sectional, fanatical and corrupt party" having brought the country to "the very verge of ruin."

Governor Horatio Seymour of New York took the gavel as permanent chairman, saying: "Mr. Lincoln values many things above the Union; we put it first of all. He thinks a proclamation worth more than peace; we think the blood of our people more precious than the edicts of the President. [Cheers.]"

The platform adopted pointed to the Constitution "disregarded in every part, and public liberty and private right alike trodden down and the material prosperity of the country essentially impaired,—justice, humanity, liberty and the public welfare demand that immediate efforts be made for a cessation of hostilities, with a view to an ultimate convention of the States, or other peaceable means, to the end that at the earliest practicable moment peace may be restored on the basis of the Federal Union of the States."

This plank would have been written somewhat differently by some of the delegates. The agreement seemed to be that a War Democrat would be nominated for the Presidency in exchange for the Peace Democrats being permitted to record a pledge that the War Democrat nominee would be opposed to war. Such was the dilemma and its straddle, in a platform

of few paragraphs saying scarcely more than that the war and the Administration were failures, and both should be ended. The definite measures of immediate action on taking power, directly pledged in the platform, were: (1) that the armies would be ordered to cease hostilities and go home; (2) that the Southern States would then be asked to join a convention to restore the Union; (3) that free speech and a free press would be allowed and no matter what opposition might be raised against the Government there would be no arbitrary arrests, while habeas corpus and trial by jury would return like perennial blooms of spring.

Whether the commanders of powerful armies in the field, on being told to stop fighting and go home, would agreeably bow low and yield to orders was one question. Whether Jefferson Davis and his associate Confederates would agreeably join in a convention to restore the Union was another question. Out of a combination of practical politicians who wanted again to feel their hands running the government machine, and sincere haters of war who wanted nothing so much as an end to war, only a platform of negatives could have been expected, with a high note on hate.

Reporting the convention in full and complete sympathy with it was the *Chicago Times*, a newspaper so violently anti-Lincoln that it was suppressed by order of General Burnside, and after several days of not being printed having its rights restored by order of President Lincoln. The *Times* gave one delegate's "favorite anecdote" of a Kentucky gentleman who thought that as Mr. Lincoln was so fond of the Negro he "should have one of the slain ones skinned and made into a pair of moccasins for his daily wear."

The *Times* quoted a Peoria delegate's prediction that the convention's candidate for President would on the next fourth of March "apply his boot to 'Old Abe's posterior' and kick him out of the Presidential chair." In and out of the convention, free and unharmed and not even threatened, went one delegate who complained of the right of free speech being gone, while he was reported in the *Chicago Times* as crying out on the convention floor against "the infamous orders of the gorilla tyrant that usurped the Presidential chair," and terming Lincoln a despot, a looter, and worse than a horse thief.

Vallandigham helped shape the platform amid cheers from his following. A peace man of shaded sincerity, Clement L. Vallandigham of Dayton, Ohio, had the country's eye. He had been schoolteacher, lawyer, State legislator, and was known as an extreme proslavery man. Tall, bearded, sonorous, he was; his self-righteousness gave him a personal exaltation; he was chosen to be the vocal instrument of absolute justice. As a delegate he was a presence. He had been places. Echoes of his jail term and banishment, echoes of the New York draft and race riots, open resistance to the Government, were heard. One New York delegate, John J. Van Alen, early intimated that he and others would not accept the nomination of General George Brinton McClellan for President, nor any candidate "with the smell of war on his garments."

These anti-McClellan peace men were given a free hand in writing the platform, with its peace planks. This element, however, had come to the convention with plenty of ideas they were wild about yet no candidate anybody was wild about. The McClellan forces had organization, enthusiasm,

money. On the final showdown McClellan had 202 ½ votes against little more than one-tenth of that number for one T. H. Seymour of Connecticut. Vallandigham amid cheers moved that the nomination of McClellan be made unanimous, which was done with further cheers. Senator George H. Pendleton of Ohio, on his record entirely satisfactory to the peace men, was named for Vice-President.

The fierce fall campaign began, speeches, tub-thumping, torchlight processions, pamphlets and leaflets flung loose as flights of wild geese on the autumn sky. In the beginning McClellan looked sure to win. Lincoln in August had in a written secret memorandum admitted almost certain defeat for himself and the National Union party loomed in the November election of '64. Then came a letter of John C. Frémont, at the head of a third party of antislavery radicals who had nominated him for President, resigning and, not without some grumblings, giving his support to Lincoln. Then vanished a secret movement in Lincoln's own party to replace him with some other man as candidate for President. Then McClellan gave out a letter saying he couldn't stand for the peace platform he was nominated on, that if he did he "could not look in the face my gallant comrades of the army and navy." This made confusion in Democratic ranks, which got worse on the breathtaking news that Sherman had taken Atlanta, Sheridan had cleared the Shenandoah Valley, and the war that had been a failure was becoming a success.

Carl Schurz, major general on leave from the Army of the Potomac, in one speech let the American Eagle scream. In fifty years the country would have 100,000,000 people, in another century 500,000,000, and the purpose of the North

was a free Republic "so strong that its pleasure will be consulted before any power on earth will undertake to disturb the peace of the world." The "rebellion" had lifted the nation from its childhood. "She did not know before how strong she was."

One Union party pamphlet signed by the French liberal Professor Edouard Laboulaye held "The world is a solidarity, and the cause of America is the cause of liberty." So long as a society of 30,000,000 people across the Atlantic lived "under a government of their choice, with laws made by themselves," Europe could hope. "But should liberty become eclipsed in the New World, it would become night in Europe," and power would go to "the whole school which believes only in violence and in success." Therefore Laboulaye and his associates were "praying God that the name which shall stand first on the ballot [of November] shall be that of honest and upright Abraham Lincoln." From the English liberal parliamentary leader John Bright came a letter wishing for Lincoln's re-election because it would over Europe "and indeed throughout the world" deepen men's faith in republican institutions.

In this fall campaign of '64 at no moment was there any letdown of the intensity of the slavery issue, the race question, the ins and outs of the Emancipation Proclamation. One side feared racial and social equality was coming soon. The other side held freedom of the slave to be inevitable and that unless the slavery institution was removed it would wreck the Union.

Overtowering all other issues was the personality and character of Lincoln, his acts, decisions, words. He was the

spokesman and the master mind of the war in a more strict sense than any other person. "I have been controlled by events," he had written in a letter he made public in the spring of '64. "My policy is to have no policy," he had said to a secretary in the spring of '61. He swung out and came back with changing tides of thought and feeling in the American people. On one issue he stood granite-hard, crystal-clear. That was the Union, its preservation. On all other issues he would have compromised, and so indicated to the public.

Year after year the two foremost American newspapers had criticized and belittled Lincoln. The *New York Herald* and its publisher James Gordon Bennett saw him as too friendly with the antislavery crowd. The *New York Tribune* and its editor Horace Greeley saw him as too slow, too hesitant, too "vacillating," too late with the Emancipation Proclamation, which should have been issued earlier, too "indecisive" in his management of the war. Many of the leading men of his own party in the Senate and the House of Representatives at Washington leaned toward this Greeley viewpoint, as did at least one member of Lincoln's Cabinet, Salmon Portland Chase, the Secretary of the Treasury, who had carried on a curious and furtive procedure aimed at undermining Lincoln and getting himself nominated for the Presidency.

Other well-educated men would not agree with this estimate of Lincoln. Colonel Theodore Lyman of General Meade's staff, for instance, would vote for Lincoln, but this was the impression he had on seeing the man, as he wrote it in a letter to his wife: "The President is, I think, the ugliest man I ever put my eyes on; there is also an expression of plebeian vulgarity in his face that is offensive (you recognize the re-

counter of coarse stories). On the other hand, he has the look of sense and wonderful shrewdness, while the heavy eyelids give him a mark almost of genius. He strikes me, too, as a very honest and kindly man; and, with all his vulgarity, I see no trace of low passions in his face. On the whole, he is such a mixture of all sorts, as only America brings forth. He is as much like a highly intellectual and benevolent Satyr as anything I can think of. I never wish to see him again, but, as humanity runs, I am well content to have him at the head of affairs."

Through trials and difficulties, even hours of agony, Lincoln moved holding a deep faith in the people. They could be trusted. He told Dick Oglesby of Illinois that if in the long run a man did right by them the people would know it and do right by him. Now he had been the first Laughing Man in the White House, yet also the most Solemn Man the Executive Mansion had ever known. To many plain folk over the land he had become a living reality, warm and keen with humor and understanding. Many others dismissed his habit of joking, and saw him actually as a tall, lean, melancholy prophet, doing probably as well as any other man could have done, maybe a lot better, in a tangle of fate and circumstance where it seemed at times the will of God was the most decisive factor.

In this mood the editor of *Harper's Weekly*, George William Curtis, wrote just before the November election: "In a few short months we may be at the end of our great troubles, and, let us hope, free forever from the anxieties that now beset us. But when that time comes, when history and tradition repeat beside every fireside in the land the trials and

the dangers and the heroism of each most faithful and noble veteran, then it will be said, 'And he, too, never faltered; he marched with us side by side; he believed in us when so many desponded; he risked all to support and sustain and reinforce us.' . . . Be slow to come to a decision, and slower to change from it; dare to be unpopular in the performance of imperative duty; set an example of calm confidence and religious trust in the hour of gloom and despondency; and you, like him, shall have it written on your tombstone and on the hearts of your fellow-countrymen, 'He, too, was worthy to be an American citizen.' . . . There is a fame which no station or absence of station can add to or diminish. His work, like that of the most obscure soldier who lies buried under the sod of Gettysburg or Antietam, has been done, and faithfully done, and no act of others can destroy or weaken or increase its honor. Faithful and consecrated to the service of his country, his memory, though it were nameless as that of any private in our armies or any nurse in our hospitals, will, like theirs, be sweet in the heart of every true American so long as the humblest hamlet remains to keep up the tradition of a good citizen."

Nathaniel Hawthorne, the great novelist, watched Lincoln handle a committee who presented the White House with a new buggy whip from a Massachusetts factory. Of the war Hawthorne had written he approved it "but I don't quite see what we are fighting for." He sketched President Lincoln as "the essential representative of all Yankees," and on arriving at high office presumably "it was his first impulse to throw his legs on the council-table, and tell the Cabinet Ministers a story." No words could tell how long and awk-

ward the President was, thought Hawthorne, "and yet it seemed as if I had been in the habit of seeing him daily, and had shaken hands with him a thousand times in some village street," the whole face "as coarse a one as you would meet anywhere in the length and breadth of the States; but, withal, it is redeemed, illuminated, softened, and brightened by a kindly though serious look out of his eyes, and an expression of homely sagacity, that seems weighted with rich results of village experience." Honest at heart, "and thoroughly so," the novelist believed, "and yet, in some sort, sly,—at least, endowed with some sort of tact and wisdom that are akin to craft. . . . But, on the whole, I like this sallow, queer, sagacious visage, with the homely human sympathies that warmed it; and . . . would as lief have Uncle Abe for a ruler as any man whom it would have been practicable to put in his place." Thus his estimate ran near that of Mrs. Hawthorne, once writing in a letter, "I suspect the President is a jewel. I like him very well."

Far had gone Lincoln's homely remark that to win the war for the Union they must "keep pegging away." Far too among the people had gone his remark to someone wanting a favor at one of the departments, "I have no influence with this administration." Once a woman asked him to use his authority in her behalf at the War Department and she quoted his reply: "It's of no use, madam, for me to go. They do things in their own way over there, and I don't amount to pig tracks in the War Department."

He moved with events, once telling a New York man, "I do not lead; I only follow," and making clear to the Prince de Joinville he had little or no "policy" as such. "I pass my life

preventing the storm from blowing down the tent, and I drive in the pegs as fast as they are pulled up."

A St. Louis clergyman mentioned a letter of Lincoln's about a disloyalty case in Missouri. This letter had been read at an assembly of churchmen and both sides in the dispute claimed the President was with them. Lincoln hearing of this was reminded of an Illinois farmer and his son out in the woods hunting a sow. After a long search they came to a creek branch, where they found hog tracks, and signs of a snout rooting for some distance on both sides of the creek. The old man said to his boy, "Now, John, you take up on this side of the branch and I'll go up t'other, for I believe the old critter is on both sides."

The humor of the man in the White House reached out and found people who considered it proper for stormy weather. A Northern governor wanting his own way sent telegrams with threats and warnings that orders from Washington could not be carried out. Lincoln insisted the orders be carried out and was reminded of a boy he saw once at a launching. "When everything was ready they picked out a boy and sent him under the ship to knock away the trigger and let her go. At the critical moment everything depended on the boy. He had to do the job well by a direct, vigorous blow, and then lie flat and keep still while the ship slid over him. The boy did everything right, but he yelled as if he were being murdered from the time he got under the keel until he got out. I thought the hide was all scraped off his back; but he wasn't hurt at all. The master of the yard told me that this boy was always chosen for that job, that he did his work well, that he never had been hurt, but that he

always squealed in that way. That's just the way with Governor Blank. Make up your minds that he is not hurt, and that he is doing his work right, and pay no attention to his squealing. He only wants to make you understand how hard his task is, and that he is on hand performing it."

In speech he liked to be short-spoken, once saying of another, "He can compress the most words into the smallest ideas of any man I ever met." Nicolay heard him tell of a Southwestern orator who "mounted the rostrum, threw back his head, shined his eyes, and left the consequences to God." He did not "care a cornhusk for the literary critics," ran one comment. The *Boston Transcript* saw him familiar with "the plain homespun language of a man of the people, accustomed to talk with the folks." The *Chicago Times*, however, spoke for a definite element in its opinion: "Such a garrulous old joker with his pen is our President. A very 'phunny' man is our President."

His somber face, his solemn purposes and words, had gone out and made their impress here and there. In his annual message to Congress in December of '62 he came near apologizing for his "undue earnestness" leading to his challenge: "The dogmas of the quiet past are inadequate to the stormy present. The occasion is piled high with difficulty, and we must rise with the occasion. As our case is new, so we must think anew and act anew. We must disenthrall ourselves." He hoped throughout each year for some plan by which the Federal Government would buy the slaves, pay the owners, set the slaves free, getting emancipation without further war, the cost of buying the slaves being so much less than the cost of more war. For any such plan he found neither

Congress nor his own Cabinet would go along with him. He sounded the deep call: "Fellow citizens, we cannot escape history. We of this Congress and this administration will be remembered in spite of ourselves. No personal significance or insignificance can spare one or another of us. The fiery trial through which we pass will light us down, in honor or dishonor, to the latest generation. . . . The way is plain, peaceful, generous, just—a way which, if followed, the world will forever applaud, and God must forever bless."

On October 13, with election not quite a month away, Lincoln in the war telegraph office penciled on a telegraph blank his estimate that in the Electoral College he would get 117 votes against 114 for McClellan. Out of 231 votes he saw himself winning by a bare majority of 3. So many times in his life when victory seemed just ahead he had been a loser—so he had a habit of underconfidence.

November 8 of '64 came. The sky hung gray. Rain fell. What would the night tell? What would the clicking dot-dashes of the Morse code bring? How would the nation vote? Lincoln was anxious though calm. So was Grant. So was Sherman. All three knew very well the election results might be far greater than any battle of the war. Lincoln in the war telegraph office told of an 1858 rainy night when he lost the election for United States Senator. Walking home on a hog-backed and slippery path, "my foot slipped from under me, knocking the other one out of the way, but I recovered myself & lit square, and I said to myself, 'It's a slip and not a fall.'"

The wires worked badly. A rain-and-wind storm had

blown up in the west. Toward midnight, noted Noah Brooks, "It was certain that Lincoln had been reëlected, and the few gentlemen left in the office congratulated him very warmly on the result. Lincoln took the matter very calmly, showing not the least elation or excitement, but said that he would admit that he was glad to be relieved of all suspense." Serenaders came with a brass band, music, cheers, calling for a speech. The rain, the storm, was over. "It is no pleasure to me," said the President, "to triumph over any one, but I give thanks to the Almighty for this evidence of the people's resolution to stand by free government and the rights of humanity."

All States except Kentucky, Delaware, and New Jersey went to Lincoln. His majority was slightly over 400,000. Of a total of 2,203,831 he had 55.09 per cent of all votes cast. Yet McClellan had carried New York City by 78,746 against 36,673 for Lincoln—and in the Empire State Lincoln won with only 50.47 of the vote as against 49.53 per cent for McClellan. Totals in the three largest States showed Lincoln winning by narrow margins. However, in the one spot where Lincoln's heart would have been sore had not the ballots thundered and roared high for him—the soldier vote—there he won home big, the forecast being fulfilled that they would vote as they shot. Also there was the point that many thousands of soldiers, because of State laws or stern campaign conditions, did not get to vote.

The election counted for more than a great battle won, Grant wired Lincoln. A day of high fate was over. The returns were in. There was no going behind the returns. At thousands of polling places some 4,000,000 men marked the

pieces of paper called ballots. A nation made a decision. Chaos, hate, suspicion, mistrust, vengeance, dark doubts, were in the air. But the marking, handling, counting, of the ballots went on in quiet and good order, fraud or violence showing only in minor incidents. The miscounts and repeaters were only ordinary. Free speech and print were so operating that either side would have flared forth about any flagrant departure from the customary election methods.

Two nights later Lincoln stepped out of a window on the north portico of the White House, in front of him a roaring, jostling crowd of serenaders. John Hay stood alongside with a candle to light the written page from which Lincoln read. "It has long been a grave question," he began, from the candlelit page, under the night stars, before floating thousands of witnessing faces, "whether any Government, not too strong for the liberties of its people, can be strong enough to maintain its existence in great emergencies. On this point the present rebellion brought our republic to a severe test, and a presidential election occurring in regular course during the rebellion, added not a little to the strain. If the loyal people united were put to the utmost of their strength by the rebellion, must they not fail when divided and partially paralyzed by a political war among themselves? But the election was a necessity. We cannot have free government without elections; and if the rebellion could force us to forego or postpone a national election, it might fairly claim to have already conquered and ruined us. . . . What has occurred in this case must ever recur in similar cases. Human nature will not change. In any future great national trial, compared with the men of this, we shall have as weak and as strong,

as silly and as wise, as bad and as good. . . . [The occasion] has demonstrated that a people's government can sustain a national election in the midst of a great civil war. Until now, it has not been known to the world that this was a possibility. It shows, also, how sound and how strong we still are."

In Middletown, Connecticut, torchlight paraders passing the house of a clergyman read a transparency: "The Angel of the Lord Called unto Abraham out of Heaven the Second Time. Genesis 22:15."

CHAPTER 23

MARCH ACROSS GEORGIA

THE time beat of the war went on, bluecoat streams pouring south and south, miles of men and boots, leather, hardtack, tents, steel, lead, powder, guns. And as miles of wagon supplies, mountains of hardtack, were used up, more and more poured south. And moving north, flung back out of the muddy and bloody recoils, came stragglers, deserters, bounty-jumpers, the furloughed, the sick and wounded—while beyond the battle fronts toward the south, living skeletons in prison offered prayers that the time beat of the war would end, that the sad music of rifle volleys and cannonading guns would close over in some sweet silence.

In the silence of the night was despair—and hope. Though torn with intestinal violence, the Government of the United States was still a vast going concern, having immense transactions in land, money, shipbuilding, immigrants thronging United States consulates in Europe with anxiety to go to "the free country" overseas, the first tentative projections of the Union Pacific Railway under way, an around-the-earth international telegraph system being wrought toward reality, mails being carried, pensions paid to widows and orphans, river and harbor works in process—the question running over the world: Would the Union Government be able to hammer out an indissoluble unity of its States?

Now in the close of '64 it was taken in the North and in

Europe as full of portent that President Davis recommended to his Congress that slaves be drafted for the Confederate armies. This plan would throw 400,000 able-bodied and armed black men against the Northern armies. Slavery would not be abolished, but the enlisted Negroes would be given freedom. To Europe went an emissary from Davis hoping to win foreign recognition of the Confederacy by this concession to world opinion. On this partial emancipation, however, planters and slaveholders of influence squarely opposed Davis. Factions in the Confederate Congress with polite contempt offered other plans to fill the thinning armies.

A movement to impeach Davis gained headway. Vice-President Stephens, the Rhett following in South Carolina, Governor Brown of Georgia, Governor Vance of North Carolina, moved slowly and guardedly, backed by a considerable public opinion in the South which held President Davis too arbitrary, too lacking in a spirit of co-operation, empty of the genius of leadership required for the terrible and immediate problems. A congressional committee sent a member to General Robert E. Lee to ask him if he would take charge of the sinking and chaotic affairs of the Confederacy—as sole dictator. Lee couldn't see that he was the man for such a post, and the old order was resumed.

Southward in Georgia were good rations for Lee and his army—grain and meat lacking transport. The railroads in the South, with no replacements during the war, were rusting and shattered. Forges, mills, machine shops, what few the South had, were almost out of commission. The blockade was letting few new materials in. The extortions of salt speculators had forced the Richmond Government to take over

saltworks and issue rations. Meat, sugar, drugs, medicines, wool, coffee, of these in many homes they learned how to do with little, to do without entirely, or to use substitutes. On every doorsill of the South were shadows and imprints of a war going on, with none of the flare and gaiety that marked its beginning.

Unfailing and undying devotion to the cause there was, perhaps most notable among women. A proposal that all Southern women cut off their hair for sale in Europe, to bring $40,000,000 for the cause, would have been carried out if practical. In plenty of instances they denied themselves meat, coffee, wines, blankets, sending these to the army and to hospitals.

As with each year of the war the South had dwindled in man power, in money and economic resources, in commerce and industry, in the comforts or necessities of life, the North had gained in each of these points. In steel, oil, railroads, munitions, textiles, and other industries, scores of large fortunes were already made, many others on their way.

Such were backgrounds in late '64 for the dramatic military performances of Sherman and Thomas and their armies in the Central and Deep South. For the first time during the war, observers in America and Europe hung breathless and wondering over the audacity and fate of a general and an army who vanished. To his wife the head of this adventure wrote that he would come out of it reputed a great general or just plain crazy. Sherman had not seen the newborn baby who had arrived to them in June. The baby would die while he was gone, while millions were wondering where he was, and he would accept this as war.

"If you can whip Lee," Sherman wrote to Grant as between family men, in September, "and I can march to the Atlantic, I think Uncle Abe will give us twenty days' leave of absence to see the young folks." This he was writing in Georgia, where he had taken Atlanta. Near by was Hood's army, which Jefferson Davis was saying had every advantage of being on home ground, so that it would yet cut Sherman's communications and destroy Sherman. To Grant, Sherman offered his plan. He would divide his army, give Thomas 60,000 with which to take care of Hood's 41,000, and then himself start on a thousand-mile march which was to end by joining Grant in Virginia, pausing at Savannah-by-the-Sea. "I can make the march and make Georgia howl!"

Hood was maneuvering to draw Sherman out of Georgia, Sherman saying, "If Hood *will* only go North, I will furnish him with rations for the trip." Long ago everyone in authority knew Sherman's theory was to punish and destroy in the South till its people were sick of war and willing and anxious for peace. "War is cruelty and you cannot refine it." Down where he was he would not consider defensive warfare. "Instead of guessing what Hood means to do he would have to guess at my plans. The difference in war is full twenty-five per cent." Thousands of people abroad and in the South would reason, wrote Sherman, "If the North can march an army right through the South it is proof positive that the North can prevail in this contest."

What Sherman was proposing sounded as peculiar and as touched with fantasy as Grant's plan a year and a half back for taking Vicksburg. Grant had every faith in Sherman. And by instinct Grant favored this latest hope of Sherman. Grant

at this point did what Lincoln so often did. He raised objections almost as though to reassure both himself and Sherman that they were headed right and not moving too fast. He mentioned to Sherman his doubt whether Sherman could get along without a seacoast base prepared for him. He added his doubt about leaving Thomas with too few men to make sure of beating Hood. Sherman replied he was sure he could strike into Georgia without a seacoast base and was also sure that Thomas, his old classmate at West Point, whom he knew well as a slow but safe fighter, would take care of Hood.

On October 11 Grant had not yet told Sherman he could go, and good luck to him. In fact on October 11 Grant sent to Lincoln by wire a statement of reasons for disapproving of Sherman's plan. Then the next day Grant changed front, wired Sherman, "On reflection, I think better of your proposition. It would be better to go south than to be forced to come north." He would have Sherman "clean the country of railroad tracks and supplies . . . move every wagon, horse, mule, and hoof of stock," arming the Negroes and giving them "such organization as you can."

Meantime came word to Grant from Lincoln. He agreed with Grant's reasons for not yet letting Sherman head south to the sea. A telegram from Stanton read: "The President feels much solicitude in respect to General Sherman's proposed movement and hopes that it will be maturely considered. The objections stated in your telegram of last night impressed him with much force, and a misstep by General Sherman might be fatal to his army."

Then Grant again exchanged telegrams with Sherman about destroying Hood before marching across Georgia. Both their

minds seemed to be playing around the idea that Hood
wanted to decoy Sherman's army out of Georgia northward.
And the strategy of both Grant and Sherman more often
ran to finding the one thing the enemy didn't want you to do
and then doing that very thing. Grant agreed with Sherman.
"I say then, go on, as you propose."

Grant now wired Lincoln: "Sherman's proposition is the
best that can be adopted. . . . Such an army as Sherman
has, and with such a commander, is hard to corner or cap-
ture." This seemed to be the day of an acid test for Lincoln
on the matter of whether he would get behind his two best
proven generals. Within three hours after Grant's telegram
arrived, Stanton telegraphed Sherman complete approval.
"Whatever results, you have the confidence and support of
the Government." Halleck added that "the authorities are
willing," serving Sherman notice that at Savannah a fleet
would be waiting for him with supplies.

Grant trusted Sherman completely, it seemed, except for
a day or two of wavering on the point of Sherman's faith
that Thomas could take care of Hood. In the end Grant de-
cided he would accept Sherman's judgment of what Thomas
could do. And Lincoln had thrown himself into complete
trust of Grant and Sherman. This trio of Lincoln, Grant, and
Sherman now worked in a co-operation as smooth as that
which had long existed between Lee and Davis.

Grant's decision in this was one Sherman had in mind
later when he said, "Grant stood by me when I was crazy,
and I stood by him when he was drunk, and now we stand by
each other." Both of them had practiced and wrought out
a technic. Their calculations partook of arithmetic and intui-

tive cunning learned in hard trials. Sherman had found what he could do in enemy territory. Grant trusted Sherman's faith in his own mobility.

In the advance on Atlanta one backwoods woman spoke to a Union officer of Sherman's capacity to have his army disappear and reappear. "You-uns don't fight we-uns fair. When Johnston crossed the High Tower he made a line and wanted you all to come square at him at Atlanta; but instead of that you-uns went away off to Dallas, and we had to leave and make a line for you there. But there again you all wouldn't fight fair, for when our line was made afront of yours, Captain Hooker, with his big regiment, came round and pitched into we-uns' eend. No Gineral can fight such unfair ways as that." This ran counter to Jefferson Davis's prediction that Atlanta would be to Sherman what Moscow was to Napoleon. As a forecaster Davis was losing reputation. Atlanta was burned, not as much as Moscow, but Sherman ordered the torch put to it.

Sherman had not intended to burn as much of Atlanta as did burn. His chief engineer under orders wrecked all railroads in and about Atlanta, heated the rails red-hot and twisted them around trees. Then smokestacks were pulled down, furnace arches broken, steam machinery smashed, holes punched in all boilers, all devices of industrial production sabotaged out of possible use. Battering crews knocked down walls and then put the torch to wrecks of what had been passenger depots, freight sheds, roundhouses, machine shops, mills, factories, a tannery, a laboratory, an oil refinery, theatres, and all hotels but one. Before this work had begun, firebugs had set in flame a score of buildings, General Slocum

offering a reward of $500 for the detection of any soldier involved. Public dwellings and churches were spared, and it was not in Sherman's plans to burn the business sections of the city. According to his chief engineer, "lawless persons" without authority had crept through back alleys and laid in

Railroad depot, Atlanta, Georgia, 1864

ashes stores and shops. Eighteen hundred Atlanta buildings went up in smoke.

Sherman rode into the city with an aide on November 15 near sunset. Roses still bloomed in a few gardens of fine houses and Atlanta was a quiet city, not soothed but calm with a hint of heavy fate. The somber red-haired Man on Horseback was about to say, and did say later, "Pierce the shell of the Confederacy and it's all hollow inside."

The night held little quiet as an engineer corps fired more fallen buildings, as flames spread to a wrecked arsenal and shell explosions rattled the windows of hundreds of homes where no sleepers lay to be awakened. A fire department of

soldiers struggled several hours of the night, managing to hold the fire mainly to the downtown and industrial districts, as intended. When Sherman rode out of the city at seven the next morning, a third, perhaps more, of Atlanta lay in ashes.

Toward the east and southward, toward Savannah and the Atlantic Ocean, toward a path that was to twist upward in the Carolinas, Sherman turned his horse. He knew this country. He had crossed many parts of it and lived in it several years of the 1840's. The ways of its people had been under his eye in part when he was superintendent of the Louisiana State Military Academy. No stranger seeing novelties was he now. So the *Macon Telegraph* called him Judas Iscariot, a betrayer, a creature of depravity, a demon "of a thousand fiends."

Toward the east by the Decatur road Sherman paused on a hill and took a last look at smoking Atlanta. On the horizons around him a bright sun slanted down on the shining rifles of 55,000 picked men, veterans of proved capacity for action, for marching, for legwork, for many disease immunities, survivors of hard campaigns. Each man carried forty rounds of cartridges, and in wagons were enough more to make two hundred rounds per man. The sun slanted too on sixty-five cannon, each drawn by four teams of horses. Six-mule wagons, two thousand five hundred of them, hauled supplies and forage. And six hundred ambulances, two horses to each, were prepared for battle service.

Between Sherman and his friend Grant at Richmond lay a thousand miles of cities and towns, lands, swamps, and rivers, alive with a bitterly hostile people hating with a deepening despair. Behind now was smoldering Atlanta and its

black smoke and its deathly stillness of ruin. Around him were glistening gun barrels of his 14th Corps, cheery and swinging boys and men, singing and joking about the thousand miles to Richmond. A band struck up the John Brown song. Men sang "Glory, glory, hallelujah!" And to Sherman's ears as he rode along came from more than one soldier something like "Uncle Billy, I guess Grant is waiting for us at Richmond." There at Richmond, as Sherman read their feeling, "there we should end the war, but how and when they seemed to care not, nor did they measure the distance, or count the cost in life, or bother their brains about the great rivers to be crossed, and the food required for man and beast that had to be gathered by the way." Among men and officers Sherman saw a "devil-may-care" feeling that made him feel his full responsibility, "for success would be accepted as a matter of course, whereas, should we fail, this 'march' would be adjudged the wild adventure of a crazy fool."

Heading the Army of the Tennessee, forming the right wing, was the one-armed O. O. Howard with two corps, one commanded by General P. J. Osterhaus, the other by General Frank P. Blair. Heading the Army of the Cumberland, forming the left wing, was the cool and tested General H. W. Slocum, with two corps led by General J. C. Davis and General A. S. Williams.

This army had 218 regiments, all but 33 from Western States. They would be heard from—sometime. The word of Sherman to Grant, to the War Department and the President, was that communications were cut off from central Georgia and his next message he hoped to send from somewhere on the Atlantic Coast.

In the Eastern regiments was noticeable more antislavery sentiment than among the Western. The emancipation idea had less motivating force among the Iowa, Illinois, Missouri, and Kentucky troops, for instance. Striding over Georgia they were Unionists, not aliens nor invaders; they held they were fighting enemies who sought to take away their Mississippi River, their uninterrupted transcontinental railways, their interstate commerce and peace.

Starting on this November 15, marching in four columns sweeping a path twenty to forty or more miles wide, this army began a systematic campaign of destruction. "The State of Georgia alone," Jefferson Davis had said in a recent speech in Augusta, "produces food enough not only for her own people and the army within but feeds too the Army of Virginia." On this storehouse and granary of the Confederacy worked the destroyers. What the army could not eat or carry away it burned, spoiled, ruined.

Language and imagery failed to tell the terror that smote this region and ran shuddering through all other yet remaining vitals of the Confederate States of America. War! And the desolation and fallen pride and hunger and deathly quiet lacking majesty because of the smoldering foul smoke and the clean air pungent with the rot and stink of conquest.

Now they had their war, was Sherman's thought, the war they had asked for. Until now the Border States had taken the punishment. Now it had come to the doorsills of the Deep South. Now sometimes you couldn't see the roses and the magnolia trees for the depot and warehouse smoke, for the dust of marching columns and rumbling wagons. Until now

hereabouts the war had been fairly polite and far off. Here was reality.

An argument began. It was to last long. Was Sherman a modern impersonation of Attila the Hun, a manner of sadist, a wanton and a monster who took pleasure in seeing an enemy people suffer? Or was he a soldier doing a necessary job, a kindhearted family man who wanted to end the war and saw no other way of ending it than by the tactics he was using? Both sides made out a case. The word in military lingo for the work of Sherman's looters and plunderers was "pillage." When Sherman's men in Georgia drove off the livestock of a farmer without paying the farmer for it—as McClellan's men always did in Virginia and as Lee's men always did (with Confederate money) in Pennsylvania—it was pillage. "In the beginning [of the war]," wrote Sherman, "I, too, had the old West Point notion that pillage was a capital crime, and punished it by shooting, but the Rebels wanted us to detach a division here, a brigade there, to protect their families and property while they were fighting. . . . This was a one-sided game of war, and many of us . . . kind-hearted, fair, just and manly . . . ceased to quarrel with our own men about such minor things, and went in to subdue the enemy, leaving minor depredations to be charged up to the account of the rebels who had forced us into the war, and who deserved all they got and *more*."

His conscience worried Sherman less than his sense of timing. He and Grant would join their armies some day, if their timing was right. Then the war would end. From Richmond to the farthest southwest corner of Texas, "all over the grand theater of war," Sherman wanted "simultaneous ac-

tion." This lesson had been learned at cost and must be applied. "We saw the beauty of time at Chattanooga and there is no reason why the same harmony of action should not pervade a continent." The man spoke in art lingo and was in some ratings a military artist. He traveled light. The saddlebags which his orderly carried held, as he enumerated the articles, "a change of underclothing, my maps, a flask of whiskey, and a bunch of cigars." He could live as plainly as rank-and-file soldiers; they had seen him sleep in his blanket on cold ground. He watched over details till midnight and past, was out early in the morning, made up lost sleep sometimes with ten- and fifteen-minute naps on the ground during the day. When his troops had orders to do things that at first seemed impossible they said, "Well, *he* can't make a mistake."

Of the railroad-wrecking, wrote Sherman, "I gave it my personal attention." Bonfires were made of crossties, the iron rails laid on and when red-hot carried to telegraph poles or trees and twisted around to make what were nicknamed "Sherman hairpins." Also they were called "Lincoln gimlets." Or again they were "Jeff Davis neckties." A month of this and 265 miles of railway were unbuilt.

Instead of the fifteen miles a day to which Sherman had accustomed them, the troops on some days saw they were making ten. This gave them extra time to forage, to make trips aside and ahead off the line of march, to collect corn, molasses, meal, bacon, sweet potatoes, and other foodstuffs. Each brigade commander had authority to detail a forage company, usually about 50 men headed by one or two commissioned officers. Before daylight this party would leave,

knowing where to rejoin their command on the march later
in the day. On foot five or six miles from the brigade route,
they visited every plantation and farm within range. On a
farm wagon or a family carriage they loaded bacon, cornmeal,
turkeys, ducks, chickens, "everything that could be used as
food or forage," to use Sherman's words. They regained the
main road, usually in advance of their wagon train, and de-
livered to the brigade commissary the day's supplies gathered.

Kilpatrick's cavalry did more than any other unit to earn
a bad name for Sherman's army. They did lay hands on old
men and choke them by the throat till the secret hiding-
places of coin, silver, or jewelry were divulged. They did
put their dirty boots on white bed linen, dance on polished
floors to the piano music of howling comrades, smash the
piano with gun butts. They did drag feather beds outdoors
and scatter the feathers like a small snowstorm. But they
were veteran troopers, hard fighters, afraid of no danger nor
hardship—and the army believed Sherman tolerated them
partly because of his own belief that as tough soldiers for
loyal active service they were among the best the earth had
ever seen, partly because to set up a military police to watch
and discipline his own men would delay when delay might
be at heavy cost.

One raw, cold night Sherman found himself in a double-
hewed log house, saw a box marked "Howell Cobb," learned
from Negroes he was in the home of a Confederate brigadier
general, one-time United States Senator from Georgia, Secre-
tary of the United States Treasury under President Buchanan.
"Of course, we confiscated his property, and found it rich in
corn, beans, peanuts, and sorghum-molasses." Sherman sent

word to a staff general "to spare nothing," and that night on the Cobb plantation "huge bonfires consumed the fence-rails, kept our soldiers warm, and the teamsters and men, as well as the slaves, carried off an immense quantity of corn and provisions of all sorts."

Arriving the next day at the State capital, Milledgeville, they found Governor Joseph Brown, the State officials, and the members of the legislature gone, the Governor's mansion stripped of carpets, curtains, furniture, food, these latter shipped away on railroad tracks soon wrecked by the Union troops. Here Federal troops used stacks of Confederate paper money for a breakfast fire. Here Federal officers held a mock session in the State legislative chamber, repealed the Ordinance of Secession, voted the State back into the Union. Here were late newspapers from over the South, one having an appeal from General Beauregard to the people of Georgia to arise, obstruct, be confident, be resolute, and "Sherman's army will soon starve in your midst." And while Sherman in Milledgeville read this and other items, thousands of bales of cotton got the torch, many cotton gins and presses were wrecked, and as Sherman reported, "I burned the railroad buildings and the arsenals; the state-house and Governor's Mansion I left unharmed."

The marching army moved on, no pauses, no days of rest, feeding on the fat of the land with a more savory bill of fare than any army during the war thus far. "It was gravy every day." Juicy steaks, pork chops, fried chicken, ham and eggs, yams rolled in Indian meal, sorghum syrup—at moments the war was a picnic and a frolic. Not so of course when the

route shifted from east southward toward Savannah, when ground under the feet of one column heaved in explosion and several men were torn by shells and torpedoes, whereupon Sherman ordered Confederate prisoners to be marched ahead. They accommodated and dug up a line of buried torpedoes.

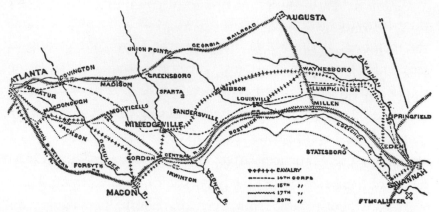

The march from Atlanta to the sea

Sherman's army feinted toward the cities of Augusta and Macon, made no real move at them, slipped smoothly past them. No time now for the taking of cities.

Confederate cavalry detached from Hood's army skirmished a little with Sherman's advance but undertook no real clash with the Union horse troops under Kilpatrick. The convicts, on Sherman's approach let loose from the State prison at Milledgeville for military service, were no help to further good order in Georgia that month. Some of them, joined up with other deserters, drifters, bushwhackers, raided here and there for loot.

As the Union army drove deeper south and east across Georgia, a bewilderment allied to panic took hold of the

Richmond Government and its ramifications. They were stunned by the audacity of it, shaken by mystification as to whether the army was heading for Savannah or Charleston, or whether in the commander's headlong march there was any logical plan.

Grant at City Point, Virginia, was saying: "Sherman's army is now somewhat in the condition of a ground-mole when he disappears under a lawn. You can here and there trace his track, but you are not quite certain where he will come out till you see his head."

An army for thirty-two days to the outside world "lost sight of," as Sherman phrased it, now had behind it three hundred miles of naked smokestacks, burned culverts, shattered trestleworks, wailing humanity. Of the railroads every rail was twisted beyond use, every tie, bridge, tank, woodshed, and depot building burned. Thirty miles ran the devastation on either side of the line from Atlanta, estimated Sherman. Kilpatrick's 5,000 horsemen had ravaged beyond the reach of foot troops. For the economy of powder they had sabered hogs, knocked horses between the ears with axes, killing more than a hundred horses on one plantation with a fine mansion and shooting every bloodhound, mastiff, or other dog that looked as though it could track runaway Negroes in swamps and forest. Over many square miles of this area now was left not a chicken, not a pig, nor horse nor cow nor sheep, not a smokehouse ham nor side of bacon, not a standing corncrib with a forgotten bushel, not a mule to plow land with, not a piece of railroad track, nor cars nor locomotives nor a bunker of coal. "The destruction could

hardly have been worse," wrote one commentator, "if Atlanta had been a volcano in eruption, and the molten lava had flowed in a stream sixty miles wide and five times as long." War as a reality, a pervasive stench of conquest, had come to Georgia.

On December 10 General Howard's right wing stood ten miles from Savannah. To Washington Howard sent a telegram notifying the Government that the march had won through. By scouts overland to Port Royal, South Carolina, and wire relays this good-news message reached Washington the evening of December 14. The next day Halleck passed on to Lincoln Howard's dispatch: "We have met with perfect success thus far, troops in fine spirit and General Sherman near by."

Over the North flashed this news. Across streets in town, over roads and fields in the country, went the jubilant cry that Sherman had got to Savannah. From Boston to Council Bluffs and points west there were cheers and prayers of thanks.

On December 13 Sherman with staff officers climbed to the top of a rice mill, looked toward the sea for the fleet, looked toward a forest edge where the 15th Corps was ready to move on Fort McAllister. The fort overlooked a river needed for supply transport between Sherman and the fleet— if the fleet had arrived as planned. For hours Sherman and his aides kept their lookout. Hour on hour slipped away and it was getting near sundown when a smokestack took clearer form, at last could be seen, and later a flag wigwagging the words, "Who are you?"

"General Sherman," said the rice-mill flag.

"Is Fort McAlister [sic] taken yet?" asked the ship.

"Not yet, but it will be in a minute."

As though this was a signal, Sherman's old Shiloh division under General William B. Hazen broke from cover, sharpshooters running out to fling themselves flat on the ground and pick off enemy gunners, the whole line soon charging through a hail of shot, shell, and rifle bullets, rushing the defenses, soon dancing on the parapets of Fort McAllister, waving their regimental flags and shooting their happy muskets up at the sky. "It's my old division," cried Sherman. "I knew they'd do it." To General Slocum he wired: "The fort was carried at 4:30 P.M., the assault lasting but fifteen minutes."

By the light of a pale moon this December 13 Sherman rode a fast yawl downstream, boarded the Union ship, the *Dandelion*, and before midnight was writing dispatches to be read five days later by Stanton, Halleck, and Lincoln— and parts of them passed on to a world starving for news and sure fact.

Over two hundred miles of railroad had been "utterly destroyed," he notified Washington, and now he asked authority to march straight north to Raleigh, North Carolina, giving the intervening country the same operation he had given Georgia, so that Lee must evacuate Richmond. "I regard Savannah as good as gained." The Georgia damage he estimated at $100,000,000.

Savannah fell, its garrison of 9,000 under General Hardee moving out and away toward the north on the night of December 20, sensing Sherman's design for their capture. Union

troops moved in. Sherman himself arrived on December 22. Sherman wrote Lincoln a message:

"I beg to present you as a Christmas gift, the city of Savannah, with one hundred and fifty guns and plenty of ammunition, also about twenty-five thousand bales of cotton."

NASHVILLE

THE campaigning of General Thomas since he and Sherman parted in northern Georgia had been strange and involved, with none of the dramatic simplicity of Sherman's march. General Schofield had written to Sherman that they in Tennessee had the work while he in Georgia had the fun. Schofield on leaving Sherman and trying to connect his force of 29,000 with Thomas at Nashville had to fight a battle with Hood's 41,000 Confederate troops at Franklin. Hood in desperate frontal attacks thrown back with losses of 6,000 as against 2,300 on the Union side, Schofield drew off. Hood followed. Schofield joined Thomas at Nashville. There Hood camped with his army, now reduced to 26,000, intending as he said in a report of December 11 "to force the enemy to take the initiative."

Meantime Washington worried. Stanton on December 2 telegraphed Grant: "The President feels solicitous about the disposition of General Thomas to lay in fortifications for an indefinite period 'until Wilson the commander of the cavalry gets equipments.' This looks like the McClellan and Rosecrans strategy of do nothing and let the rebels raid the country. The President wishes you to consider the matter." On this same December 2 Grant sent two dispatches to Thomas urging him to take the offensive, Thomas replying that in two or three days he would probably be ready. Four days

later Grant's sharp-toned order to Thomas ran: "Attack Hood at once and wait no longer for a remnant of your cavalry. There is great danger of delay resulting in a campaign back to the Ohio River." He would obey the order, responded Thomas, adding his belief it would be hazardous with the small force of cavalry at his service. Stanton the next day indulged himself with the telegraphed remark to Grant: "Thomas seems unwilling to attack because it is hazardous, as if all war was anything but hazardous."

Should Thomas have lashed out at Hood with all he had there in early December? Around this question military strategists of either desk or field could argue long. Thomas was naturally slow-moving, preferred walking his horse to a gallop. In the fierce and tumultuous campaign before Atlanta Sherman wrote of one action that it was "the only time during the campaign I can recall seeing General Thomas urge his horse into a gallop." Yet Thomas also, as Sherman saw him, had on occasion a granite-and-glacier certainty of movement.

On December 8 Grant wired Halleck: "If Thomas has not struck yet, he ought to be ordered to hand over his command to Schofield. There is no better man to repel an attack than Thomas but I fear he is too cautious to ever take the initiative."

Grant tried on this December 8 a further telegram to Thomas: "Why not attack at once? By all means avoid the contingency of a foot-race to see which, you or Hood, can beat to the Ohio." Thomas still delayed. In cavalry Hood outnumbered him four to one; he was getting remounts and hoped to have a force of 6,000. He wired Grant that in troop

concentration and transport "I have made every effort possible."

On Halleck's telegraphing Thomas that Grant was uneasy about the delay Thomas answered that he felt conscious of having done everything in his power to prepare, "and if General Grant should order me to be relieved, I will submit without a murmur. . . . The troops could not have been gotten ready before this. . . . A terrible storm of freezing weather has come on." The rain froze as it fell. A sheet of ice glazed the ground. Men and horses slipped. The weather favored defense. Grant to Thomas: "I have as much confidence in your conducting a battle rightly as I have in any other officer; but it has seemed to me that you have been slow, and I have had no explanation of affairs to convince me otherwise."

Thomas called his corps commanders, told them of the orders to attack Hood. The generals agreed that their commander should not fight till he was ready on the slippery hills around Nashville. No news of an attack reaching Grant, he wired December 11, "Let there be no further delay," Thomas replying, "I will obey the order as promptly as possible. The whole country is covered with a perfect sheet of ice and sleet." He would have attacked "yesterday had it not been for the storm."

Then came news that Thomas had launched his troops at Hood's army. Thomas telegraphed, December 15: "I attacked the enemy's left this morning, and drove it from the river below the city very nearly to the Franklin pike, a distance of about eight miles. . . . The troops behaved splendidly, all taking their share in assaulting and carrying the enemy's breast-works." That night the whole army slept on its guns

in line of battle and the next day pushed a broken and re-
treating enemy at all points. "I beheld," later wrote Hood,
"for the first and only time a Confederate army abandon
the field in confusion." No rout of the war had been so com-
plete. One factor was the cavalry for which Thomas had
delayed action. Hood's army as a unit vanished. Parts of it,
to the number of 15,000 men, held intact through the gen-
eralship of Forrest, who saved them for other Confederate
commands. The Confederate losses in killed and wounded
at least equaled the Union casualties of 3,000—and 4,462 Con-
federate prisoners were taken.

Sherman took pride in his friend "Old Tom" and was to
write of this battle that it was the only one of the war "which
annihilated an army." A famous metaphor was coined: the
Rock of Chickamauga became the Sledge of Nashville. To
a commission naming Thomas for the vacant major-general-
ship in the regular army Grant and Lincoln joined their
signatures.

For Grant the week had been, according to Colonel Horace
Porter, "the most anxious period of his entire military career,"
and before the victory came "he suffered mental torture."
To Grant, Thomas was one piece in a big game involving
other pieces and Grant was trying to time and co-ordinate
them toward destroying the three Confederate armies left.
When Thomas won, there would be only two.

Piece by piece the Union armies had now carried the Fed-
eral flag into an area much more than half the size of the
seceded States. The slicing of the Confederacy in two by
Sherman's march had now about wrecked Confederate trans-

fers of troops and supplies between eastern and western se-
ceded States.

The land areas lost to the Confederacy spelled men lost
too. "The need of men was never greater," wrote Lee to
Davis in October. If the entire arms-bearing population in
Virginia and North Carolina, along with Negroes to relieve
all labor details, could be gotten into service, "we may be
able, with the blessing of God, to keep the enemy in check
till the beginning of winter. If we fail to do this, the result
may be calamitous." Now after two months Lee's tone to
Davis was still graver.

Lee's distressing need for men ran back in part to an
order of Grant in April that not another Confederate pris-
oner of war should be paroled or exchanged until certain
conditions were met that Grant probably knew would never
be met. Not until August did Grant come out with his real
reason for this policy. Cruel it was, he admitted, but neces-
sary. "Every man we hold, when released on parole or other-
wise, becomes an active soldier against us at once either di-
rectly or indirectly. If we commence a system of exchange
which liberates all prisoners taken, we will have to fight on
until the whole South is exterminated. If we hold those caught
they amount to no more than dead men." At the particular
time in late summer when the Confederate Government pro-
posed to exchange prisoners man for man, said Grant, it
"would insure Sherman's defeat" and "compromise safety"
at Richmond.

Many were the influences brought to bear on Lincoln to
reverse or modify this policy of Grant. Arguments based on
political power and made in the name of reason, cries and

prayers for the sake of humanity, rang in his ears. But Lincoln stood by his general. He let Grant have his way. And at this time there raged over the North a propaganda of horror with proposals of vengeance for the inhuman handling of Union soldiers in Southern prisons. They were starved. And they died of starvation. This was fact. They festered in rags and became living skeletons, chilled and shivering. This, for many, was fact. Atrocities monstrous and almost beyond belief were told of in Northern newspapers and pulpits and on political platforms. These too had some basis of fact. But the South had its answers. And these too held facts. Where in the South were any such parades of pleasure and riots of luxury as could be seen in the metropolitan centers of the North? Measure the South's suffering, estimate its starvation and deprivation, and see how it would compare with that of the North. A shelf of competent testimony would reduce to a verdict of both sides making war as war had always been made, with results of suffering distributed alike among good and bad people, the innocent with the guilty—and meaning brought to the word "agony." The so-called laws of war were being violated, as in former wars, on both sides.

"Andersonville" in the North meant horror beyond words. A 27-acre piece of marshland in southwestern Georgia, fenced and stockaded for Union prisoners, bare of trees and hiding-places, was Andersonville. Those in the North supposed to inform the kinfolk of a man that he had been sent to Andersonville found it hard to say the name of the place, or they said something else or the tone of voice dropped low. A man going there died a dirty and lingering death; or killed himself by stepping over a line where guards at once

put a bullet through him for attempted escape; or lost his mind; or by slim chance issued forth to freedom somehow with a woebegone look and a wild-animal stare in his eyes. When a few of these hunted ones had crept into Sherman's camp one night at Milledgeville, the sight of them had brought mutterings of revenge.

The place named Andersonville won distinction as the one spot on the North American map where war was more hideous to look at than any other spot that could be named. In its close-packed and swarming population was less food and more scurvy and starvation; less soap and more filth and lice; less medicine and more gangrene, fever, and sores, than anywhere else in America.

The bloodiest battle of the war had not taken such a toll of death as Andersonville from June to September, 1864, with its record of 8,589 dying. This reduced the peak population of 32,000 and enlarged the average space of six square feet per man.

The Southern summer heat was bad for men from the North, and the Northern zero winter weather not so good for those from the South. Official statistics ran that twelve of every hundred Confederate prisoners died at the North, while fifteen died of every hundred Union captives in the South. Medical men agreed too that the Southern troops were undernourished because of their own armies' inferior food supply, and therefore less resistant to disease.

Food was a factor. The Union armies were better fed. Nothing in all the letters and communications of Robert E. Lee stood forth more tragically heroic than his calm and but slightly emotional statements to President Davis about the

supply wagons going out and coming back with little or
nothing. The inference for Davis was that Lee and his men
would not cry nor complain, they would go on fighting,
though they could fight better on less empty bellies.

Want and hunger, however, threatened the life arteries of
the Confederacy less than its own internal strife. The No-
vember message of President Davis to the Confederate Con-
gress spoke desperately of conspiracies, of traitors and spies
inside their own house. Was there one fatal flaw he was
barred from discussing? If each State was sovereign, and suffi-
cient to itself in authority, how could the central Confederate
Government at Richmond demand or enforce complete
loyalty of any State wavering in duty? The Confederacy
was built on the basic theory that each State could do as it
pleased and the first duty of any citizen was to be loyal to
his State. What any State capital announced was more im-
portant and authoritative to the people of that State than
any proclamations from the Richmond Government. This
faith in States' Rights as much as want or military defeat
was a gnawing and devitalizing factor in the Confederacy,
giving rise to its President being distressed over conspiracies,
traitors, and spies within their own house.

Not yet had there been open secession among the Con-
federate States of America, but the temper and tone in which
its Government was challenged indicated that in peacetime,
could it achieve a peace, it would be a loose league of sover-
eign States and not a nation.

Outside the gates of Richmond sat Grant with 75,000
troops, 20,000 having been sent to take Fort Fisher. And
Grant in this December of '64 gave to Colonel Sharpe, his

chief of secret information, the cold and brutal facts of the present strategy. "Lee's present 55,000 is not at all the old material. It is all that he can rake and scrape—clerks, Government employes, detailed men and all. Of his old fighting stock he has about 22,000 men left. These men *we must kill* before the country can have peace. They are old soldiers and fierce slave-holders. These men have got to be used up." Of his own army, "sadly reduced" from what it was when the spring campaign started, Grant would reply to those saying it had accomplished nothing: "This year in ruining itself in nine pitched battles, it ruined Lee and one week's more fighting would have left him nothing to fight with." And of the present stand: "Lee can keep his army just where it is, but he can't attack, nor can he fight a battle. Victory or defeat would be alike ruinous."

Naval operations and the stranglehold of the blockade had now left only one port into which blockade-runners could bring supplies from England. This port of Wilmington, North Carolina, would be lost if its defending Fort Fisher should fall. General Butler's wily head worked out a plan to run a powder-loaded steamer near the shore under the fort, have a clockwork blow up the boat, and in the ensuing havoc and confusion move in troops to take the fort. "I had no confidence in the success of the scheme, and so expressed myself," wrote Grant later; "but as no serious harm could come of the experiment, and the authorities at Washington seemed desirous to have it tried, I permitted it."

General Benjamin F. Butler of Massachusetts, heavy of body and somewhat corpulent, sleepy-eyed with cunning, a cast in his eye, was at every moment an actor, with ready

answers fitting his favorite combined role of the Man of the People and the Man Who Knows How. He was believed by many to be crooked in law and politics.

Admiral Porter with a naval squadron, General Butler with troop transports, joined their efforts. After Butler sailed from Fortress Monroe "three days of fine weather were squan-

A bow gun

dered," according to Grant. Then heavy storms delayed action. At last on the night of December 23 the powder steamer was towed in near the fort, the clockwork set, and everybody left. "At two o'clock in the morning," wrote Grant, "the explosion took place—and produced no more effect on the fort, or anything else on land, than the bursting of a boiler anywhere on the Atlantic Ocean." Porter shelled the fort with no damaging results. Butler landed troops, won footings, then drew away, put his troops back on the transports, and told Porter he was through.

Grant, however, on hearing from Admiral Porter that the

army had quit when they nearly had Fort Fisher, sent word to Porter to hold on, to stay near Wilmington, that they would soon close that last Confederate port through which came medicine, food, metals, clothing, salt, arms, blankets, from Europe.

Late on the night of January 15, 1865, after three days' bombardment by a fleet under Admiral Porter, and desperate hand-to-hand fighting between the garrison and the assaulting infantry under General Alfred H. Terry, Fort Fisher fell. Wilmington, the last open port of the Confederacy, was closed to incoming supplies and outgoing cotton.

The *Richmond Enquirer* dismissed the event with "Nothing from abroad is indispensable to a brave and determined people." The *Richmond Whig* had seen New Orleans lost, the Mississippi River lost, Savannah lost, and each time the Confederacy had survived. "Therefore, we can stand the loss of Fort Fisher." One thing the Confederacy could not survive, "loss of spirit and determination," continued the *Whig*. "Let the people be firm, let them show determination to resist to the last dollar and the last man, and the capture of all our seaports will be of no moment whatsoever."

To no one was the taking of Fort Fisher more galling news than to Major General Benjamin F. Butler. Practically every move in the capture of the fort had been the same as when Butler advanced on it in December—except that instead of returning the troops to the transports and saying the job was impossible, as in December under Butler, General Terry sent the troops in and they took the fort, losing in round numbers of 600 as against the same for the garrison.

CHAPTER 25

HEAVY SMOKE—DARK SMOKE

A SOCIAL revolution moved toward its final collapses and shadows. The Southern planter class read a handwriting on the wall of fate. Not yet did the letters spell out the shape of their doom—but doom enough had already come to make it a dark story.

For thirty years this class had kept its hands on the economic controls of the South, managed its main political decisions, developed and spread as a necessity the doctrines of States' Rights, secession, the sanctity of the institution of slavery not to be compromised, modified, nor in any essential touched.

From this class came enough spokesmen and influence in the Confederate Congress at Richmond this fourth winter of the war to overcome the proposals of Davis, Lee, and others that Negro slaves be freed to fight alongside their masters for Southern independence. That Lincoln had blocked European recognition of the Confederacy by an Emancipation Proclamation revealed nothing to these die-hards. That they might have won recognition, supplies, funds, fresh replacements of black troops, had they changed front and with a wide gesture abolished slavery—this never dawned on them. To Davis and Lee there seemed this winter a last hope of holding out against the North by giving freedom to blacks who would

fight. To the extremist slaveowning element this had no appeal, seemed near treason to the Confederate cause.

Into Richmond came Lee one day to speak for the underfed, ragged Army of Northern Virginia, a valiant and proved army. To and fro in his own home he paced after dinner, tramping with his hands behind him, grave, troubled, as his son Custis later told it. Suddenly he stopped before Custis seated by the fire.

"Well," said General Lee . . . "I have been up to see the Congress and they do not seem to be able to do anything except to eat peanuts and chew tobacco, while my army is starving. I told them the condition the men were in, and that something must be done at once, but I can't get them to do anything, or they are unable to do anything." Bitter was General Lee's tone of voice. He paced to and fro again. He stopped and spoke again to his son. "Mr. Custis, when this war began I was opposed to it, bitterly opposed to it, and I told these people that unless every man should do his whole duty, they would repent it, and now"—pausing as if for emphasis—"they will repent."

At the Confederate White House, members of the Congress advised General Lee to "cheer up," one saying, "We have done good work for you today," in passing a bill "to raise an additional 15,000 men for you." Lee bowed. "Yes, passing resolutions is kindly meant, but getting the men is another matter." He hesitated a moment, then with flashing eyes, "Yet, if I had 15,000 fresh troops, things would look very different."

So the hour seemed at hand when the Confederacy had put into use its last white man—and the efforts of Davis and

Lee to put black men in fighting service were blocked by an element afraid of it as a departure from traditions of the white race and from long-sanctioned property rights.

In the coming April the war would have lasted four years. This four-year period of fierce, open, and declared war had suddenly issued from a thirty-year minor storm, preparatory weather filled with angry debate, tumults and threatenings, open and covert violence.

Entanglements and obstacles not foreseen by the secessionists when they launched their revolution in '61 stood now more clear. At the start they had to erect a government, starting "from scratch" without practice in administration of such a government. They were outnumbered to begin with and while the war went on the North grew further in numbers. The rumor ran across the South in January of '65 that Lincoln was raising a final army of 1,000,000 men. It was troublesome even where it was discredited—because it was nearly half true. The blockade had tightened. The partial isolation of the South was becoming complete. In munitions, supplies, transport, the South began with handicaps and now made a desperate comparison with the North steadily reaching new production peaks. The agricultural South was losing to the industrial North. The South had correctly forecast that New England would furnish abolitionist cohorts to fight with passion for Negro freedom—and guessed completely wrong on the depth of the Union sentiment of Northwest, Midwest, and Border States. Elemental passion underlay Congressman John A. Logan's saying in '61 that if the South attempted to close the Mississippi River "the men of the

Northwest would hew their way to the Gulf with their swords."

Sherman's men now at Savannah-by-the-Sea felt themselves perhaps intruders but no aliens there—they saw themselves fighting for the inherent right of Iowa, bounded by two muddy rivers, to ship its corn and cattle freely at any port on the two coasts of the United States. In inland South Carolina Sherman's men were to feel themselves somewhat alien, believing that soil a grower of treasons, and they were preparing to treat its people and cities with a vengeance they had not let loose in Georgia. And from "the mother-country," as the *Charleston Mercury* formerly so often termed England, had come help but no recognition, no British fleet to relieve Southern ports—this because the instigators of secession in '61 had guessed wrong on world sentiment regarding slavery, on an immense humanity shaken with feeling that the buying and selling of human beings, even if black-skinned and primitive, should be outlawed.

Those blaming Jefferson Davis for Southern failure were in part hunting a scapegoat, as he was not to blame for the basic handicaps of the Confederacy. He personified the Southern planter class in its pride, its aristocratic feudal outlook on life and people, its agrarian isolation barred from understanding that fraction of the North which held the Union of States a dream worth sacrifice; in its lack of touch with an almost world-wide abhorrence of slavery as distinguished from what was called "nigger-loving."

The war years rolled on and Davis failed to become either an idol or a name and a figure of faith—like Robert E. Lee. Yet Lee had never been such a spokesman of the Confederate

cause as Davis. On the death of his wife's mother in 1862
Lee emancipated the slaves to which his family fell heir. Pri-
vately Lee spoke of slavery as a sinister, insidious, menacing
institution—the view of his high exemplar George Washing-
ton. As a voice of States' Rights and secession Lee had no
reputation at all; he was a Virginian, a trained man of war,
a born fighting man loyal to Virginia even after Virginia se-
ceded and moved, against his wish, out of the Union. In his
very silence about why the war was being fought, in the
wide and deep love for him because while keeping silence
he fought so magnificently—in this was some clue to the hu-
man dignity of a certain remnant of the Confederacy ready
for sacrifice rather than submit to those they termed invaders.

As the pressure became fiercer in early '65 Lee consented,
in perfect accord with Davis, to take chief command of all
the Confederate armies. As a first move he appointed General
Joseph E. Johnston to head an army, made from various
fragments, to block the path of Sherman from Savannah up
across the Carolinas. This reflected Lee's judgment that
Davis had been mistaken in his abrupt dismissal of Johnston.

"If a surgeon is within call, and not too busy," said John-
ston once in battle as he reeled in his saddle from a bullet
shot, "at his convenience, perfect convenience—he might as
well look me over." Johnston had what they called "the iron
bearing of the soldier." With this commander Davis had
kept up a running quarrel throughout the war. With Nathan
Bedford Forrest, Davis had not so much of a quarrel, though
he refused to agree with those who held Forrest the full
equal of Stonewall Jackson in daring, mobility, strategy—the

Forrest who, Sherman admitted, gave him more trouble than any Confederate commander on the horizon.

A host of personal matters such as the foregoing were covered in a *Charleston Mercury* editorial of January 10, 1865, drawing a deadly parallel between Davis and Lincoln. The contrast was appalling, sickening, noted the *Mercury*. In all departments, military, foreign, political, everywhere in the Confederate Government reigned "a pandemonium of imbecility, laxness, laxity, weakness, failure." Brave and able men were not lacking in the army. "We have an abundance of both. But they are so circumscribed and controlled as to produce weakness throughout."

The *Mercury* spoke for the faction which brought chief command to Lee. Hands with an iron will must be lifted toward the executive authority, with the earnest words "Do as we command, or vacate your position." This editorial was probably the most shrill and tragic cry of despair—and the most inequitable assessment of justice—that had as yet been raised in the Confederacy against the Davis regime in Richmond.

In the North disputes over how to run the war rose less often now. The war machine ran with fewer blowups. To Lincoln's desk came fewer tangled military matters for his final decision. During many sessions of House and Senate the war was scarcely mentioned. Discussions ran as though no war at all was on, almost as though peace had settled on the country and the call now was to build the Pacific railway, improve rivers and harbors, dig canals, make land grants to railroads and homesteaders, perfect coast surveys, ease commerce between the States, resettle Indian tribes. The draft

now had stiffer enforcement, less resistance and evasion. Deserters met less mercy.

On the point of information service Grant now had the advantage of Lee. Deserters each month by thousands, tired of short rations and hard fare in the Confederate Army, crossed the picket lines, nightly expected and welcomed by the Union forces. Always some of them would talk.

Now for the first time since the Confederate capital had been moved to Richmond, Jefferson Davis asked his Vice-President Alexander Stephens to meet him in conference. Also Davis called his Cabinet on the matter of sending commissioners to Lincoln to negotiate over peace. Stephens suggested the names of three commissioners. Davis agreed with one of the names, John A. Campbell, Assistant Secretary of War and former United States Supreme Court Justice, added R. M. T. Hunter, Senator and ex-Secretary of State, and Stephens himself. These were all three "peace men" or "submissionists" rather than uncompromising last-ditchers.

The short, stubby, deep-chested man Ulysses S. Grant sat writing before an open fire in a log cabin lighted by a sputtering kerosene lamp. Another short man, at first shadowy and elusive to look at, having a wax-white face with burning eyes, the frail Alexander H. Stephens, sat watching Grant work. No guards nor aides were around, noticed Stephens, who had expected more show-off in the headquarters of the General in Chief of the United States armies. The two men just naturally liked each other, they found out. It was easy for them to talk. Both were old Steve Douglas Democrats. Both hoped for peace soon. But peace how?

With his two fellow commissioners Stephens had come to the Union Army lines on the evening of January 29, claiming that an understanding existed with General Grant to pass them on their way to Washington. On this being telegraphed to Washington, Lincoln at once sent Major Eckert of the war telegraph office with written directions to let the commissioners in with safe-conduct if they would say in writing that they were ready to talk peace on the basis of peace for "our one common country." Before Eckert arrived with this message the commissioners applied by a written note to General Grant for permission "to proceed to Washington to hold a conference with President Lincoln upon the subject of the existing war, and with a view of ascertaining upon what terms it may be terminated."

On receiving their note to him at dusk of evening Grant at once telegraphed it to Stanton and Lincoln. Lincoln decided he would not personally meet the commissioners. Instead he sent Seward to meet them at Fortress Monroe, giving Seward written instructions that he was to make known to them three things as indispensable to peace: "1. The restoration of the national authority throughout all the States. 2. No receding by the executive of the United States on the slavery question from the position assumed thereon in the late annual message to Congress, and in preceding documents. 3. No cessation of hostilities short of an end of the war, and the disbanding of all forces hostile to the government." All propositions of theirs, not inconsistent with these points, would be considered in a spirit of sincere liberality. "You," Seward was instructed, "will hear all they may choose to say, and

report it to me. You will not assume to definitely consum-
mate anything."

With this in his pocket Seward started February 1, while
Lincoln telegraphed Grant to let the war go on while peace
was talked. "Let nothing which is transpiring change, hinder,
or delay your military movements or plans." Grant promised
in reply there would be no armistice, that troops were "kept
in readiness to move at the shortest notice."

On this same day of February 1 Major Eckert arrived at
City Point, and acting under Lincoln's instructions went
alone to meet the three Confederate commissioners. Eckert
told the commissioners all proceedings must be in writing,
gave them a copy of his instructions from President Lincoln,
and left them studying those instructions.

The three commissioners considered the very explicit in-
structions from the President of the United States that they
must agree in writing to no peace talk except on the basis of
peace for "our one common country." Their answer was a
refusal. So their mission seemed at an end. They might as
well go back to Richmond. So it seemed. Eckert telegraphed
Lincoln that their reply was "not satisfactory" and notified
the commissioners they could not proceed.

About an hour after their refusal to meet Lincoln's terms,
Grant sent a long telegram to the Secretary of War, stating
"confidentially, but not officially—to become a matter of
record" that he was convinced on conversation with Messrs.
Hunter and Stephens "that their intentions are good and
their desire sincere to restore peace and union." And the
Grant so shrewd in management of men put the high point
of his letter in one sentence: "I am sorry, however, that Mr.

Lincoln cannot have an interview with the two named in this despatch [Stephens and Hunter], if not all three now within our lines."

Lincoln the next morning walked over to the War Office, read Major Eckert's report, was framing a telegram to call Seward back, when Grant's long telegram of the night before was put in his hands. "This despatch," wrote Lincoln later . . . "changed my purpose." It spoke to him.

He at once wired Grant: "Say to the gentlemen I will meet them personally at Fortress Monroe as soon as I can get there."

Down the Potomac on a naval vessel to Hampton Roads alongside Fortress Monroe, his personal guard a White House valet or footman carrying his traveling bag, Lincoln journeyed to meet a former United States Senator from Virginia, a former Associate Justice of the Supreme Court of the United States, and a former Georgia member of the United States House of Representatives.

"On the night of the 2d [of February]," ran Lincoln's account, "I reached Hampton Roads, found the Secretary of State and Major Eckert on a steamer anchored offshore, and learned of them that the Richmond gentlemen were on another steamer also anchored offshore, in the Roads; and that the Secretary of State had not yet seen or communicated with them. . . . On the morning of the 3d, the three gentlemen, Messrs. Stephens, Hunter, and Campbell, came aboard of our steamer, and had an interview with the Secretary of State and myself, of several hours' duration." The instructions which the President had written for Seward were insisted on. "By the other party, it was not said that in any event or

on any condition, they ever would consent to reunion; and yet they equally omitted to declare that they never would so consent. They seemed to desire a postponement of that question [of reunion of the States], and the adoption of some other course first which, as some of them seemed to argue, might or might not lead to reunion; but which course, we thought, would amount to an indefinite postponement. The conference ended without result."

So the war would go on.

SHERMAN IN SOUTH CAROLINA

OUT of Savannah on February 1 Sherman moved, his plan of campaign a secret, his lines of march baffling, the outside world unaware whether he was heading along the coast to Charleston or inland to Columbia. Now a dispatch came through to Stanton and Lincoln that his route was inland, crossing the Salkehatchie River first, moving into Whippy Swamp. Before starting Sherman had said this march would be ten times as difficult, ten times more important, than the one from Atlanta to the sea. Able Confederate generals believed it impossible. Hardee at Charleston was sure that Sherman would not be so reckless. General Joseph E. Johnston, one of the supreme strategists of the war, waiting in North Carolina with 40,000 Confederate troops to meet Sherman, wrote that his engineers reported it was "absolutely impossible for any army to march across lower portions of the State in winter." To Johnston came a telegram from Hardee, "The Salk [short name for Salkehatchie] is impassable." Undoubtedly similar reports of a fearful area to traverse had come to Lincoln at Washington. His anxiety was deep. If Sherman now came through, the long war might be near its end.

In two columns with outriding cavalry Sherman's 60,000 men moved over the soil of the State that had led off in secession. Continuous winter rains had swollen all streams. Coun-

try not under water was mud and quagmire. They marched day on day with rain about two days out of three. They crossed five large navigable rivers, swollen torrents. From high waters near the Savannah River, they plunged into the

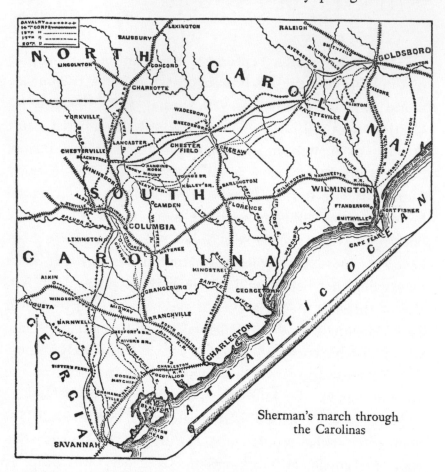

Sherman's march through
the Carolinas

swamps of the Combahee and the Edisto, negotiated the hills and rocks of the Santee, crossed flats of river land where Confederate cavalry with details of Negro laborers had cut down trees, burned bridges, and pulled out culverts. The advance pioneer corps performed heavy and skilled labor. At

times every private in the army served as a pioneer, split saplings and carried fence rails for corduroy roads, laid pontoons, cleared entanglements. They waded streams, no time to bridge. Some forces worked for hours waist-deep in icy floodwaters. General Joseph E. Johnston said at a later time, "I made up my mind there had been no such army since the days of Julius Caesar."

The personnel of this army of Sherman had names that meant nothing beyond its picket lines, men who loved war as a game and were born to it. These men knew each other—though to the outside world they were nameless shadows whose work and bravery in degree underlay the mighty name of Sherman. At the War Department or in the White House at Washington, as an instance, the name of Joseph Anthony Mower meant nothing in particular, a rather ordinary division or corps commander. Yet Mower was a phenomenon, one of the strangest personalities of the war. No West Pointer, a Mexican War volunteer private, in September of '61 commissioned a captain, he so fought and marched with his men that in August of '64 he was made major general of volunteers. A rough, irascible, hairy six-footer, swearing through his dark tawny whiskers, "you always had to look for him in the front line," said other officers. "He never spoke of himself," said Sherman, who added without reserve, "A better soldier or a braver man never lived."

Over and again Grant and Sherman had used Mower as a smasher. They could count on him to bore in and crack an enemy line. He had a marvelous instinct for holding his men, letting the enemy dash himself to pieces against his rifle fire, then knew precisely the split second to yell "Charge!" The

reports were monotonous: "General Mower drove the enemy two miles." He wrote few letters, seemed careless of distinction. Several successive sets of his staff officers had been killed in action while trying to keep pace with him. From a work of clearing Missouri of Confederate forces, on Sherman's request Mower had been ordered East, had hurried to join up for the march from Savannah. In the forefront, a terrific marcher of men, he led them through rain and mud, through icy hip-deep waters, taking the punishments of bad weather and outdoor sleeping with his troops. His fellow officers could hardly find words to describe how superbly he handled his men in the push through the Salkehatchie swamps. One of the greatest of American soldiers, he was also one of the many valorous, picturesque unknowns, a grim, silent man with a contempt of either death or fame.

Confederate forces of about 15,000, chiefly under General Wade Hampton, made no headway in stopping the Northern invaders, who seemed to have saved their fury for South Carolina. Sherman wrote later of noticing that his men were determined to visit on South Carolina "the scourge of war in its worst form," and of his conclusion that "we would not be able to restrain our men as we had done in Georgia." Troops of the 2d Minnesota heard Kilpatrick, the cavalry head: "There'll be damn little for you infantrymen to destroy after I've passed through that hell-hole of secession." This from Kilpatrick just after the crossing of the Savannah River, when torpedoes mining the roadway had exploded, killing and wounding several soldiers.

Troops of the 15th Corps were heard to say, "Here is where treason began and, by God, here is where it shall end."

Officially Sherman's orders, as in Georgia, were against wanton violence and destruction, but they were not repeated now. He wanted terror and proceeded to achieve it. His theory was that South Carolina more than any other State had instigated the war, had welcomed it when it began, had asked for what it was now to get, "a bellyful of war."

At the start of this march Sherman wrote to a lifelong friend, a Baltimore woman, "I will enter Carolina not as they say with a heart bent on desolation and destruction but to vindicate the just powers of a government which received terrible insults at the hands of the people of that State."

Undoubtedly his men went farther in robbery, violence, and vicious capers than he cared to have them, but their toils and marches, their readiness for hardship and fighting, were such that Sherman could not bring himself to penalize them. For himself he slept in a tree one night of flood, another night on a hard board church pew, living mostly as plain as any private. More than once he threatened to send the 8th Missouri to the rear for punishment, but knowing their valor over and again in battle, he said, "I would have pardoned them for anything short of treason."

Foragers stripped the country of many farm buildings, farm animals, fences, much property, and food of all descriptions. The railroads were torn up, and weather permitting, bridges burned, cotton bales set blazing, vacant dwellings and barns fired. Looters and "bummers" (as the South called Sherman's men) stole jewelry, watches, and silverware, smashed pianos and shattered mirrors, though the extent and the manner of these outrages became an issue of veracity as between Northern and Southern witnesses.

Eighteen Union soldiers were found with papers fastened to them reading "Death to foragers," some throats slit from ear to ear. Kilpatrick came storming to Sherman about this; the order from Sherman was to "kill man for man" and to mark the bodies in the same style.

It was heartbreak time in South Carolina. The rains fell on the drooping Spanish moss of the live oaks.

In bloody actions of February 5, 6, and 7 Grant had so struck at Lee that by no chance could Lee send any men toward Sherman.

In Washington on February 22 by order of the President there was a night illumination of the high domed building on the top of Capitol Hill—lights and singing bright windows in honor and celebration of victories resulting in Columbia, Charleston, Wilmington, and a fresh wide area coming again under the United States flag.

LINCOLN VISITS GRANT'S ARMY

DURING the month of March, 1865, more than 3,000 Confederate deserters were received in Washington, thousands more at Fortress Monroe, Annapolis, and other points. Further thousands of Confederate soldiers, absent without leave, had gone home or joined guerrilla and bushwhacker outfits or had gone North and found jobs. Of the total of 600,000 Confederate troops in the field two years before it was believed at least half of those alive had left the service for home and were now deaf or indifferent to any calls for fighting men. They had seen enough.

Sheridan the destroyer had driven the last of Early's army out of the Shenandoah Valley and his report in late March listed 780 barns burned, 420,000 bushels of wheat taken, also 700,000 rounds of ammunition, 2,557 horses, 7,152 head of beef cattle. So often now the wagons of Lee went out for food and came back empty. In comparison Grant's military city, and its line of tents and huts along a forty-mile front south of Richmond, was rather snug and cozy. When it wanted food, clothing, supplies, guns, munitions, telegrams went north and by steam transport on land and water, the cargoes arrived. The besiegers had nearly everything requisite of material and supplies. In beleaguered Richmond was starvation and want.

At last after long bickering, and through the Confederate Senate reversing itself and by a majority of one voting to arm the slaves for defense, President Davis signing the bill—at last the Negro slave was to be put in the army to fight for his master. This was one final hope for more soldiers.

Apricot blossoms came out and the bright Judas tree, the redbud, again failed not this spring—but down the river the low roar of Grant's guns broke on the air. And Robert E. Lee took note of the Union Army having "an overwhelming superiority of numbers and resources."

Meantime Johnston on March 11 notified Lee that if a Federal force of some 20,000 moving from the seacoast and Wilmington should manage to join Sherman's 60,000, Johnston with his 40,000 would not be able to stop them from marching up into Virginia. Up across North Carolina marched Sherman to Fayetteville, then to Goldsboro, where he paused for rest. There at Goldsboro March 23 he met General Terry and the troops that had taken Fort Fisher and Wilmington.

Another Sherman campaign was over, this time with 80,000 men answering roll call.

Sherman's 60,000 had a right to a rest. Behind them toward Savannah lay four hundred and twenty-five miles of foraged and ravaged country, Sherman terming their exploit "one of the longest and most important marches ever made by an organized army in a civilized country." Their legs had performed. Add the hike from Atlanta to the sea, then add other footwork since raids in Mississippi in July of '63—and their mileage was colossal. They had come on their feet no less than 2,500 miles, fording ordinary streams and flooded rivers,

through rains and hot sun, over mountains and plains, across marshes and swamps where day after day every private was a toiling unit of the engineer corps. On speared bayonets some now carried potatoes, others pigs. Many were ragged, their trousers half gone from tussling through underbrush. More than half had thrown away their worn-out shoes, some walking barefoot, others with feet wrapped in blanket pieces. They leaped and shouted as they slid into new issues of shoes, uniforms, overcoats, at Goldsboro.

They were mainly from the West, the Midwest, and the Northwest. Already was talk in the North about whether they were to go on and take Richmond and Lee's army, with the result that history would say Westerners won the war. But that was a small matter. It could wait. They had joyous legs. Spring shone with lilacs and apple blossoms. The new shoes and trousers felt good. Not much longer could the war last. Daylight was ahead and home folks, girls and women.

These weeks in latter March and early April, Grant wrote later, were for him "the most anxious" of the whole war. Lee was hemmed in with food and supplies cut off to such an extent that Grant figured Lee must soon try to break through or swing around the Union lines. "I was afraid, every morning, that I would awake from my sleep to hear that Lee had gone, and that nothing was left but a picket line. He had his railroad by the way of Danville south, and I was afraid that he was running off his men and all stores and ordinance except such as it would be necessary to carry with him for his immediate defense. I knew he could move much more lightly and rapidly than I, and that, if he got the start, he would

leave me behind so that we would have the same army to fight again farther south—and the war might be prolonged another year."

On the news that Sherman with 80,000 troops rested and waited in North Carolina not far from the Virginia line, Lincoln left Washington to visit with Grant, to stay with Grant's army he did not know how many days, perhaps a week or two. Grant on March 20 sent Lincoln as cordial an invitation as could be asked: "Can you not visit City Point for a day or two? I would like very much to see you, and I think the rest would do you good." By this visit Lincoln would serve two purposes. He would have a needed vacation, a breakaway from many pressures at Washington. And he might in various ways accomplish something around the question of what terms should end the war. Early in March this matter came to a head. Word from Lee to Grant then could be taken to mean that those two commanders might get together, agree to disband their armies, and end the war with confusion in the air. Wherefore on March 3 Lincoln wrote an order for Stanton to send to Grant.

This order indicated Grant's line of authority in dealing with any proposals for peace. The President wished him to have no conference with General Lee unless it should be for the capitulation of Lee's army, or on some minor or purely military affair.

On the *River Queen*, with the *Bat* as convoy, the Lincoln family made the trip. Down the Potomac and up the James River they went on a holiday—and some very strict and secretive business.

They pulled away from the Sixth Street wharf in Washington at 1 P.M., March 23, and about nine o'clock the evening of the next day tied to the wharf at City Point, from the deck gazing off into the night and the grim quiet mystery lying just yonder where 130,000 well-fed, well-clad Union soldiers for ten months had been trying to trap 50,000 ill-fed, ill-clad Confederates.

The sun would rise in the morning and go down in the evening how many times, with how many men broken and mangled, before this drama of national agony would be over? This the whole world was asking. Here on this Virginia ground the immediate action, the fury and the grief, would take place.

Grant came aboard with greetings and the news. Any hour he expected the enemy, because of their forces dwindling through desertion, to make a desperate attempt to crash the Union lines and force a path toward joining Johnston in North Carolina. Such an attempt was preparing as he spoke, and came before daylight. But the Confederate assault was repelled.

Officers, including Admiral David D. Porter, came aboard to pay their respects in the morning of the twenty-fifth. The party went ashore and walked to Grant's headquarters. Lincoln wanted to look over the scene of the morning fight. Grant said the President couldn't be exposed to fire. On later reports Grant said the President could go.

Behind a slow-going locomotive in a jolting coach over the military railroad from City Point toward the front Lincoln rode past scenery where in the first daylight hours that morning men were mowed down by fort guns and men had

fought hand to hand with bayonet and clubbed musket. Confederate troops under General John B. Gordon had taken Fort Stedman and pressed on with the aim of destroying a railroad and Union supply store. Had they won through, Lee would have had an open road to Johnston in North Carolina. Grant expected an attempted break through his lines and made a close guess as to where it would come. At the embankment of the railroad which Gordon sought to destroy, the Union troops had rallied, had driven the enemy back and retaken Fort Stedman.

Lincoln's coach halted at the point on the railroad embankment where the Unionists began to regain lost ground. This was where Lincoln first saw close up the results of desperate combat on more than a small scale. Reports gave Union losses at 500 killed and wounded, 500 captured; Confederate losses 800 killed and wounded, 1,800 captured.

It was a fine day, without wind, spring in the air, the earth awaking again after the winter sleep under changing rain, snow, and sleet. In company with General Meade, Lincoln rode to a high slope and viewed the landscape over which the Confederate thrust had swept forward, halted, broken.

The entire action that day, of which Lincoln saw vividly a section, was later sketched by Grant in five sentences: "Parke threw a line around outside of the captured fort and batteries, and communication was once more established. The artillery fire was kept up so continuously that it was impossible for the Confederates to retreat, and equally impossible for reinforcements to join them. They all, therefore, fell captives into our hands. This effort of Lee's cost him about

four thousand men, and resulted in their killing, wounding and capturing about two thousand of ours."

On the soil where Union countercharges began Lincoln saw the dead in blue and gray and butternut lying huddled and silent, here and there the wounded gasping and groaning. Burial squads were at work. Surgeons were doing their service and Sanitary Commission workers giving out water and

Soldier huts at Dutch Gap

food. Herded by their guards was a collection of prisoners taken that morning, a ragged and dusty crew.

Beyond the immediate scene that Lincoln gazed on that day other fighting had gone on. The Union troops advanced along the whole of Lee's right, taking entrenched picket lines. The Union estimate put their own losses at 2,080 as against 4,800 to 5,000 Confederate. Lee the next day was writing President Davis, "I fear now it will be impossible to prevent a junction between Grant and Sherman." Johnston, Lee further informed Davis, reported only 13,500 infantry, a loss of 8,000 men, largely by desertion. The united armies of Grant and Sherman, Lee estimated, "would exceed ours by nearly one hundred thousand." It was seven weeks since Lee

had notified the Secretary of War at Richmond, "You must not be surprised if calamity befalls us."

Out in the dark that night along a forty-mile front 100,000 men and more lived hugging the dirt of the earth, some in tents but more in huts and shelters flung up somehow amid

An angle of Fort Hell (Sedgwick), showing gabions, chevaux-de-frise, abatis, and fraise. From a photograph.

trenches, forts, rifle pits, embrasures, barricades, and the first frail works of far picket lines where lonesome squads spoke, if at all, in whispers. Soon they might go into the wildest, bloodiest battle of the whole war. This was quite possible. Beyond a horror-dripping victory ending the war lay the solemn matter of what kind of a peace should be signed.

Four years now the war had gone on, four years lacking not quite three weeks since Fort Sumter at Charleston crumbled. Now that fort was under repair, getting fixed over, and

a flag-raising ceremony was to be held, with the Union banner again floating from that citadel where the war began. A white-haired old man, feeble for his sixty years, proud of Sherman and saying of the man whose strategy had again brought Fort Sumter into Federal control, "He is one of my boys"—Robert Anderson on the retired list was to go to Charleston for the flag-raising over the ramparts where he had seen his flag shot away.

Down in North Carolina that week Sherman said: "I'm going up to see Grant for five minutes and have it all chalked out for me and then come back and pitch in. I only want to see him for five minutes and won't be gone but two or three days." A steamer put Sherman ashore at City Point late in the afternoon of this March 27. Grant was there waiting. They had parted just a year ago in Cincinnati—and the strategy they then talked had worked.

As Sherman with long strides moved toward Grant, he heard, "How d'you do, Sherman!" answered, "How are you, Grant!" and the two of them locked hands in a long warm handshake and a laughter like two ticklish schoolboys. They walked to Grant's cabin. Sherman talked. They kept at him to talk. He had a big story to tell and they wanted to hear it.

After nearly an hour Grant interrupted. "I'm sorry to break up this interesting conversation, but the President is aboard the *River Queen*, and I know he will be anxious to see you. Suppose we go and pay him a visit before dinner." "All right," said Sherman. They took Admiral Porter and soon the three found Lincoln alone in the after cabin of the steamer.

Sherman found Lincoln "full of curiosity" about the

marches, the "bummers," the foraging, along with anxiety about what might happen to the army while its commander was gone. Sherman explained that the army was snug in good camps at Goldsboro, that it would require some days to collect forage and food for another march, that General Schofield was competent to command in his absence.

Next morning, March 28, came another conference of the three pivotal Northern men of the war, with Admiral Porter also present. Grant explained that at the very instant Sheridan was crossing the James River below City Point, that Sheridan had a large effective cavalry force for striking Lee's only remaining railroad connections, that a crisis was drawing near, that his only apprehension was that Lee would not wait long enough. In case Lee did break through, or swing around, Grant was sure there would be hot pursuit.

Both Grant and Sherman supposed that one or the other of them would have to fight one more bloody battle, and that it would be the *last*. "Mr. Lincoln exclaimed, more than once," wrote Sherman, "that there had been blood enough shed, and asked us if another battle could not be avoided." The generals told Lincoln they could not control that event. That the war might be ended without another big dance of death and wholesale slaughter seemed a deep and constant hope with Lincoln. Sherman pictured his army as probably having a final big fight somewhere near Raleigh. Grant's picture depended on Lee. If Lee yet waited a few more days, he would be able to stop Lee from joining Johnston. Grant could only be sure that if Lee did get between him and Johnston he would be on Lee's heels and moving fast.

Sherman came now to a momentous point. For his army,

the country North and South and the society to be molded
in the immediate future, it was momentous. Sherman's ac-
count, written years later, reported:

"I inquired of the President if he was all ready for the end
of the war. What was to be done with the rebel armies when
defeated? And what should be done with the political leaders,
such as Jeff. Davis, etc? Should we allow them to escape,
etc? He said he was all ready; all he wanted of us was to
defeat the opposing armies, and to get the men composing
the Confederate armies back to their homes, at work on their
farms and in their shops. As to Jeff. Davis, he was hardly at
liberty to speak his mind fully, but intimated that he ought
to clear out, 'escape the country,' only it would not do for
him to say so openly."

Lincoln was this day talking with two men like himself
terribly intimate with awful authority, more personal power
than any of them enjoyed handling. They hoped soon to be
free from their daily arithmetic of slaughter, disease, hunger.
They had, as foretold, ridden in blood up to the horses'
bridles. Their smoke and its remembrance were to stay long.
They were hammering out a national fate, not seeing at all
in any clear detail the shape of things to come. Before them
hazards and intricacies lay too vast to put on paper. Lin-
coln hesitated at outlining for his generals any peace terms
or reconstruction policies beyond the few simple conditions
he had named at Hampton Roads.

So now Sherman asked about the end of the war, the
crushed Confederate armies, the flying and fugitive Con-
federate political leaders. "I inquired," wrote Sherman. He
was eager to hear any specific recommendations that might

have occurred to the mind of the President. Always Sherman tried to look ahead and be ready for contingencies. Now what? Of the President's answers, Sherman later wrote:

"Mr. Lincoln was full and frank in his conversation, assuring me that in his mind he was all ready for the civil reorganization of affairs at the South as soon as the war was over; and he distinctly authorized me to assure Governor Vance and the people of North Carolina that, as soon as the rebel armies laid down their arms, and resumed their civil pursuits, they would at once be guaranteed all their rights as citizens of a common country; and that to avoid anarchy the State governments then in existence, with their civil functionaries, would be recognized by him as the government *de facto* till Congress could provide others.

"I know, when I left him, that I was more than ever impressed by his kindly nature, his deep and earnest sympathy with the afflictions of the whole people, resulting from the war, and by the march of hostile armies through the South; and that his earnest desire seemed to be to end the war speedily, without more bloodshed or devastation, and to restore all the men of both sections to their homes. In the language of his second inaugural address, he seemed to have 'charity for all, malice toward none,' and, above all, an absolute faith in the courage, manliness, and integrity of the armies in the field."

On the swift armed steamer the *Bat* Sherman started down the James River that afternoon. Arriving at New Bern and hurrying toward his army, Sherman met his army mailman and confidential messenger, Colonel Markland. At a candle-lighted breakfast Markland learned that easy peace terms

would be offered Joe Johnston, and as to Davis and his Cabinet: "Said Mr. Lincoln, we will leave the door open; let them go! We don't want to be bothered with them in getting the Government to running smoothly."

To Lee that week Johnston telegraphed his summary of what he might expect to do against his old antagonist: "I can no more than annoy him."

Back at City Point Lincoln kept close to Grant, whose company he would lose in a day or two, when a big push was to begin and Grant would live at the fighting front with his troops in motion.

From the deck of the *River Queen* that night as Sherman sped south on a steamer and Grant made ready to move his army out of camps, shelters, huts, and trenches they had occupied ten months, Lincoln could look out toward near-by hills and rolling land where he had seen ground torn and gashed, large spaces for miles naked of trees cut by shellfire or chopped down for fuel, trenches, forts, traverses, defenses, huts. On a wide front the army would move tomorrow. And for what? For another shambles and again burying squads and again the surgeons amputating till the arms and legs piled high for wagonloads?

That sword of Robert E. Lee—how it had vanished and come back and held its ground beyond prophecies! Could Lee and those valiant bayonets of his on which the Confederate Government had been carried for three years, could he again swing round and baffle pursuit, perhaps win to the mountains, fight guerrilla style till he could recruit a new army? This was the forecast among a few—not many—observers.

What did the night's darkness hold? In a few days, in a week, Lincoln would set foot in Richmond, the Southern capital in Northern hands—this was one prediction. And then what? Would Grant take Lee? If he did, then both the structure and the dream of a Confederate States of America were sunk with the fabrics of all shadows and dust. A republican Union of States cemented and welded with blood and iron would stand for a long time among World Power nations, committed to government of, by, and for the people. Only for the assurance of that reality had Lincoln cared to live these last four years of burdens and bitterness.

Beyond the screen and mist of the night lay what? Peach blooms and apricot blossoms had risen in the air the last few days in rare spots. April was so near. What of this April?

GRANT BREAKS LEE'S LINE

AT eight-thirty on the morning of March 29, 1865, Lincoln went ashore. They were putting the horses aboard the railroad train that was to take Grant and his staff to the Petersburg front.

At the train the President gave a warm handshake to the General and to each member of the staff, and then stood near the rear end of the car while they went aboard. The train was ready to start. They all raised their hats in respect to the President. His hat went off to them and his voice was broken and he couldn't hide it as he called to them: "Good-by, gentlemen. God bless you all! Remember, your success is my success." The whistle sounded. The train moved. Grant was off to a campaign all hoped would be his last and the last of the war.

The news that day and the next was rain. Over all was the rain. Fair weather of several days on the evening of March 29 gave way to torrents from the sky. On the two armies, on the just and the unjust, on Grant and Lee in the field, on the Davis home in Richmond, on the *River Queen* cabins sheltering the Lincoln family, the rain poured down all night of the twenty-ninth and all day on the thirtieth.

In dense underbrush and in swampy ground where troops were under orders to move, fields became beds of quicksand. Troops waded in mud above their ankles. Horses sank to

their bellies and had to be pulled out with halters. Wagon wheels sank to the hubs and in some cases above the axles to the wagon box. Roads became sheets of water. Soldiers cried to officers, "I say, fetch along the pontoons," or "When are the gunboats coming up?" Marching on such a terrain was only worse than trying to sleep in wet blankets on soaked ground. On March 30 men's tempers showed. Some went in for profanity contests. At headquarters Rawlins gloomed and told his chief it might be better to fall back and later make a fresh start. Grant held that soon as the weather cleared up the roads the men would be gay again. Sheridan arrived on a white pacer and was all for action.

On his maps Lincoln traced the troop dispositions ordered by Grant from right to left: Weitzel in front of Richmond, with a portion of the Army of the James, Parke and Wright holding Union works in front of Petersburg, Ord extending to the intersection of Hatcher's Run and the Vaughan Road, Humphreys stretching beyond Dabney's Mill, Warren on the extreme left reaching as far as the junction of the Vaughan Road and the Boydton Plank Road, and Sheridan at Dinwiddie Court House. For thousands of men each of these names came to have meanings of struggle, hardship, laughter, terror. Over mud and quicksand they built miles of corduroy road for the hauling of heavy artillery. At noon of the thirty-first Lincoln had a telegram from Grant: "There has been much hard fighting this morning. The enemy drove our left from near Dabney's house back well toward the Boydton plank road. We are now about to take the offensive at that point, and I hope will more than recover the lost ground." Before three o'clock came a second telegram from Grant:

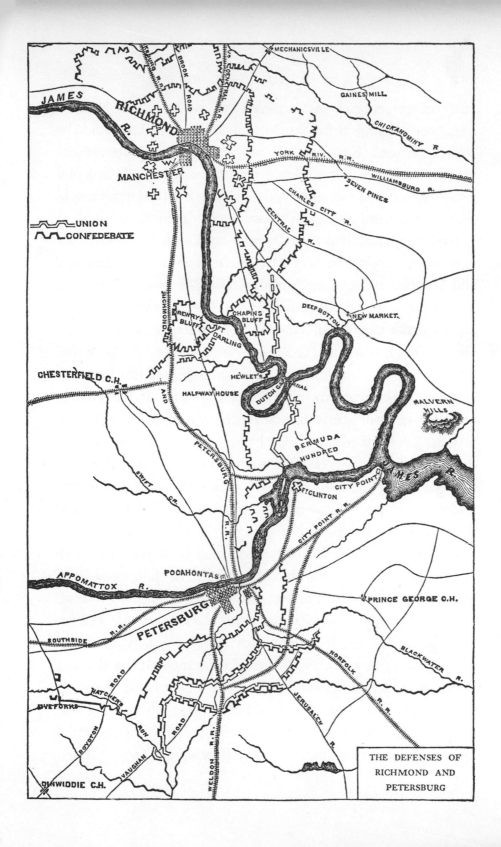

THE DEFENSES OF
RICHMOND AND
PETERSBURG

"Our troops, after being driven back to the Boydton plank road, turned and drove the enemy in turn, and took the White Oak road, which we now have. This gives us the ground occupied by the enemy this morning. I will send you a rebel flag captured by our troops in driving the enemy back. There have been four flags captured to-day."

Sheridan had fallen back from Five Forks in good order before an attack conducted by Lee's nephew Fitzhugh Lee and General Pickett, the same commander who had led the famous charge at Gettysburg. In Sheridan's taking his troops back to wait for reinforcements, he "displayed great generalship," Grant officially reported. The next morning, noted Horace Porter, the 5th Corps of the Army of the Potomac "seemed eager once more to cross bayonets with their old antagonists." Sheridan chafed at delay in moving forward, struck the clenched fist of one hand into the palm of another, and fretted like a caged tiger, once saying, "This battle must be fought and won before the sun goes down." Skirmish lines followed by assaulting columns began their action on Pickett's entrenched line.

One skirmish line halted and seemed to waver. Sheridan put spurs to his black Rienzi, who had carried him from Winchester to Cedar Creek, and dashed along the front from regiment to regiment shouting cheer and counsel. Horace Porter, sending his messages every half-hour to Grant, saw and heard much that day of Sheridan. A man on the skirmish line was struck in the neck; the blood spurted as if the jugular vein had been cut. "I'm killed!" he cried, and dropped on the ground. "You're not hurt a bit!" cried Sheridan. "Pick up your gun, man, and move right on to the front." These

words brought the man up, he snatched his musket, and rushed forward a dozen paces before he fell never to rise again. Over mud roads, swampy fields, and through dense undergrowth the spattered and foaming Rienzi carried Sheridan from point to point rallying his men.

Once where the lines had broken under a staggering fire, Sheridan rushed in. "Where is my battle flag?" And as the color sergeant rode up and handed him the crimson and white banner, the wild Irish commander waved it over his head, cheered the ranks on—while bullets hummed like swarming bees. One pierced the flag itself, another brought down the sergeant who had carried it; horses of two staff officers went down from the flying lead.

A regimental band mounted on gray horses, playing lively tunes, cheered the fighters on till a bullet went through the trombone horn and another split the snare drum, after which the band quit its music and took a hand in combat.

Sheridan went on dashing where the fire was most furious, waving his battle flag, praying, swearing, shaking his fist, yelling threats and blessings, a demon in the flesh dedicated to fighting. With fixed bayonets and a final rousing cheer, the Union columns under Ayres overran the enemy earthworks, swept everything before them, killed or captured in their immediate front every man whose legs had not saved him.

Rienzi with a leap carried Sheridan over the earthworks, landing amid a line of prisoners who had thrown down their muskets. Some called, "Whar do you want us-all to go to?" Sheridan's battle rage turned to humor. "Go right over there," pointing toward the rear. "Get right along, now. Oh, drop your guns; you'll never need them any more. You'll all be

safe over there. Are there any more of you? We want every one of you fellows." Some 1,500 of the ragged and butternut-clad troops were escorted to the rear from this angle.

Lincoln while this battle raged did his best at picturing it from a dispatch sent by Grant, sending to Washington the message that "Sheridan, aided by Warren had at 2 P.M. pushed the enemy back so as to retake the five forks. The five forks were barricaded by the enemy and carried by Diven's [sic] division of cavalry. This part of the enemy seem to now be trying to work along the White Oak road to join the main force in front of Grant, while Sheridan and Warren are pressing them as closely as possible."

Across the next two days Lincoln sent to Stanton a series of Grant's dispatches, relayed as Grant wrote them, and these the Secretary of War gave to the press. Thus millions of readers in the North had what they took as authentic information about the crumbling of Lee's lines around Richmond and the foreshadowing of the capture of Petersburg and the fall of Richmond.

From the afternoon of April 1 to the evening of April 2 this series of telegrams told the main story, chiefly in Grant's text as forwarded by Lincoln. Anxious Northern readers saw in the public prints that Sheridan with his cavalry and the 5th Corps had captured three brigades of infantry, a train of wagons, several batteries, several thousand prisoners—that Grant on the morning of April 2 ordered an attack along the whole line—that Wright and Parke got through the enemy's lines, that on further breaking the enemy entrenched lines they had taken forts, guns, prisoners, that Wright was tearing up the Southside Railroad, that the 6th Corps alone took

3,000 prisoners, that the Union lines were enveloping Petersburg. Grant telegraphed at 4:30 P.M. April 2: "The whole captures since the army started out will not amount to less than 12,000 men, and probably fifty pieces of artillery. . . . All seems well with us, and everything is quiet just now."

Now Robert E. Lee was making his decision that his troops move out of Petersburg. This would give Richmond to Grant and Lincoln. Lee had stretched his line of men till it was too thin. It was thin because he had too few men, only 1,100 men to the mile, or a five-foot length for each soldier. Each of these soldiers, however, had the advantage of an elaborate system of zigzag approaches and crisscrossed connecting trenches, with bombproof shelters, batteries, rifle pits. As some of the assaulting Union troops gazed at sectors of the line they had taken that day they wondered how anyone could ever have gotten through. Possibly they wouldn't have gotten through had not hunger, desertion, dissension, and a confused and weakening Confederate morale cut down the number of Lee's effective troops. The prime factor perhaps was that Southern man power, in its total, had been steadily slashed from the first battle of Bull Run on through successions of bloody battles to Five Forks, till the list of brave men in gray killed, dead, captured, or disabled from wounds or disease was of mournful extent. The dead Stonewall Jackson and J. E. B. Stuart, so precious to Lee, had been joined that morning of April 2 by General A. P. Hill, so long a reliable outrider with Lee.

On a dapple-gray horse Hill had ridden out and on in a morning fog, suddenly encountering two Federals who answered the call of "Surrender!" with rifle shots. And A. P.

Hill toppled out of his saddle. Tears came to Lee's eyes on hearing of it.

The human cost of breaking Lee's line, however, was less than it might have been. It had not reached such a major conflict as Lincoln had feared. At a lesser price than predicted Lee's army was cut off from Richmond, and on the night of April 2 his troops, ordered out of Petersburg and other points on the line, were reconcentrating to march west, aiming to move around Grant and join with Johnston's army in North Carolina. This movement of Lee, Grant's preparations to head off Lee, the expected fall of Richmond, were the immediate items of war interest.

As Lincoln visited the sick and wounded among avenues of hospital tents at City Point that week, a nurse heard the camp talk that when the President's party came to one set of tents, a young doctor pointing at them said, "Mr. President, you do not want to go in there."

"Why not, my boy?"

"They are sick rebel prisoners."

"That is just where I do want to go," and he strode in and shook hands from cot to cot and spoke such words as came to him which he thought might comfort.

Shot-torn in both hips, in one ward the only Confederate among wounded Union officers, lay Colonel Harry L. Benbow of South Carolina, who had commanded three regiments at Five Forks. Down the long aisle between cots came the Union President, bowing and smiling "Good morning." And according to Colonel Benbow:

"He halted beside my bed and held out his hand. I was lying on my back, my knees drawn up, my hands folded across my

breast. Looking him in the face, as he stood with extended hand, 'Mr. President,' I said, 'do you know to whom you offer your hand?' 'I do not,' he replied. 'Well,' said I, 'you offer it to a Confederate colonel who has fought you as hard as he could for four years.' 'Well,' said he, 'I hope a Confederate colonel will not refuse me his hand.' 'No, sir,' I replied, 'I will not,' and I clasped his hand in both of mine."

RICHMOND SURRENDERS

ON the Sabbath day of April 2, 1865, Robert E. Lee by telegraph talked with Jefferson Davis. From the field out near Petersburg Lee was issuing orders that his men destroy many supplies and guns that could not be moved, with further orders that as the troops moved west they were to wreck all bridges after the last Confederate forces had crossed. To President Davis, Lee dictated a telegram which was carried to Richmond. Then, a story goes:

In the Davis family pew of St. Paul's Episcopal Church, seated erect and calm under the chancel, Jefferson Davis was in attendance in a congregation chiefly of women in black and rusty black attire. Their menfolk in the main were keeping the Sabbath at battle and marching fronts. The clergyman intoned, "The Lord is in His holy temple; let all the earth keep silence before Him," and in the pause following, an adjutant, mud on his boots, a hard-riding man, holding his saber so it wouldn't clank or jingle, came up the aisle in a swift military stride and handed a paper to President Davis. It rustled as it unfolded. In quiet with everybody gazing at him and wondering what the news might be, Davis read the words General Lee had long delayed and sent at last when imperative: "I advise that all preparation be made for leaving Richmond tonight. I will advise you later, according to circumstances."

Taking his hat, President Davis arose, walked down the aisle, erect as ever, his face calm, white, marble-cold. Going from the church to the War Department, Davis telegraphed to Lee that a move from Richmond that night would "involve the loss of many valuables, both for the want of time to pack and of transportation." Lee in the field on receiving this message, according to one of his staff men, tore it into bits, saying, "I am sure I gave him sufficient notice," and replying calmly by telegraph to Davis that it was "absolutely necessary" to abandon the position that night.

On a Richmond & Danville Railroad train at eleven that Sabbath night, Davis with his Cabinet and other officials left their capital city, their Executive Mansion, their arsenals and remaining stores, arriving safely in Danville, North Carolina, the next afternoon.

Word spread in Richmond this Sabbath that Lee's army, so long their shield and fortress, had taken its last man and gun out of Petersburg—and Richmond would fall next. On railroad trains, on wagons, carts, buggies, gigs, on horses piled with bundles and belongings, the Government and many citizens in flight had a moving day. "Dismay reigned supreme," wrote Captain Clement Sulivane, in charge of the evacuation.

Burning and dynamiting of bridges, arsenals, and warehouses went on through the night. Those who knew their Richmond tried to read the marching devastation by the booms they heard. One by one the bridges went. Before daylight only the one from Richmond to Manchester was standing. Three high arched bridges blazed with tall flames and lighted the two cities and the sparkling, snarling river between.

Heavy smoke clouds rose from cotton warehouses. Every now and then a powder magazine went into the air, a fountain of white smoke shooting to the sky, followed in an instant by a deafening roar and a quaking of the ground on which Richmond stood, in another instant hundreds of shells exploding in high air and sending down an iron spray—with a little aftermath of stores of ignited cartridges rattling with low thunder the same as volley fire of musketry on the battlefield. The theory was that the Confederacy must shoot these off now or later they might be shot at Confederate troops as the war went on.

Fire began sweeping in wide paths over the city itself. "Either incendiaries, or (more probably) fragments of bombs from the arsenals, had fired various buildings," wrote Captain Sulivane, "and the two cities, Richmond and Manchester, were like a blaze of day amid the surrounding darkness." Near dawn a few thundering explosions down-river told Sulivane that some of the last gunboats of the Confederate Navy were sunk.

Also just after daylight on April 3 a crowd of thousands of men, women, and children swarmed at the doors of a commissary depot. They represented that part of the people of Richmond hardest hit by food scarcity and high prices. Many of them had not tasted a full, nourishing meal in months. Behind those depot doors they had heard—and heard correctly —were barrels of ham, bacon, whisky, flour, sugar, coffee. Why these had not been put into the hands of General Lee and his army weeks ago was a question for responsible officials to answer. The desperation of rampaging human animals heaved at those depot doors, so long guarded, no longer held

by men with rifles. The doors went down. Crying, yelling, raging, laughing, snarling, the crowd surged in; men fought with each other over the best pickings.

The commissary looters scattered right and left as a final handful of Confederate cavalry came galloping to cross the only bridge standing. Their commander, General Gary of South Carolina, pointed at his last bunch of gray horsemen taking the bridge at headlong speed, touched his hat to Captain Sulivane and ordered: "All over, good-bye—blow her to hell."

Sulivane and an engineer officer walked slowly across the bridge setting fire to prepared combustibles. Soon the bridge sagged and went down in smoke and flame. Captain Sulivane and two companions at the other end of the bridge sat in their saddles a half-hour and watched strings of horsemen in blue taking over Richmond. Across the way he could see columns of blue infantry arriving and he heard a new sound floating on the air from across the river—cheers for the United States flag.

General Godfrey Weitzel received the surrender of Richmond that morning of April 3 at the city hall. By midafternoon his troops had stopped rioting and the main disorders, had begun issue of provisions to the needy, and blown up several city blocks of houses to check the fire.

Lincoln had come up the James River on navy vessels, landed at a place called Rockett's. The crowd ashore receiving the President of the United States on his first visit to Richmond was entirely of Negroes. By the grapevine some had heard he was coming. One old-timer of sixty years sprang forward: "Bress de Lawd, dere is de great Messiah! I knowed

him as soon as I seed him. He's bin in my heart fo' long yeahs. Glory, hallelujah!" He fell on his knees and bowed at the President's feet. Other Negroes came likewise. The President: "Don't kneel to me. You must kneel to God only and thank him for your freedom." The old-timer had his excuse: "Yes, Massa, but after bein' so many years in de desert widout water, it's mighty pleasant to be lookin' at las' on our spring of life. 'Scuse us, sir, we means no disrespec' to Marse Linkum." From corners that had seemed deserted suddenly sprang out black folk, some silent and awe-struck, others turning somersaults and yelling with joy. They had heard they would be "free"—now they were sure of a new time.

Twelve armed sailors formed a guard for the President's entry into the former Confederate capital. At his left the President had Rear Admiral Porter and Captain Penrose, at his right his bodyguard William H. Crook holding little Tad Lincoln by the hand—in the advance and the rear six sailor boys each with the sawed-off rifle known as the carbine. This queer little detachment, not long enough to be termed a procession, marched toward downtown Richmond nearly two miles in heat and dust, past sidewalks of crowded bystanders, past windows crowded with faces, past Libby Prison that had held so many Union officers and men.

A girl of perhaps seventeen, blooming and graceful, ran out with a bouquet of flowers which they let her hand to the President. One Union soldier called out, "Is that Old Abe?" One older Negro was heard, "Go 'way, dat ain' no Fadder Abraham. Why, dat man look lak a onery ol' famah [farmer], he do."

A cavalry escort met them. They moved to the Confederate Executive Mansion, went in dusty and sweating, tired of seeing so many burned buildings and ruins on their march.

Lincoln asked for a glass of water, sat in the chair where Jefferson Davis had handled the documents of the Confederacy, sat somber and solemn. Later with a cavalry escort he rode over Richmond in a carriage with General Weitzel. He was reminded of no anecdote and his eyes had a dreaminess. At one street corner a Negro woman held up her sick child for a look at Lincoln and the child turning its head away the mother finally said: "See yeah, honey, look at de Savior, and you'll git well. Touch de hem of his gahment, honey, and your pain will be done gone."

Weitzel's aide Graves went along on this ride, and of it wrote that he heard General Weitzel ask one very important question, namely, What should he, Weitzel, do in regard to this conquered people? "President Lincoln replied," wrote Graves, "that he did not wish to give any orders on that subject, but, as he expressed it, 'If I were in your place, I'd let 'em up easy, let 'em up easy.' " This was another way of saying what he had said to Sherman at City Point.

Off to the west, not many miles, horsemen and foot troops were harassing Lee's army in retreat. At Amelia Court House Lee's men found no food supplies as expected. The Confederate officials at Richmond in charge of this vital matter had either misunderstood General Lee's orders or in the hurry of flight had mismanaged. Anyhow at this point where they had hoped to eat was practically nothing to eat. The wagons went out and sought rations but came back practically empty. Not

since the times of George Washington and Nathanael Greene had the troops of an important army marched and fought on such short rations as Lee's men this week.

At the same time Grant was in top form, alive every hour to each move reported to him. Near midnight of April 6

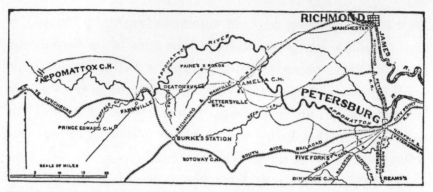

The Confederate retreat from Richmond and Petersburg to Appomattox

Grant wired Lincoln a message from Sheridan. In this Sheridan reported captures of several thousand prisoners, including Custis Lee, the son of General Robert E. Lee, and Generals Ewell, Kershaw, Button, Corse, and Debray. Taken also in this sweep were many wagons and 14 cannon, Sheridan closing his dispatch, "If the thing is pressed I think that Lee will surrender."

Lincoln thought about this and near noon wired Grant:

GENERAL SHERIDAN SAYS "IF THE THING IS PRESSED I THINK THAT LEE WILL SURRENDER." LET THE THING BE PRESSED.

APPOMATTOX—APRIL 9, 1865

IN the race westward to see whether Grant could stop Lee from heading south and joining Johnston, no one could be sure what was going to happen. On the Peninsula, at Fredericksburg and Chancellorsville, at Gettysburg and in the Wilderness and at Spotsylvania Court House, the traps had been set for the Army of Northern Virginia and it had broken through, at times handing bloody punishment to an enemy having twice as many troops. Now again Grant hoped to throw such a ring of men and steel around Lee that another escape would be impossible or too costly to think about.

In ten days of latter March and early April, 1865, Lee lost 19,000 men to Grant as prisoners. In a series of desperate fights the total of Lee's killed and wounded ran high—and of effective troops he had none to spare. The race westward on parallel lines was clocked with running battles. The rank and file of Lee's army marched on slim rations, mainly of parched corn. The officers fared little better, Lee's dinner at times amounting to no more than a single head of boiled cabbage.

At a branch of the Appomattox River named Sayler's (or Sailor's) Creek enough of the Union Army had overtaken Lee to force a combat that resulted in Lee's saying to one of his officers, "General, that half of our army is destroyed."

Hunger was a helper of Grant—hunger counting more than

guns and munitions. The cannon of Lee were on short rations as well as the foot soldiers and cavalry horses. The artillerists knew if they went into a straight frontal battle they wouldn't have shells to last through. For this the North had played, and Sherman and Sheridan had devastated and Grant had hammered and Lincoln had toiled and held on—for this, the exhaustion of the South—a whittling away and a wearing down till the Army of Northern Virginia was a spectral shadow of the body that not quite two years ago had invaded Pennsylvania and threatened Philadelphia and Baltimore.

Many were barefoot, many had toes and heels out from their shoes; hats and clothes testified to wear and weather, and their blanket rolls were thin and down to final necessities— in the kind of marching and fighting they had gone through every useless ounce of weight was left behind. Yet as troops they were proved and fast. Whatever General Lee asked they would give. The basic essential remnant of this army was ready for death or starvation or retreat to the mountains and guerrilla warfare till the last man was gone. They had fought, dug, pivoted, maneuvered, till they knew each other and had timing and concentration down to fine points.

Grant knew probably better than anyone that he could beat this army, smash pieces of it and send it recoiling in retreat. But he wouldn't swear he could capture it. To bag such an army of proved wit and flair—to take the whole of it and end the war—that was something else. Anything could happen. Of his own Army of the Potomac Grant was proud. Never, he was saying now, had it marched and fought with such fine co-ordination, commanders and men at times outdoing what he ordered and expected. The immediate objective however

was immense—and might be lost—no one could tell before-hand.

So the night of April 8, Grant the iron man, Grant the cool and imperturbable, Grant the model of self-possession and personal control during heavy and fierce action, Grant in the rear of the Army of the Potomac pressing Lee's rear guard, stopped at a farmhouse with a sick headache. Grant spent the night bathing his feet in hot water and mustard, putting mustard plasters on his wrists and the back of his neck, moving restlessly on a sitting-room sofa trying to snatch a little sleep. He was a worn man, keeping his saddle day and night, living on scant and hurried meals, now at the rear and again at the farthest front, where troops seeing him said, "The old man is here—the fur is going to fly!"

His mind had concentrated intensely on notes he wrote to Lee and Lee's answers. Each of these great and adroit commanders was making deep guesses about what was going on in the mind of the other. Rawlins in one of his frank outbursts was telling Grant that Lee's latest note was "cunningly worded," false, and deserving of no reply, Grant quietly replying: "Some allowance must be made for the trying position in which General Lee is placed. . . . If I meet Lee he will surrender before I leave." Rawlins exploded farther: "You have no right to meet Lee, or anybody else, to arrange terms of peace. That is the prerogative [Rawlins was a lawyer back home in Galena, Illinois] of the President and the Senate. Your business is to capture or destroy Lee's army." Then Rawlins brought out the instructions which Lincoln had sent to Grant on March 3 saying Grant was held strictly to mili-

tary matters and must not assume "to decide, discuss, or confer upon any political questions."

Grant however believed he knew the mind and feeling of Lincoln beyond these instructions. Their many talks at City Point made him sure of what he could offer Lee that would be as though from the President. So he refused to string along with Rawlins, and sent Lee another note to the effect that while he had "no authority to treat on the subject of peace," he would however state "that I am equally anxious for peace with yourself, and the whole North entertains the same feeling." Lee read the note as an invitation for him to meet Grant and discuss terms of surrender, this in line with Grant's hope "that all our difficulties may be settled without the loss of another life."

Whatever might be the communications of men at daybreak this morning of April 9, the earth spoke of peace. The oaks flung out fresh tassels. Trees leafed out pale green. Peach trees sang with blossoms. New grass and opening buds put the breath of spring on the air. Winter had said good-by a week or so before when troops had shaken a white frost off their blankets before the morning coffee. Now softer nights had come. Now it was Palm Sunday, April 9, 1865, a date to be encircled in red, white, and blue on calendars.

Across the path of Lee's army and blocking its way this morning stood the cavalry of Phil Sheridan. At five o'clock this morning General Lee on high ground studied the landscape and what it held. Through a fog he looked. What had arrived yonder? Was it Sheridan only, or did the horse have supporting foot troops? He would wait. He had seen his troops breakfast that morning on parched corn, men and

horses having the same food. He had seen his officers breakfast on a gruel of meal and water. He had not been seen to eat any breakfast himself. He had put on his handsomest sword, coat, hat, boots and spurs looking new and fresh, the array topped with a sash of deep-red silk, saying when General Pendleton asked about this gay garb, "I have probably to be General Grant's prisoner and thought I must make my best appearance."

Eight o'clock came. Also came word that Sheridan's cavalry had fallen slowly back and widened out. Behind the cavalry and screened by woodland waited heavy bodies of infantry in blue; these were the troops of Ord and Griffin, who had made an almost incredible march of thirty miles the night and day before, coming up at daybreak to support Sheridan and invite battle. To the left, to the rear, were other Union lines. Their circle of campfires reflected on clouds the night before told of their surrounding the Army of Northern Virginia.

Robert E. Lee now had three choices. He could go into frontal battle, fight the last, bloody, forlorn conflict of the war. He could escape with a thin remnant to mountains lying westward and carry on guerrilla warfare. Or he could surrender.

He asked Longstreet and other generals whether the sacrifice of his army in battle would help the Confederate cause elsewhere. They said in effect that a battle lost now against overwhelming numbers and resources would be of no use. To General Alexander, Lee spoke of the lawless futility of bushwhacking and guerrilla fighting, which "would bring on a state of affairs it would take the country years to recover from."

Lee's staff officers heard him say, "There is nothing left me to do but to go and see General Grant, and I would rather die a thousand deaths."

"Oh, General," protested one, "what will history say of the surrender of the army in the field?"

"Yes, I know they will say hard things of us! They will not understand how we were overwhelmed by numbers. But that is not the question, Colonel: The question is, is it right to surrender this army. If it is right, then I will take all the responsibility."

He looked over the field at a lifting fog and spoke as though tempted to go out where, the war being still on, he would be one easy target. "How easily could I be rid of this, and be at rest! I have only to ride along the line and all will be over!" For a moment he seemed almost helpless, then recovered. "But it is our duty to live."

Lee wrote a note asking Grant for an interview "with reference to the surrender of this army." Grant on receiving it at once wrote Lee to name the place for their meeting.

And it became a folk tale and a school-reader story how at the McLean house on the edge of Appomattox village, ninety-five miles west of Richmond, the two great captains of men faced each other in a little room and Lee gave over his army to Grant, and the two men looked so different from each other. Lee tall and erect, Grant short and stoop-shouldered. Lee in a clean and dazzling military outfit, Grant in a rough-worn and dusty blouse telling his high rank only by the three stars on the shoulders. Grant apologizing to Lee that he had come direct from the field and hadn't time to change his uniform. Lee fifty-eight years old with silver hair, near the eve-

ning of life, Grant forty-two with black hair and unspent strength of youth yet in him.

Lee inside was writhing over the bitter ordeal, and Grant later admitted that he was embarrassed—though both of them wore grave, inscrutable faces and no one could have read the mixed feelings masked by the two commanders. Grant had never been a Republican, never voted for Lincoln till '64, never traveled with the abolitionists. Lee had never advised the secession of Virginia; had never been a slaveholder except by inheritance and had immediately sold the slaves; had never given to the Confederacy his first and deepest loyalty, which for him belonged to Virginia; had never said otherwise than that he would have stayed out of the war if Virginia had stayed out of the Confederacy; had never sought to devise a grand strategy of the war based on the whole Confederacy; had never, so it seemed, in reality considered the Confederacy as a nation, but rather as a loose league of States, each one a sovereign nation.

Both saw slavery as a canker and an evil. Neither cared for war as a game for its own sake. Each loved horses, home life, wife and family. And Lee, though it would have been an insolent lie to call him a Union man, had some mysterious, indefinable instinct about a Union of States, one common country, if it could be effected with honor. The Jefferson Davis vision of a Confederate slave empire stretching from the Ohio River to the Isthmus of Panama, including the Island of Cuba, had never had mention or approval from Lee. And yet, what he was doing this day in the McLean house came hard, and was, as he said, worse than dying a thousand deaths.

"I met you once before, General Lee," began Grant in even

voice, "while we were serving in Mexico. . . . I have always remembered your appearance, and I think I should have recognized you anywhere."

"Yes, I know I met you on that occasion, and I have often thought of it and tried to recollect how you looked, but I have never been able to recall a single feature."

Talk about Mexico ran into memories of that war when they both wore blue. Grant just about forgot why they were there, it seemed, or else the old and early bashfulness of Grant was working. Lee brought him to the point. "I suppose, General Grant, that the object of our present meeting is fully understood. I asked to see you to ascertain upon what terms you would receive the surrender of my army."

Not a shading of change crossed Grant's face. He went on as between two good neighbors. "The terms I propose are those stated substantially in my letter of yesterday—that is, the officers and men surrendered to be paroled and disqualified from taking up arms again until properly exchanged, and all arms, ammunition and supplies to be delivered up as captured property."

Lee nodded assent. That was what he had hoped for, though one of his generals had predicted that the army would be marched off to prison in shame and disgrace. "Those," said Lee to Grant, "are about the conditions I expected would be proposed."

Grant, seated at a table, put it in writing, his staff aides and corps commanders standing by, Lee seated with his aide standing behind his chair. Grant rose, stepped over to Lee, and handed him the paper scrawled in pencil. Lee took out spectacles from a pocket, pulled out a handkerchief and wiped

the glasses, crossed his legs, and read slowly and carefully the strangest and most consequential paper for him that had ever met his eyes.

At the words "until properly" he suggested that General Grant must have meant to add the word "exchanged."

"Why, yes," said Grant, "I thought I had put in the word 'exchanged.' "

Lee said that with Grant's permission he would mark where the word "exchanged" should be inserted. "Certainly," said Grant. Lee felt his pockets for a pencil and seemed that day to have no pencil. Colonel Horace Porter stepped forward with a pencil. Lee thanked him, put a caret where the word "exchanged" was to go in, read to the finish, and then with his first touch of warmth said to Grant, "This will have a very happy effect on my army."

Grant asked for any further suggestions. Lee had one. In his army the cavalrymen and artillerists owned their horses. He wanted these men who owned their mounts to have them on their farms for spring plowing. Grant said this subject was quite new to him. He hadn't known that private soldiers owned their horses. In his own army the rank and file had only government horses and mules. However, "I take it that most of the men in the ranks are small farmers, and as the country has been so raided by the two armies, it is doubtful whether they will be able to put in a crop to carry themselves and their families through the next winter without the aid of the horses they are now riding." So without changing the written terms he would instruct officers receiving paroles "to let all the men who claim to own a horse or mule take the animals home with them to work their little farms."

Lee showed relief. "This will have the best possible effect upon the men. It will be very gratifying and will do much toward conciliating our people."

Lee shook hands with some of Grant's generals who offered theirs, bowed, said little, was too heavy of heart to join in a pleasantry from one old West Point acquaintance, then turned to Grant saying that a thousand Union prisoners, including some officers, had been living the last few days on parched corn only; they required attention, and of provisions "I have, indeed, nothing for my own men." This was discussed briefly and Grant directed that 25,000 rations be sent to Lee's men.

Lee wrote an acceptance of Grant's terms, signed it, and at 3:45 in the afternoon of this Palm Sunday, April 9, 1865, the documents of surrendering an army were completed. There remained only such formalities as roll call and stacking of arms. Union gunners made ready to fire a salute of grand national triumph, but Grant forbade any signs of rejoicing over a broken enemy that he hoped hereafter would no longer be an enemy. Grant directed his men that no cheers, no howls of triumph, were wanted—and few were heard. The rank and file of these two armies, "bluebelly" and "butternut," had traded tobacco and coffee and newspapers on the picket lines enough to have a degree of fellowship and affection for each other.

Lee rode among his men—who crowded around him crying, "We'll fight 'em yet"—and explained, with tears and in a choked voice, that they had fought the war together, he had done his best, and it was over. Many were dazed. Some wept. Others cursed and babbled. The army could die but never surrender, they had hoped. Yet they still worshiped

Lee. They touched his hands, his uniform; they petted Traveller and smoothed his flanks with their hands.

A gentleman fighter, in dirt and rags, reached up a hand saying: "General, I have had the honor of serving with this army since you took command. If I thought you were to blame for what has occurred today, I could not look you in the face. God bless you!" Another gripped the commander's hand with "Farewell, General Lee. . . . I wish for your sake and mine that every damned Yankee on earth was sunk ten miles in hell!"

Perhaps no man in either army did better at briefly sketching what had happened than Meade writing to his wife: "Lee's army was reduced to a force of less than ten thousand effective armed men. We had at least fifty thousand around him, so that nothing but madness would have justified resistance."

For Grant it was one more odd day. Three times now he had bagged a whole army. Three times now—at Fort Donelson, at Vicksburg, at Appomattox—he had been the center figure of operations bringing in an entire army for surrender. But he admitted that he worried more before Appomattox than at Donelson or Vicksburg. He had kept his pledge to Lincoln that he would do his best to avoid a final bloody battle. He was in faith with Lincoln's spirit at City Point in his order to stop the firing of salutes: "The war is over; the rebels are our countrymen again; and the best sign of rejoicing after the victory will be to abstain from all demonstrations in the field."

The next day it rained. The paroles amounted to 28,231. Grant and Lee sat their horses between lines for a farewell talk. Grant said he was interested in peace and hoped to have

soon the surrender of the other Confederate armies. Lee re-
plied that the South was a large country and the Federals
might be compelled to march over it three or four times
before the war was entirely ended, but the Federals could do
this, he said, because the South could no longer resist. For
his own part, he hoped there would be no further sacrifice of

life. Grant said that not a man in the South had so great an
influence with soldiers and people as General Lee, that if Lee
would now advise the surrender of the other armies his advice
would be followed. Lee said he could not do this without first
consulting President Davis. And with no misunderstandings
Grant and Lee said good-by.

The giving up of ragged and shot-pierced battle flags came
hard. Veterans wept as they stood them alongside surrendered
muskets. In a few instances color-bearers hid the flags under
their shirts and carried them home. Still other banners were
torn into pieces and shared out among men who had heard
shells and bullets singing around the old emblem. They un-

derstood General Lee's farewell order of that day saying they had been "compelled to yield to overwhelming numbers and resources," and though they were "steadfast to the last" they had arrived where "valor and devotion could accomplish nothing to compensate the loss . . . the useless sacrifice." Back to their homes and fields, toward the things that used to be, they started, in columns, in squads, as lone stragglers, some of them wondering what they might find where Sherman and Sheridan had been.

Yes, it was to become a folk tale and a school-reader story, how at Appomattox Grant and Lee signed papers. For a vast living host the word Appomattox had magic and beauty. They sang the syllables "Ap-po-mat-tox" as a happy little carol of harvest and fields of peace and the sun going down with no shots in the night to follow.

TATTOO
(Final roll call of a soldier's day)

PLANS FOR PEACE

AMONG those high in the Government persistently vocal for punishing the defeated Confederates was Vice-President Andrew Johnson. To Dana in Richmond he insisted "their sins had been enormous," and if they were let back into the Union without any punishment the effect would be very bad, raising dangers in the future.

To Grant it came that Vice-President Johnson in Washington, in Richmond, had an "ever-ready" remark: "Treason is a crime and must be made odious." To Southern men who went to Johnson for assurances that they might begin some sort of rebuilding, he offered merely vehement denunciations. To Grant this was a sorry performance, Grant believing that the Lincoln view had behind it "the great majority of the Northern people, and the soldiers unanimously," the Lincoln view favoring "a speedy reconstruction on terms that would be the least humiliating to the people who had rebelled against their government . . . being the mildest, it was also the wisest, policy. . . . The people who had been in rebellion . . . surely would not make good citizens if they felt that they had a yoke around their necks."

One outstanding impression in Grant's mind stayed on from the conference he and Sherman held with Lincoln at City Point. This was Lincoln's report to the two generals of what he had said to the Confederate peace commissioners at Hamp-

ton Roads. To Grant and Sherman in thinking about it afterward it seemed to have more guidance value to them for armistice terms than any other rules, if any, laid down by Lincoln. The matter was precisely one where Grant, usually meticulous in such a piece of testimony, though writing in the third person seemed to have kept some of the flavor of Lincoln's speech. "Mr. Lincoln said to the peace commissioners when he met them at Hampton Roads . . . that before he could enter into negotiations with them they would have to agree to two points; one being that the Union should be preserved, and the other that slavery should be abolished; and if they were ready to concede these two points he was almost ready to sign his name to a blank piece of paper and permit them to fill out the balance of the terms upon which we could live together."

Sherman's ideas about peace terms and reconstruction, it would be too easy to say, were identical with those of Grant; Sherman held torrents of thought and feeling that outran expression in words. The Union general who more than any other favored a war strategy of punishment and destruction of the South decidedly favored a mild and kindly peace policy. And opposing him he had a different case from Grant. Grant and Lee had respect for each other, with little or no affection. Between Sherman and Joe Johnston was not merely respect but a curious affection. They were two fighters who each knew that the other always fought fair and clean, each having admiration for the style of the other. Not often does it happen in war, but a curious fellowship had grown up between these two commanders. Neither Sherman nor Johnston had ever owned slaves. Both disliked Jefferson Davis.

Grant knew Sherman would drive no hard bargain with the bald little leader who had written Lee that he "could no more than annoy" Sherman's army.

Sherman had shown to Stanton, on the visit of the Secretary of War to Savannah, a letter to a Savannah man wherein Sherman wrote his belief "that according to Mr. Lincoln's Proclamation and Message, when the people of the South had laid down their arms and submitted to the lawful powers of the United States, *ipso facto*, the war was over as to them; and furthermore, that if any State in rebellion would conform to the Constitution of the United States, cease war, elect Senators and Representatives to Congress, if admitted (of which each House of Congress alone is the judge), that State becomes instanter as much in the Union as New York or Ohio."

All of which in this crowded hour of decision meant power beyond fathoming in Lincoln's hand. Lincoln, Grant, and Sherman were a triumvirate holding such actual power that if imperative they could set up a dictatorship. The historic point to be reckoned in the balances during early April was that the three high commanders and a million soldiers were, to use Grant's word, "unanimous" for ending the war on practically any terms that would bring a restored Union with slavery gone. To these two major conditions all else was minor and could be threshed out in parliamentary debate and political battles in the old-fashioned American way.

Grant was wishing luck to Jefferson Davis, hoping the fugitive would escape from the United States. This wish and hope he believed "Mr. Lincoln shared." Off in the immense areas of Texas or thereabouts in the trans-Mississippi region,

Davis might set up a new, though shrunken Confederacy with outfits of restless, unemployed young men drawn from the various abandoned Confederate armies. Besides this, believed Grant, Lincoln wanted Davis to escape because as the Federal President he did not wish to deal with the matter of punishment for the Confederate chieftain. Grant saw Lincoln as the best possible man to be in power as umpire during the wrangling and bitterness to come. And Grant believed that an overwhelming majority of the Northern people, "and the soldiers unanimously," thus saw Lincoln in this hour that Grant traveled toward Washington for an interview with the President and a joining of counsels.

Ward Hill Lamon had an anecdote used by Lincoln when he was asked what he would do with Jefferson Davis when that marvelously stubborn and unrepentant Confederate leader was captured, Lincoln saying: "When I was a boy in Indiana, I went to a neighbor's house one morning and found a boy of my own size holding a coon by a string. I asked him what he had and what he was doing. He says, 'It's a coon. Dad cotched six last night, and killed all but this poor little cuss. Dad told me to hold him until he came back, and I'm afraid he's going to kill this one too; and oh, Abe, I do wish he would get away!' 'Well, why don't you let him loose?' 'That wouldn't be right; and if I let him go, Dad would give me hell. But if he would get away himself, it would be all right.' Now," said Mr. Lincoln, "if Jeff Davis and those other fellows will only get away, it will be all right. But if we should catch them, and I should let them go, 'Dad would give me hell.' "

If Lincoln had his wish, it was evident, Jeff Davis would

skip the country and make a home in Mexico, Peru, London, Paris, anywhere beyond reach of the United States Government. As an exile Davis could do little harm. As a martyr buried after trial and hanging, his name betokening sacred ashes, the Confederate leader would throw a moving shadow. An example was the ghost of John Brown, his body a-moldering, his tongue alive. That line of hate sung by millions—"We'll hang Jeff Davis to a sour apple tree"—was good enough for war propaganda, for stirring the will to kill, but now Lincoln wanted that song line forgotten.

CHAPTER 32

THE HURRICANE SPENT

FROM mid-April of '61 to mid-April of '65 some 3,000,000 men North and South had seen war service—the young, the strong, the physically fit, carrying the heavy load and taking the agony. The fallen of them had seen Antietam, Murfreesboro, Fredericksburg, Chancellorsville, the Wilderness, Spotsylvania, Cold Harbor, each a shambles, a human slaughterhouse. In the burnt and blackened Shenandoah Valley were enough embers of barns and men to satisfy any prophet of doom.

From Malvern Hill and Gettysburg down to Chickamauga, Chattanooga, Island No. Ten, Vicksburg, the Red River and beyond, the burying-grounds deep and shallow held the consecrated dead—some of them lone white skeletons not yet accorded burial—falling from flying lead and steel, from the reapers typhoid, dysentery, inflammations, prison starvation—thousands having crawled away to die alone without witnesses or extreme unction—tens of thousands buried in trenches with mass markers for the nameless and unidentified: UNKNOWN.

They were a host proven in valor and sacrifice—swept to the Great Beyond. No man who actually and passionately loved the cause of either flag could evade moments when he reproached himself for being alive. Robert E. Lee had those moments, well attested. So did Abraham Lincoln.

Killed in action or dead from wounds and disease were

some 620,000 Americans, 360,000 from the North, 260,000 of the South—planted in the tomb of the earth, spectral and shadowy, blurred and discordant in their testimonies for posterity as to why they fought the war and cut each other down in the heyday of youth.

They were a host. They were phantoms never absent from Lincoln's thoughts. Possibly from that vanished host, rather than from the visible and living, Lincoln took his main direction and moved as though the word "reconciliation" could have supreme beauty if he could put it to work.

On the calendar it was Holy Week and April the Fourteenth of '65 was Good Friday. Some were to say they had never before this week seen such a shine of beneficence, such a kindling glow, on Lincoln's face. He was down to lean flesh and bone, thirty pounds underweight, his cheeks haggard, yet the inside of him moved to a music of peace on earth and goodwill to men. He let it gleam in the photograph Alexander Gardner made this Holy Week. He let it come out in pardons given without inquiry, given even with laughter, as when Senator John A. J. Creswell of Maryland asked release of an old friend who had drifted into the Confederate Army and was now a prisoner in Federal hands. Lincoln told of a lot of young folks who went on a May frolic. "To reach their destination they had to cross a shallow stream, and did so by means of an old flat boat. When they came to return, they found to their dismay that the old scow had disappeared. They were in sore trouble, and thought over all manner of devices for getting over the water, but without avail. After a time one of the boys proposed that each fellow should pick

up the girl he liked the best and wade over with her. The masterly proposition was carried out, until all that were left upon the island was a little short chap and a great long gothic-built elderly lady. Now, Creswell, you are trying to leave me in the same predicament. You fellows are all getting your own friends out of this scrape, and you will succeed in carrying off one after another until nobody but Jeff Davis and myself will be left on the island, and then I won't know what to do. How should I feel? How should I look lugging him over? I guess the way to avoid such an embarrassing situation is to let them all out at once."

From the north White House portico on the night of April 11, to a crowd jubilating over the surrender of Lee's army, he had argued and pleaded for admission to the Union of the Louisiana State government, organized and ready for return to the Union. Out of the grandeur of the ending of the war he could picture a long involved misery to follow unless an imperfect beginning was hazarded. "Concede that the new government of Louisiana is only to what it should be as the egg is to the fowl, we shall sooner have the fowl by hatching the egg than by smashing it." He was weary of government applied by force and gave his forecast: "We, in effect, say to the white man: You are worthless or worse; we will neither help you, nor be helped by you. To the blacks we say: This cup of liberty which these, your old masters, held to your lips we will dash from you, and leave you to the chances of gathering the spilled and scattered contents in some vague and undefined when, where, and how. If this course, discouraging and paralyzing both white and black, has any tendency to bring Louisiana into proper practical

relations with the Union, I have so far been unable to perceive it."

He would turn from these dark visions. "If, on the contrary, we recognize and sustain the new government of Louisiana, the converse of all this is made true. We encourage the hearts and nerve the arms of 12,000 [Union loyalists of Louisiana] to adhere to their work, and argue for it, and proselyte for it, and fight for it, and feed it, and grow it, and ripen it to a complete success."

This speech gave Lincoln's outline of the policy, or direction of compass, as to how he would reconstruct the Union. He could not go as far as the antislavery radicals in Congress on new civil rights to be immediately given to the Negro freedmen, though he favored the Negro freedmen being given those rights eventually. He believed that the present course of those radicals might stir a strife and a resistance that in the end would bring fresh wrongs to the Negro freedmen. He shrank from having one fixed policy and inflexible plan for every State to be brought back into the Union. And he reasoned with his radical friends: "So great peculiarities pertain to each State, and such important and sudden changes occur in the same State, and withal so new and unprecedented is the whole case that no exclusive and inflexible plan can be prescribed as to details and collaterals. Such exclusive and inflexible plan would surely become a new entanglement."

Again, said opponents of the President, he was "backward," he played with "compromises," and what he termed "magnanimity" was in reality weakness, the same lack of decision he had shown so often in conduct of the war. They wanted to capture, try, and hang Jeff Davis. They could not under-

stand the report of Lincoln saying: "This talk about Mr. Davis tires me. I hope he will mount a fleet horse, reach the shores of the Gulf of Mexico, and ride so far into its waters that we shall never see him again." Nor could the inflexible radicals gather what was in the President's mind in such a case as that of Jacob Thompson, a Confederate commissioner in Canada who had fomented raids and ship explosions in the Great Lakes region. To a War Department query whether they should arrest and hold Thompson if found in Maine as expected, Lincoln drawled, "No, I rather think not. When you have an elephant by the hind leg, and he's trying to run away, it's best to let him run."

Whether the spirit and method of Lincoln were to have their way throughout the reconstruction of the Southern States, or whether his radical opponents would control, no one knew on this April the Fourteenth.

On that night the President and Mrs. Lincoln with two friends are seated in a box in Ford's Opera House, watching a second-rate play titled *Our American Cousin*. The play has gone on till past ten o'clock. In an easy rocking chair and hidden from the audience by curtains at his left, Lincoln leans back free from immediate cares.

And where might he be roaming in thought? If it is life he is thinking about, no one could fathom the subtle speculations and hazy reveries resulting from his fifty-six years of adventures drab and dazzling in life. Who had gone farther on so little to begin with? Who else as a living figure of republican government, of democracy in practice, as a symbol touching freedom for all men—who else had gone farther over America,

over the world? If it is death he is thinking about, who better than himself might interpret his dream that he lay in winding sheets on a catafalque in the White House and people were wringing their hands and crying "The President is dead!"— who could make clear this dream better than himself?

Furthermore if it is death he is thinking about, has he not philosophized about it and dreamed about it and considered himself as a mark and a target until no one is better prepared than he for a sudden deed? Has he not a thousand times said to himself, and several times to friends and intimates, that he must accommodate himself to the thought of sudden death? Has he not wearied of the constructions placed on his secret night ride through Baltimore to escape a plot aimed at his death? Has he not laughed to the overhead night stars at a hole shot in his hat by a hidden marksman he never mentioned even to his boon companion Ward Hill Lamon, to whom he did report one occasion of a shot whizzing past him on one horseback ride when he lost his hat? And who can say but that Death is a friend, and who else should be more a familiar of Death than a man who has been the central figure of the bloodiest war till then known to the Human Family—who else should more appropriately and decently walk with Death?

Through an outer door and through a little hallway to the door of the box where Lincoln is seated comes an Outsider. He has waited, lurked, made intricate preparations for this moment. Through a little hole he had gimleted in the box door that afternoon he studies the occupants of the box and his Human Target seated in an upholstered rocking armchair. Softly he opens the door, steps toward his prey, in his right

hand a one-shot brass derringer pistol. He lengthens his right arm, runs his eye along the barrel in a line with the head of his victim less than five feet away—and pulls the trigger.

A lead ball crashes into the left side of the head of the Human Target, "crossing the brain in an oblique manner" and lodging behind the left eye. For Abraham Lincoln it was lights out, good night, farewell and a long farewell to the good earth and its trees, its enjoyable companions, and the Union of States and the world Family of Man he had loved. He lingered, unseeing, unconscious. At a house across the street the last breath was drawn at 7:21 the next morning.

Wild scenes followed at the national capital and over the country. The assassin, one John Wilkes Booth, a stage trage-dian, tainted with insanity yet marvelous with primitive cun-ning, surrounded by pursuers in a burning barn in Virginia, died from a bullet. Deep shifts in government policy began. The mourning over Lincoln was vast and not merely national but international. More than any other figure he towered as some token and foreshadowing of a free world learning free-dom and discipline.

The funeral procession of Lincoln took long to pass its many given points. Many millions of people saw it and per-sonally moved in it and were part of its procession.

The line of march ran seventeen hundred miles.

As a dead march nothing like it had ever been attempted before.

Like the beginning and the end of the Lincoln Administra-tion, it had no precedents to go by.

It was garish, vulgar, massive, bewildering, chaotic.

Also it was simple, final, majestic, august.

In spite of some of its mawkish excess of show and various maudlin proceedings, it gave solemn unforgettable moments to millions of people who had counted him great, warm and lovable.

The people, the masses, nameless and anonymous numbers of persons not listed nor published among those present—these redeemed it.

They gave it the dignity and authority of a sun darkened by a vast bird migration.

They shaped it into a drama awful in the sense of having naïve awe and tears without shame.

They gave it the color and heave of the sea which is the mother of tears.

They lent to it the color of the land and the earth which is the bread-giver of life and the quiet tomb of the Family of Man.

Yes, there was a funeral.

From his White House in Washington—where it began—they carried his coffin and followed it nights and days for twelve days.

By night bonfires and torches lighted the right of way for a slow-going railroad train.

By day troops with reversed arms, muffled drums, multitudinous feet seeking the pivotal box with the silver handles.

By day bells tolling, bells sobbing the requiem, the salute guns, cannon rumbling their inarticulate thunder.

To Baltimore, Harrisburg, Philadelphia, New York, they journeyed with the draped casket to meet overly ornate catafalques.

To Albany, Utica, Syracuse, moved the funeral cortege always met by marchers and throngs.

To Cleveland, Columbus, Indianapolis, Chicago, they took the mute oblong box, met by a hearse for convoy to where tens of thousands should have their last look.

Then to Springfield, Illinois, the old home town, the Sangamon near by, the New Salem hilltop near by, for the final rest of cherished dust.

Thus the route and the ceremonial rites in epitome.

In Greensboro, North Carolina, at a rather ordinary house, in an upstairs room having a bed, a few small chairs, a table with pen and ink, Jefferson Davis, with four remaining Cabinet members and two veteran generals, held a final meeting over the affairs of the Confederate States of America, its government, its armies and prospects.

President Davis spoke to a man he had humiliated and quarreled with more than three years. "We should like to have your views, General Johnston."

With sharp intensity as if in anger, General Johnston: "My views are, sir, that our people are tired of the war, feel themselves whipped, and will not fight. . . . We cannot place another large army in the field. . . . My men are daily deserting in large numbers. . . . Since Lee's defeat they regard the war as at an end. . . . I shall expect to retain no man beyond the by-road or cow-path that leads to his house. . . . We may perhaps obtain terms that we ought to accept."

Davis sat unmoved. He had been calm throughout, having said: "Our late disasters are terrible, but I do not think we should regard them as fatal. I think we can whip the enemy

yet, if our people turn out. . . . Whatever can be done must be done at once. We have not a day to lose." Thus Johnston had answered, as though to break the calm of the unruffled President Davis who still seemed to carry himself as the head and front of a powerful government, commander in chief of

The farmhouse where Johnston and Sherman talked surrender terms

powerful armies that had not melted away, innocent of realities.

His eyes on the table, his fingers folding and refolding a piece of paper, Davis heard Johnston, waited, and suddenly in low easy tone: "What do you say, General Beauregard?" The reply: "I concur in all General Johnston has said."

They agreed a letter should be written to Sherman asking for terms. Johnston asked President Davis to write it—which he did. They parted.

In a little farmhouse near Greensboro, North Carolina, the two generals William Tecumseh Sherman and Joseph E. Johnston signed a peace closing out the war. Sherman had his

talk with Lincoln and Grant in mind and in the first draft peace terms were about what those other two would have arranged. Then Stanton interfered, gave the public statements outrageously unjust to Sherman, so the peace terms were re-written to agree with those Grant and Lee signed at Appomattox. From the Potomac to the Rio Grande military operations ended, the armies went home.

The sunset of the Confederacy had shaded over into evening stars, into lasting memories of a Lost Cause.

In its Richmond capitol building the enemy pawed among remaining fragments of its archives.

In its earlier and first capitol building at Montgomery, Alabama, Union horsemen made merry.

In the sky its final embers of hope had flickered and sunk and the overhead constellations lighted tall candles for remembrance.

For millions of the struggling masses of Southern people the war had settled nothing in particular, and their lives centered around the same relentless question that guided them before the war began—"How do we earn a living?"

Some would find welfare and kindness in the old Union. Two sections of the country fought a duel and came out with honors enough for both—this was the philosophy of some who really loved two flags—and why was a mystery— was their personal secret. Some who had starved and suffered and taken wounds in the rain and lived on the food of rats and lost everything except a name for valor and endurance— some of these could never repent or be sorry.

A Kentucky father who had lost two sons, one dying for

the North, the other for the South, set up a joint monument over their two graves, inscribed: "God knows which was right."

Peace was beginning to smile. Rough weather and choppy seas were ahead—but the worst was over and could not come again. The hurricane was spent, the high storm winds gone down.

Tragedy was to go on and human misery to be seen widespread. Yet it was agreed two causes directed by Lincoln had won the war. Gone was the old property status of the Negro. Gone was the doctrine of Secession and States' Rights. These two.

Black men could now move from where they were miserable to where they were equally miserable—now it was lawful for them to move—they were not under the law classified as livestock and chattels. Now too the Negro who wished to read could do so; no longer was it a crime for him to be found reading a book; nor was it now any longer a crime to teach a Negro to read. The illiterate, propertyless Negro was to be before the law and the Federal Government an equal of the illiterate, propertyless white—and many sardonics were involved. And in spite of its many absurd and contradictory phases the Negro had a human dignity and chances and openings not known to him before—rainbows of hope instead of the auction block and the black-snake whip.

Decreed beyond any but far imagining of its going asunder was Lincoln's mystic dream of the Union of States, achieved. Beyond all the hate or corruption or mocking fantasies of democracy that might live as an aftermath of the war were assurances of long-time conditions for healing, for rebuilding,

for new growths. The decision was absolute, hammered on terrible anvils. The Union stood—an amalgamated and almost an awful fact.

Now too, as Lincoln had pledged, a whole mesh of trammels and clamps on Western migration were to be cut loose. The homesteaders held back by the Southern landed proprietors could go. And the Pacific railways could go; the jealousies suffocating them were out. With almost explosive force the industrial, financial, and transportation systems of the North could be let loose, free to go. The war had done that. Incidental costs might be staggering, but the very onrush of them was to testify that they had been under restraint. Now they could go—with all their benefits and exploitations, their mistakes from which they must later learn to cease and desist.

Now also, as a result flowing from the war, the United States was to take its place among nations counted World Powers. The instinct of the Tories and the imperialists of the British Empire that they, if the North won its war for the Union, would have a rival was correct. And as a World Power the expectation was it would be a voice of the teachings of Washington, Jefferson, Jackson—and Lincoln—speaking for republican government, for democracy, for institutions "of the people, by the people, for the people." That too was the hope of the British masses, the workingmen whose decisive stand for the Union and emancipation had helped the North win, as also did the counsels of Queen Victoria, the Duke of Argyll, and a fraction of the upper classes. Though there might come betrayals and false pretenses, the war had put some manner of seal on human rights and dignity

in contrast with property rights—and even the very definitions of property.

In a storm of steel and blood, without compensation and rather with shrill crying of vengeance, with the melancholy and merciless crying out loud that always accompanies revolution, property values of some $3,000,000,000 had gone up in smoke, had joined the fabrics of all shadows. In sacrifice and moaning one property category had been struck off into emptiness and nothing. At terrific human cost there had been a redefinition of one species of property.

The delicately shaded passages of the second inaugural wept over the cost of doing by violence what might have been done by reason. Yet looking back it was seen that violence and not reason was ordained. With all its paradoxes and perfect though cruel sincerities, with all its garrulous pretenses and windy prophecies, the war testified to the awfulness of pent-up forces too long unreasonably held back. Of what avail the wisdom of the wise who could not foresee a House Divided and prepare it against storm that threatened final hopeless wreck and ruin? Of what service either the eminently practical men or the robed and assured professional and learned classes if human advance must be at such cost of suffering?

Out of the smoke and stench, out of the music and violet dreams of the war, Lincoln stood perhaps taller than any other of the many great heroes. This was in the mind of many. None threw a longer shadow than he. And to him the great hero was The People. He could not say too often that he was merely their instrument.

These were meditations and impressions of the American people in days following April 14 of 1865.

The ground lay white with apple blossoms this April week. The redbird whistled. Through black branches shone blue sky. Ships put out from port with white sails catching the wind. Farmers spoke to their horses and turned furrows till sundown on the cornfield. Boys drew circles in cinder paths and played marbles. Lilac bushes took on surprises of sweet, light purple. In many a back yard the potato-planting was over. In this house was a wedding, in that one a newborn baby, in another a girl with a new betrothal ring. Life went on. Everywhere life went on.

To General Robert E. Lee in Northern Virginia one day came a young mother. She wanted his blessing for her baby. He took the little one in his arms, looked at it, looked at her. Then came the slow words: "Teach him he must deny himself."

TAPS ("LIGHTS OUT")

INDEX

This index contains all names of persons and places (including rivers) connected with the war; not those casually referred to, or later references to battles. Confederates are designated (*CSA*), but not Union government or army men. Inclusive paging often means *passim*. Newspapers and magazines are not included.